JOCK MACDONALD
EVOLVING FORM

JOCK MACDONALD
EVOLVING FORM

ART GALLERY
OF GREATER VICTORIA

The
Robert
McLaughlin
Gallery

Vancouver
Artgallery

black dog
publishing
london uk

COVER IMAGE
Etheric Form, 1934 (detail)
oil on panel
38.1 x 30.5 cm
Collection of the Vancouver Art Gallery,
Gift from an Anonymous Donor

Contents

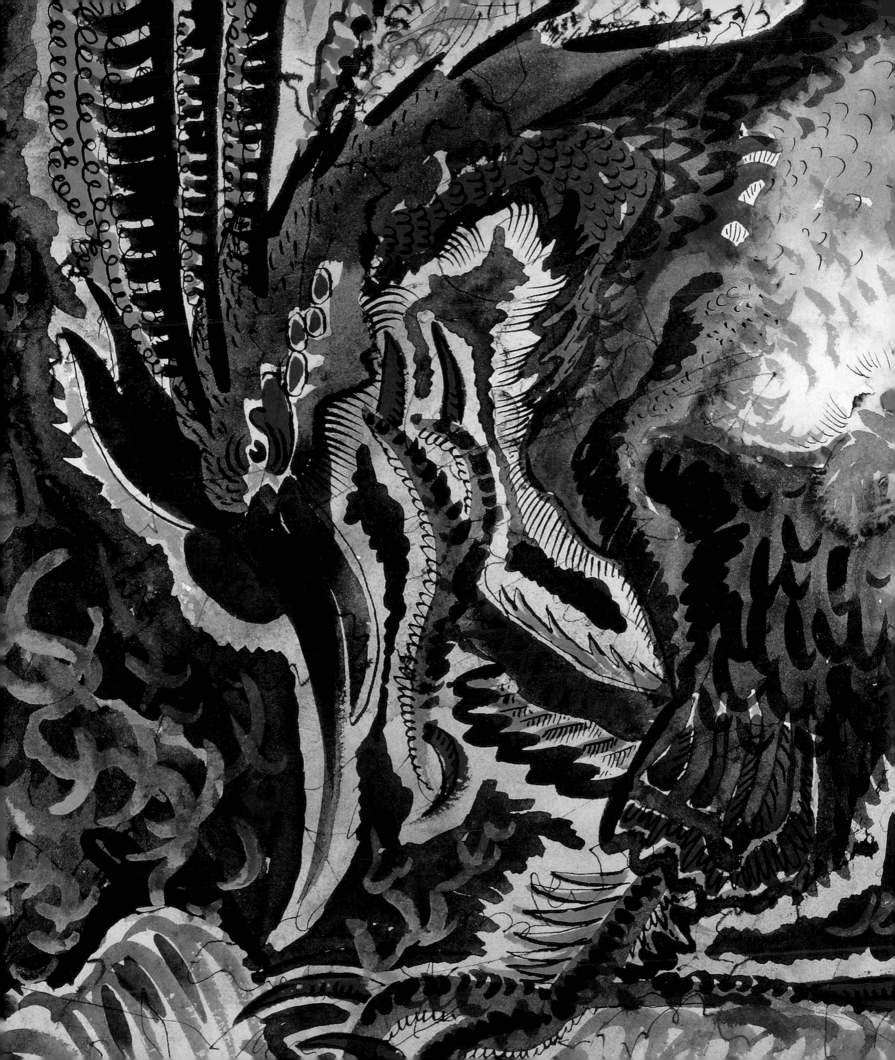

Directors' Foreword

Kathleen S. Bartels, Director, Vancouver Art Gallery
Gabrielle Peacock, Chief Executive Officer, The Robert McLaughlin Gallery
Jon Tupper, Director, Art Gallery of Greater Victoria

It has been over three decades since the last solo exhibition of Jock Macdonald's visionary artwork toured the country. We are pleased to introduce this significant artist to an entirely new generation of Canadian audiences.

Macdonald, as the essays in this book make clear, was an exceptional individual whose journey as an artist had profound effects on both his own life and art, as well as that of many others. An enormously distinguished teacher in Vancouver, Calgary, Banff and finally Toronto, Macdonald was an inspiration to his students and a great supporter of other artists' work.

It is fitting that the Vancouver Art Gallery, Art Gallery of Greater Victoria and The Robert McLaughlin Gallery should come together to celebrate Macdonald and his work. The artist touched each of these institutions in important ways. In Vancouver, he was active in the life of the Vancouver Art Gallery, where for over a decade he was a member of the Gallery Council and taught children's art classes. His *Indian Burial, Nootka* (1937) was one of the institution's important early purchases. He was also one of the few artists in the city who actively supported Emily Carr, buying one of her small paintings in 1938 even though he and his wife were chronically short of money. In the summer of 1952, Macdonald was invited to be artist in residence at the Art Gallery of Greater Victoria, where he presented an exhibition of automatic watercolours and conducted lectures and classes for an enthusiastic public. His painting *Contemplation* (1958), acquired in 1964, was one of the first abstract works the AGGV would purchase. Macdonald was a founding member of Painters Eleven and two of his paintings, *Rust of Antiquity* (1958) and *Phoenix* (c.1949)— both of which are in this exhibition—were part of Alexandra Luke's original gift that started The Robert McLaughlin Gallery's permanent collection, which now has one of the most important collections of Macdonald works in a public museum.

Each of our institutions recognizes the significance of exhibitions and scholarship on historical Canadian art. It is through presentations such as *Jock Macdonald: Evolving Form* and this accompanying book—as well as our permanent collections—that art galleries make critical contributions to the history of Canadian art.

We congratulate the curators—Michelle Jacques, Linda Jansma and Ian M. Thom— for realizing such an ambitious undertaking. The result is an exhibition that will be a revelation to most viewers and a confirmation of Macdonald's singular vision and significant impact on Canada's artistic development. We also appreciate the important text that Anna Hudson has written for this book and extend our thanks to Duncan McCorquodale and Black Dog Publishing for their immeasurable support and enthusiasm for the publication.

The Museums Assistance Program of the Department of Canadian Heritage has generously supported this project. The Vancouver Art Gallery extends great appreciation to the Richardson Family as our Visionary Partner Supporting Publications, and to Barry and Drinda Scott for their generous contribution to the exhibition in Vancouver. Finally, each of us is grateful to our Boards of Trustees, who provide essential support in all of our endeavours.

Phoenix, c. 1949 (detail)
watercolour, ink on paper
25.4 x 35.7 cm
Collection of The Robert McLaughlin
Gallery, Oshawa, Gift of Alexandra
Luke, 1967

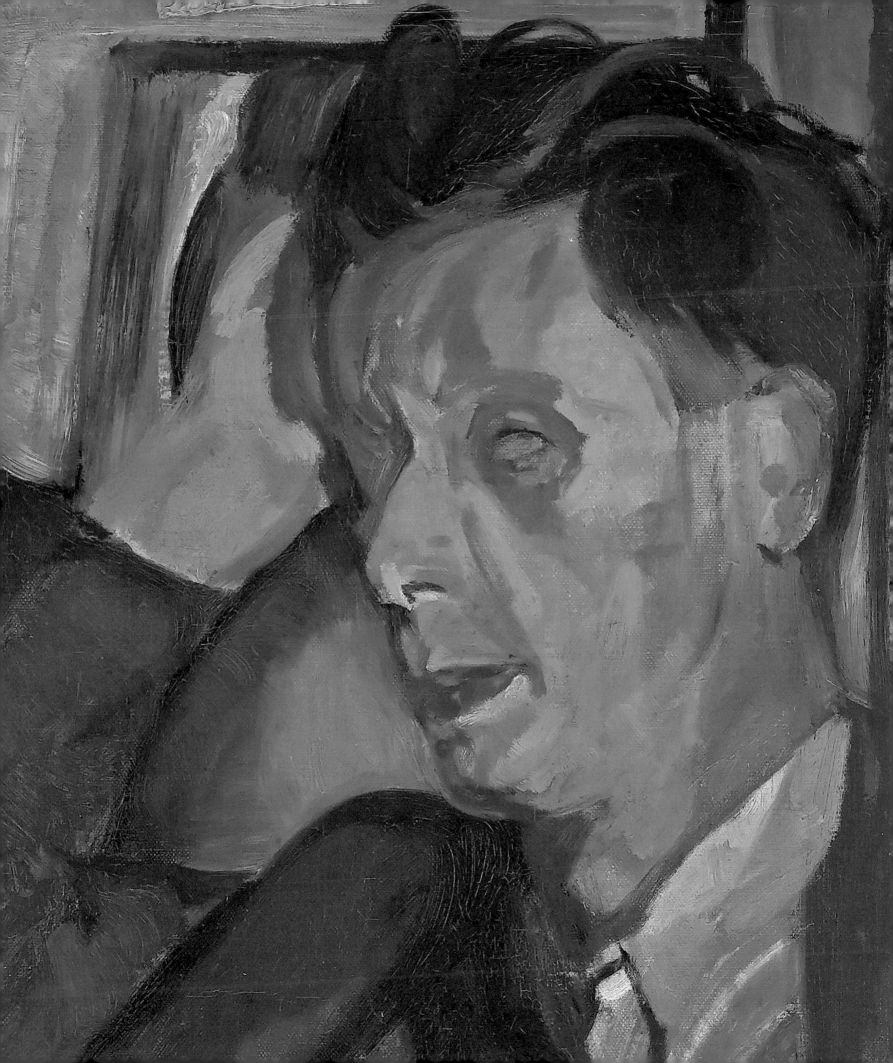

Jock Macdonald: A Biographical Sketch

Ian M. Thom

James Williamson Galloway Macdonald, who went by the name "Jock," was born in Thurso, Scotland in 1897. He attended school in Thurso and later in Edinburgh.[1] The son of an architect, he initially worked as an architectural draftsman in Edinburgh and seems to have had no artistic training before World War I. In 1915, he enlisted in the 14th Argyll and Sutherland Highlanders and was sent to France, where he was a gunner.[2] Wounded in 1918, he spent several months recuperating in Ireland. Upon his return to Scotland in 1919, he enrolled in the Edinburgh College of Art. There he studied design, training with artists Charles Paine (1895–1967) and John Platt (1886–1967), and seems to have specialized in textiles, commercial design and woodcarving. A gifted student, Macdonald received prizes and scholarships. He graduated in 1922 with a Design Diploma in Art and a Specialist Art Teacher's Certificate.[3] The year was also important in his personal life, for he married fellow student Barbara Niece.

His first major employment was with the textile design firm Morton Sundour Fabrics Limited in Carlisle, England. Unfortunately, while we know that he was actively involved in designing patterned textiles—carpets, draperies, etc.—for the next three years we have no designs that can be attributed to him. He did, however, tell his friend Maxwell Bates (1906–1980) that he had designed curtains for Edinburgh's Holyrood Palace.[4] This practical experience within the design world was doubtless what attracted him to the Lincoln School of Art, where he assumed the duties of Head of Design in 1925.[5] His stay there was extremely short, for in early 1926 he answered a newspaper advertisement for a position offered by the fledgling Vancouver School of Decorative and Applied Arts. The school's principal, Charles Hepburn Scott (1886–1964), invited him to take up duties as Head of Design and Instructor for Commercial Art in the fall term of 1926. Macdonald began his work—joining Scott, Grace Melvin (1892–1977) and most importantly, Frederick Horsman Varley (1881–1969)—in September of that year.[6]

The artistic community in Vancouver was very much centred on the School (now Emily Carr University of Art + Design), which had opened its doors under the auspices of the Vancouver School Board in 1925. Varley, a member of the Group of Seven who had come from Sheffield by way of Toronto, was hired to lead the Painting Department and the two recent immigrants became colleagues and close friends. At this point in his career, the twenty-eight-year-old Macdonald considered himself not a painter, but a designer.

It is likely that Macdonald began to go sketching with Varley and students from the School in 1927. Both his colleagues and his wife, who had studied painting herself, encouraged him. As the artist later observed, it was difficult to change a design sensibility into that of a painter:

Frederick Horsman Varley
J.W.G. (Jock) MacDonald, 1930 (detail)
50.7 x 45.9 cm
Collection of the Winnipeg Art Gallery,
Acquired with Funds from the Collection
of the Winnipeg Foundation
and an Anonymous Donor

As one of their designers in the factory, I had certain expressions of design forms, colour combinations and commercial mannerisms well saturated in my blood. It was the hardest battle to get them out of my system when I commenced to paint. The line and decorative forms were always forcing themselves too much, so much so that I can clearly see now what my wife and Varley meant when they remarked that I was producing coloured drawings.[7]

We know that initially Macdonald felt more comfortable with drawing the landscape than painting it, but by 1931 the artist was confident enough to exhibit a canvas— *Lytton Church* (1930), now in the collection of the National Gallery of Canada—in the Royal Canadian Academy Annual and had established himself as a painter.[8] Macdonald also became involved in the new Vancouver Art Gallery, joining the Council in 1932. The year following, he became one of the founding members of the Canadian Group of Painters.

It appears that all was well with Macdonald's work at the School for several years, but in 1933 the Depression forced the institution to take drastic measures and salaries were slashed. Macdonald and Varley felt that they were unable to continue and instead opened their own competing school, the British Columbia College of Arts, where again Macdonald was to run the Design and Commercial Art Department.[9] The College had a brief and glorious blossoming, approaching art education in a new, cross-disciplinary way. By 1935, however, it was clear that there were neither the students nor the funds to continue and the College closed. Macdonald was left to settle its debts so that it would not close "in bad odour."[10]

Macdonald, finding himself in straitened economic circumstances and unable to find work in Vancouver, made a remarkable decision. He, along with his wife, daughter Fiona and three others from the College (Harry Tauber, Leslie Planta and John Varley), decided to move to Nootka Sound on the west coast of Vancouver Island. As Joyce Zemans has pointed out, the relocation represented "an opportunity to renew contact with nature and to seek the stimulation for revitalized artistic activity."[11] Macdonald spent more than a year in this remote area, in very difficult and trying circumstances. The experience was, however, a deeply rewarding one artistically, as it allowed Macdonald to get really close to nature in a way that had not been possible in the city. A back injury forced him to return to Vancouver in the fall of 1936.[12]

There was little employment opportunity for Macdonald in Vancouver. He taught initially at the Canadian Institute of Associated Arts, then at Templeton High School and finally Vancouver Technical School. Although his situation was difficult, he was recognized as one of the leading figures in Vancouver's art community at the time. In 1939 he was one of several artists asked to contribute to the decorative scheme of the new Hotel Vancouver. He chose to depict a scene loosely based on Friendly Cove, Nootka, which had also been the subject of canvases, such as the painting *Indian Burial, Nootka* (1937) that he had sold to the Vancouver Art Gallery in 1938. He formed a friendship with Lawren Harris (1885–1970), who settled in Vancouver in 1940, and the two went sketching in the Rockies in 1941. He also served as President of the British Columbia Society of Artists in 1941 and, in that capacity, attended the Kingston Conference that laid the groundwork for the future Canada Council for the Arts.

Macdonald and his former colleagues at the College, as well as Harris, were all deeply interested in ideas of spiritualism in art. Macdonald had read the work of P. D. Ouspensky, *Tertium Organum: A Key to the Enigmas of the World*, and this no

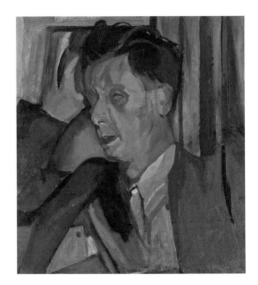

Frederick Horsman Varley
J.W.G. (Jock) MacDonald, 1930
50.7 x 45.9 cm
Winnipeg Art Gallery, Acquired with
Funds from the Winnipeg Foundation
and an anonymous donor

doubt disposed him favourably to surrealist ideas. He probably met the surrealist artist and psychiatrist Dr. Grace W. Pailthorpe in 1944 and began to produce automatic works under her influence in 1945.[13]

Despite the respect of his colleagues, it was difficult to make a living and Macdonald needed to support his family. This was not possible in Vancouver and so in the fall of 1946 he took a position teaching at the Calgary Institute of Technology. He only lived in Calgary for one year, where he met the artist and architect Maxwell Bates, who became a lifelong friend.

The fall of 1947 saw Macdonald take up his final teaching position at the Ontario College of Art in Toronto. The artist was now teaching painting, which demonstrated the shift in emphasis that had occurred in his career and his growing importance as a painter. He continued to teach at the College until the end of his life. He also travelled extensively through the period, often visiting western Canada. In 1953, he became one of the founding members of Painters Eleven. These abstractionists represented some of the most advanced art being produced in Canada.[14]

The final years of Macdonald's life were ones of enormous artistic growth. In the summers of 1948 and 1949 he studied with Hans Hofmann in Provincetown, Massachusetts. Hofmann urged him to loosen up his style and reduce his reliance on line in favour of colour.[15] The year 1949 also saw recognition of his work as a teacher, as he was invited to Breda in The Netherlands to teach for UNESCO during the summer; the following year, he was invited to do the same in France.

Jock MacDonald, 1957
Photo by Peter Croydon

Macdonald had begun exhibiting in the early thirties, but by 1950 he had solo exhibitions at the Vancouver Art Gallery (1944 and 1946), the San Francisco Museum of Art (1947) and Hart House, Toronto (1947). He had taught at the Banff School of Fine Arts several times since the summer of 1945 and was highly regarded there as well. He returned there to teach again in 1951 and 1952. He was also artist in residence at the Art Centre of Greater Victoria (now the Art Gallery of Greater Victoria) in the summer of 1952 and had a solo exhibition there that August. Having spent the last several years working predominantly in watercolour, it is appropriate that he was also elected President of the Canadian Society of Painters in Water Colour in 1952. He also became an executive member of the Ontario Society of Artists that year.

Macdonald was a very important teacher and certainly one of the most popular with his students at the College. One of those students, William Ronald, was the prime initiator behind what was to become Painters Eleven in 1953. Macdonald was invited to be a member and took part in their inaugural exhibition at the Roberts Gallery in Toronto in 1954. Painters Eleven offered a new focus for modernist ideas in Toronto and was a breath of fresh air compared to the academicism that Macdonald found at the College. Another important break for Macdonald in 1954 was his receipt of a Royal Society of Canada fellowship that would allow him to work and study in France. Without the restrictions of teaching, Macdonald could devote himself to painting more completely. After travels that took him back home to Scotland, as well as to London and Paris, Macdonald eventually settled in Nice. There he met Marc Chagall (1887–1985) and, more importantly, Jean Dubuffet (1901–1985).

When Macdonald showed Dubuffet his work, he was advised: "speak in oil as you speak in watercolour."[16] This guidance encouraged him to look "to experiment, to find my next pathway."[17] In 1957 he began painting with pyroxylin, a fluid and quick-drying medium that allowed him a greater freedom of movement in his work. The real breakthrough came, however, when fellow Painters Eleven artist Harold Town introduced him to Lucite 44.[18] The new freedom that a mixture of Lucite 44 and oil allowed was transformational for Macdonald's work.[19]

That same year saw the first serious writing on Macdonald's career in the form of an article in *Canadian Art* by Bates. Entitled "Jock Macdonald Painter-Explorer," the article suggests the seriousness of Macdonald's endeavour and quotes the artist extensively. Although, as Zemans has noted, there were issues with illustrations and getting the article accepted in a timely manner, this text was a major affirmation of Macdonald's importance as an artist.[20]

In the fall of 1957, Macdonald had another solo exhibition at Hart House. It was very well received, as the artist noted in a letter to Bates, which led to the offer of another solo show at The Park Gallery in Toronto in April 1958.[21] Amazingly, despite his hectic teaching duties and his participation in exhibitions with Painters Eleven, Macdonald was able to produce enough work for the exhibition. His output was prodigious and, as he reported to Bates in May 1958, he had done almost a painting a week for the previous year.[22]

While the warm reception that Macdonald's work was receiving must have been welcome, the pressure of exhibiting, teaching and making work was undoubtedly considerable. This culminated in 1960, the final year of Macdonald's life. Early in the year he had a solo exhibition at the Here and Now Gallery in Toronto, after which he was offered a singular honour: a retrospective at the Art Gallery of Toronto

(now the Art Gallery of Ontario). This show was the first to look at the whole of Macdonald's career and was the first retrospective the Gallery offered to a living artist who was not a member of the Group of Seven.[23] It was very well received and Macdonald, who had previously expressed concerns about the presentation to his friends Marion (1909–1985) and Jim (1892–1986) Nicoll,[24] was able to report on its success to Bates: "The critics spoke very highly of my work, the artists have been quite appreciative and the public thoroughly interested—thank heaven, all is well!"[25]

Macdonald was clearly at the peak of his game. Tragically, it was not to last. That summer he taught at the Doon School of Fine Arts and returned to the College in the fall. In November he suffered a heart attack. After a brief convalescence in hospital he returned home, expecting to paint over the next few weeks. On December 3, 1960, he suffered a fatal heart attack.

ENDNOTES

1. "Top Canadian Artist Dies in Toronto," *Toronto Telegram*, December 5, 1960.
2. "Who's Who in Ontario Art," *Ontario Library Review*, 33:3 (August 1949): 257–258.
3. *British Columbia College of Arts Limited: Illustrated Prospectus 1934–1935* (Vancouver: British Columbia College of Arts Limited, 1934).
4. Macdonald to Maxwell Bates, January 2, 1957 (McCord Museum Archives, Montreal).
5. Prospectus.
6. VSDAA records, held at Emily Carr University of Art + Design, Vancouver.
7. Macdonald to G. H. Tyler, January 2, 1936 (copy in National Gallery of Canada Archives, Ottawa).
8. Beatrice Lennie, quoted by R. Ann Pollock, in *Jock Macdonald Retrospective Exhibition* (Ottawa: National Gallery of Canada, 1969), 4.
9. Prospectus.
10. Macdonald to H. O. McCurry, December 29, 1936 (National Gallery of Canada Archives).
11. Joyce Zemans, *Jock Macdonald: The Inner Landscape* (Toronto: Art Gallery of Ontario, 1981), 59.
12. This crucial period in Macdonald's development is discussed in my essay *The Early Work: An Artist Emerges* and Macdonald's *Nootka Diary*, both of which are included in this publication.
13. Linda Jansma, "Jock Macdonald, Dr. Grace W. Pailthorpe, and Reuben Mednikoff: A Lesson in Automatics," 39.
14. Michelle Jacques, "Finding His Way: Jock Macdonald's Toronto Years," 75.
15. Zemans, 152.
16. Macdonald to Bates, March 20, 1955 (McCord Museum Archives).
17. Ibid.
18. Macdonald to Bates, July 3, 1957 (McCord Museum Archives).
19. Zemans, 193.
20. Zemans, 192.
21. Macdonald to Bates, December 10, 1957 (McCord Museum Archives).
22. Macdonald to Bates, May 17, 1958 (McCord Museum Archives).
23. Arthur Lismer, Fred Varley and A. Y. Jackson had all been accorded retrospectives during the fifties; Lawren Harris received one in 1948.
24. Macdonald to Marion and Jim Nicoll, March 5, 1960 (McCord Museum Archives).
25. Macdonald to Bates, May 10, 1960 (McCord Museum Archives).

The Early Work: An Artist Emerges

Ian M. Thom

In February 1940, Jock Macdonald delivered a lecture in Vancouver entitled "Art in Relation to Nature."[1] It was a statement of his artistic beliefs and ideas, which had been influenced by the course of his life, his colleagues and the studying he had done since his arrival in Vancouver in 1926. The lecture reveals Macdonald as a man deeply concerned with making art that transcends the quotidian and strives for something greater, "achieving values beyond the material."[2]

It is worth quoting a few passages, as they reveal a great deal about Macdonald and his thoughts on art. He begins by asking the question: "What do we mean by Nature?" It is clear that for him Nature is an expansive and comprehensive term that extends beyond the specifics of flora and fauna to the universal.

> Great Art is not found in the mere imitation of nature, but the artist does perceive through his study of nature the awareness of a force which is the one order to which the whole universe conforms. Art in all its various activities is trying to tell us something about life. Art must include in its study of nature the whole universe, if it is to envisage some aspect of the universal truth and help humanity to become conscious of the meaning of life.[3]

Macdonald touches on the ideas of Jay Hambidge, P. D. Ouspensky, Sir James Jeans and others, but the essence of his argument—a distillation of many sources—is that art must strive to break out of the tangible reality of daily experience to realize the highest "planes of art expression."[4] He identifies himself, and by implication his art, as a voice for the new and states: "The expression of this new art cannot help itself evolving—it is the art which is the conscious expression of our time."[5]

The purpose of this essay is to examine the work that allowed Macdonald to come to the positions that he espouses in this important lecture. This journey is a remarkable one, especially when one considers that the artist was not a painter when he arrived in Vancouver. He had come to the city to teach design at the young Vancouver School of Decorative and Applied Arts, which was established only the year before under the aegis of the Vancouver School Board. The School's principal was the painter Charles Hepburn Scott, who had hired two new teachers: Macdonald and the painter Frederick Varley. Soon after meeting, Varley encouraged Macdonald to consider painting and the two began sharing a studio in 1927.[6] The earliest examples of Macdonald's work are graphic designs that he produced for the School and later the British Columbia Society of Fine Arts, as well as a group of line drawings from the late twenties. One of the latter, *Old Trees, Chekamus Canyon* (1929), demonstrates his considerable skills as a draftsman and his command of linear pattern. The subtle forms of the trees, the blacks of the shadows and the light areas give the composition rhythm and spirit.

Formative Colour Activity, 1934 (detail)
oil on canvas
77 x 66.4 cm
Collection of the National Gallery of
Canada, Ottawa, Purchase, 1966

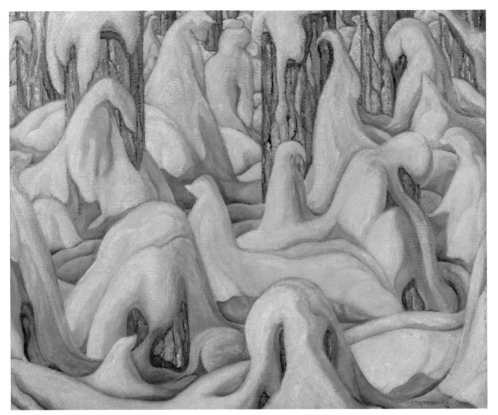

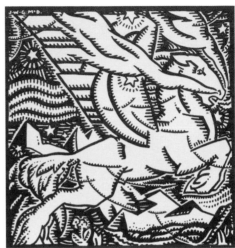

In these early years, Macdonald also provided the illustrations for Annie Charlotte Dalton's *The Neighing North*, published in 1931. Although the drawings are uneven, the frontispiece is a graphic tour de force. At the same time, Macdonald had begun to paint, encouraged by both Varley and his wife Barbara. A notable early success was *Lytton Church, BC* (1930), which he sold to the National Gallery in 1932. This painting marked Macdonald's emancipation from Varley's direct tutelage, because he submitted it for exhibition without showing it to his colleague first.[7]

A more successful canvas, *Yale Valley, BC* (c.1932), is based on a small panel that is now in a private collection. The intricate linear pattern of the train tracks, the aerial view and the taut composition represent a considerable move beyond the rather awkward forms of *Lytton Church, BC*. Although clearly informed by Macdonald's strong design sense, the work is an accomplished image; most striking is the development of the artist's sense of space, which is far beyond the shallow decorative schema of *Chekamus Canyon*. Here he is willing to adopt an elevated viewpoint that allows a panoramic view, while not being constrained by literal representation. The lines of the railway tracks seem to float over the entire composition. This distancing is something that would be of use at other points in his treatment of landscape subjects.

The year 1932 also saw the production of two other major canvases: *In the White Forest* and *The Black Tusk, Garibaldi Park*. A quick comparison of the three works reveals that they share virtually nothing in common, aside from the fact that they are landscapes. All three reveal the complexity of influences that were helping to form Macdonald's style. Aside from Varley, the artist was influenced by discussions at Vanderpant Studios; Harry Tauber's recent arrival in Vancouver (likely 1931 or early 1932), who brought with him the ideas of Rudolph Steiner and other European

LEFT
In the White Forest, 1932
oil on canvas
66 x 76.2 cm
Collection of the Art Gallery of Ontario, Toronto, Purchase, 1975

RIGHT
Illustration for *The Neighing North*, 1931
Private Collection

The Black Tusk, Garibaldi Park, 1932
oil on canvas
71 x 90.8 cm
Collection of the Vancouver Art
Gallery, Gift of Michael Audain and
Yoshiko Karasawa

modernists; as well as his likely exposure, through Annie Dalton, to the ideas of Lawren Harris.[8] The spectral light that illuminates *In the White Forest* is, as Joyce Zemans has noted, clearly reminiscent of some of Harris' work, but it is also heavily inflected with Macdonald's design sensibility.[9] He alludes to what he was searching for in this work in a letter: "The subject in its expression conveys more the inner (mental) interpretation of snow in the forest much more so than the other visible impression."[10] The work has a beguiling beauty and subtlety in its use of colour, but it would be a mistake for us to think that this is an actual depiction of the natural world. The search for something beyond the literal is a characteristic that animated all of the artist's work through the thirties. *The Black Tusk, Garibaldi Park* is a dramatic image that can easily hold its own with Varley's images of the same region—such as *The Cloud, Red Mountain* (c. 1928) and *Early Morning, Sphinx Mountain* (c. 1928)—but it is, clearly, a work by Macdonald that demonstrates he has moved beyond emulation of his older colleague. If these works by the two artists share something of the same heightened colour palette, the powerful dynamism of the composition and the paint application mark the *Black Tusk* image as distinctly Macdonald's.

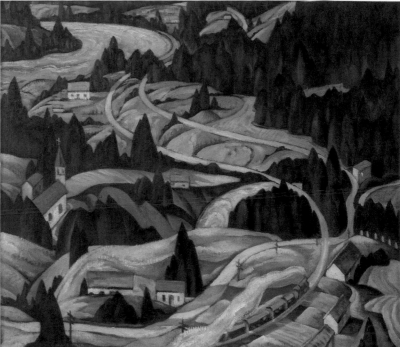

The issue Macdonald faced in these years was how to move these disparate aspects of his interests—nature, philosophical and scientific thought—forward within the context of his art. As both Zemans[11] and Allison Colborne[12] have convincingly argued, the ethos in which the artist was working was a complex one, which had wide implications for modernist art. A clear indication of how Macdonald sought a direction for his art emerges in a canvas from 1934, *Formative Colour Activity*. Macdonald recalled the creation of the work as follows:

> The idiom suggested flowers. At that time I was interested in colour + had been, for some time, carefully observing colour in flowers and plants. But I created the canvas with no pre-conceived planning. I drew nothing on the canvas. I started off with pure vermillion. Well do I remember doing it. I painted the canvas from beginning to end without stopping to eat or rest. I was in an extasy + was pale and exhausted, but terribly exhilerated, when I finished.[13]

The composition is a fascinating one. While clearly having a basis in nature, the work also strives toward the ineffable. We look into and beyond the actuality of nature and the swirling forms only just cling to definition. It is, as Zemans writes, "key to Macdonald's future investigations."[14] *Formative Colour Activity* was painted at a time of enormous change in Macdonald's life. He and Varley had left the School in 1933 and started their own institution, the British Columbia College of Arts. Harry Tauber and others joined them in this endeavour and it seemed to be a time of great promise and new beginnings. However, the harsh economic realities of trying to run a private art school during the Depression soon asserted themselves and the school was only fully operational for two terms. The closing of the College in 1935 strained Macdonald's friendship with Varley. After attempting to wind up the institution's affairs, Macdonald and his family left Vancouver to try living and working on the west coast of Vancouver Island. It was to be both an exciting and extremely difficult period of his career.

LEFT
Formative Colour Activity, 1934
oil on canvas
77 x 66.4 cm
Collection of the National Gallery of Canada, Ottawa, Purchase, 1966

RIGHT
Yale Valley, BC, c. 1932
oil on canvas
77 x 86.5 cm
Courtesy of John A. Libby Fine Art, Toronto

OPPOSITE
Indian Church, Friendly Cove (recto), 1935 (detail)
oil on wood panel
37.9 x 30.5 cm
Collection of the Art Gallery of Ontario, Toronto, Purchased with assistance from Wintario, 1979

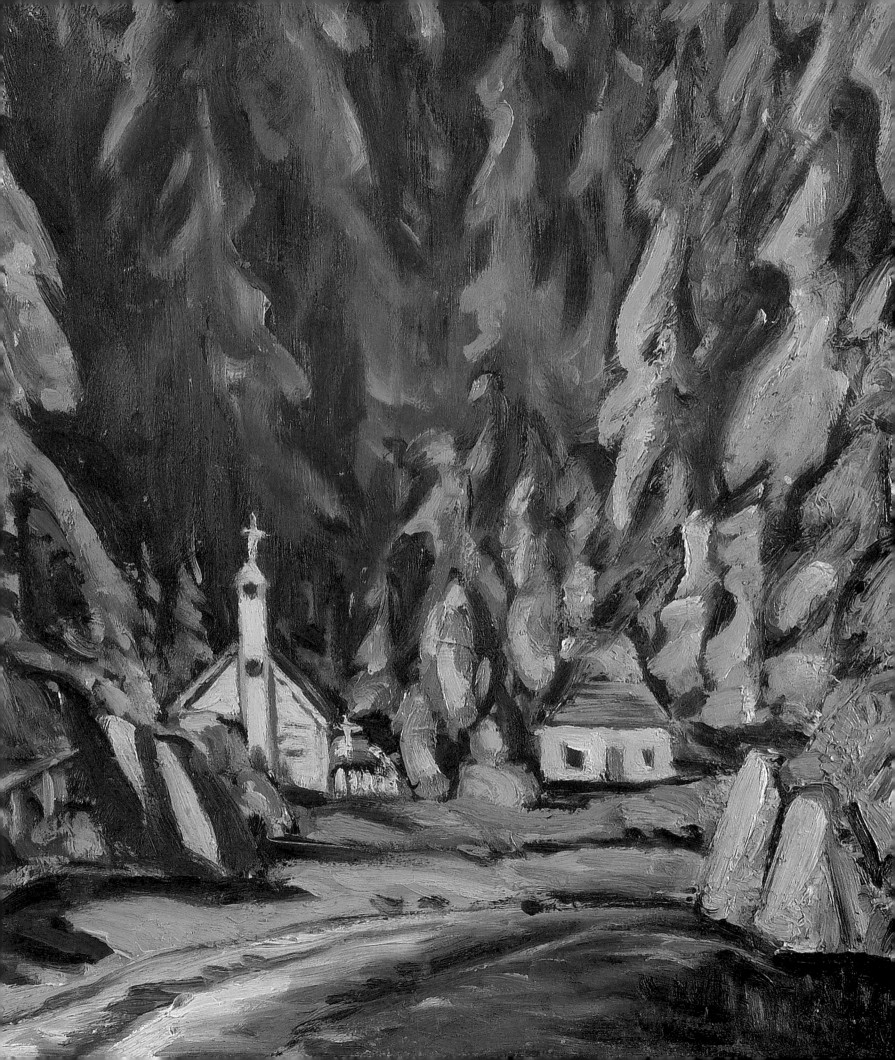

The Macdonald family did not make the journey to the Island's Friendly Cove on Nootka Sound by themselves; Harry Tauber and his friend/lover Leslie Planta joined them, and together they planned to make a community in this remote region.[15] When they arrived, the artist and his family tried to rehabilitate some abandoned cabins. It was a period of enormously hard work, punctuated by injury and poverty, and—remarkably—it was a time when his work grew deeper and richer. He produced a large number of oil on panel sketches, drawings and watercolours, several of which were sent to Vancouver to be sold and therefore generate some modest income. Macdonald's landscapes of the region are strikingly vivid compositions and it is significant that he was able to produce so much work, of such quality, in the face of such difficult circumstances. The artist's observations of the local Nuu-Chah-Nulth people's culture gave him an important new subject and, in 1935, Macdonald also produced the first of his major canvases of First Nations subjects, *Friendly Cove, Nootka, BC*.

What is even more noteworthy in this period is the fact that Macdonald developed his practice to amplify and expand the direction seen in *Formative Colour Activity*.

Indian Church, Friendly Cove (recto), 1935
oil on wood panel
37.9 x 30.5 cm
Collection of the Art Gallery of Ontario, Toronto, Purchased with assistance from Wintario, 1979

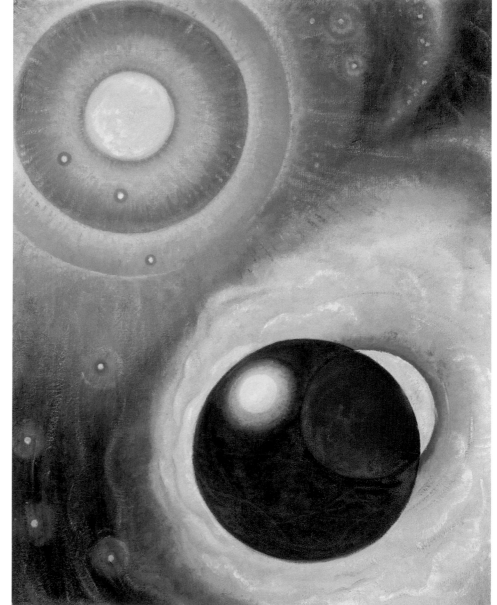

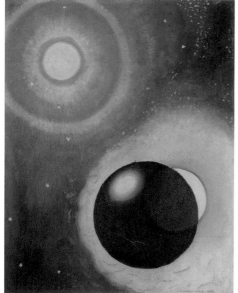

Three small panels reveal the range and ambition of his thinking. The first is a double-sided work, *Indian Church, Friendly Cove/Departing Day* (1935). The *Indian Church, Friendly Cove* recto side of the panel depicts a few buildings, including the church that Emily Carr memorably depicted in her own work, *Indian Church* (1929), and another building almost overwhelmed by the dense forest landscape. The image suggests that Macdonald had witnessed the scene and, like other sketches from the period, had produced it outdoors before the subject. The composition on the reverse is a startling expression of all that the artist was striving for; *Departing Day* is set in a cosmos that incorporates some of his ideas of the fourth dimension, a realm beyond easy apprehension. The second panel, *Etheric Form* (1935), which Zemans has described as "the most successful of Macdonald's early abstractions," makes "a symbolic statement about the nature of the universe."[16] The work depicts an unknowably deep spatial realm and yet it is surprisingly flat. The glowing orb—a star perhaps—hangs on a shimmering rope of light. Macdonald was deeply struck by the landscape of the region, but was also discussing the ideas of Steiner,

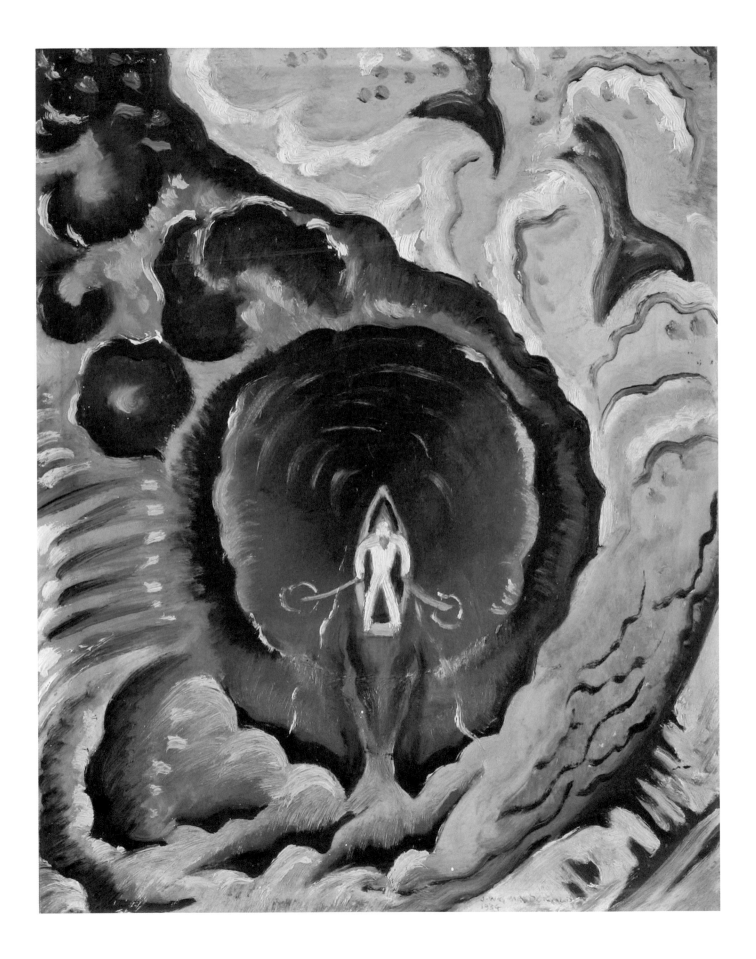

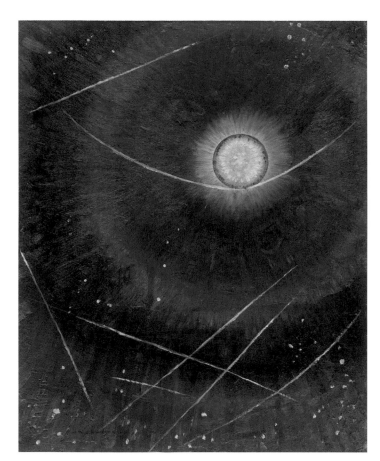

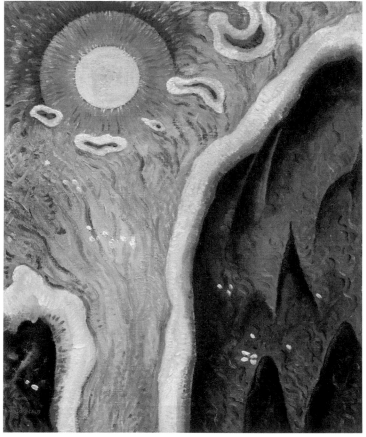

Ouspensky and D. H. Lawrence while living a pioneer life on Nootka Sound; *Pacific Ocean Experience* (c. 1935), the third panel, is perhaps the most accomplished expression of Macdonald's connection through nature to a world beyond. The image shows a single oarsman, seen from above, in a sweeping ocean landscape that is complete with two whales at the upper right corner of the image. It is a mind's-eye view that suggests the insignificance of humankind and its activities within the natural world. At the same time, somewhat paradoxically, the figure in the rowboat is contained within a mandorla or halo, a point of stillness within the swirling forces that surround him. Macdonald's diary of his time spent in Nootka often speaks of rowing to and from the lighthouse and across the lagoon near where they were attempting to renovate their cabins. Here we see an expression of the microcosm of humanity within the macrocosm of Nature. The overtones of spirituality associated with the mandorla give the work a sense of awe and wonder that transcends lived experience and enters the realm of higher consciousness, something deeply influenced by the tenets of theosophy and anthroposophy.

Another work painted in Nootka is even more mysterious. *Day Break* (1936), also inscribed *May Morning* by Macdonald, is an imaginative depiction of the passing of night into day. The whole work shimmers with energy and it is unclear if we are looking at ocean or sky. Brilliant yellows and oranges mark the divisions between darkness and light, and strange triangular shapes appear within the dark section. At the top left of the canvas is the orb of the sun, surrounded by a halo of clouds. Clearly Macdonald is creating a view of nature that can be seen by the imagination rather than the eye. The work shares an aerial viewpoint with *Pacific Ocean Experience*, but where that work reflects something of the artist's lived experience within the vastness of nature, *Day Break* reveals his rich visual imagination and remarkable

ability to transcend the enormous difficulties that he and his family faced while in this remote region of British Columbia.

Macdonald produced few canvases while in Nootka, but the experience provided him with much subject matter for the next few years. A fine small panel of 1935, *Graveyard of the Pacific*, which was painted outdoors, served as the source for a more developed canvas produced the following year, *The Pacific Combers*. Of the ocean experience that inspired the image, Macdonald noted: "I felt that the curve of a wave, a breaker on the beach and the foam on the sand wasn't all of the sea. The sea has a solidity and transparency, cruelty and tenderness, joy and terror, cunning and friendship, all included in visual observation."[17] The water in the image does indeed have a weight and viscosity that is striking and compelling. We feel irresistibly drawn toward the ocean even though we are aware, as Macdonald was, of its great dangers.

Of his experience on Vancouver Island, which had been marked by great adversity, Macdonald wrote: "My time in Nootka has provided me with a new expression (which is only yet being born) which belongs to no school or already seen expression. To fail to follow through the force which is driving me...would be destruction of my soul."[18] As Macdonald's time in Nootka came to an end—he left in the fall of 1936—he had raised his art to a new level of accomplishment. These new "thought-forms" or "modalities" marked him as one of the most innovative painters working in Canada at the time, and the spiritual striving inherent in them is seen in all of his future work.

Back in Vancouver, in the years immediately following his time in Nootka, Macdonald produced a notable body of work that expanded both the visual vocabulary of the modalities he was using and his understanding of symbolic landscape. The two Nootka landscapes he produced upon his return to Vancouver, *Indian Burial, Nootka* (1937) and *Drying Herring Roe* (1938), both demonstrate his sympathy for the situation of the Nuu-Chah-Nulth people and his interest in creating heightened landscapes.

Indian Burial, Nootka offers a telling contrast between the Christianity of the missionaries and the old ways of the Nuu-Chah-Nulth. The graveyard, with the gravesites surrounded by white picket fences, is clearly Christian, complete with several crosses to mark graves; and yet, witnessing the burial is a dramatic mask held by one of the mourners. The fact that this mask does not appear in the small sketch for the work suggests that Macdonald added it to make a direct reference to the suppression of First Nations peoples' traditions by both religious authorities and the Canadian government. While the cleric is clearly dominant and the figures are all clad in contemporary garb, the inclusion of this traditional ceremonial mask reveals the artist's awareness of the tensions between the dominant Eurocentric culture and that of the Nuu-Chah-Nulth. The work is, of course, also a superb demonstration of Macdonald's skills as a designer. The checkerboard pattern on the jacket of the foreground figure is echoed in the gravesite in the middle ground. The sinuous roadway leads our eyes into the distant background where, tellingly, there are two totems on the shore, not the crosses of the foreground. In the distance is the Nootka lighthouse and the ocean beyond. The space is almost cinematic in scope, like a swooping single take which begins high up behind the viewer and sweeps out over the landscape to the distance.

Drying Herring Roe presents a more traditional glimpse of the Nuu-Chah-Nulth culture, although Christian elements are still present. Macdonald felt strongly

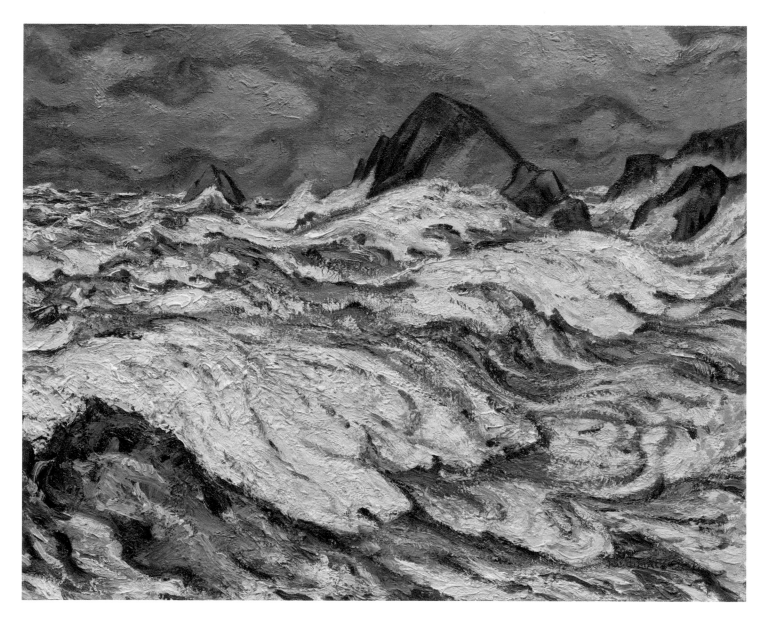

about the work, writing: "I believe it is to be the best picture I ever painted, typically west coast, much purer in colour and direct in composition."[19] The composition was, however, one that the artist took pains to explain when he submitted it for exhibition:

> About the time the herring are due to spawn, the Indians cut long twenty foot branches from spruce and cedar trees, take them out in canoes to deep water close to headlands and sink them twenty feet in the water. In two weeks the branches are raised up, plastered with herring eggs. They are taken to the villages and hung up on wires, ropes, etc.; to dry out and cure in the sun. The village is festooned with masses of mimosa coloured (yellowish) hanging foliage...branches are taken down, the eggs shaken off and packed for winter food. Eggs are boiled before eating.[20]

The Pacific Combers, 1936
oil on canvas
60.5 x 76.3 cm
Collection of VBCE Vancouver Bullion
& Currency Exchange

The fact that Macdonald had so carefully observed this activity in the midst of his struggles to create a viable life for himself in Nootka Sound is remarkable. As Zemans has pointed out, these works have a "decorative" quality and are not specifically

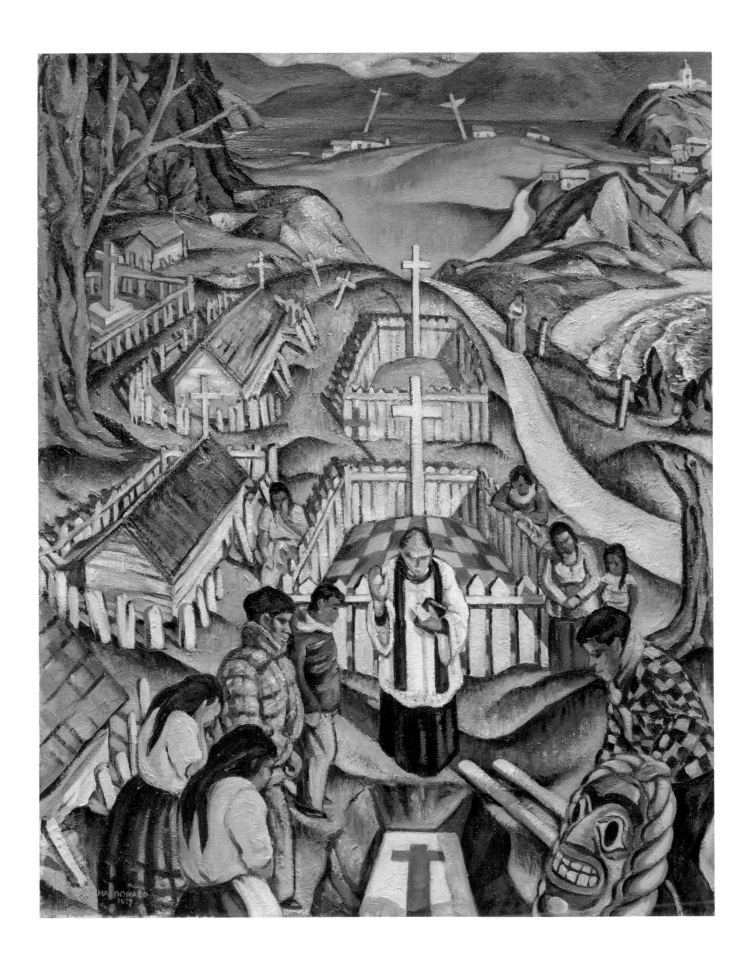

OPPOSITE
Indian Burial, Nootka, 1937
oil on canvas
91.9 x 71.8 cm
Collection of the Vancouver Art
Gallery, Founders' Fund

ABOVE
Drying Herring Roe, 1938
oil on canvas
71.1 x 81.3 cm
Private Collection

portraits of a place, rather they are suggestions of the "spirit of Nootka and its life."[21] This work was likely drawn from Macdonald's mind, a summing up of his Nootka experience and his relationship with the Nuu-Chah-Nulth First Nation.[22] Magnificent though the painting is, the artist's real interest lay elsewhere: in his modalities or thought-expressions. As he wrote to his friend John Varley, "now I can get back to my modalities which are for me much more exciting than landscape."[23]

In 1937, in addition to *Indian Burial, Nootka*, Macdonald painted two radically different canvases that must be seen, I would suggest, as modalities: *Pilgrimage* and *Fall (Modality 16)*. The latter is explicitly titled a modality, but retains strong overtones of his interest in the natural world. *Pilgrimage* is, as Zemans has observed, a "strange painting"[24] that is partly landscape, partly a vorticist cathedral illuminated from the right by shafts of light. In the foreground there is a shoreline and two Nuu-Chah-Nulth canoes fastened to a tree. It is as if Macdonald has provided us with these two, almost *trompe l'oeil* canoes as real-world referents to allow us to more completely

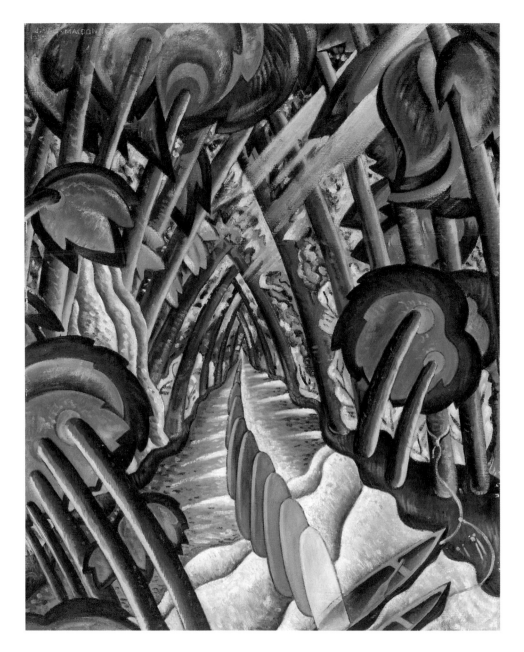

accept a composition that does not relate to the world as we experience it. What are we to make of the waterfall on the left side of the canvas or the line of grave markers that shift from pale yellow to green and recede into the distance? The eye is drawn inexorably into the distance by the forms of arching trees and these markers. A light seems to emanate from this point in the horizon, but it casts an unearthly, spectral glow that is markedly different from the shafts of sunlight that stream into the composition from the upper right. This is an image that touches on the fourth dimension, as implied in the title and the sense of movement within the canvas. It is a fascinating work but, perhaps, not entirely successful in combining elements from the observed and imagined worlds.

When discussing Macdonald's modalities, Zemans advanced the theory that a selection of them—*Fall (Modality 16)*, *Spring Awakening*, *Untitled Modality* and *Winter*—might have been conceived as a group of paintings marking the seasons.[25] These 1937 works all have, with the exception of *Winter*, strong geometric elements

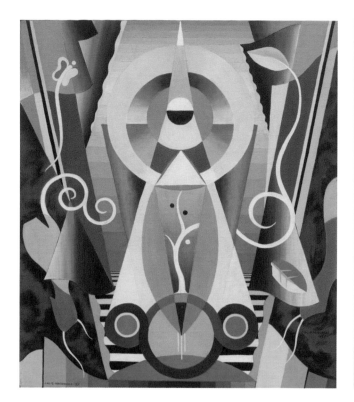

and each includes some aspect of nature: *Winter* has feathers, tree fronds and snow; *Spring Awakening* has stylized seedlings that are beginning to come to life; *Fall (Modality 16)* has some plant fronds, a bare tree, some leaves and a butterfly; and *Untitled Modality*, the most stripped down of the works, has only a stylized butterfly in the centre as its reference to the natural world. The similarities to Harris' work—through the use of geometric shapes—are interesting, but it is clear that Macdonald was much more connected to the natural world than Harris was at this point in his career. It is difficult to know what, if any, exposure the artist might have had to Harris' abstracts but, as has been noted, he was likely aware of the Group of Seven painter's landscapes since at least 1931. The presence of Harris' Santa Fe address in Macdonald's *Nootka Diary* (1935–36) suggests that he may have been aware of his colleague's move to abstraction well before 1938, which is when he commended these works to Harry McCurry.[26]

A more organic approach to nature is visible in *Chrysanthemum* (1938), which—while echoing some of the elements of *Formative Colour Activity*—is dramatically more ambitious. A lively composition that shoots upward from the rounded shape in the lower section of the canvas, the work reveals Macdonald's background as a designer with its balance of shape and colour throughout the image. The chrysanthemum itself is only just suggested. In these works Macdonald is, as Zemans has indicated, looking "for the spiritual through the material."[27] The range of Macdonald's imagination is evident in another modality from the period, *Rain* (1938).[28] Highly stylized, the forces of nature animate a moody sky: torrential rain falls in both columns and individual drops, and a rainbow contrasts with the darkness of the clouds. These overlapping, amoebic clouds recall something of the planets in *Departing Day* and the energized barrier between light and dark echoes *Day Break*. Macdonald's awareness of art-deco design also influences the composition. To Macdonald's surprise, these works—which were by far the most advanced paintings being produced in British Columbia—were apparently well received when displayed as a group at the Vancouver Art Gallery. He wrote

OPPOSITE
Pilgrimage, 1937
oil on canvas
78.6 x 61.2 cm
Collection of the National Gallery
of Canada, Ottawa, Purchase, 1976

LEFT
Fall (Modality 16), 1937
oil on canvas
71.1 x 61 cm
Collection of the Vancouver Art Gallery,
Acquisition Fund

RIGHT
Untitled Modality, c. 1937
oil on canvas
91.4 x 91.4 cm
Private Collection

ABOVE
Winter, 1938
oil on canvas
56 x 45.9 cm
Collection of the Art Gallery of Ontario,
Toronto, Gift of Miss Jessie A. B. Staunton
in memory of her parents, Mr. and Mrs. V.
C. Staunton, 1961

OPPOSITE
Spring Awakening, c. 1936
oil on canvas
76.2 x 60.9 cm
Private Collection

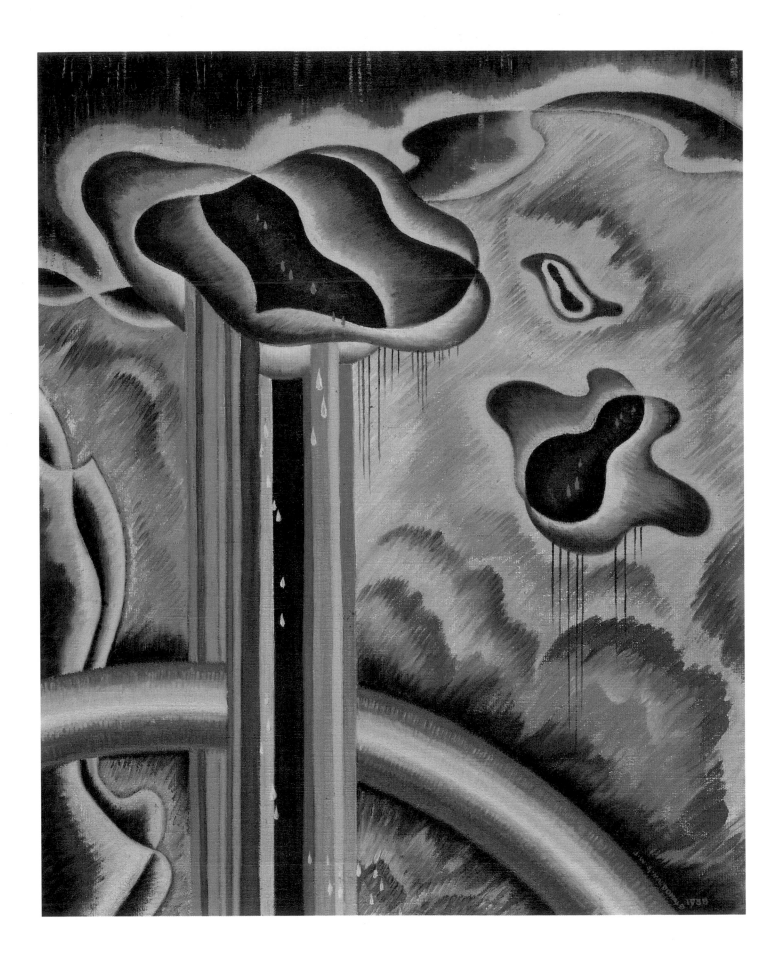

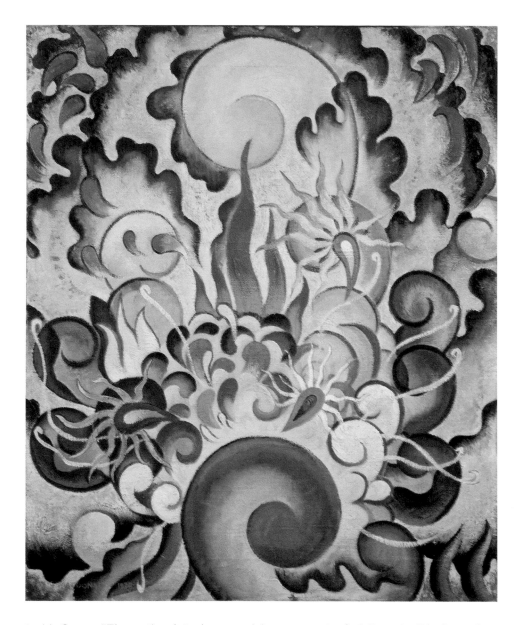

to McCurry, "They stimulated a surprising amount of visitors to [the] studio—demanding private views and numerous requests for purchases."[29] Macdonald also laid out what he was seeking in his work of the time in a later letter to McCurry:

> ...idioms of nature—not completely geometrical, but containing a nature form in extension. It means the same as saying the 4th dimension is an extension of the third dimension; it contains an essence of the 3rd, but has a different space and a different time, and through its added value of motion, it is an entirely new dimension.[30]

It is highly unlikely that most viewers got these ideas from Macdonald's art, but the works could also be appreciated as highly accomplished paintings both formally and for his often dramatic use of colour.

In 1939 the artist produced three more modalities: *Flight*, *The Wave* and *Departing Day*, which was a larger version of an earlier composition of the same name. The first reflects Macdonald's knowledge of international art movements such as

OPPOSITE
Rain, 1938
oil on canvas
56.2 x 46.2 cm
Collection of the National Gallery
of Canada, Ottawa, Purchase, 2007

RIGHT
Chrysanthemum, 1938
oil on canvas
55 x 45.6 cm
McMichael Canadian Art Collection,
Purchase, 1993

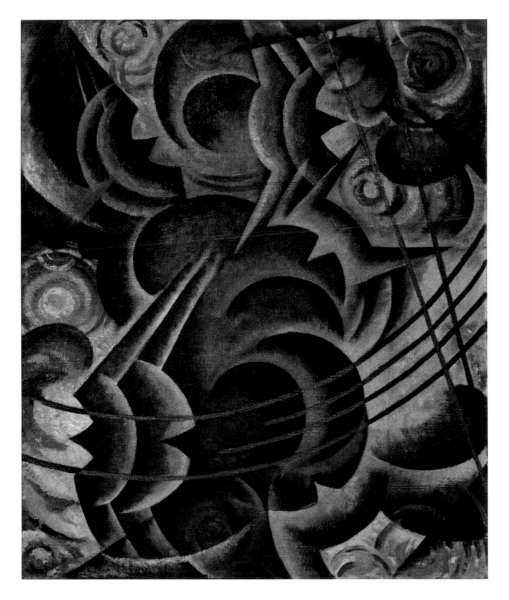

Futurism and perhaps Vorticism,[31] but it also bears a remarkable resemblance to a work executed much closer to home, Beatrice Lennie's *Night Flight* (1938). In a world so familiar with flying, it is well to remember that, in the thirties, flight was still a remarkably adventurous pastime and unknown to most people. The drama of aviation is realized in Macdonald's work, which is animated by swooping lines of force and intersecting winged shapes. *The Wave* is an extension of ideas seen in earlier works, such as *Day Break*, *Chrysanthemum* and, to an extent, perhaps even *Pilgrimage*. Developed from an earlier sketch,[32] *The Wave* views the world from above, as in *Pacific Ocean Experience*. This work is even more stylized, however, and Macdonald both denies and confirms our sense of space. The diagrammatic ocean on the right gives way to an amorphous and indeterminate sky on the left. The two areas interpenetrate through the two wave shapes and the streamlined water droplets. The work is pure fantasy, but Macdonald has brought us back to earth by embedding grains of sand in his paint surface. *Departing Day* also returns to a sketch from 1935, but it is largely a transcription of the earlier work, suggesting that the sketch for *The Wave* may have been equally radical. This reveals how Macdonald was able to sustain both a representative and more imaginative practice simultaneously.

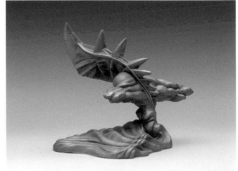

LEFT
Flight, 1939
oil on canvas
36.5 x 46.4 cm
Private Collection

RIGHT
Beatrice Lennie
Night Flight, 1938
plaster, paint
40.7 x 32 x 43 cm
Collection of the Vancouver Art Gallery,
Gift of Mrs. Louise Brittain

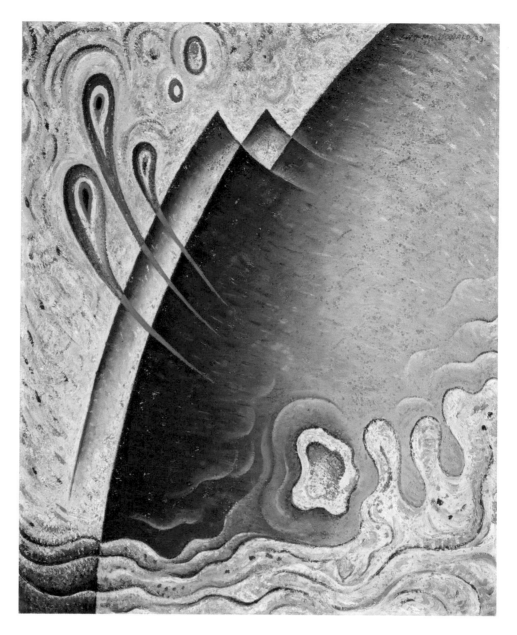

The Wave, 1939
oil, sand on canvas
102.2 x 82 cm
Collection of the Montreal Museum of
Fine Arts, Purchase, Horsley and Annie
Townsend Bequest

Macdonald first met Harris in 1940, after the older artist and his wife Bess moved to Vancouver. The beginning of World War II had made for many shifts in individual circumstances, and for Harris this meant leaving Santa Fe and returning to Canada. Macdonald was already a keen follower of Harris' work and the two formed a close bond, visiting the Rockies together in the summer of 1941, where Macdonald produced a number of fine sketches such as *Mount Kitchener and Glacier, Columbia Icefields, Alberta*.

It is tempting to look at Macdonald's mountain paintings from the forties through the lens of Harris' influence. Certainly, there is a greater clarity and precision in works such as *Castle Towers, Garibaldi Park* (1943); the colour sense is quite distinct from that seen in earlier works such as *The Black Tusk*, which were so strongly influenced by Varley, but it remains Macdonald's colour sense and not Harris'. Perhaps the time spent with Harris, who loved the mountains, allowed the artist to see a way to "reveal both the majesty of the mountain scenery and the cosmic harmony" that he sought in his work, whether abstract or representational.[33]

When Macdonald came to Vancouver in 1926 he was not a painter, but a designer. By the beginning of World War II, he was a major figure in Canadian painting. The complexity and ambition of Macdonald's artistic journey to this point can be summed up in his own words:

> Man's consciousness is always in a state of change. With the change of consciousness comes the change of Art. Art is a record of the evolution of Humanity. Our knowledge of Nature has changed. The Artist's expression must change as the artist finds his inspiration for ever stimulated by searching into nature.[34]

Macdonald always responded to change, to a widening range of influences, and soon change was to come again to his work and his understanding of the world.

Castle Towers, Garibaldi Park, 1943
oil on canvas
71.3 x 96.7 cm
Collection of the Vancouver Art Gallery,
Acquisition Fund

ENDNOTES

1. Private Collection, handwritten text reproduced in Joyce Zemans, *Jock Macdonald: The Inner Landscape* (Toronto: Art Gallery of Ontario, 1981), 268–278. Macdonald delivered the lecture on the evening of February 7, 1940 at Vancouver's Medical Dental Auditorium. As Zemans has noted on page 268 (and as changes to the manuscript itself indicate), the lecture was delivered more than once.
2. Macdonald, "Art in Relation to Nature," 5 (Zemans, 272).
3. Ibid., 1 (Zemans, 268).
4. Ibid., 10 (Zemans, 277).
5. Ibid., 9 (Zemans, 276).
6. Zemans, 264.
7. Macdonald to G. H. Tyler, January 2, 1936 (National Gallery of Canada Archives, Ottawa).
8. Zemans, 29.
9. Zemans, 39.
10. Macdonald to H. O. McCurry, April 2, 1937 (National Gallery of Canada Archives).
11. Zemans, Chapters 2 to 7, 22–95.
12. Allison J. Colborne, "Jock Macdonald: The Search for the Universal Truth in Nature" (unpublished master's thesis, Concordia University, 1992, copy in Library and Archives Canada).
13. Macdonald to Maxwell Bates, July 30, 1956 (McCord Museum Archives).
14. Zemans, 56.
15. Macdonald's account of this extraordinary episode in his life is recorded in a diary that he kept during the period. This diary, which was unknown to previous scholars, is published in this volume for the first time.
16. Zemans, 65.
17. Jock Macdonald quoted by Bates, "Jock Macdonald: Painter-Explorer," *Canadian Art*, vol. 14, no. 4 (Summer 1957), 152.
18. Macdonald to McCurry, March 26, 1937 (National Gallery of Canada Archives).
19. Macdonald to McCurry, June 16, 1938 (National Gallery of Canada Archives).
20. Ibid.
21. Zemans, 80.
22. He also produced two other works with First Nations' subjects: a massive mural for the Hotel Vancouver in 1939, which regrettably is no longer extant, and the gouache *BC Indian Village* (1943), which was used as the basis for a screenprint published by Sampson-Matthews Silkscreen Prints.
23. Macdonald to John Varley, May 30, 1938 (National Gallery of Canada Archives).
24. Zemans, 75. Zemans notes that the image came to Macdonald in a dream and may reflect the stress he was feeling about his artistic and financial circumstances upon his return to Vancouver.
25. Zemans, 90. At the time of Zeman's writing, both *Spring Awakening* and *Untitled Modality* were known only through photographs. Zemans thought that the latter was meant to be the winter painting. I am suggesting here that *Winter* is, in fact, the winter work and *Untitled Modality* represents summer. It is also likely that three of the four works were done in 1937, although *Untitled Modality* is undated.
26. Macdonald to McCurry, June 16, 1938 (National Gallery of Canada Archives).
27. Zemans, 86.
28. This work was exhibited in the 28th BC Society of Fine Arts Exhibition held at the Vancouver Art Gallery during April and May 1938, together with *Chrysanthemum, Day Break* and *Winter*.
29. Macdonald to McCurry, June 16, 1939 (National Gallery of Canada Archives).
30. Macdonald to McCurry, May 10, 1943 (National Gallery of Canada Archives).
31. Zemans, 85.
32. Zemans, 69 and note 34, 253.
33. Zemans, 104.
34. Macdonald, "Art in Relation to Nature," 11 (Zemans, 278).

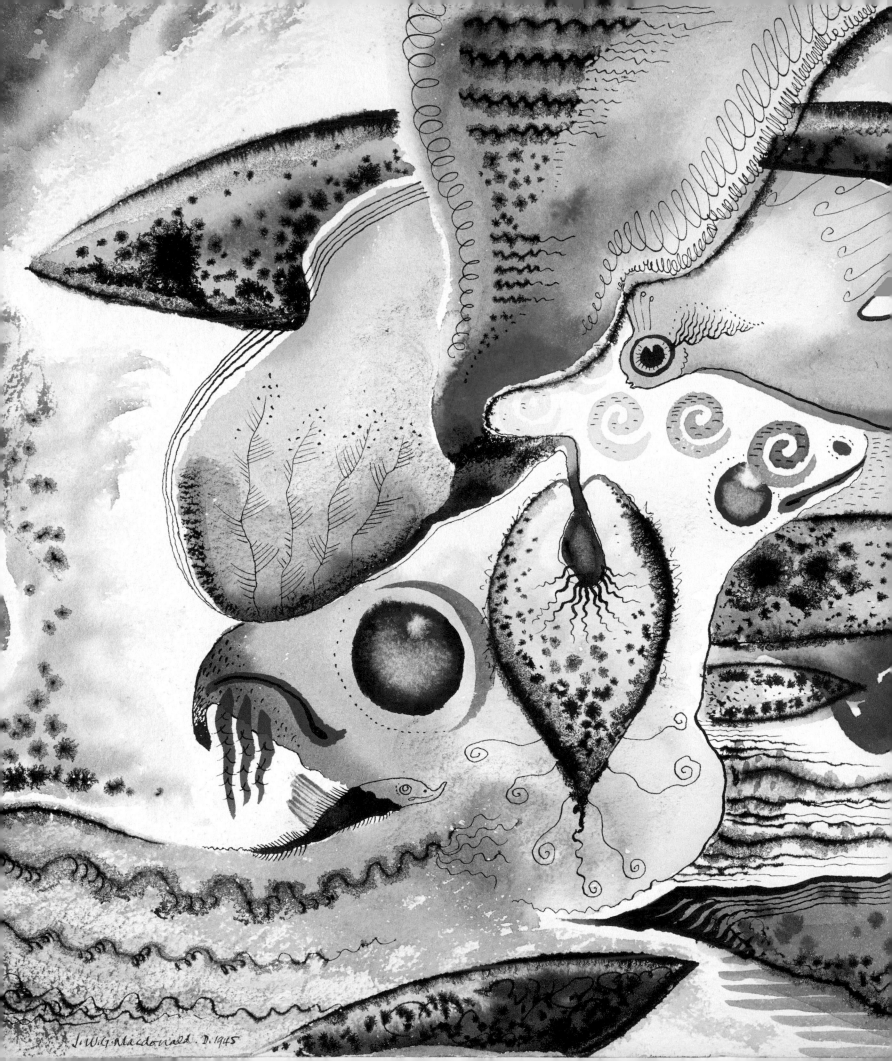

J.W.G.Macdonald. D. 1945

Jock Macdonald, Dr. Grace W. Pailthorpe and Reuben Mednikoff: A Lesson in Automatics

Linda Jansma

And, I feel that I so greatly need your friendship and advice that I would undoubtedly be isolated and alone without it. Never can you know how indebted I am to you both for the awakening and releasing of my inner consciousness. Your coming to this distant outpost has been an initiation for me, into the higher plane of creative understanding—one of the most marvelous enrichments in my life. Definitely, for me, an eternal awakening in experience which my soul was seeking for so many years. Thank you both.

Jock Macdonald to Dr. Grace W. Pailthorpe and Reuben Mednikoff, 1946[1]

Jock Macdonald attended the Edinburgh College of Art from 1919 to 1922. Perhaps appropriately, today, only two-and-a-half kilometres away, the Scottish National Gallery of Modern Art Archive houses eighty-six of his pen and ink drawings and watercolour automatics. These works can be found within the archival fond of British surrealists Dr. Grace W. Pailthorpe and Reuben Mednikoff, archives that were purchased in 1999 and 2000 from relatives of Mednikoff. These works on paper have been, until now, unknown to a Canadian audience. Accompanying these artworks are thirty-eight pieces of correspondence Macdonald sent to Pailthorpe and Mednikoff, as well as four additional letters from his wife Barbara, three of which were sent following Macdonald's death in December 1960.

Macdonald first began to experiment with abstraction in the 1930s; these works were always founded in the natural world and evoked a deep sense of its mystic and spiritual qualities. In the mid-1940s, after meeting Pailthorpe and Mednikoff, his approach to abstraction would forever change.

In her authoritative 1981 text on Macdonald for a retrospective at the Art Gallery of Ontario, Joyce Zemans discusses the artist's introduction to Pailthorpe and Mednikoff and his subsequent conversion to working in an automatic manner; however, the impact and longevity of their relationship has yet to be explored. The three months Macdonald spent studying under the pair is reflected in the works in the Archive, beginning with quick pen and ink drawings and culminating in the automatic watercolours for which he is best known. The letters, addressed to Dr. Pailthorpe and Riki (Mednikoff), are dated from April 1946—soon after their departure from Vancouver to England—until May 8, 1960. They contain references to three visits that Macdonald made to England, as well as an obvious ongoing

Untitled [December 1946], 1946 (detail)
watercolour, ink on paper
25.2 x 35.4 cm
Collection of the Scottish National Gallery of Modern Art, Edinburgh

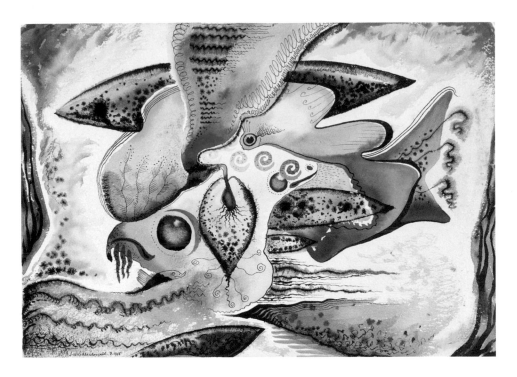

moral support given to Macdonald in his pursuit of the "awakening and releasing of [his] inner consciousness." While extensive correspondence sent by Macdonald fortunately exists in Canadian archives—including letters to the National Gallery of Canada's H. O. McCurry and artists Maxwell Bates, Marion Nicoll, Alexandra Luke and Julius Lebow—those that were sent to Pailthorpe and Mednikoff reveal a unique relationship of student to teachers, rather than the teacher-to-student dynamic that is more apparent in his communication with the aforementioned artists. Within the extensive Archive there are also transcripts of lectures given by both Pailthorpe and Mednikoff during their stay in Vancouver from 1942 to 1946, including a transcript of the lecture given by Pailthorpe at the Vancouver Art Gallery on April 14, 1944, which is credited for introducing Surrealism to the West Coast.[2] This rich repository allows for a further examination of Macdonald's work and his early forays into automatism in the context of his relationship with two of Britain's well-known surrealists.

Dr. Grace W. Pailthorpe and Reuben Mednikoff

Dr. Grace W. Pailthorpe (1883–1971)[3] was born in Sussex and attended the London School of Medicine for Women, graduating with a Bachelor of Medicine and a Bachelor of Surgery from the University of Durham in 1914. She served as a surgeon in various hospitals between 1915 and 1918, during World War I, and she continued to work as a general practitioner in Australia and New Zealand after the war. Following her return to England in 1922, Pailthorpe began to study female offenders in order to focus on the prevention, rather than punishment, of criminal behaviour within the English penal system. She returned to Durham University, where she specialized in psychology, graduating with a Doctorate of Medicine in 1925. While working at Birmingham Prison, she began to use art in her practice to test prisoners' "imagination, apperception and their recognition of a situation."[4] In her 1944 lecture at the Vancouver Art Gallery, Pailthorpe notes: "In 1935 I had a 'hunch' as a result of working for many years as a psycho-analyst. At about the same time I met Mr. Mednikoff and in talks with him I realised there was

Untitled [December 1946], 1946
watercolour, ink on paper
25.2 x 35.4 cm
Collection of the Scottish National Gallery
of Modern Art, Edinburgh

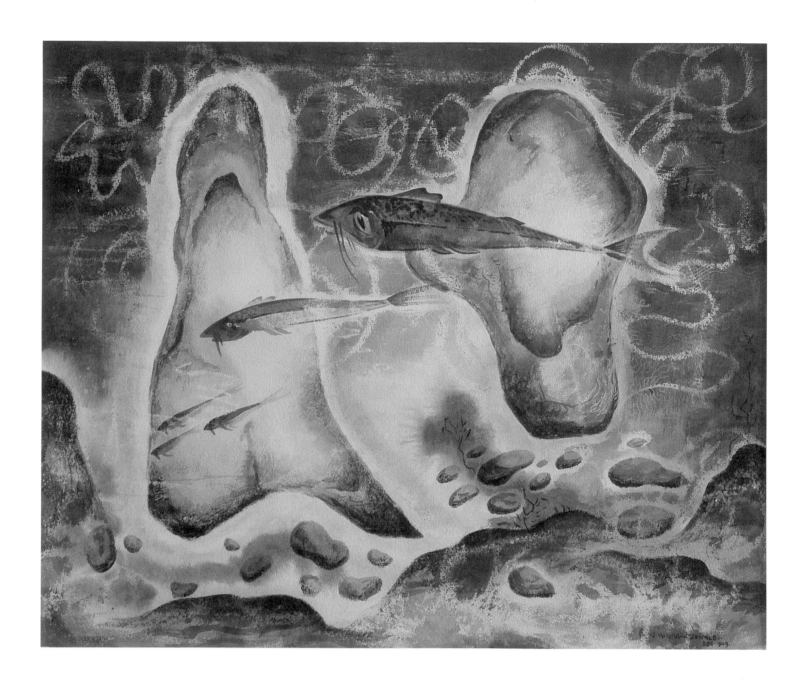

Fish Family, 1943
watercolour on paper
36.5 x 44.5 cm
Hart House Permanent Collection,
University of Toronto, Purchased by the
Art Committee 1949/1950

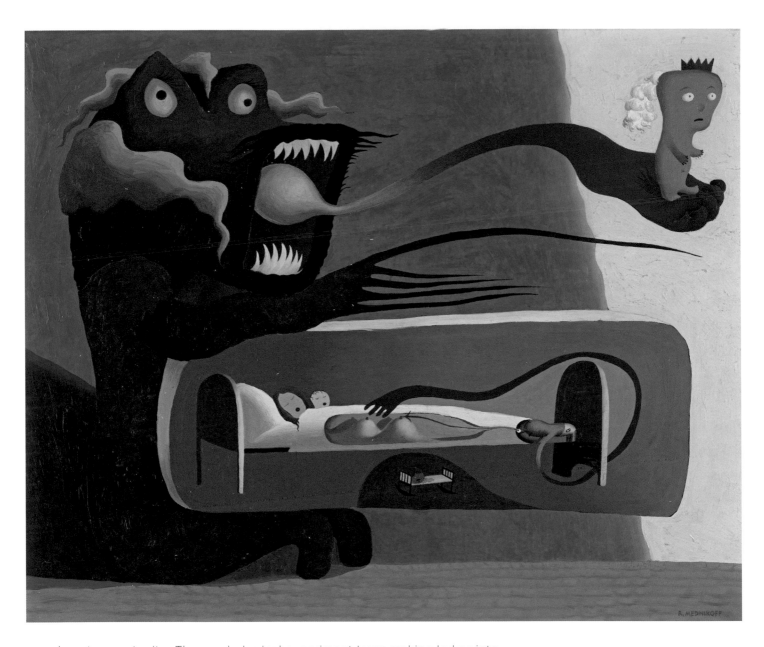

a god-sent opportunity...The psychological experiment I was making led us into the realm of art: Automatic art and writing were frequently in use."[5]

Reuben Mednikoff (1906–1972) was born in London and studied at St. Martin's School of Art from 1920 to 1923. Little, however, is known of his early artistic career before he began his lifelong work with Pailthorpe. Mednikoff was working as a commercial artist when they met, through mutual friends, at a party at Pailthorpe's home in February 1935. The following month she visited his studio, where he introduced her to automatic work within the practice of Surrealism; he also encouraged her to produce her own work.[6] It is likely that Mednikoff was introduced to Surrealism through his friendship with David Gascoyne, the English poet who not only translated into English Surrealism co-founder André Breton's 1924 *Surrealist Manifesto*, but also wrote the 1935 book *A Short Survey of Surrealism*. Pailthorpe and Mednikoff were invited to submit their work to the 1936 *London International Surrealist Exhibition* at the New Burlington Galleries, as well as New York's Museum of Modern Art's *Fantastic Art, Dada, Surrealism*, organized by

Reuben Mednikoff
October 17, 1938. 10a.m. (The king of the castle), 1938
oil on composition board
41.8 x 52 cm
Collection of the National Gallery of Victoria, Melbourne, Purchased by the NGV Foundation with the assistance of the Duncan Elphinstone McBryde Leary Bequest, 2011

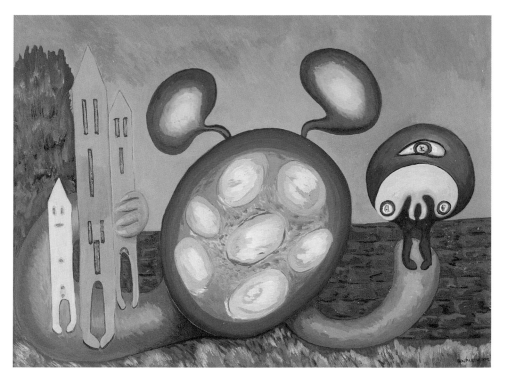

LEFT
Dr. Grace W. Pailthorpe and Reuben
Mednikoff on Granville Street,
Vancouver, 1944

RIGHT
Dr. Grace W. Pailthorpe
April 20th, 1940 (The Blazing Infant), 1940
oil on cardboard
42 x 57 cm
Collection of Susie and Michel Remy

founding Director Alfred H. Barr at the end of 1936. It was Breton who singled out Pailthorpe's work for praise, stating that hers was "the best and most truly surrealiste of the works exhibited by English artists."[7]

In an essay entitled "The Scientific Aspect of Surrealism," Pailthorpe asserts, "Surrealism is one of the outcomes of a demand, on the part of those dissatisfied with the world, for the complete liberation of mankind from all fetters which prevent full expression." She continues in the same paper: "It is impossible to create a well-organised external world *unless at the same time* the internal mental world is harmonised, since it is only through mental acquiescence on the part of the units that go to form the whole machinery of civilization that it can function smoothly."[8] For both Pailthorpe and Mednikoff, Surrealism was based in science and its significance was for healing. Yet Michel Remy writes: "Such reduction of the aims of surrealism was a misunderstanding, if not betrayal, of its [Surrealism's] basic principles, which never implied that individual freedom meant harmonious socialization and perfect integration into the outside world."[9]

While the pair showed their work in various surrealist exhibitions, including a two-person presentation in 1939 at Peggy Guggenheim's London gallery Guggenheim Jeune, a power struggle occurred within the British surrealist ranks when they (along with others, including author Herbert Read) insisted on being able to exhibit and publish their work outside of the movement's auspices. While Surrealism became increasingly political, Mednikoff invited his colleagues to join a renewal of the group "with freedom of political bias or activity as part of its constitution."[10] E. L. T. Mesens, the leader of the British surrealists, saw this as a direct attack on his authority, which eventually led to the pair's position outside of the main group. At the beginning of World War II, Pailthorpe and Mednikoff's disillusionment with surrealist opportunities in Britain, coupled with her desire to publish a book on her research, prompted them to travel to the United States in the fall of 1940 with the assistance of a grant from the William C. Whitney Foundation. They stayed in Berkley, California until 1942, when the Foundation

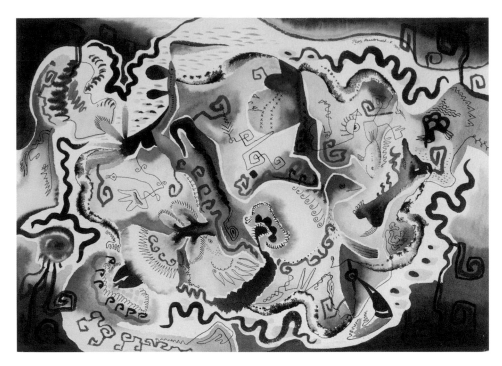

could no longer support their research. Pailthorpe set off for a vacation in Vancouver and later arranged for Mednikoff to join her. That year she became employed at the provincial mental hospital Essondale, just outside of Vancouver, and during this time she formed the Association for the Scientific Treatment of Delinquency.

Despite their, at times, rocky relationship with the British surrealists, Nigel Walsh, in *Sluice Gates of the Mind: The Collaborative Work of Pailthorpe and Mednikoff*, states that "far from inhabiting the margins [of Surrealism] where they've often been placed, they [Pailthorpe and Mednikoff] played a pivotal role."[11]

The Beginnings of Surrealism in Canada

In 1938, the Canadian National Exhibition in Toronto hosted *Surrealist Art*, an exhibition organized by the Gloucester Guildhall that included work by Pailthorpe and Mednikoff, but also other European surrealists such as Salvador Dalí, René Magritte, Max Ernst and Roland Penrose. Of this presentation, Remy writes: "The impetus it gave to the development of automatism was to affect Canadian art for several decades, and as Britain was still the country to which Canadian culture referred, the Toronto show became a step in the development of Canadian artistic identity."[12] This British identity would not, of course, apply to francophone artists in Quebec. In 1941 Alfred Pellan brought first-hand knowledge of European Modernism to Quebec upon his return from Paris, where he had lived since 1926, while Paul-Émile Borduas accessed publications on Surrealism and the writings of Breton at the École du meuble de Montreal library, as early as 1937.[13] Borduas held an exhibition of his work at Théâtre de l'Ermitage in Montreal in 1942, entitled *Oeuvres surréalistes de Paul-Émile Borduas*, and at this time both he and Pellan were seen to be Canada's "outstanding, most astonishing painters";[14] however, "The Automatists were not concerned with automatism in its connection with mediums or psychiatry, but in its painterly expression, particularly in the way it expressed itself nonfiguratively."[15]

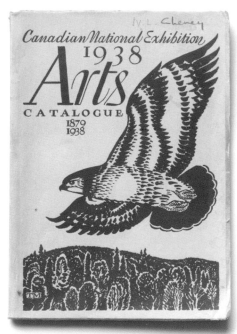

LEFT
Russian Fantasy, 1946
watercolour, ink on paper
21.7 x 35.7 cm
Collection of the Art Gallery of Ontario, Toronto,
Purchased by the Peter Larkin Foundation, 1962

RIGHT
Canadian National Exhibition's 1938
Arts catalogue

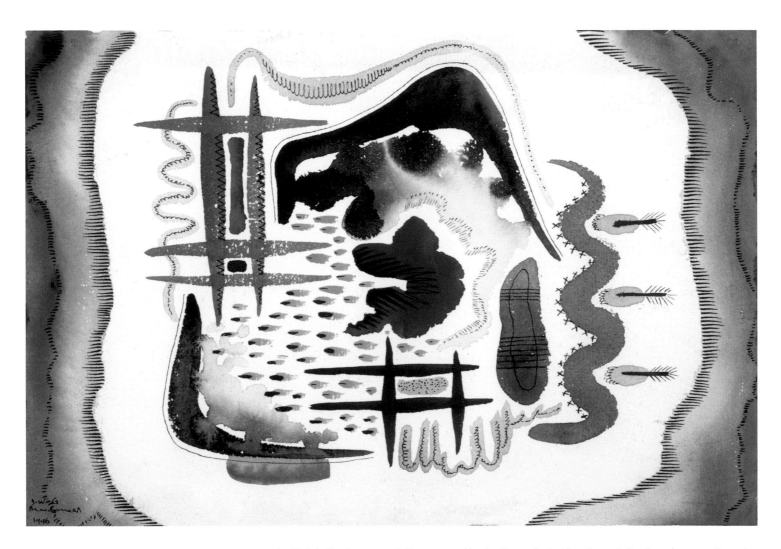

In 1944, Breton spent three months in Canada in the Gaspé Peninsula near Percé Rock writing *Arcanum 17,* a book in which he contemplates "war, love and the resurrection," as Europe was being freed from Nazi oppression.[16] During his time in Quebec, Breton met Pellan and eventually invited the automatists to become members of the European surrealist group; however, automatist member Fernand Leduc declined the invitation in order to maintain the movement's independence.[17] It is interesting to note that while Pailthorpe expresses the importance of automatic art as a mechanism that "tells the tale and expresses for us all the fantasies, and many of them very beautiful fantasies, for which we need outlet,"[18] Macdonald's theory regarding automatism is more closely aligned to the ideas Breton expressed in 1944: "What Breton feels he has learned from his time in Quebec, and sees as Surrealism's current importance to the world, is the movement's ability to reconnect humanity to nature and to explore the marvel and mystery of the natural world."[19] After 1955, Macdonald writes: "Automatic art, for me, is a reflection of one's experiences in life as all that one has observed is retained in the deeper inner mind and in Automatic art one is painting imaginatively one's impressions of nature."[20]

Abstract-Vermilion Centre, 1946
watercolour, ink on paper
17.8 x 25.5 cm
Collection of The Robert McLaughlin Gallery,
Oshawa, Gift of M. Sharf, 1983

Introducing Surrealism to Vancouver

The lecture Pailthorpe gave at the Vancouver Art Gallery introduced Surrealism to western Canadian audiences and was well documented in local newspapers.

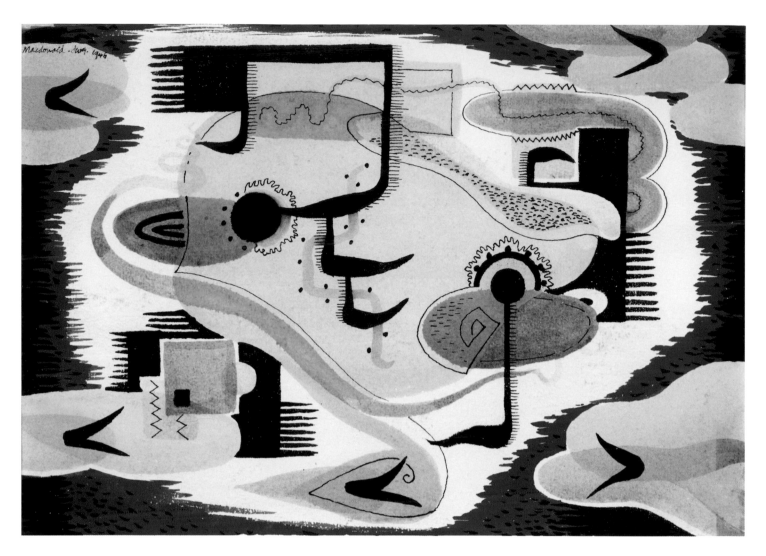

However, a letter Mednikoff wrote to "Charles" two weeks after her talk offers a richer perspective:

> Did I tell you Doc gave a lecture at the Vancouver Art Gallery on Surrealism?... It was a tremendous success. The gallery was crowded out and people had to be sent away—in the rain, too. It was the first time such had happened in the history of the gallery...The result is that there are now two schools of thought in Vancouver art circles—for and against. Before it was all against. It seemed that we were the first Surrealists to have appeared on this coast. Pioneering again, were we. People now want to hear more about it.

The letter also explains how Pailthorpe and Mednikoff came to show their work in a two-person exhibition at the Gallery from June 13 to July 2:

> There is one artist here, an abstract painter, who lords it over the city. He is the papa. Everything he says is taken as law. It is as well since his ideas are definitely progressive and "way ahead" of the rest of the Victorian old ladies who festoon the art schools...This Papa artist came to see our works. We showed him only drawings and watercolours. To our astonishment he was knocked flat with amazement at the quality and richness of our creations—and their faultless compositions. He couldn't understand how automatic works

Music Hour, 1946
watercolour, ink on paper
18 x 25.8 cm
Collection of The Robert McLaughlin
Gallery, Oshawa, Purchase, 1979

OPPOSITE
Dolls and Toys, 1946 (detail)
watercolour, ink on paper
25.5 x 35.6 cm
Collection of The Robert McLaughlin
Gallery, Oshawa, Gift of M. Sharf, 1983

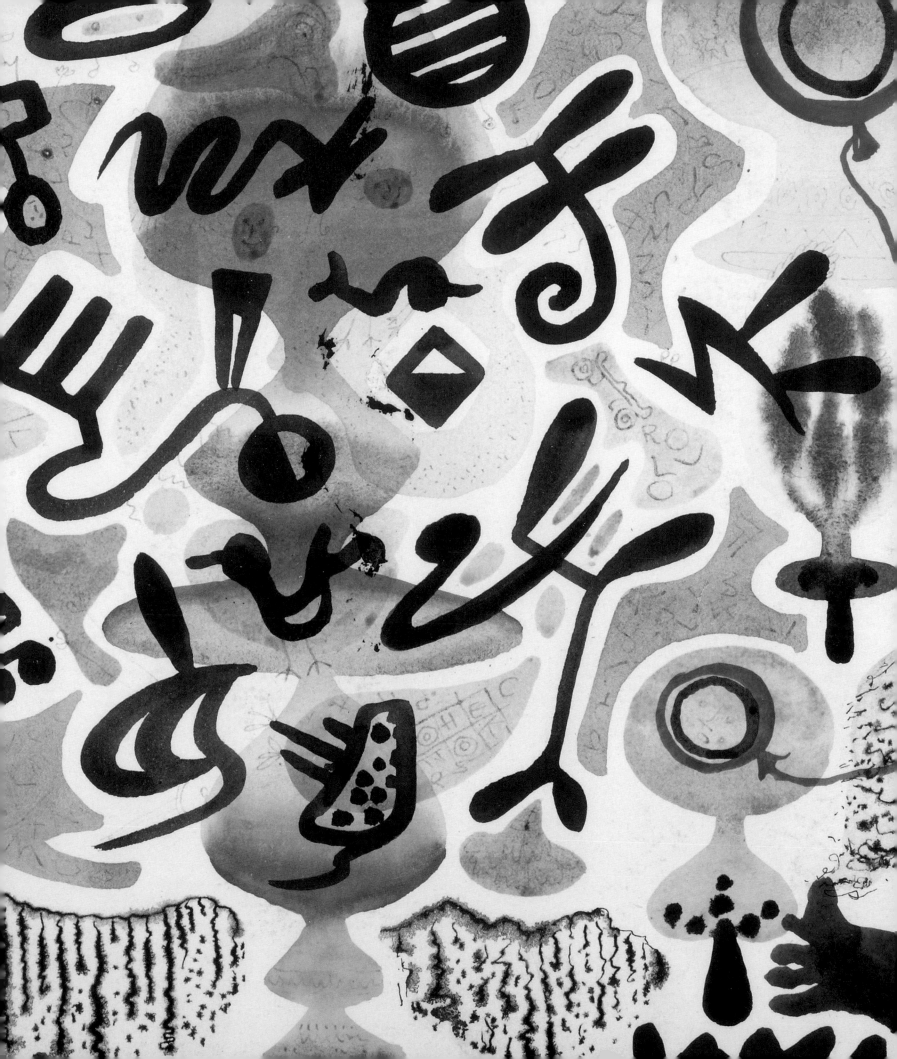

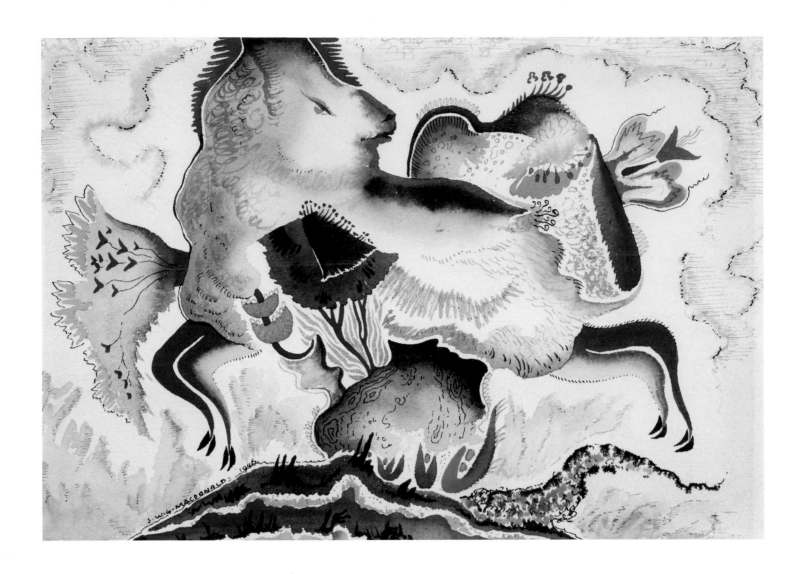

The Ram, 1946
watercolour, ink on paper
17.8 x 25.6 cm
Collection of The Robert McLaughlin Gallery,
Oshawa, Purchase, 1979

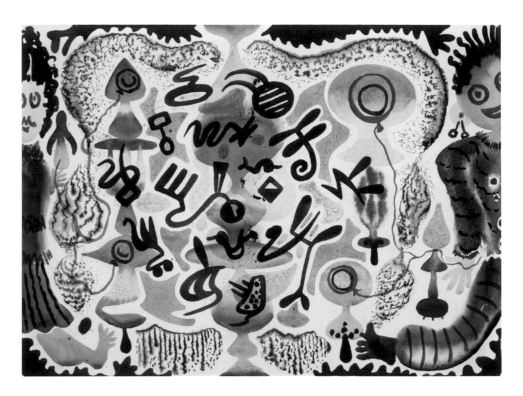

could be like that...Since he is the great panjoram of the art gallery it was a good thing for us. On the way to the lecture he asked if we would exhibit... At the close of the lecture it was announced that such an exhibition would take place in June.[21]

Undoubtedly, the "papa" Mednikoff refers to was Lawren Harris, who had arrived in Vancouver in 1940 and was Chairman of the Vancouver Art Gallery's Exhibition Committee. Jock Macdonald also served on this committee and had become friends with Harris upon his arrival in Vancouver; in Harris, "Macdonald once more discovered the artist/confidant with whom he could share his deepest concerns about the nature of art."[22] Harris' opinion of Macdonald's new automatic work was important to the artist, which was obvious in his first letter written to Pailthorpe and Mednikoff: "Lawren Harris came over to see my work...When he asked me if he could take Dr. Morley [Dr. Grace Morley, Director of the San Francisco Museum of Modern Art] over to see my work I then knew that he was more than just interested... Lawren Harris said my work 'is simply magnificent.'"[23]

A short article in the *Vancouver Sun* mentions Pailthorpe and Mednikoff's exhibition, as well as the Vancouver Art Gallery's attempt to mitigate any possible vandalism to the works by showing them "under glass." The report states: "When the artists... gave their first exhibition in London, England, irrate spectators expressed their opinions freely. Some of the angriest wrote what they thought right on the pictures."[24] When asked by a *News Herald* reporter if it bothered them that their work was at times met with antagonism, Pailthorpe replied: "It pleases me as well to have my works disliked as liked...for in either case it is compliment to the work, which is meant to provoke some definite response. After a time, antagonisms subside, and a liking for what had upset you gradually grows."[25]

Shortly after this exhibition, Pailthorpe was invited to speak on the CBC Radio program *Mirror for Women*; the fifteen-minute address was recorded in Vancouver on July 10, 1944. She spoke of Surrealism's roots in Dadaism and Breton's experimentation

Dolls and Toys, 1946
watercolour, ink on paper
25.5 x 35.6 cm
Collection of The Robert McLaughlin
Gallery, Oshawa, Gift of M. Sharf, 1983

in automatic writing, as well as his growing awareness of the unconscious through work with soldiers as an orderly in psychiatric wards of World War I hospitals. She stated: "Groping his way thus, he [Breton] finally defined pure psychic automatic work as Surrealism."[26] Pailthorpe used Gascoyne's translation of Breton's definition of Surrealism: "Pure psychic automatism by which it is intended to express, verbally in writing or by other means, the real process of thoughts. Thought's dictation in the absence of all control exercised by the reason and outside all aesthetic or moral preoccupations."[27]

On November 24, 1944, artist B. C. Binning invited Pailthorpe to speak to the Vancouver branch of the Canadian Federation of Artists. During her presentation she has her audience perform an exercise, asking them to "very quickly, and without hesitation," respond to the automatic drawing that she presents (in the marginalia of the transcription, she notes that the work is Mednikoff's *Awe inspiring Facade*).[28] She says that she has previously given this same lecture, then proceeds to read some of the earlier participants' responses, as they "serve to demonstrate how each of you interprets a drawing in an individual way."[29] Pailthorpe goes into great detail to describe Mednikoff's work and the symbolism that connects it directly to his own childhood. She concludes her remarks by stating: "Every automatic painting or drawing is full of unconscious meaning."[30] Although Pailthorpe and Mednikoff are seen as the artists who brought Surrealism to the West Coast, upon their arrival in Vancouver in 1942 they had very little—if any—connection to European or British surrealists. Indeed, in an April 1946 letter to the pair, Macdonald writes: "I don't suppose you have had time to discover much about the sur-realist work in England yet."[31] Rather than seeking association with the movement, their interest was in their own exhaustive research into the connection between art and science, and how, as Pailthorpe wrote to Breton, when "welded together, [these two fields] have much to give that is of vital importance to humanity."[32]

The Lessons

Pailthorpe and Mednikoff would have undoubtedly met Macdonald at one or more of their public appearances.[33] But what did they teach him and when? In a letter to the pair dated "4 July, 1946," Macdonald writes: "Calgary + Banff are fortunate things for me but the greatest fortune I have known this last twelve months is your kindness in initiating me to automatic expressions + fortunate enough to be counted as one of your friends."[34] While he most certainly met them before July 1945, Macdonald's foray into a Pailthorpe and Mednikoff–instigated automatism seems to have occurred, at the earliest, midway through 1945.

Pailthorpe describes automatics as "hieroglyphic inscriptions of memories buried deep in the unconscious mind,"[35] and in her CBC Radio talk she explains how automatic work occurs without thought, as well as how her method is more layered:

> Automatic art is easy enough to do. Every time you take up a pencil and begin scribbling, while waiting at a telephone for a call, and your thoughts are not concentrated on what you are scribbling, you are drawing automatically. You are not consciously aware of what your hand is creating. You are not in a trance; but your mind is not consciously interfering with what your hand is making the pencil do...Freedom from conscious interference can be to some degree attained through practice in this form of automatic scribbling; but full freedom from conscious interference can

Untitled [11 p.m., September 16, 1945],
1945 (detail)
ink on paper
23 x 30.5 cm
Collection of the Scottish National Gallery
of Modern Art, Edinburgh

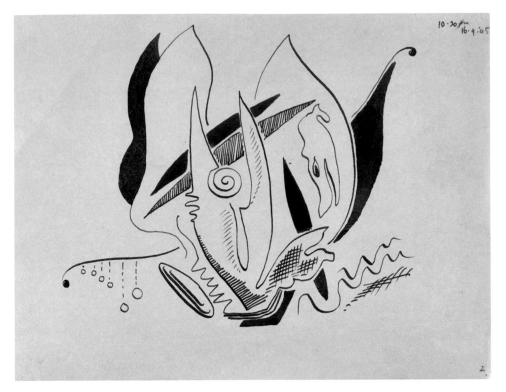

only be brought about by a method devised by myself during a research into the psychology of the so-called normal man. This, of course, cannot be elaborated here.[36]

Gerald Tyler has outlined the methods of Pailthorpe's technique: "just take a brush and put on a great big splash," and further, "stop working as soon as conscious effort took over from the unconscious."[37] The Macdonald-trained and Calgary-based artist Marion Nicoll has also recalled her teacher's guidance into the automatic technique: "You take a pencil, you are in a quiet place, you put the pencil on the paper and you sit there until your hand moves of its own accord...You do that every day...It will happen without any effort on your part."[38] The work in the Scottish National Gallery of Modern Art Archive serves to illustrate Pailthorpe and Mednikoff's teaching methodology. For example, the pair consistently dated and often timed their work to assist with its analysis and obviously encouraged their students to undertake this practice as well.[39] The earlier Macdonald works are both timed and dated, and eventually they are given either a month initial and year date or simply the year. There are twenty-six individual and serial drawings that are untitled, specifically dated and range from one work to as many as thirteen. Within the Archive, the earliest Macdonald drawing is dated "16.9 '45," presumably September 16, 1945, while the latest is dated "J 1946." The former and one other work are both from the September 16 session and are timed forty minutes apart.[40] His work from "10.20 p.m." is an ink wash with a central motif. The composition is made up of a series of continuous lines, hatches and cross-hatches. Areas are inked in with solid colour. Within the design is a single creature whose open mouth points to the bottom of the page. In the work from "11 p.m." the composition encompasses more of the paper, with sweeping forms that pull the eye toward the top-left corner of the page. Figures with hats can be made out in both the top-right and bottom-left corners of the page. These two works show that Pailthorpe and Mednikoff encouraged the process to be monochromatic prior to the introduction of other mediums. Of the works within the Archives, those from Macdonald's initial seven sessions

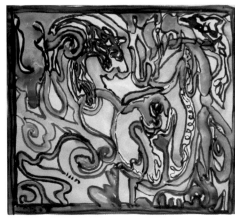

LEFT
Untitled [10.20 p.m., September 16, 1945], 1945
ink on paper
22.8 x 30.4 cm
Scottish National Gallery of Modern Art, Edinburgh

RIGHT
Marion Nicoll
Untitled (Automatic Drawing), 1948
watercolour on paper
30 x 22.5 cm
Art Gallery of Alberta Collection, Purchased with funds donated by Gulf Oil Canada Ltd., 1981

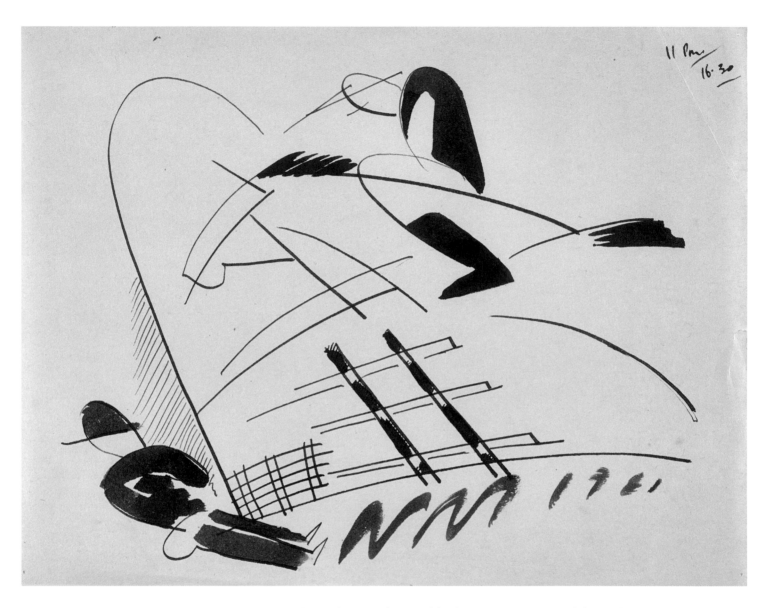

Untitled [11 p.m., September 16, 1945], 1945
ink on paper
23 x 30.5 cm
Collection of the Scottish National Gallery
of Modern Art, Edinburgh

are all in either graphite or black wash; it is not until the eighth session—dated October 22, 1945—that the watercolour medium appears. This is likely how Macdonald first taught his students as well—not unlike Pailthorpe's "telephone scribbling" in pencil.

The Archive also contains a series of eight ink wash drawings Macdonald dated October 12, 1945. The first one, timed at "9.5 pm," states that the work was done "at home." The artist produced subsequent drawings that each took five minutes (although "9.15" is not part of the group, as Macdonald notes on the "9.20 pm" drawing that "the one of 9.15 pm was taken away"). While "9.5" is an ink wash sketch, in "9.10 pm" he adds pen and ink flourishes that look like dancing figures. The "9.20 pm" depicts the first of his obvious birds, with its beak turned to the upper corner, defined further by its wing and legs. The "9.30 pm" work increases the drawing component, while "9.35 pm" presents a more complex, dynamic composition with winged heads, birds and falling figures. Macdonald has created a specific composition in "9.40," with two figures in a car preceded by two birds. He completes the set at "9.45," going back to a simpler fish form jumping over what might be seen as a landscape.

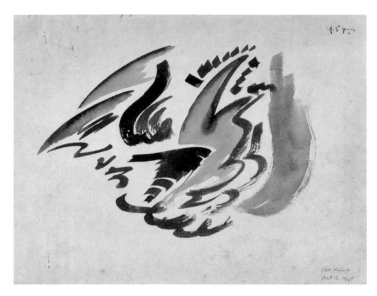

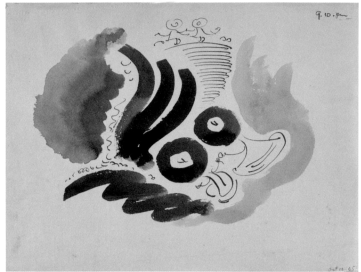

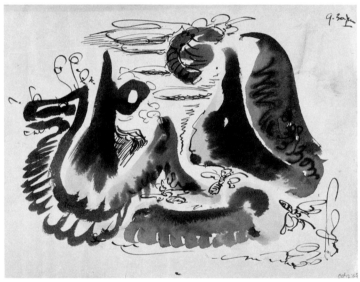

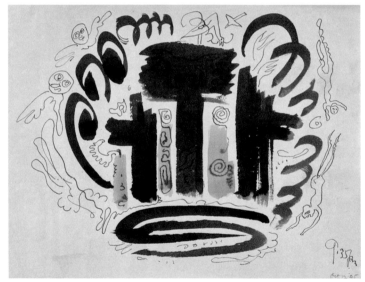

Untitled [9.5 p.m., October 12, 1945], 1945
ink on paper
22.9 x 30.5 cm
Collection of the Scottish National Gallery
of Modern Art, Edinburgh

Untitled [9.10 p.m., October 12, 1945], 1945
ink on paper
22.6 x 30.5 cm
Collection of the Scottish National Gallery
of Modern Art, Edinburgh

Untitled [9.30 p.m., October 12, 1945], 1945
ink on paper
23 x 30.5 cm
Collection of the Scottish National Gallery
of Modern Art, Edinburgh

Untitled [9.35 p.m., October 12, 1945], 1945
ink on paper
23 x 30.5 cm
Collection of the Scottish National Gallery
of Modern Art, Edinburgh

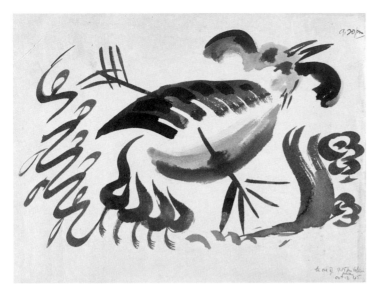

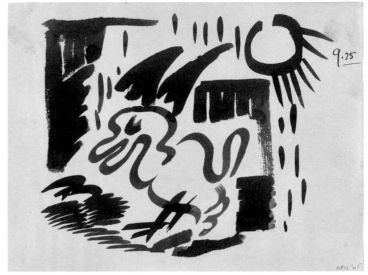

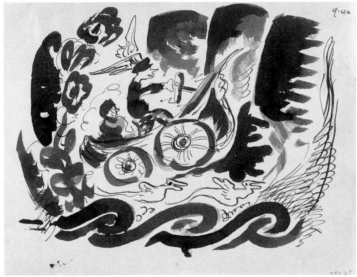

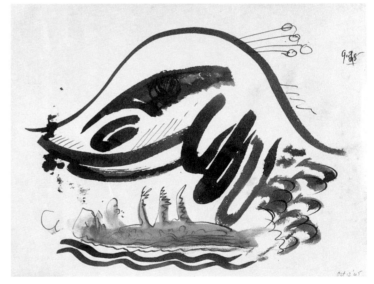

Untitled [9.20 p.m., October 12, 1945], 1945
ink on paper
22.7 x 30.5 cm
Collection of the Scottish National Gallery
of Modern Art, Edinburgh

Untitled [9.40 p.m., October 12, 1945], 1945
ink on paper
23 x 30.5 cm
Collection of the Scottish National Gallery of
Modern Art, Edinburgh

Untitled [9.25 p.m., October 12, 1945], 1945
ink on paper
22.8 x 30.4 cm
Collection of the Scottish National Gallery
of Modern Art, Edinburgh

Untitled [9.45 p.m., October 12, 1945], 1945
ink on paper
23 x 30.6 cm
Collection of the Scottish National Gallery of
Modern Art, Edinburgh

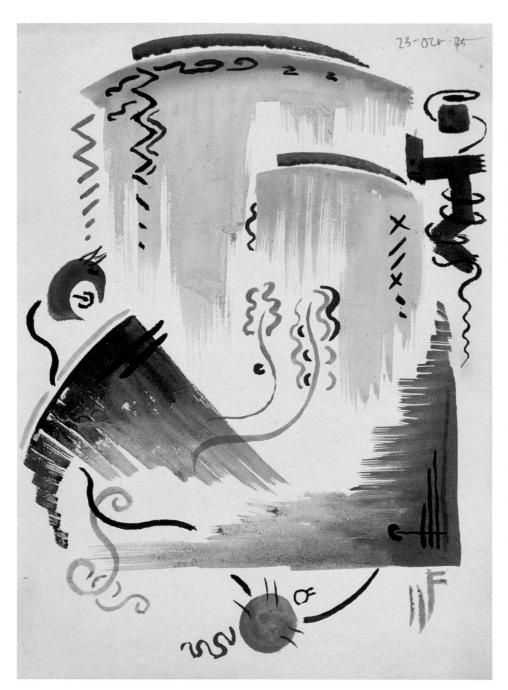

LEFT
Untitled [October 23, 1945], 1945
watercolour, ink on paper
30.5 x 22.7 cm
Collection of the Scottish National Gallery
of Modern Art, Edinburgh

RIGHT
Untitled [October 23, 1945], 1945
watercolour, ink on paper
30.3 x 14.7 cm
Collection of the Scottish National Gallery
of Modern Art, Edinburgh

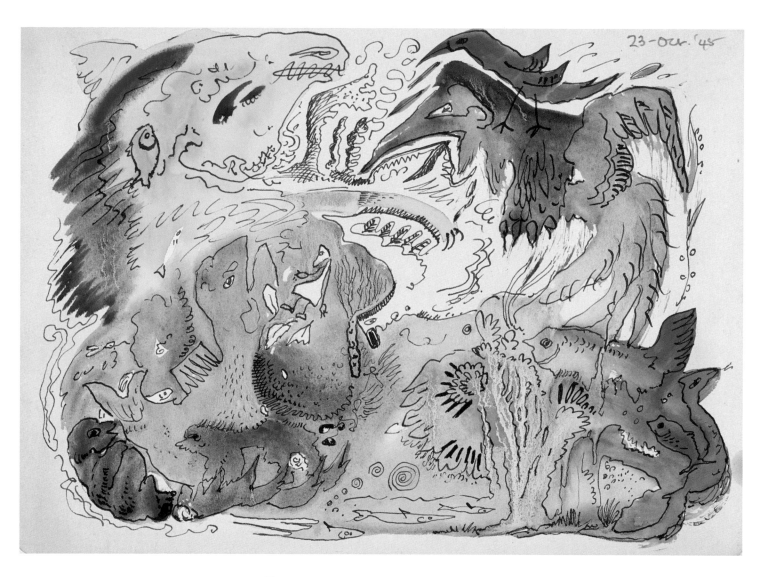

Untitled [October 23, 1945], 1945
watercolour, ink on paper
22.8 x 30.4 cm
Scottish National Gallery of Modern
Art, Edinburgh

There is no sequence to the three works dated October 23, 1945, but it might be assumed that the watercolour and pen-and-ink works came before the combined pen, ink and watercolour work, as it merges elements of both. In the first, Macdonald uses watercolour to create a series of swept brush strokes in blue, black, pink and red, with some decorative elements added; the following uses pen and ink to create a tighter vertical composition; and the final uses the same palette, but adds the pictorial elements of fish and birds, which often appear in his future automatics.

The three works dated October 26, 1945 show a progression from a tighter and more decorative composition to the use of watercolour alone. On the bottom-right corner of the first—which includes depictions of a rooster, human figure and winged bugs—Macdonald has written: "This was followed by a talk." What was discussed has obviously loosened Macdonald's automatic work, freeing it from the specific images portrayed in the first. He was undoubtedly being encouraged to let his unconscious take over completely and to free himself of a need for decorative flourish. In the final work in the series, yellows, reds, pinks, blues and blacks bleed into each other, creating a swirl of movement that cannot be anchored by the yellow and red form at the lower right of the composition. This series demonstrates the commitment with which Macdonald approached

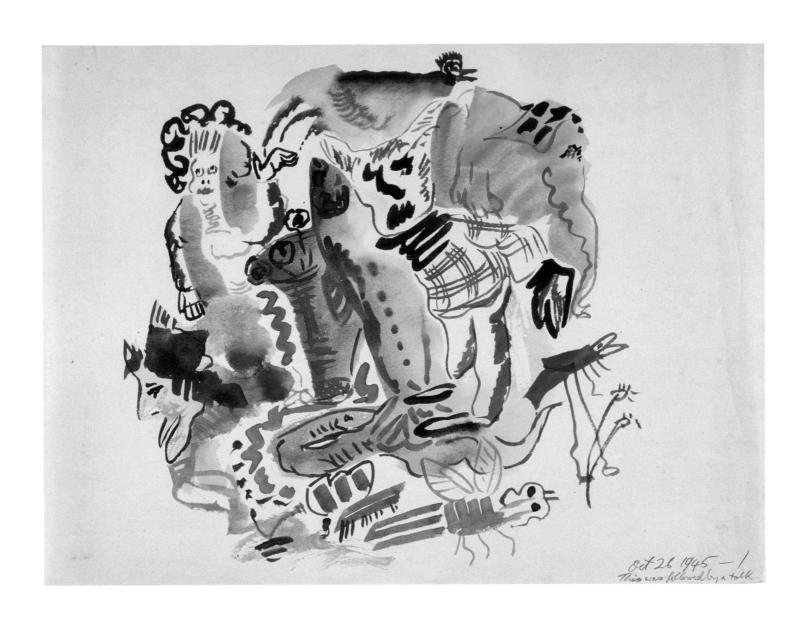

Untitled [October 26, 1945 – 1], 1945
watercolour, ink on paper
22.8 x 30.4 cm
Collection of the Scottish National Gallery
of Modern Art, Edinburgh

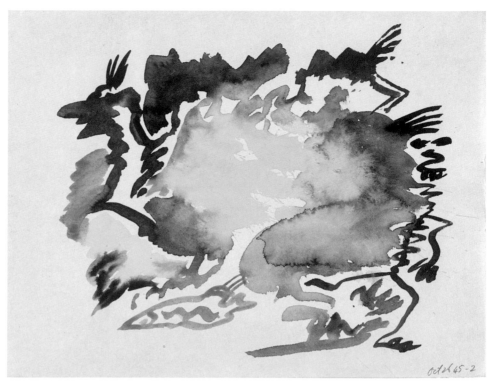

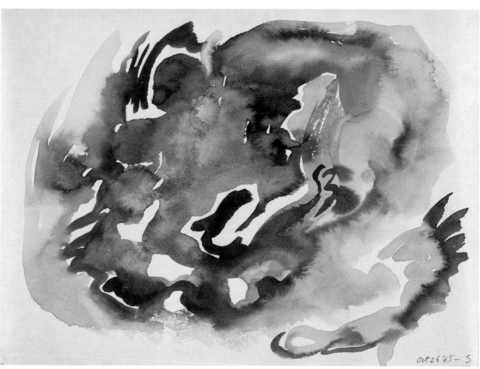

TOP
Untitled [October 26, 1945 – 2], 1945
watercolour, ink on paper
22.8 x 30.5 cm
Collection of the Scottish National Gallery
of Modern Art, Edinburgh

BOTTOM
Untitled [October 26, 1945 – 3], 1945
watercolour, ink on paper
22.8 x 30.4 cm
Collection of the Scottish National Gallery
of Modern Art, Edinburgh

Untitled [November 8, 1945 – 1], 1945
watercolour, ink on paper
22.8 x 15.3 cm
Collection of the Scottish National Gallery
of Modern Art, Edinburgh

OPPOSITE
Untitled [November 8, 1945 – 2], 1945
watercolour, ink on paper
30 x 22.8 cm
Collection of the Scottish National Gallery
of Modern Art, Edinburgh

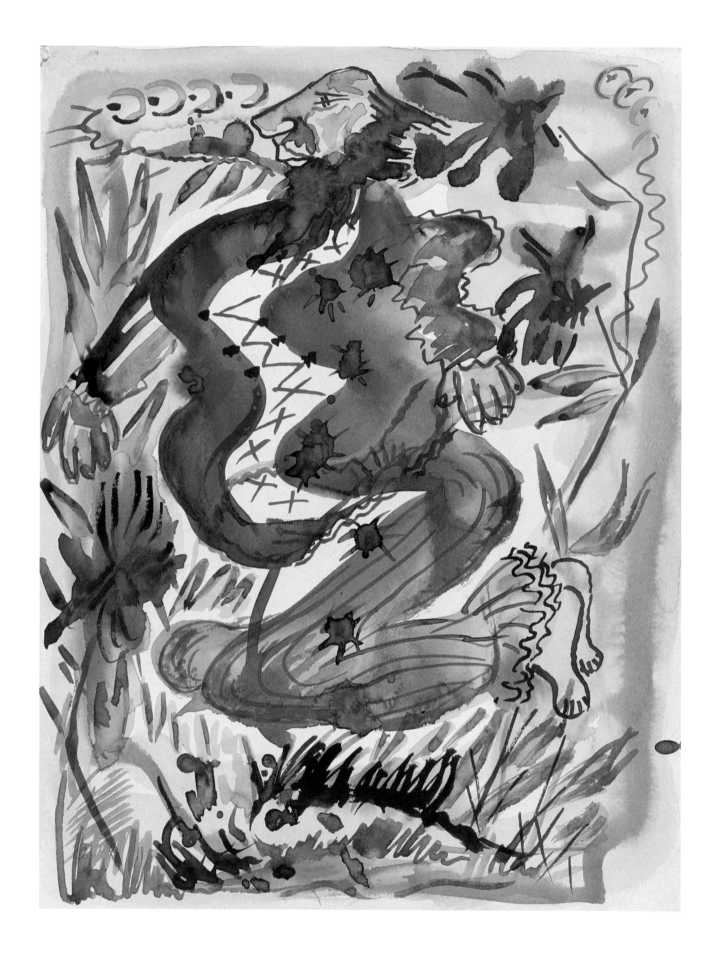

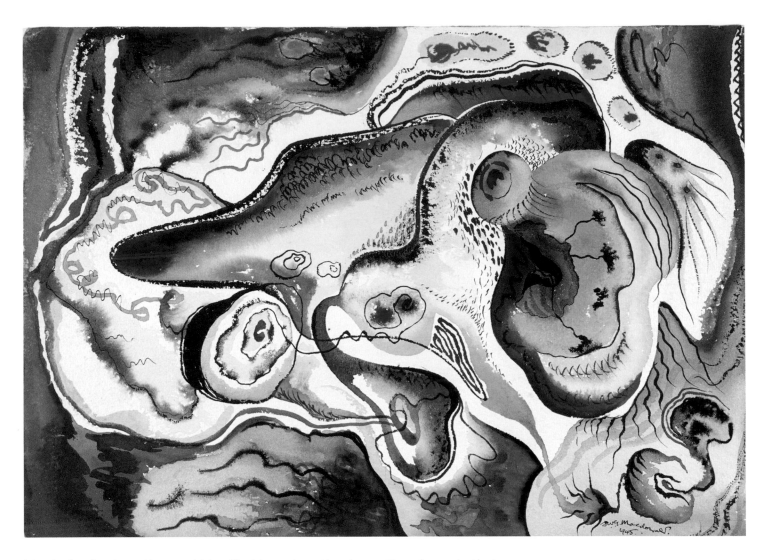

his study of automatism and his effort to reduce the decorative elements that ultimately became a signature of his work.

Within the Archive, the work created on November 24, 1945 is Macdonald's first automatic that he deemed complete enough to sign. Using a vivid palette, the artist paints a series of biomorphic objects that are then outlined in black ink, which assists the eye in moving throughout the composition. The colours are vibrant and, while much of the sheet is painted, Macdonald also uses the white of the paper as a compositional element. This work is the first larger automatic that appears in the Archive and shows his increased confidence in working in this manner.

Of all the work in the Archive, a 1946 watercolour—dated "J 1946," presumably meaning January—can be considered one of the most distinctly surrealist Macdonald ever produced. This work is a surrealist map that marks Leeds and London in England on the left side of the composition, and San Francisco and Vancouver along the west coast of North America on the right. The watercolour was laid down prior to the complex imagery that is drawn on top of it; the central image is a face with one eye opened wide and the other, under a furrowed brow, dripping red tears. Below this is a fenced graveyard that contains a cross-shaped tombstone, which is not dissimilar to his earlier painting, *Indian Burial, Nootka,* from 1937. Four additional figures are present: a woman with a small boy stands to the right of an

ABOVE
Untitled [November 24, 1945], 1945
watercolour, ink on paper
25.2 x 35.5 cm
Collection of the Scottish National Gallery of Modern Art, Edinburgh

OPPOSITE
Untitled [January 1946], 1946 (detail)
watercolour, ink on paper
25.2 x 35.4 cm
Collection of the Scottish National Gallery of Modern Art, Edinburgh

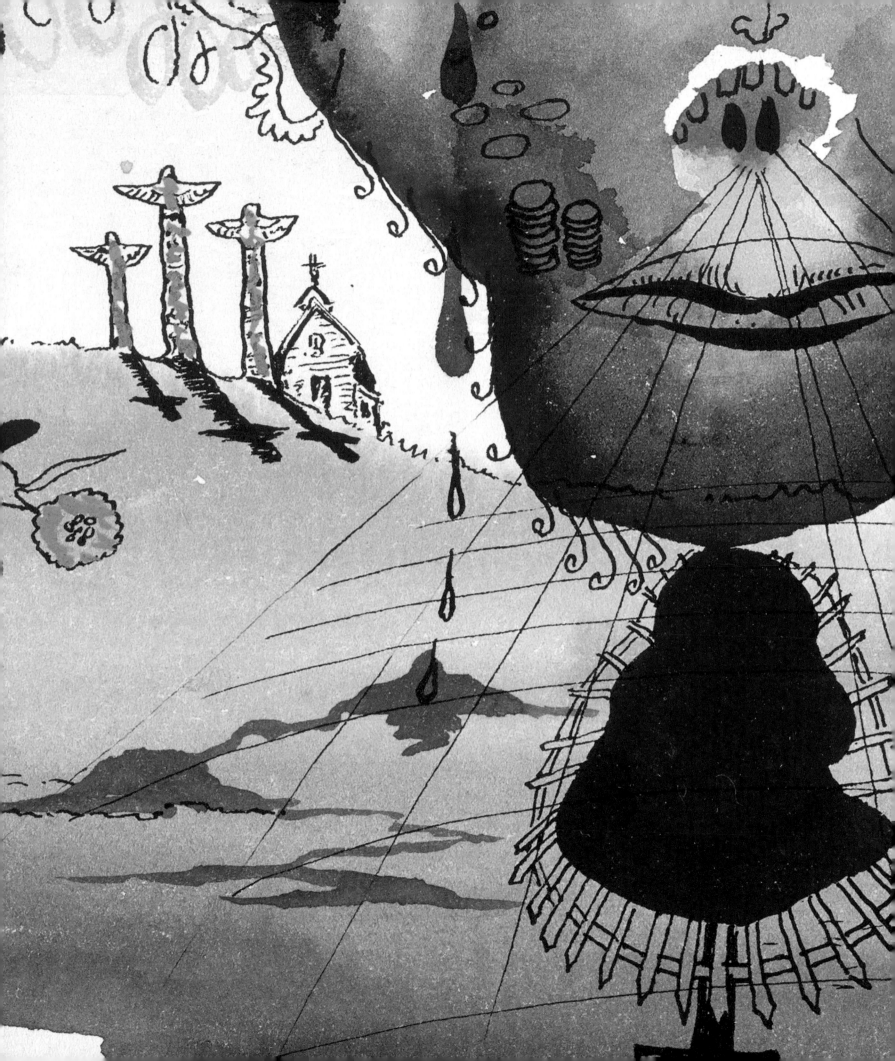

Untitled [January 1946], 1946
watercolour, ink on paper
25.2 x 35.4 cm
Collection of the Scottish National Gallery
of Modern Art, Edinburgh

open grave and two male figures appear on either side of the face. To the left, on a hill, stand three totem poles with a church behind them and above are six spires—three that of a Western church and three the domes of an orthodox place of worship. To the right is the ocean, which leads to a ridge of mountains and a line of hydro wires, with footprints coming from the distance into the front of the picture plane. Finally, above the signature in the lower right corner is the word "CHILI."

It is obvious that Macdonald is deliberately working through something significant in this watercolour. Would Pailthorpe and Mednikoff, who kept such meticulous diaries of the meaning behind their own work (their analytical observations and interpretations are part of the Archive's Pailthorpe/Mednikoff fond), have encouraged Macdonald to mine his unconscious to produce such a surrealist work? As Pailthorpe remarked to her Vancouver Art Gallery audience in April, 1944: "Surrealism has widened the aesthetic horizon by establishing a new conception of art, that of the value of the 'marvelous' and the beauty of irrational thought and creation and has courageously made use of the symbol language of the psyche..."[41] Mapping has precedence in Surrealism, as is evident in *The World at the Time of the Surrealists*, published in the Belgian journal *Variétés* in 1929. That map, like Macdonald's, changes known geographical references. In this case, however, the specificity of the map seems to indicate a particular person; although, the Leeds reference in particular is obscure. Macdonald, as well as Pailthorpe and Mednikoff, had been to—and in the pair's case lived just outside of—San Francisco and of course both had lived in Vancouver. Pailthorpe and Mednikoff had also lived in London and Macdonald had visited the city. The central landscape is obviously Vancouver, with figures who represent law and medicine, as well as multiple references to Christianity in the spires, domes, church and totem pole shadows that suggest the crucifixion. Are the woman and child First Nations figures and are they witness to a burial in a similar way to those in *Indian Burial, Nootka*? The totem poles could reference the contact that Macdonald made with First Nations people while on Nootka Sound. He writes in the July 15, 1935 entry in his *Nootka Diary*: "Much discussion took place over the Indian art of the present day (Totem Poles). H [Harry Tauber] discussed

Untitled [January 1946], 1946
watercolour, ink on paper
17.7 x 25.3 cm
Collection of the Scottish National Gallery of Modern Art, Edinburgh

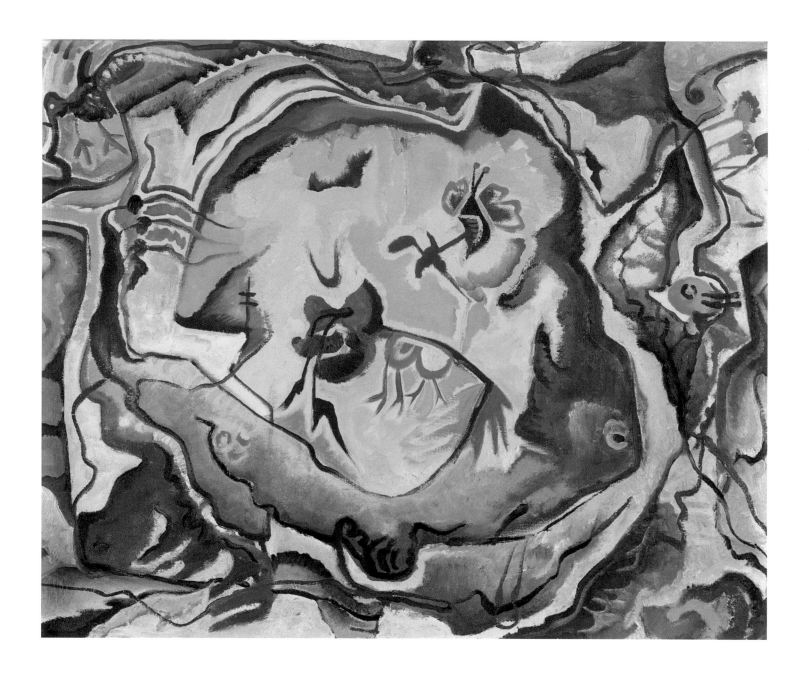

ABOVE
Automatic (Untitled), c. 1948
oil on canvas
69.8 x 83.8 cm
Collection of the Art Gallery of Ontario,
Toronto, Purchased with assistance
from Wintario, 1977

OPPOSITE
Automatic, c. 1946 (detail)
ink, watercolour on paper
46.4 x 55.2 cm
Collection of Lynda M. Shearer

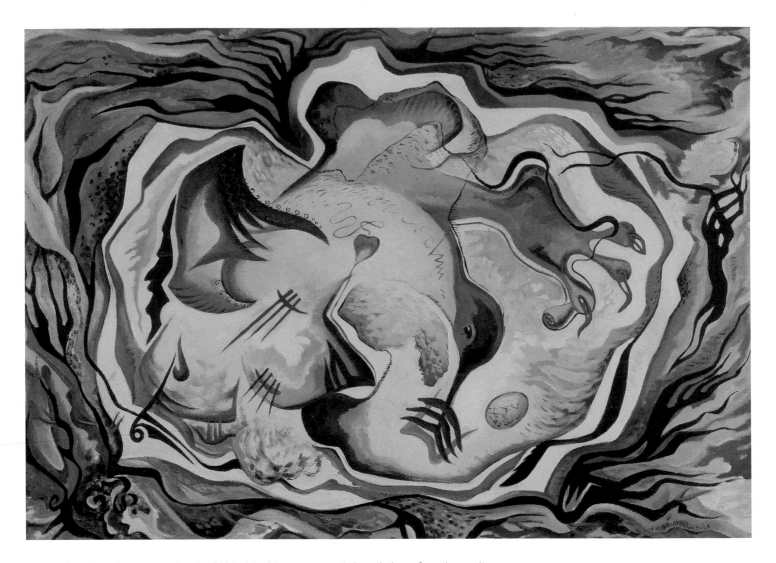

the point that the present art of this kind is commercial and therefore loses its value as a creative art. The old poles were true creative efforts."[42] Furthermore, Zemans asserts that Macdonald came to see "indigenous subject[s] as worthy as the mountains and glaciers he had come to love."[43] While surrealists, including Pailthorpe and Mednikoff, were fascinated with First Nations' cultures—and this work could be a reflection of that, as well[44]—this painting surely represents one of the most remarkable and personal in Macdonald's oeuvre with references that may remain obscure forever.

What follows from this three-month series of sessions with Pailthorpe and Mednikoff are the automatics for which Macdonald is best known. Interestingly, despite their attempts to dissuade him from adding line—exemplified in the works dated October 26, 1945 that he created following a talk on automatic methods—Macdonald's tendency would be to add inked images, designs and flourishes after initially laying down the watercolour automatic. Macdonald trained as a designer and obviously felt his automatics were incomplete until these final details were added. It would seem that he used the watercolour aspect of the work as a guide, while continuing to anchor his work in nature as he states in his biographical notes: "It is from nature that one increases one's vocabulary of forms and colour. Without this planned contact, I feel that one can become sterile of imagination and creative power."[45]

Bird and Environment, 1948
oil on canvas
64.9 x 88.1 cm
Private Collection

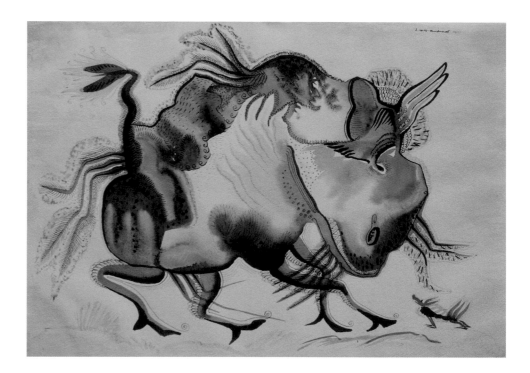

In the 1930s Macdonald's modalities and his experiments with depicting the spirit of nature launched his practice into abstraction; the eighty-six works in the Scottish National Gallery of Art Archive represent the point at which he allowed his subconscious to guide him. These artworks represent the largest collection of works by one of Pailthorpe and Mednikoff's "students." Did Macdonald offer his mentors such a large number of experimental works to further their research or was he seeking their approval? Did the pair see Macdonald as a "star" pupil whose practice clearly demonstrated their methods? In any case, the collection represents a unique opportunity to witness the development of one of Canada's most respected abstractionists, while the Pailthorpe and Mednikoff archival material further elucidates the pair's ideas regarding Surrealism and automatism that were so influential to Macdonald.

The Correspondence

Macdonald's correspondence with Pailthorpe and Mednikoff is the most extensive within the pair's comprehensive archives. In his letters Macdonald provides updates on him and his wife Barbara's lives; his various teaching positions in Vancouver, Banff, Calgary and Toronto; as well as his progress sourcing art supplies for them because of post-war conditions in Britain. Macdonald and his wife also sent parcels with food, and in return they received a large number of art books. This correspondence serves an important function, as it provides a running commentary on his automatic work. In a letter dated June, 1946, he notes that he will have a slide of recent work made in order to keep them "...in touch with the direction in which I am moving. 'Fish' have now disappeared. The things are partly primitive, partly oriental, and often just loose flowing forms. But I greatly miss having a word of advice from both of you."[46] He speaks of artistic isolation when moving to Calgary in 1946: "We have met quite a number of nice people, but in the art field and appreciation of new expressions I find myself out on a limb in companionship. This naturally makes it interesting for me to try and awaken the art conscious people but also at the same time I feel a loneliness."[47]

Automatic, c. 1946
ink, watercolour on paper
46.4 x 55.2 cm
Collection of Lynda M. Shearer

In the fall of 1947 he writes of the reaction to his solo exhibition of automatics, which was presented at the University of Toronto's Hart House that same year: "My automatics caused tremendous reaction at the Toronto University showing… They stated that they never had a show which caused so much discussion + gave so unusual an expression." He goes on to write that he was invited to speak at the gallery and that "Prof Fry…was most impressed + remarked that my short talk was the clearest exposition on 20th century art he had ever heard from any artist."[48] In 1948, he reacts to being asked to forward work to the pair: "Oh Yes! I would be most anxious to send something over to you to be placed in an exhibition of your student's work + I hope to have some new things by the time you would desire the show."[49] Again that year, he enthusiastically writes of going to Provincetown and meeting Hans Hofmann for the first time: "From Hofmann's dynamic + critical statements I gained most valuable knowledge + was tremendously interested in his philosophy of plastic-space expression from the objective subject matter. He, however, values automatic expression as the essence of creative work + has (+ does) much work in this field."[50]

Two photographs of Macdonald and Pailthorpe, dated 1949, are included in an album in the Scottish National Gallery of Modern Art Archive. Beneath one photo, Mednikoff writes: "Jock and Doc on Redington Rd. It was his first visit to us since we parted in Vancouver in 1946. He had been selected to lecture in Holland at the Canadian seminar on the strength of his painting, which we had trained him to produce."[51] Following the visit, Macdonald writes to Pailthorpe and Mednikoff in the renewed position of a student:

Jock Macdonald and Dr. Grace W. Pailthorpe, 22 Redington Road, London, August 1949

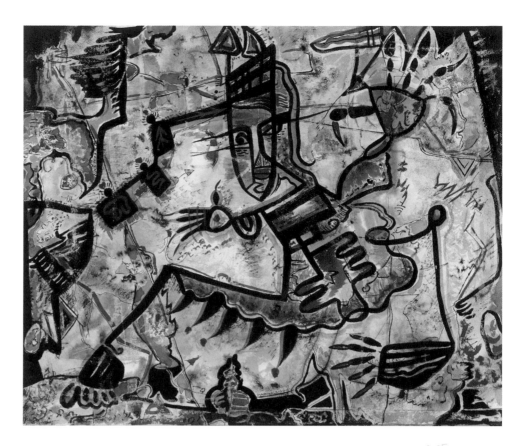

I really hope to work hard this year on 'automatic' painting. It may not have appeared obvious to you but, never-the-less, I was raised to a point of enthusiasm, to increase my efforts, by seeing your work in your apartment and listening to your confirmation of the fact that the essence of real creative effort (expression) is that emanating from the sub-conscious.[52]

In April, 1954 he writes to Pailthorpe and Mednikoff to tell them about the formation of Painters Eleven and the reaction to the group's February exhibition, which was "very successful, with a number of sales and record crowds."[53] In 1957, he states: "I have at last managed to paint freely in oil—automatically—as I did earlier in water-colour."[54] His final archived letter is dated "8 May, 1960." Macdonald writes of his "three one-man shows" and how: "I am well aware of the fact that this could never have happened had I not, during the 40's had the great fortune to receive your teaching. From that time I commenced to speak in a creative way and apparently I am still doing so in the eyes of the so called critics...Our love to you both."[55]

A sense of respect and admiration for what Pailthorpe and Mednikoff did for Macdonald in the mid-1940s, as well as how they continued to influence his work in his final years, is evident throughout the correspondence. Their relationship was much deeper than merely professional; in them he found fellow artists with whom he could share his nascent experimentation and, ultimately, a friendship that transcended both time and distance. The mature work that he produced in the last years of his life can most certainly be credited to Pailthorpe and Mednikoff's guidance and influence. That such a rich archive was saved by the pair is a tribute to them and a trove for those interested in mid-century Canadian Modernism.

The Witch, 1948
watercolour, ink on paper
37.4 x 45.3 cm
Collection of the Art Gallery of Ontario,
Toronto, Gift from the Albert H. Robson
Memorial Subscription Fund, 1950

ENDNOTES

1. Jock Macdonald to Dr. Grace W. Pailthorpe and Reuben Medniknoff, June 6, 1946 (Scottish National Gallery of Modern Art Archive, Edinburgh, Scotland. SNGMA, GMA A62/1/171).

2. Yves Laroque explores the pair's impact on the introduction of Surrealism to a West Coast audience in both his PhD dissertation, *Le surréalisme et le Canada: histoire de l'idée du surréalisme au Canada anglophone entre 1927 et 1984* (PhD thesis in Art History, University Paris 1: Panthéon-Sorbonne, November 1995), and the article "Grace Pailthorpe et Reuben Mednikoff à Vancouver. La transmission du surrélisme au Canada anglais, 1942–1946," *RACAR*, no. XXXII (2007): 1–2.

3. Biographical information for both Pailthorpe and Mednikoff, as cited in Lee Ann Montanaro, "Surrealism and Psychoanalysis in the work of Grace Pailthorpe and Reuben Mednikoff: 1935–1940" (PhD thesis in Art History, University of Edinburgh, 2010).

4. Montanaro, 24.

5. Dr. Grace W. Pailthorpe, "Lecture on Surrealism at Vancouver Art Gallery" (lecture manuscript, dated in pencil April 14, 1944. SNGMA, GMA A62/1/037), 6–7.

6. Montanaro, 75–76.

7. Pailthorpe in a letter to André Breton, reminding him of his remarks regarding her work and requesting that he write a foreword for an exhibition catalogue (SNGMA, A62/1/26/2/4).

8. Dr. Grace W. Pailthorpe, "The Scientific Aspect of Surrealism," *London Bulletin*, no. 7 (December 1938–January 1939), as cited in Walsh: 97, 99.

9. Michel Remy, *Surrealism in Britain* (Aldershot: Ashgate Publishing Limited, 1999), 206.

10. Andrew Wilson, "The unconscious is always right," *Sluice Gates of the Mind: The Collaborative Work of Dr. Grace W. Pailthorpe and Reuben Mednikoff* (Leeds: Leeds Museums and Galleries, 1998), 33. In her Vancouver Art Gallery lecture, Pailthorpe notes how the surrealist movement "met inevitable difficulties and how it split in two—one group going one way and ourselves another—how these two groups are going to the same end by two different routes," 9.

11. Nigel Walsh, "Foreword," in *Sluice Gates of the Mind: The Collaborative Work of Dr. Grace W. Pailthorpe and Reuben Mednikoff* (Leeds: Leeds Museums and Galleries, 1998), 5.

12. Remy, 153.

13. Roald Nasgaard, "The Automatiste Revolution in Painting," *The Automatiste Revolution, Montreal, 1941–1960* (Vancouver: Douglas & McIntyre; Markham: Varley Art Gallery, 2009), 8. Nasgaard states: "Montreal's Automatisme had its basis in Surrealist writing and not in Surrealist painting," 52.

14. Charles Doyon cited in Ray Ellenwood, *Egroegore: The Montreal Automatist Movement* (Toronto: Exile Editions Ltd., 1992), 17.

15. Ellenwood, 173.

16. Anna Balakian, "Introduction," in André Breton, *Arcanum 17*, trans. Zack Rogow (Toronto: Coach House Press, 1994), 11.

17. Nasgaard, 18–19.

18. Pailthorpe, "Lecture on Surrealism," 8 (SNGMA, GMA A62/1/037).

19. Stephen Cain, "André Breton in Canada," eds. Gregory Betts and Beatriz Hausner in *Open Letter*, Fifteenth Series, no. 3 (Summer 2013): 44-45.

20. Jock Macdonald, "Biographical notes," McCord Museum archives, undated (after 1955), iii.

21. Mednikoff to Charles, April 28, 1944, 1 (SNGMA, GMA A62/1/37).

22. Joyce Zemans, *Jock Macdonald, The Inner Landscape* (Toronto: Art Gallery of Ontario, 1981), 101.

23. Macdonald to Pailthorpe and Mednikoff, April 3, 1946 (SNGMA, GMA A62/1/171), 3.

24. "Surrealist Pictures To Be Protected," *Vancouver Sun*, June 10, 1944.

25. "Unconscious Mind Aids Art," *News Herald*, June 14, 1944.

26. Pailthorpe, "Surrealism and Psychology, A Radio Talk," July 10, 1944, 3:15 p.m. (SNGMA, GMA A62/1/37), 2.

27. Walsh, 97.

28. Pailthorpe, "Talk to Canadian Federation of Artists (Vancouver)," November 24, 1944 (SNGMA, GMA A62), 1.

29. Ibid., 2.

30. Ibid., 17. Interestingly, there are references to the word "surrealist" within her lecture manuscript, but Pailthorpe has crossed out the majority of them. It is worth noting that in the seventeen-page typed manuscript, seven references to the

word "surrealist" have been crossed out, with only one remaining. However, of the thirteen times she uses the word "automatic" or one of its other forms, the word is crossed out only once. One can speculate that during numerous discussions among the pair and Macdonald the term "surrealist" was not used as frequently as the term "automatic"—a word that Macdonald uses exclusively in describing his own automatic work, which he may easily have referred to as surrealist.

31. Macdonald, April 3, 1946 (SNGMA, GMA A62/1/171), 4.
32. Pailthorpe to Breton, undated (SNGMA, GMA A62/1/26/2/4).
33. Mednikoff was also invited to lecture at the University of British Columbia Student Christian Movement on February 12, 1945 on the topic "On Understanding the artist and art," as well as at the Federation of Canadian Artists on February 23, 1945, where he spoke on the topic "The Critic and the Artist."
34. Macdonald to Pailthorpe and Mednikoff, July 4, 1946 (SNGMA, GMA A62/1/17/4), 6.
35. Pailthorpe, "Lecture on Surrealism" (SNGMA, GMA A62/1/37), 5.
36. Pailthorpe, "Surrealism and Psychology" (SNGMA, GMA A62/1/37), 4.
37. Gerald Tyler, interview with Joyce Zemans, February 2, 1978, cited in Zemans, 113–114.
38. Quoted in Ann Payne, "Jim and Marion Nicoll," *Art West*, VI (1977): 14, as cited in Joyce Zemans, "From Landscape to Abstractionism, Alexandra Luke," *Vanguard*, vol. 13, no. 1: 16.
39. Macdonald encouraged dating and timing to his students of the automatic technique: "I did books and books and books of automatics and he [Macdonald] said to keep track of them, to date them," Marion Nicoll, interview with Joan Murray, May 24, 1979, The Robert McLaughlin Gallery Archives, and "Like [Marion] Nicoll, she [Alexandra Luke] carefully followed Macdonald's advice, keeping track of the automatics, dating them and recording the time they were completed," in Zemans, 17.
40. Macdonald consistently used the same paper within each session; this, along with the time stamp and stylistic similarities, suggest that these works are both from the September 16 session (although a logical explanation for why Macdonald wrote "30" has yet to be determined).
41. Pailthorpe, "Lecture on Surrealism" (SNGMA, GMA A62/1/37), 8.
42. Macdonald, *Nootka Diary*, July 15, 1935 (Vancouver Art Gallery Archives), 23–24.
43. Zemans, 29.
44. Dawn Ades writes: "The Pacific Northwest was a magnet for surrealist travellers and collectors and masks and other objects were absorbed into their studios." Dawn Ades, "Exhibiting Surrealism," *The Colour of My Dreams: The Surrealist Revolution in Art* (Vancouver: Vancouver Art Gallery, 2011), 45. Swiss surrealist Kurt Seligmann travelled to the Northwest Coast of British Columbia in 1938 returning with objects, including a totem pole, while Viennese surrealist Wolfgang Paalen also collected works by Native artists during his 1939 trip to the British Columbia coast. Ron Sakolsky in his prose piece "A Chronicle of Surrealist Voyages in Pacific Northwest," *Open Letter*, Fifteenth Series, no. 3 (Summer 2013) succinctly addresses the interests of surrealists in the Pacific Northwest. In the Pailthorpe/Mednikoff archives, displayed in a photo album, is a black and white postcard of Thunderbird Park totem poles in Victoria, British Columbia, a park that opened in 1941; Mednikoff notes in the album that within the park is "A very fine collection of Totems + other native carvings, which were displayed in the open air" (SNGMA, GMA A62/3/23).
45. Macdonald, "Biographical Notes."
46. Macdonald to Pailthorpe and Mednikoff, June 5, 1946 (SNGMA, GMA A62/1/171), 6.
47. Ibid., February 23, 1947 (SNGMA, GMA A62/1/171), vi.
48. Ibid., November 9, 1947 (SNGMA, GMA A62/1/171), 4.
49. Ibid., January 13, 1948 (SNGMA, GMA A62/1/171), 1.
50. Ibid., September 29, 1948 (SNGMA, GMA A62/1/171), 2.
51. Photo album of Pailthorpe and Mednikoff (SNGMA, GMA A62/3/17).
52. Macdonald to Pailthorpe and Mednikoff, September 24, 1949 (SNGMA, GMA A62/1/171), 1-2.
53. Ibid., April 15, 1954 (SNGMA, GMA A62/1/172), 2.
54. Ibid., Christmas 1957 (SNGMA, GMA A62/1/171). It is interesting to think that while most refer to his latest work as abstract expressionist, here, at least, Macdonald refers to them as automatic.
55. Ibid., May 8, 1960 (SNGMA, GMA A62/1/171), ii, iii.

Finding His Way: Jock Macdonald's Toronto Years

Michelle Jacques

In autumn 1947, Jock and Barbara Macdonald relocated to Toronto, Ontario from Calgary, Alberta, where the artist had spent just one year teaching at the Provincial Institute of Technology. He had accepted a post in the painting and drawing department of the Ontario College of Art, and although he had left western Canada with some reluctance ("I will never become an Eastern artist"), he would teach at the College for nearly fourteen years—the rest of his life.[1] The trials and tribulations of Macdonald's time in Toronto are well-known and have been explored in great depth by Joyce Zemans in the catalogue essay for *Jock Macdonald: The Inner Landscape*, the retrospective exhibition of his work presented at the Art Gallery of Ontario in 1981. Undoubtedly, however—given the profound evolution his work underwent while living there and the strength of his artistic output in the last years of his life—his time in Toronto was also a period of inspiration, breakthrough and growth.

As Linda Jansma notes in her essay, "Jock Macdonald, Dr. Grace W. Pailthorpe and Reuben Mednikoff: A Lesson in Automatics," the content of Macdonald's letters to Pailthorpe, a physician, surgeon, Freudian analyst and practitioner of automatic painting, and her lifelong companion Mednikoff, a surrealist artist, "reveal a unique relationship of student to teachers, rather than teacher to student."[2] Macdonald came to know them during their residence in Vancouver in the mid-1940s, and wrote that Pailthorpe possessed a "spiritual awareness...and quality of consciousness of true value to humanity."[3] His dispatches to "Doc and Riki," as he affectionately addressed them, focus as much on his achievements as his obstacles. The artist's assessment of the situation at the College, which he expressed to artist Maxwell Bates as "academic sleepwalking," is echoed in the first letter he wrote to Pailthorpe and Mednikoff from Toronto;[4] however, he emphasizes the fact that he was enlisted precisely to upend the conservatism: "Now, you will ask, what about the instruction? Isn't the place very academic + conservative? Yes! decidedly so. But I have taken it that I have been asked here to break through the old academic instruction + this I am doing already."[5] Macdonald's correspondence to the pair provides an opportunity to consider his Toronto years through a new, more optimistic lens.

As Zemans notes in her exploration of Macdonald's life and work, even in 1956, after nearly ten years of effort on his part, "[T]he city was still alien territory for an abstract artist...Macdonald still had to defend the very existence of abstract painting in Toronto. His students adored him, but his OCA colleagues continued to damn modern painting and its exponents."[6] Yet, Toronto was the city in which Macdonald found his way, as he emphatically reported to Pailthorpe and Mednikoff at the close of 1957.[7] He taught at the College almost twice as long as any other institution and it was in Toronto that he came to be revered by scores of students, including William Ronald, the young alumnus who would invite him to be a part of Painters Eleven, the collective of artists who would finally turn English Canada's

Fish, 1945 (detail)
watercolour, ink on paper
22.3 x 30.3 cm
Collection of The Robert McLaughlin Gallery, Oshawa, Purchase, 1979

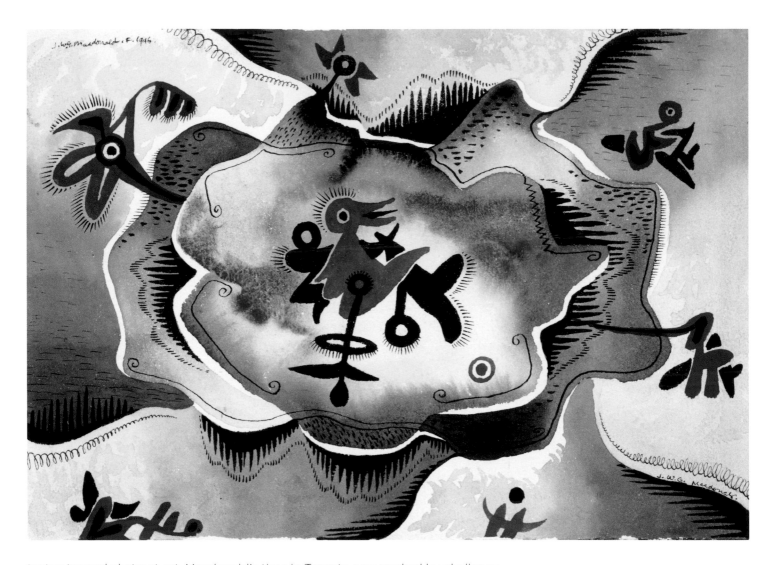

tastes toward abstract art. Macdonald's time in Toronto was marked by challenge, yes, but it was also the place of his ultimate breakthrough.

Today, Toronto is a city that supports a diversity of artistic practices. There is no identifiable school, brand or narrative to describe the work produced there. Given the tensions around the introduction of abstraction in the 1950s that Macdonald described, it is hard to imagine that during the decade following his death abstraction would become mainstream; that many of the city's artists would begin to work with film, video, performance, conceptual, textile and other alternative mediums; and that this multiplicity of practice would become a touchstone of the city's cultural landscape. As David Blackwood writes:

> Jock Macdonald was an exceptional teacher and a great artist. His philosophy of art was very broad and style was of no importance to him. He was totally capable of confronting realism and non-objective approaches to painting. He was a great believer in the evolution of the artist, sustained development and the maturing of individual vision, something not quite tolerated today perhaps but nevertheless vital to all serious art.[8]

Undoubtedly, Macdonald's artistic output tells a remarkable story of singular vision, dedicated struggle and unique expression that makes him one of Canada's

Orange Bird, 1946
watercolour, ink on paper
18.5 x 26.4 cm
Collection of The Robert McLaughlin
Gallery, Oshawa, Gift of M. Sharf, 1983

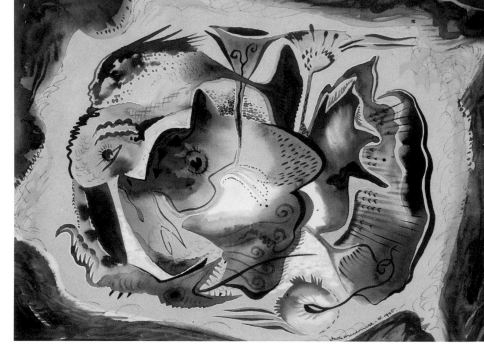

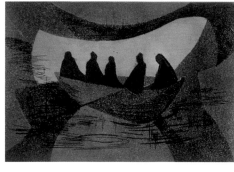

great abstract painters. Perhaps, though, his truly great achievement during his Toronto years was all that he did to promote abstraction, change the teaching philosophy of the Ontario College of Art and—ultimately—transform the cultural character of that city.

Toronto, This is Jock Macdonald

In October 1947, just after Macdonald had arrived in Toronto, his exhibition *Paintings by James W. G. Macdonald*—which had been presented at the San Francisco Museum of Art (now the San Francisco Museum of Modern Art) a few months prior—was remounted at the University of Toronto's Hart House. The exhibition featured his automatic watercolours from 1945 and 1946, such as *Prehistoric World* (1945), *Fish* (1945), *Orange Bird* (1946) and *Sandpiper* (1946). Created according to Pailthorpe's lessons in the automatic process, the works are characterized by expanses of colour animated with lively delineated forms. While there are shared elements among certain works, taken as a whole his automatics are varied in their aesthetic qualities—which is to be expected given his use of a method that was intended to spontaneously emerge from his subconscious. Writing about his colleague's work in 1957, Bates notes:

> Jock Macdonald must be regarded as a pioneer of automatic and abstract painting in Canada. He was the first artist in this country seriously and consistently to adopt the automatic process. Because of its exploratory nature his work is difficult to evaluate, and like all such artists his paintings are best seen in a one-man exhibition. Then one can see the remarkable diversity of approach and technique adds up to the inner vision of an individual.[9]

Macdonald was apprehensive about the move to Toronto, particularly how he and his work would be received, and saw the Hart House exhibition as the most direct

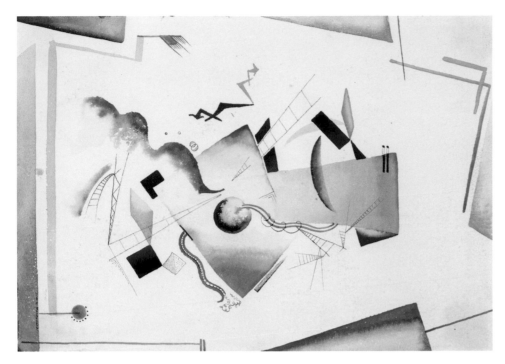

way to convey the nature of his artistic production and its underlying concerns. Several months before his relocation east he had written to his friend Nan Cheney, a British Columbian portrait painter and medical artist, "What reactions the 'pollywogs' will have on my new appointment to the College goodness only knows. It will be easier for me to explain my attitudes towards art in this show than for me to say it in words."[10] He must have been pleasantly surprised by the response to the exhibition. After its closure, he wrote to Pailthorpe and Mednikoff:

> My automatics caused tremendous reaction at the Toronto University showing in Hart House. They stated that they never had a show which caused so much discussion + gave so unusual an expression. They invited me to talk there + invited me to return time + time again to meet certain people. Prof. Fry, who has just brought out a book on William Blake—"Splendid Symmetry" (I believe) was most impressed + remarked that my short talk was the clearest exposition on 20th century art he had ever heard from any artist.[11]

Despite the success of the Hart House show, Macdonald was still struggling in the studio. He wanted desperately to be able to express his automatic explorations in oil on canvas. Before the close of the year he would produce *Ocean Legend* (1947), his first automatic oil and the work that would come to convey his abstract methods to other cities in eastern Canada:

> I heard last night that the Canadian Group of Painters accepted for exhibition my first automatic oil. The exhibition is to be in Toronto first, then Montreal + after that Ottawa. I wondered very much if they would accept it as it is entirely out of the usual line of exhibition pictures. It is a 24" x 38" (upright). I named the painting "Ocean Legend."[12]

Macdonald did not consider the painting to be wholly successful. "Truthfully, I am not altogether satisfied with it—not enough depth in it + a bit too busy. However, it is a start and more will come in the future."[13]

LEFT
Abstract Space, 1947
watercolour, ink on paper
35.6 x 25.2 cm
Collection of The Robert McLaughlin Gallery, Oshawa, Gift of M. Sharf, 1983

RIGHT
Jock Macdonald, right, instructs a class in still life painting at the Ontario College of Art
Photo by John E. Milne

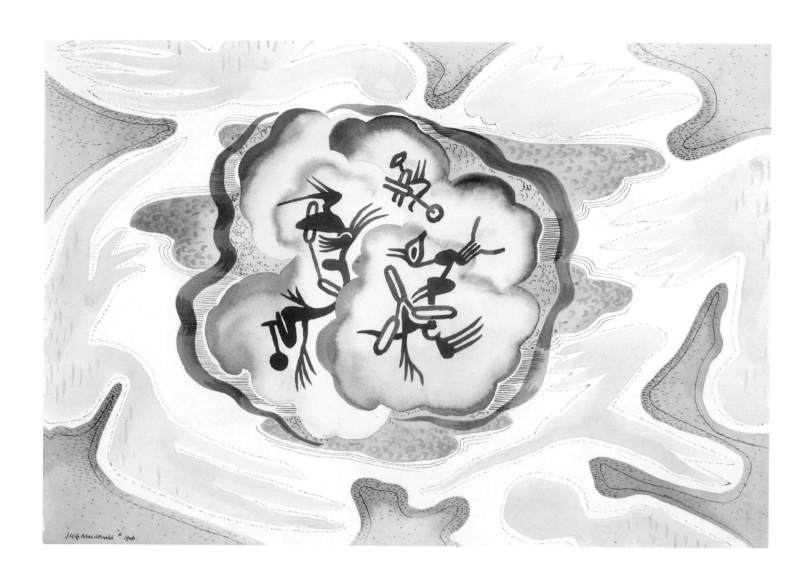

Sandpiper, 1946
watercolour, ink on paper
25.5 x 35.8 cm
Collection of The Robert McLaughlin
Gallery, Oshawa, Gift of M. Sharf, 1983

Inside and Outside the Ontario College of Art

Macdonald had been glad to leave Calgary's "isolation, the lack of understanding about art in general; and the environment of the Technical School itself."[14] Although the painting department at the Ontario College of Art was then defined by conservative inclinations and a very conventional pedagogical approach, Macdonald was quickly able to introduce his non-traditional teaching methodologies. He was given first- and second-year students, a fact which pleased him as he felt they were still "formative + there are no barriers to break down."[15] He taught the second-year students still life and composition, and although he was required to teach them basic painting techniques, he described his composition classroom as one in which the students worked "purely on expressive + creative ideas—with music, with any medium they desire, and all emphasis on space, motion, etc."[16] At this early stage of his tenure, with Frederick S. Haines—who had hired him—as principal, he felt quite supported: "I don't expect to be 'hauled over the coals' for being too reactionary as Mr. Haines, the principal, told me I was free to instruct according to my experience + I asked him at the beginning if he really <u>meant</u> that. He said <u>yes</u>, very decisively."[17] At the end of his first year, Macdonald reported to Pailthorpe and Mednikoff that "the boss—Mr. Haines—told me the other day that I had done notably + was a distinct addition. They are adding Carl Schaeffer to the staff next year—another for our side."[18]

Phoenix, c. 1949
watercolour, ink on paper
25.4 x 35.7 cm
Collection of The Robert McLaughlin Gallery, Oshawa, Gift of Alexandra Luke, 1967

TOP
Revolving Shapes, 1950
watercolour, wax resist on paper
24.8 x 25.1 cm
Collection of the Art Gallery of Greater
Victoria, Gift of Colin and Sylvia Graham

BOTTOM
Land of Dreams, 1948
watercolour, wax resist on paper
38.7 x 48.3 cm
Collection of The Robert McLaughlin
Gallery, Oshawa,
Gift of M. Sharf, 1983

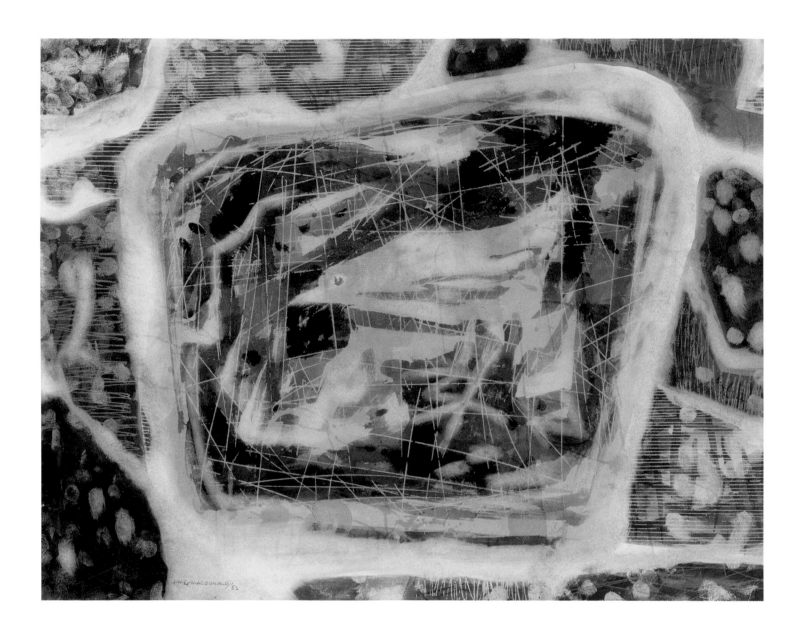

The White Bird, 1952
watercolour, coloured ink on paper
37.3 x 47.8 cm
Collection of the Art Gallery of Ontario,
Toronto, Gift from the John Paris Bickell
Bequest Fund, 1953

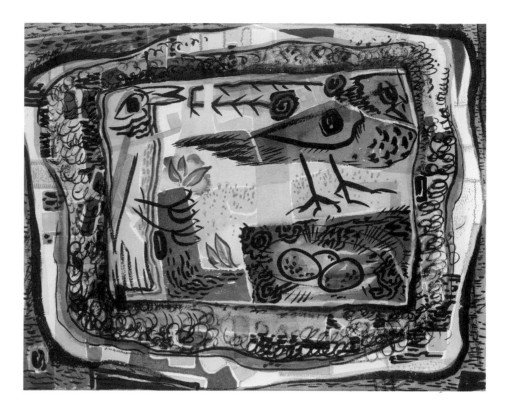

When Macdonald accepted the position at the College he assumed he would no longer have to supplement his day job with extracurricular teaching and that, ultimately, he would find himself with more time and money to dedicate to his own painting. Yet, as early as the summer of 1948—his first after joining the College faculty—he was back teaching at the Banff School of Fine Arts' summer school. The income he gained there soon became a necessity, as his financial situation was about to take a major downturn. "Things are a bit unsettled financially in college as the staff, unitedly, has forwarded a memorandum to the council complaining of the fact that during the past five years no additions have been added to the salaries to balance with the cost of living increase during that time. The cost of living has gone up 48% here during the five years."[19] For the rest of his life, Macdonald would teach most summers, and he also offered private tutoring to make extra money. In addition to the recurring posts in Banff from 1945 to 1948, and again in 1951 and 1953, he also taught at the Doon School of Fine Arts in Kitchener from 1958 to 1960. In the summers of 1949 and 1950, he was appointed Professor of Art at the International Students' Seminars, UNESCO, first in Breda, The Netherlands, and then in Pontigny, France. These UNESCO invitations were opportunities to travel to Europe—a luxury for an underpaid art college instructor—and his trip to Scotland during the 1949 appointment was the first time he had visited his childhood home since immigrating to Canada twenty-three years earlier.[20] Travelling to Europe was also an opportunity for a profoundly inspirational reunion with Pailthorpe and Mednikoff:

> It may not have appeared obvious to you but, never-the-less, I was raised to a point of enthusiasm, to increase my efforts, by seeing your work in your apartment + listening to your confirmation of the fact that the essence of real creative effort (expression) is that emanating from the sub-conscious. Looking at my own work again I realize more fully that what I have been expressing in the past has its own distinct individuality and has more quality than I had thought.[21]

Birds in a Field, 1951
brush, black ink, watercolour on paper
41 x 50.9 cm
Collection of the National Gallery
of Canada, Ottawa, Purchase, 1995

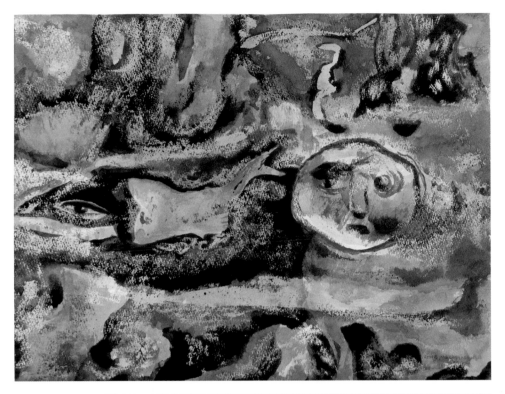

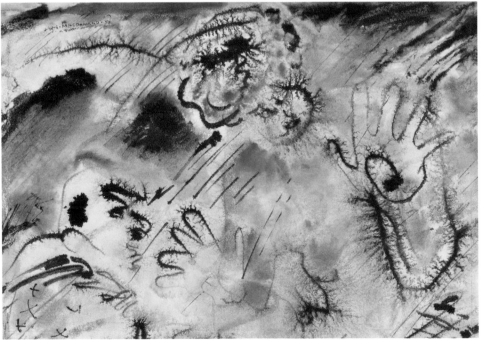

TOP
Reflections in a Pond, 1953
watercolour on paper
33 x 45.1 cm
McMichael Canadian Art Collection,
Gift of Mrs. B. E. Macdonald

BOTTOM
The Argument, 1952
watercolour, ink on paper
24.8 x 35.5 cm
Collection of the Art Gallery of Greater
Victoria, General Art Purchase Fund

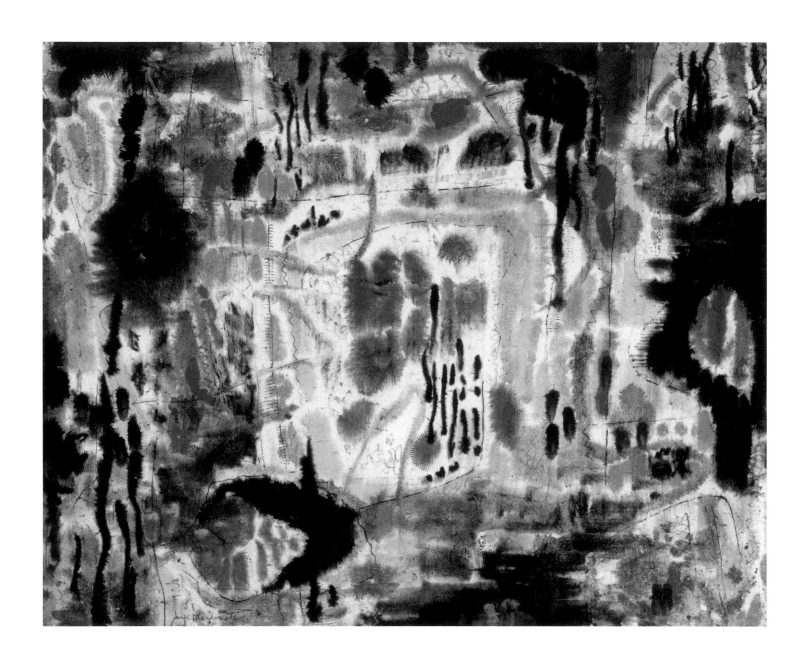

Scent of a Summer Garden, 1952
watercolour, coloured inks on paper
35.6 x 45.7 cm
Collection of the Agnes Etherington Art
Centre, Queen's University, Kingston,
Gift of Ayala and Samuel Zacks, 1962

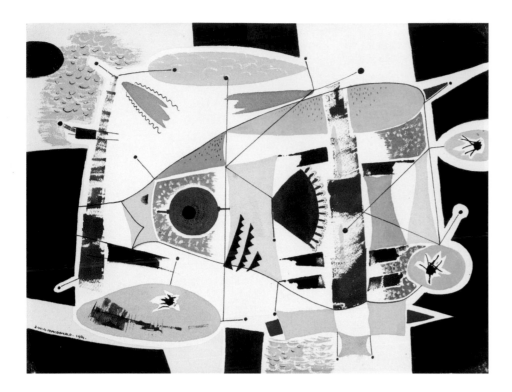

In 1952, Macdonald revisited Vancouver Island, where he had lived in 1935 and 1936. While his earlier residency had been in the isolated region of Nootka Sound, this time he would be artist in residence at the Art Centre of Greater Victoria (now the Art Gallery of Greater Victoria). While in Victoria he taught five painting classes a week, delivered three public lectures and mounted a solo exhibition. Despite this hectic schedule, he would report that he "did just as well financially as [he] would have done at Banff, with only ½ the work."[22] Another remarkable opportunity to travel and focus on his work came in 1954, when Macdonald was invited to spend a full year in France. As he informed Pailthorpe and Mednikoff: "...I have just received the very surprising news that I have been awarded a Canadian Government Fellowship to France, for one year. We have to be in Paris by September or perhaps a little sooner. After reporting to the Canadian Embassy we can then go wherever we like in France. I am completely free to paint for the year + am not obliged to adhere to any commitments..."[23]

Macdonald seemed reinvigorated upon his return to Toronto from his summer teaching and travel stints; if not fully re-energized, he was at least refocused on his goal of bringing the Ontario College of Art's curriculum into the modern era. In September 1948, after a summer teaching in Banff and travelling western Canada, he wrote to Pailthorpe and Mednikoff about the start of his second year at the College:

> You will remember my saying that I introduced to the college last year a course of instruction relating to 20th century creative expressions. Well, this work has been accepted as absolutely necessary + this year I have been specially asked to continue in this way. Not only that, but I am now given classes (painting) in the 1st, 2nd + 3rd year. To have the college recognizing values in any type of expression other than Academic is really something...[24]

Macdonald was also committed to exhibiting his work, presumably to help foster an appetite for "creative expressions" in the artistic community and the broader public.

Untitled, 1954
watercolour, ink on paper
32.9 x 42.9 cm
Collection of The Robert McLaughlin Gallery, Oshawa, Gift of Mary Hare, 1990

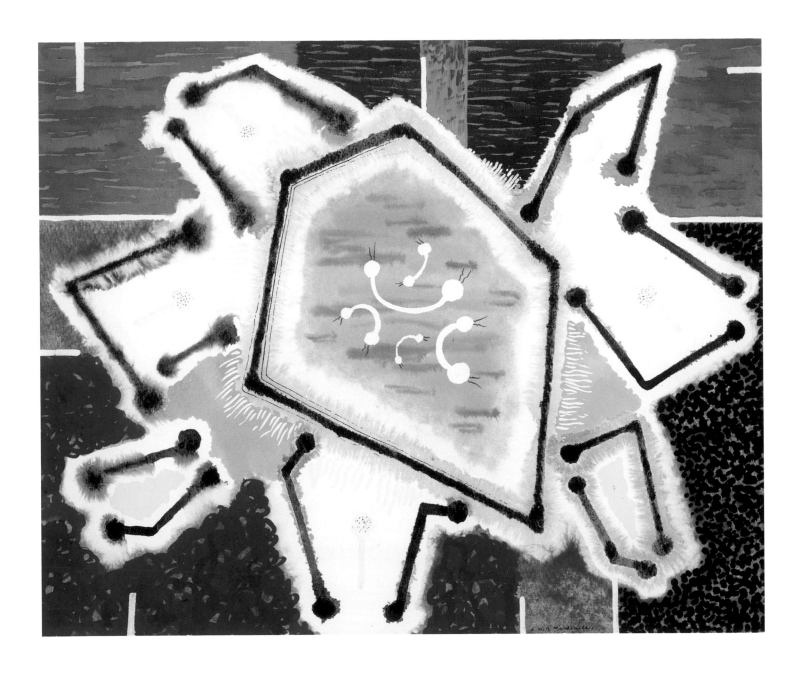

Nature's Pattern, 1954
gouache, ink on paper
39 x 46.8 cm
Collection of The Robert McLaughlin
Gallery, Oshawa, Purchase, 1971

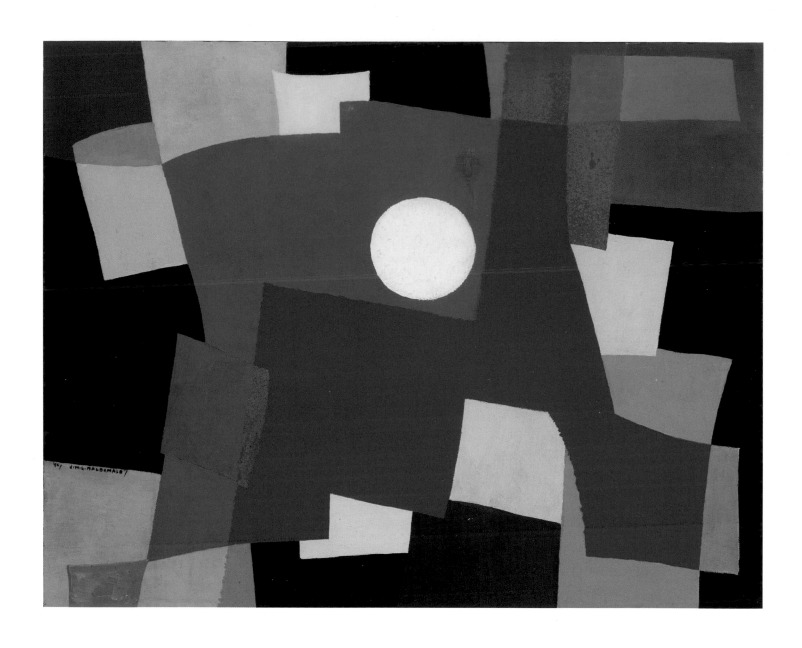

Orange Impulse, 1955
oil, graphite on canvas
73 x 91.8 cm
Collection of The Robert McLaughlin Gallery,
Oshawa, Donated by the Ontario Heritage
Foundation, 1988, Gift of M. F. Feheley

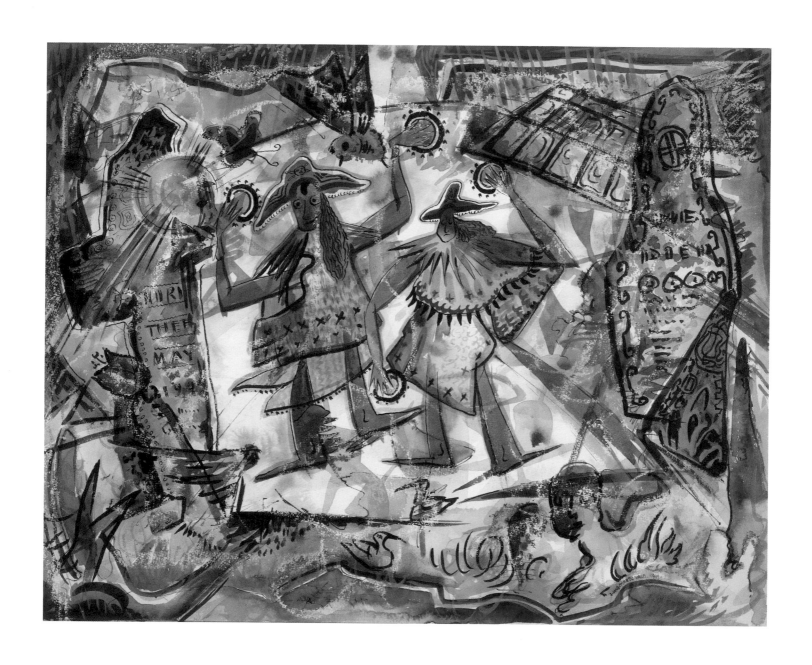

Ritual Dance, 1949
watercolour, wax resist, ink on paper
38.9 x 48.1 cm
Collection of The Robert McLaughlin
Gallery, Oshawa, Gift of M. Sharf, 1983

Birds Dreaming, 1949
watercolour, ink on paper
39.8 x 47.5 cm
Collection of The Robert McLaughlin
Gallery, Oshawa, Gift of Isabel
McLaughlin, 1987

OPPOSITE
Leaves of a Book, 1950 (detail)
watercolour, wax resist, ink on paper
38 x 47 cm
Collection of the Art Gallery of Greater
Victoria, Gift of Mrs. Maxwell Bates

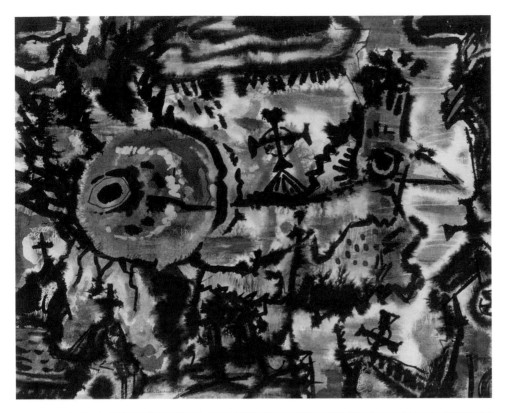

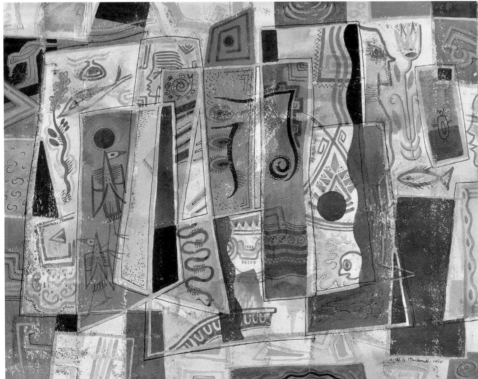

TOP
Fabric of Dreams, 1952
watercolour on paper
37 x 46.9 cm
Collection of the Art Gallery of Ontario, Toronto,
Purchased by Peter Larkin Foundation, 1962

BOTTOM
Leaves of a Book, 1950
watercolour, wax resist, ink on paper
38 x 47 cm
Collection of the Art Gallery of Greater
Victoria, Gift of Mrs. Maxwell Bates

He became involved in the Toronto chapters of a number of societies and was elected to the membership of the Canadian Society of Painters in Water Colour in 1948, which he would go on to be an executive member of in 1951 and 1952, and the Ontario Society of Artists in 1949, which he would serve as president of from 1952 to 1954. This involvement kept him in public view; as he told Pailthorpe and Mednikoff: "My work has been exhibited in every show I have entered since coming here…The Canadian Society of Painters in Water Colour took four of them this year in their exhibition—only one other artist had four works accepted—and they elected me a member of their society. Only two new members were elected this year."[25]

Although Macdonald was an active and dedicated teacher, he was an artist first and wanted his work to be seen—hence the active involvement in these artistic societies. His accomplishments as an artist only augmented his success as a teacher. As Richard Gorman, who had studied under Macdonald at the College in the late 1950s, once noted: "He was a great man, a fine man, a very sensitive person. He had guts. He carried with him a certain attitude about his own art and teachers always teach best by example. He pursued his art in a certain way and this was impressive to students. He was practicing art out there: he wasn't just a teacher, he was an artist."[26] In 1981, Joan Murray, then Director at The Robert McLaughlin Gallery, curated *Jock Macdonald's Students* to coincide with the retrospective of his work at the Art Gallery of Ontario; her catalogue documents the admiring comments of fifteen of the artist's former students. Although he didn't always find support among fellow faculty at the College, he did enjoy—in his relationships with his protégés—the challenge, stimulation and respect that he deserved.

Great teachers are often so because they themselves know how to remain open to learning. In the springs of 1948 and 1949, Macdonald attended Hans Hofmann's School of Art in Provincetown, Massachusetts. Ten years after the fact, the artist wrote to Bates: "Have you picked up the September issue of *Canadian Homes and Gardens*? If so, what do you think of the Canadian Art spread? I knew nothing about this project and am a bit surprised to see my name and the remark 'studied with Hofmann.' I did so for ten days."[27] Earlier, in 1948—shortly after his first session in Provincetown—Macdonald had informed Pailthorpe and Mednikoff that "[f]rom Hofmann's dynamic + critical statements I gained most valuable knowledge + was tremendously interested in his philosophy of plastic-space expression from the objective subject matter. He, however values automatic expression as the essence of creative work + has (+ does) much work in this field."[28] Despite trying to distance himself from Hofmann's lessons in 1959, in 1948 he seemed to take the artist's advice to heart: "I am painting in my studio too—in oils—but with this work I am not satisfied. After the direction I received from Hofmann I feel that my oils are weak efforts but something will happen before long. I certainly feel I need to know more from him."[29] Although he would not break the oil barrier just yet, after his contact with Hofmann he created some of his most characteristic works in watercolour, such as *Birds Dreaming* (1949), *Ritual Dance* (1949), *Leaves of a Book* (1950), *Forms Evolved* (1951) and *Fabric of Dreams* (1952). When his solo exhibition of automatic watercolours was mounted at the close of his Art Centre of Greater Victoria residency in August 1952, a local reviewer remarked on the "endless succession of richly symbolic forms" in the paintings, judging Macdonald to be the best watercolour painter in Canada.[30]

In 1951, L. A. C. Panton replaced Haines as principal of the College. At the time, Macdonald reported to Pailthorpe and Mednikoff that:

TOP
Richard Gorman
Untitled, 1959
oil on canvas
127 x 91.44 cm
Courtesy of Christopher Cutts Gallery

BOTTOM
Hans Hofmann
Untitled, 1948
gouache, crayon on paper
43 cm x 35.7 cm
Wadsworth Atheneum Museum of Art,
Gift of Mr. Herrick Jackson, 1976

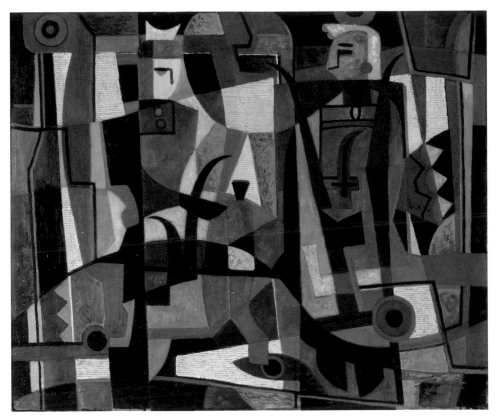

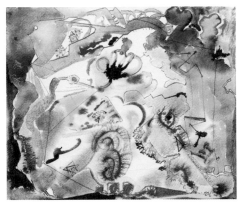

The College opens in a week with L. A. C. Panton as new head. I fear that the place will become a regimented joint—organized right down to the venetian blinds or what have you. Naturally, we will buck hard but I will be most surprised and delighted if things should continue in the old freedom ways of Haines. I am also expecting to be chocked off by certain classes in creative composition being taken away from me by Pepper, the Head of the painting department, as my influence in this work has grown so powerful that the students give very little heed to any other form of academic instruction.[31]

But while things were regressing inside the College, outside Macdonald was about to find a community of like-minded abstract painters.

Painters Eleven

In the autumn of 1952, Macdonald participated in an exhibition that Alexandra Luke, an artist whom he had taught in Banff in 1945, organized for the YWCA in Oshawa, Ontario. The *Canadian Abstract Exhibition* has been deemed Ontario's first art exhibition dedicated entirely to abstract art.[32] Macdonald contributed the painting *Bearer of Gifts* (1952), which appeared alongside works by William Ronald, Jack Bush, Oscar Cahén, Tom Hodgson, Ray Mead and Luke. One year later, in October 1953, all of the artists from the Oshawa show—except Macdonald —and a new contributor, Kazuo Nakamura, exhibited their work in the furniture department of the Robert Simpson Company in Toronto. The exhibition, entitled *Abstracts at Home*, was initiated by Ronald, who was also a former student of Macdonald's. Ronald worked in the Simpson's display department and collaborated with the store's interior decorator, Carrie Cardell, to show the paintings in settings of contemporary furniture.[33] The *Abstracts* artists subsequently formalized their

LEFT
Bearer of Gifts, 1952
oil on canvas
79.1 x 94.6 cm
Private Collection

TOP RIGHT
Alexandra Luke
Circus, 1948
watercolour, ink on paper
32.8 x 38.4 cm
Collection of The Robert McLaughlin
Gallery, Oshawa, Gift of Mr. and Mrs.
E. R. S. McLaughlin, 1971

BOTTOM RIGHT
Portrait of the artists who participated
in the 1953 exhibition *Abstracts at Home*
Photo by Everett Roseborough

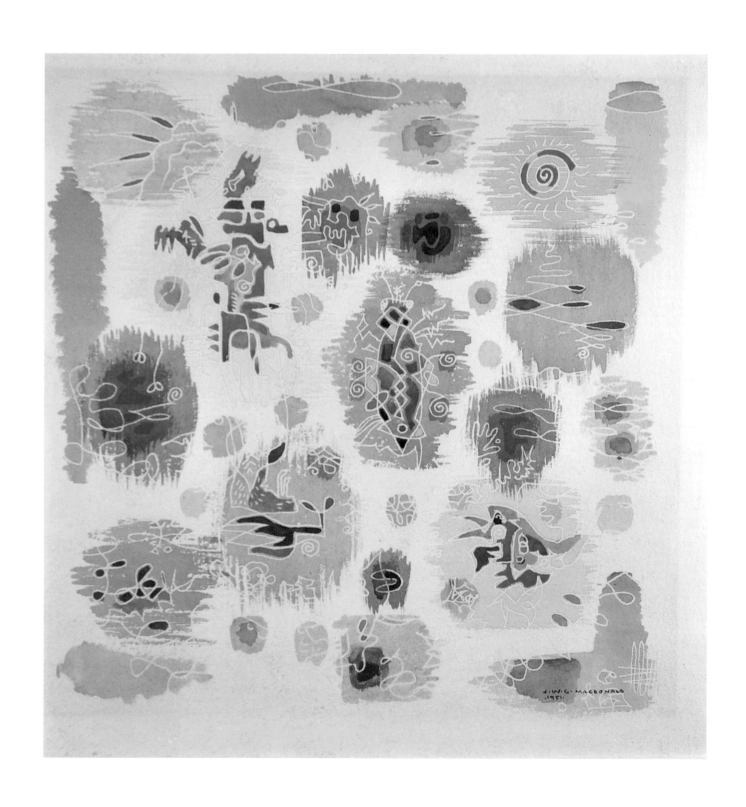

Forms Evolved, 1951
watercolour, scraffito on paper
29.7 x 29.4 cm
Collection of the Art Gallery of Greater
Victoria, Anonymous Gift

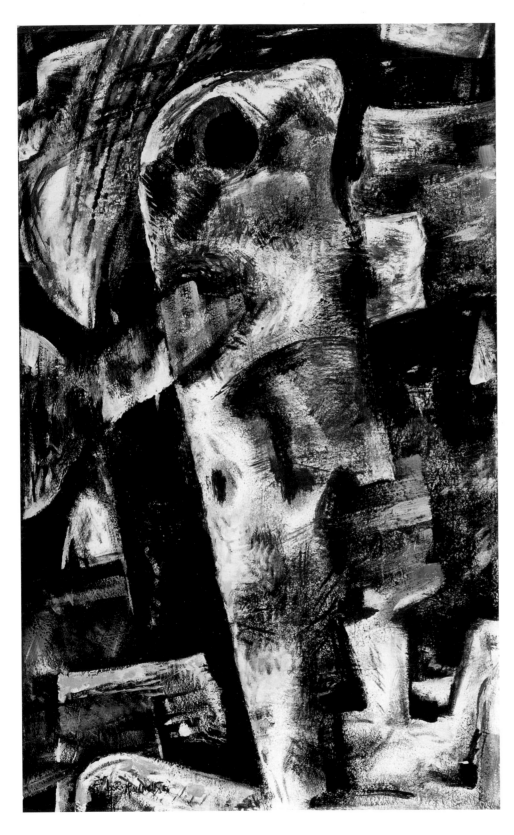

Obelisk, 1956
oil on canvas
101.5 x 61.5 cm
Collection of the National Gallery of
Canada, Ottawa, Purchase, 1984

OPPOSITE
Coral Fantasy, 1958 (detail)
oil, Lucite 44 on Masonite
106.4 x 122 cm
Collection of the National Gallery
of Canada, Ottawa

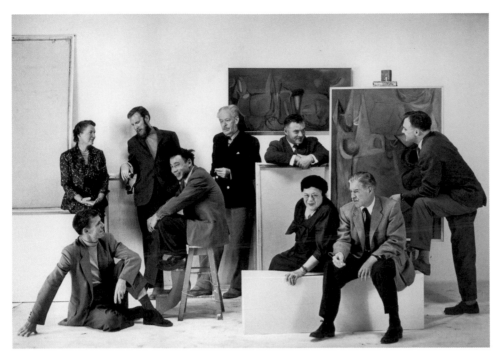

affiliation, creating a collective dedicated to abstract painting. Four new artists joined the original seven: Macdonald, who was invited by Ronald; Harold Town and Walter Yarwood, who were invited by Cahén; and Hortense Gordon, who joined at the invitation of Mead. They called themselves Painters Eleven.

A few months after the establishment of Painters Eleven, Macdonald created the first large abstract work of his mature period, *White Bark* (1954). It was just after the formation of Painters Eleven that he wrote to Bates that he felt:

> ...like ripping up every piece of work I've ever done. Somehow or other, I seem to have an idea that what I may do now will contain a more durable quality and say something which is more truly myself. It isn't that I have imitated other artists but I do believe that I have not yet got down to the roots of myself. I don't think that I am bluffing myself—I *must* grasp the hours ahead.[34]

The statement is an expression of intense frustration to be sure, but it also reveals how Macdonald's enduring and intimate involvement with like-minded artists resulted in a productive period of self-reflexivity and transformation.

In February 1954, Painters Eleven organized their first exhibition at Toronto's Roberts Gallery.[35] While the group had hoped the show would reap more sales than it did, they were pleased by the fact that "[t]he huge crowd at the opening was unlike any the staid Roberts Gallery had ever seen."[36] The presentation was quickly followed by another at Ottawa's Robertson Gallery in March, and it was shortly thereafter that Macdonald was granted the fellowship that allowed him and his wife Barbara to spend a year in Europe. This honour came at an opportune time, as he had begun to find his situation at the College so unbearable that he was considering resigning.[37] The Macdonalds sailed to Europe in August 1954 and remained there until July 1955. Nice and Vence, cities in the south of France, were the settings for Macdonald's studio activity whilst in Europe, but he did take the opportunity to visit relatives in Scotland—as well as Pailthorpe and Mednikoff in

LEFT
Portrait of Painters Eleven, 1957
Photo by Peter Croydon

RIGHT
Painters Eleven logo

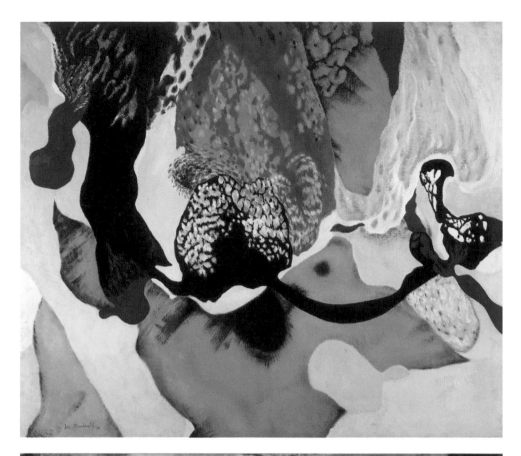

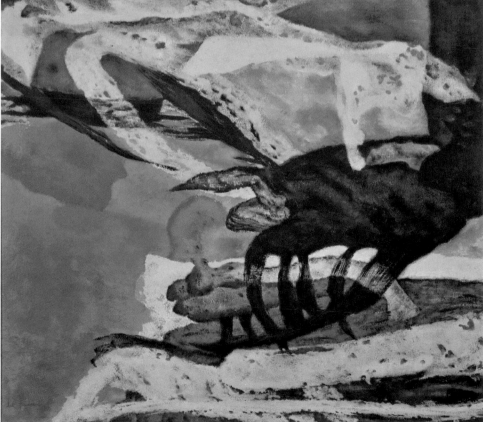

TOP
Coral Fantasy, 1958
oil, Lucite 44 on Masonite
106.4 x 122 cm
Collection of the National Gallery
of Canada, Ottawa

BOTTOM
Desert Rim, 1957
oil, Lucite 44 on Masonite
119.7 x 134.6 cm
Collection of Museum London, Purchased
with a Canada Council Matching Grant
and Acquisitions Funds, 1960

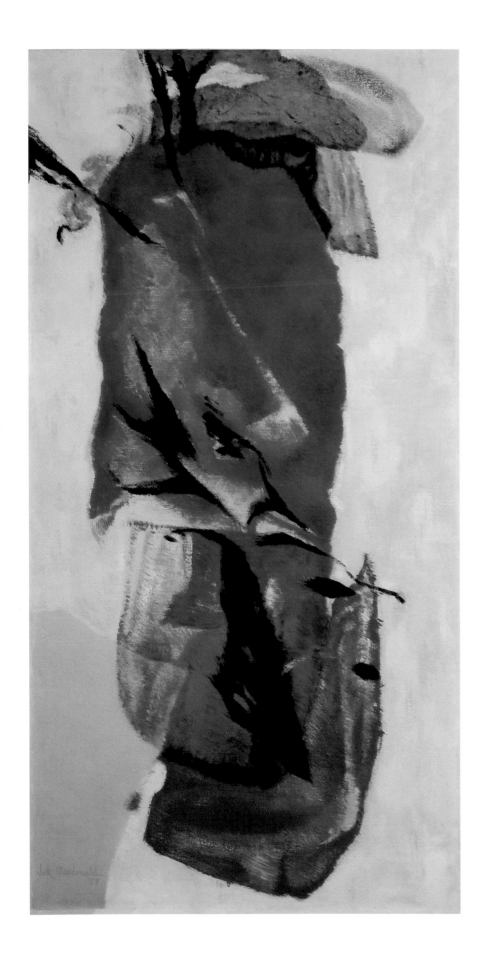

Real as in a Dream, 1957
oil, Lucite 44 on Masonite
121.09 x 61 cm
Private Collection

England—and to spend time in London and Paris promoting the work of Painters Eleven. In his absence, Painters Eleven had mounted a second exhibition at Roberts Gallery in February 1955.

Macdonald returned to Toronto in 1955, but it would be a full year before he could find the time to focus on his painting. In the summer of 1956 he began experimenting with pyroxylin, a commercial enamel paint marketed as "Duco," which had a composition that made it fluid and quick drying. It had become a popular medium among the members of Painters Eleven, but Macdonald found Duco difficult to use and its odours extremely noxious:

> I have been exclusively experimenting in plastic [Duco] paints all summer. I had to discover how to use them. The chief gain from straight oil techniques is the speed with which one must work and with the rapid drying. Also, of course, the fluid quality. After a session of trial and error I began to get control and more feeling for painterly qualities. Although I have done a dozen things —four of them 42" x 48"—I cannot say I have fallen for the medium "hook line and sinker." There is this difference, however, I find my work far freer— much less tight, more painterly and frankly, I think, more advanced. In winter I will not continue this medium as I could not stand the odour, without the ability to dilute it with wide open windows and all the fresh air I can get into the studio.[38]

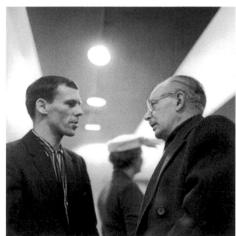

While Macdonald had returned from France with the impression that he had secured the group an exhibition at the Canadian Embassy in Paris, that project was not to materialize.[39] For the time being he would have to be satisfied with the group's Ontario exhibitions at Adelaide House in Oshawa in March 1955 and again at Roberts Gallery in February 1956, as well as a travelling exhibition that toured the Western Ontario gallery circuit for much of 1956.[40] They were also invited to participate in an exhibition at the Riverside Museum in New York in the spring of 1956, titled the *20th Annual Exhibition of American Abstract Artists, With 'Painters Eleven' of Canada.*

The group maintained a steady record of exhibitions in commercial galleries and public institutions. There were exhibitions at The Park Gallery in Toronto in October 1957 and November 1958. The 1958 exhibition—*Painters Eleven and the work of ten distinguished artists from Quebec*—was indicative of the collective's ongoing aim to broaden the context in which their work would be considered. In addition to presenting Montreal abstractionists in Toronto, Painters Eleven gained a presence in Montreal with an exhibition of their work at the École des Beaux-Arts de Montréal in May 1958 and at The Stable Gallery at the Montreal Museum of Fine Arts in April 1960. Although they did not formally disband until 1960, the vitality of Painters Eleven activities abated after Cahén's untimely death in a car accident in the fall of 1956 and Ronald's resignation from the group in 1957.

TOP
Opening of the *20th Annual Exhibition of American Abstract Artists*, New York, 1956
Photo by Bob Cowans

BOTTOM
Tom Hodgson and Jock Macdonald at The Park Gallery opening, 1958
Photo by The New Studio Photography

Finding His Way

In the spring of 1957, Macdonald travelled to New York to attend Ronald's opening at Kootz Gallery. There he encountered Hofmann again, and met—for the first time—the art critic Clement Greenberg. Upon his return to Toronto, he suggested at a Painters Eleven meeting that they invite Greenberg to visit their studios. Although Town and Yarwood objected to involving an American critic

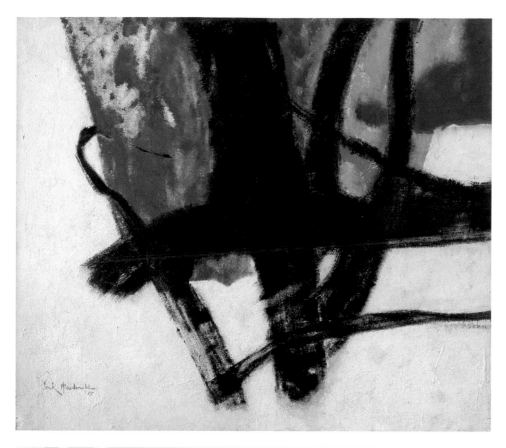

TOP
Airy Journey, 1957
oil on panel
112.5 x 127.5 cm
Hart House Permanent Collection,
University of Toronto, Purchased by
the Art Committee

BOTTOM
Iridescent Monarch, 1957
oil, acrylic, resin, Lucite 44 on Masonite
106.7 x 121.9 cm
Collection of the Art Gallery of Hamilton,
Gift of the Canada Council, 1960

Flood Tide, 1957
oil, Lucite 44 on Masonite
76 x 121.9 cm
Collection of The Robert McLaughlin
Gallery, Oshawa, Purchase, 1970

in the group's activities, Greenberg arrived in Toronto a few weeks later and spent half a day in each Painters Eleven member's studio, save the two who had protested his visit.[41]

Earlier in 1957, Town had introduced Macdonald to a new product, Lucite 44, and this was the medium the artist would take to "hook, line and sinker." Lucite 44 allowed him to manipulate oil paint with the same eloquence he demonstrated with watercolour. Assessing the Lucite works during his visit to Macdonald's studio, Greenberg said that he considered the new medium to be "a tremendous step forward in the right direction."[42] Macdonald was profoundly assured by Greenberg's input and by the potential of this new medium:

> I have twenty-two new things done since the college closed in the middle of May…They are altogether different from anything I have ever done and in our opinion far superior. I am really surprised. Using "Lucite" with the oil has enabled me to paint with a flow and quickly—but not slap dash…Greenberg gave me such a boost in confidence that I cannot remember ever knowing such a sudden development.[43]

From this point forward, Macdonald used Lucite and oil paint almost exclusively. When, in the fall of 1957, he had a solo exhibition at Hart House—his first in Toronto since his automatic watercolours were presented in the same venue in 1947—it included paintings like *Flood Tide* (1957), *Airy Journey* (1957) and *Iridescent Monarch*

Red Bastion, 1957
oil, Lucite 44 on hardboard
121 x 121 cm
Collection of the Vancouver Art Gallery,
Acquisition Fund

(1957). Reviewing the Hart House show for the CBC, Toronto art critic Robert Fulford infamously described Macdonald as "the best young abstract or non-objective painter in Canada, even though 61 years old."[44] Macdonald received continued encouragement—from Greenberg, who was in Toronto again in January 1958 and told Macdonald that his work was "hitting absolute tops," and from the Guggenheim competition jury, who chose his painting *Slumber Deep* (1957) as the Ontario selection.[45]

Over the Easter break of 1959, Macdonald visited New York again. This time, he was not wholly impressed with what he saw: "I found painting in N.Y. not to my liking. New York seems to be filled with set fashions of painting. Last Easter it was all 'action' painting on white grounds. I was told that if I painted in this manner I could get a show in the city. I said I wasn't a factory painter + would not go on to any band-wagon no matter what it might mean for me."[46] Despite his associations with Hofmann and Greenberg, figures of the American abstract art movement, and the lyrical, non-representational composition of the canvases of his final years, to the end Macdonald's motivations stemmed from automatic explorations. While works like *Heroic Mould* (1959), *Fleeting Breath* (1959) or the yellow canvases such as *Memory of Music* (1959) can be described with the language of formal abstraction, in fact, they stem from the same automatic processes that Pailthorpe and Mednikoff had introduced to him.

Jock Macdonald's Legacy in Toronto

Macdonald opened a solo show at Dorothy Cameron's Here and Now Gallery in Toronto in January 1960. In April of that year he had a semi-retrospective exhibition

Slumber Deep, 1957
oil, Lucite 44 on canvas
121.9 x 135.3 cm
Collection of the Art Gallery of
Ontario, Toronto, Gift from the McLean
Foundation, 1958

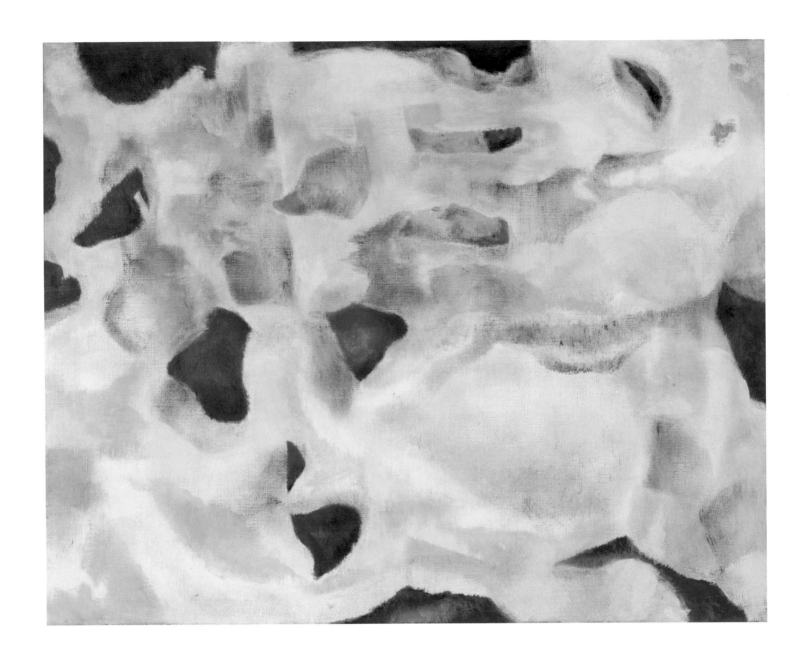

Memory of Music, 1959
oil, Lucite 44 on canvas
81.3 x 100.3 cm
Collection of the Vancouver Art Gallery,
Purchased with the Assistance of a
Movable Cultural Property Grant accorded
by the Minister of Canadian Heritage

OPPOSITE
Heroic Mould, 1959
oil, Lucite 44 on canvas
183 x 121.8 cm
Collection of the Art Gallery of Ontario,
Toronto, Bequest of Charles S. Band,
Toronto, 1970

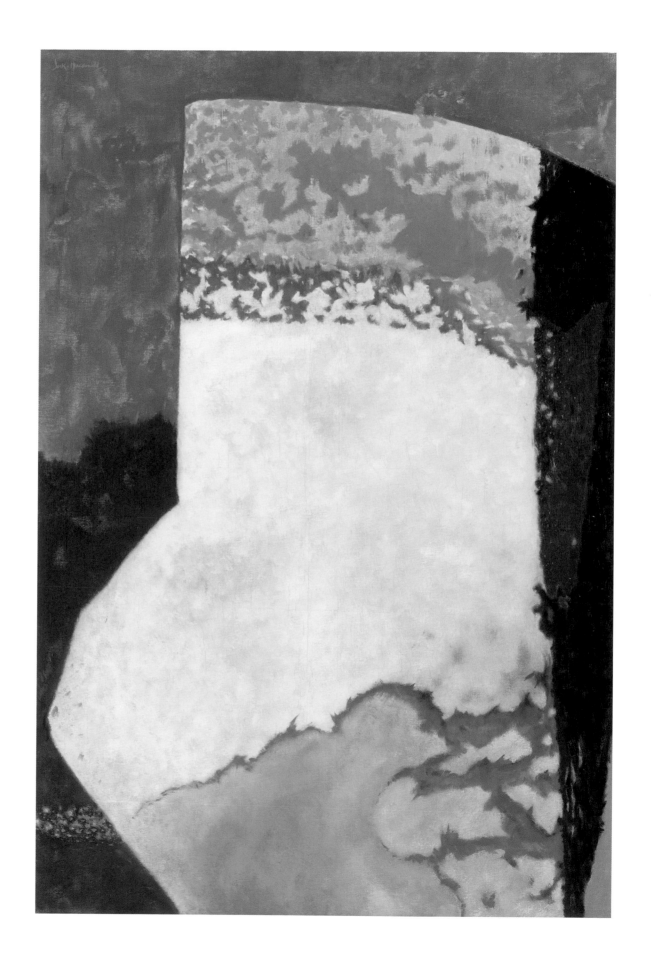

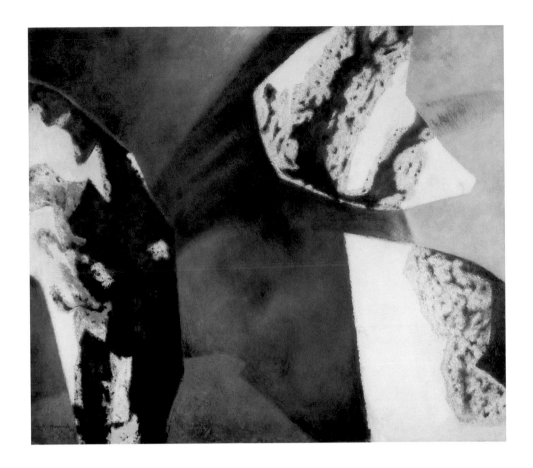

Transitory Clay, 1958
Lucite 44 on board
106.5 x 122 cm
McMichael Canadian Art Collection,
Gift of ICI Canada Inc.

OPPOSITE
Growing Serenity, 1960 (detail)
oil, Lucite 44 on canvas
91.5 x 106.8 cm
Collection of the Art Gallery of
York University

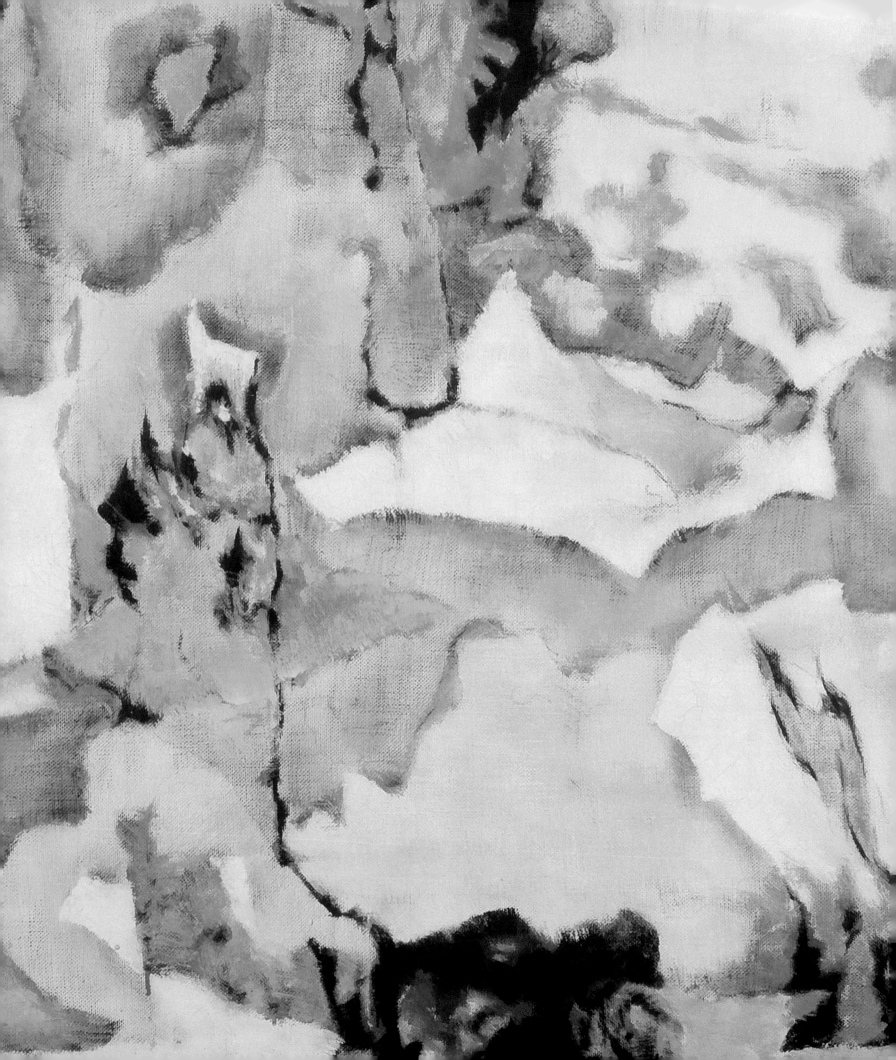

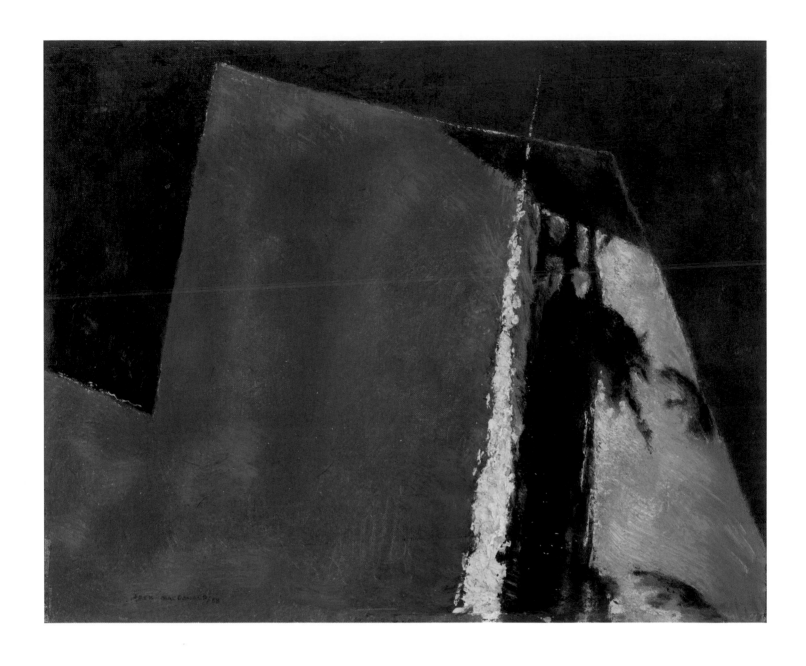

Rim of the Sky, 1958
oil on Masonite
40.5 x 50.8 cm
Collection of The Robert McLaughlin
Gallery, Oshawa, Gift of Joan Murray, 1997

at the Art Gallery of Toronto, joining just a few members of the Group of Seven as the only living artists that had been afforded this opportunity. Around this time, Roberts Gallery asked to represent him and he was offered a teaching post at the University of Southern California that would take place in the summer of 1961. In the autumn, Macdonald painted *Growing Serenity* (1960), an oil and Lucite work that truly merged his new facility with oil and the strengths of his earlier automatic explorations. The artist had achieved this breakthrough with his discovery of Lucite 44 and in 1960 he was at the height of his talents. In November of that year, he was suddenly hospitalized after apparently suffering a heart attack; however, when he was released from the hospital he was told "they could find nothing wrong with his heart."[47] Macdonald returned to teaching upon leaving the hospital and taught through to the last day of the term.[48] The day after, Saturday, December 3, 1960, Macdonald suffered a second heart attack. This time he did not recover.

Macdonald was of a time when an artist was expected to have that breakthrough, find a unique and singular voice, and create a life's worth of work in that language. Clearly he held that expectation of himself and did not believe that he had achieved success until he found a way to express in oil on canvas as he had long known how to in watercolour. While Macdonald's highest ambition was to find his way as an artist, his prolific correspondence to friends and colleagues—especially his mentors Pailthorpe and Mednikoff—also tells the story of an artist dedicated to education; to sharing ideas with students, fellow artists and the broader public; to fully participating in the artistic community and to maintaining the spiritual centre of his life and work through it all. The letters create a telling self-portrait of an artist who somehow found the time to introduce emerging artists—and nascent audiences—to new forms of artistic expression. Macdonald achieved the remarkable feat of finding his own way, while helping countless others to find theirs.

Growing Serenity, 1960
oil, Lucite 44 on canvas
91.5 x 106.8 cm
Collection of the Art Gallery of
York University

ENDNOTES

1. Jock Macdonald to Nan Cheney, June 27, 1947 (National Gallery of Canada, Ottawa), cited in Joyce Zemans, *Jock Macdonald: The Inner Landscape* (Toronto: Art Gallery of Ontario, 1981), 132.

2. Linda Jansma, "Jock Macdonald, Dr. Grace W. Pailthorpe and Reuben Mednikoff: A Lesson in Automatics," 39.

3. Macdonald to Margaret McLaughlin, December 19, 1954 (The Robert McLaughlin Gallery, Oshawa), cited in Zemans, p. 113.

4. Macdonald to Maxwell Bates, March 17, 1951 (McCord Museum, Montreal), cited in Zemans, 160.

5. Macdonald to Dr. Grace W. Pailthorpe and Reuben Mednikoff, November 9, 1947 (SNGMA GMA A62/1/171/10), 3.

6. Zemans, 186.

7. As expressed by Macdonald to Pailthorpe and Mednikoff, probably in December 1957: "Now that I have found my way, completely my own way—I am now painting continuously throughout my free moments from teaching. Excuse this long ramble about myself. I felt that you would be interested to know that your valuable guidance is now beginning to flower" (SNGMA, GMA A62/1/172/15), inside no. 1.

8. Joan Murray, "Blackwood's Newfoundland: An Interview with David Blackwood," *Canadian Forum*, vol. LVIII, no. 681 (May 1978): 9.

9. Maxwell Bates, "Jock Macdonald, Painter-Explorer," *Canadian Art*, vol. XIV, no. 4 (summer 1957): 153.

10. Macdonald to Cheney, June 27, 1947 (National Gallery of Canada), cited in Zemans, 133.

11. Macdonald to Pailthorpe and Mednikoff, November 9, 1947 (SNGMA, GMA A62/1/171/10), 4. "Prof. Fry" refers to Northrop Fry, and the publication Macdonald mentions is *Fearful Symmetry: A Study of William Blake*, published in 1947.

12. SNGMA, GMA A62/1/171/10, 6.

13. SNGMA, GMA A62/1/171/10, 6.

14. Macdonald to Cheney, June 27, 1947, quoted in Zemans, 132.

15. Macdonald to Pailthorpe and Mednikoff (SNGMA, GMA A62/1/171/10), 3.

16. SNGMA, GMA A62/1/171/10, 3-4.

17. SNGMA, GMA A62/1/171/10, 4.

18. Macdonald to Pailthorpe and Mednikoff, May 14, 1948 (SNGMA, GMA A62/1/171/14), back.

19. Macdonald to Pailthorpe and Mednikoff, September 26, 1950 (SNGMA, GMA A62/1/172/4), back.

20. "B. thought I'd be crazy to turn it down + naturally I blessed the star that gave me a return visit to Britain after 23 years." Macdonald to Pailthorpe and Mednikoff, June 8, 1949 (SNGMA, GMA A62/1/171/17), 2.

21. Macdonald to Pailthorpe and Mednikoff, September 24, 1949 (SNGMA, GMA A62/1/171/20), middle.

22. Macdonald to Pailthorpe and Mednikoff, September 12, 1952 (SNGMA, GMA A62 1 172 8), front

23. Macdonald to Pailthorpe and Mednikoff, April 15, 1954 (SNGMA, GMA A62/1/172/10), front.

24. Macdonald to Pailthorpe and Mednikoff, September 29, 1948 (SNGMA, GMA A62/1/171/15), 6.

25. Macdonald to Pailthorpe and Mednikoff, April 7, 1949 (SNGMA, GMA A62/1/171/16), 3. The work purchased was *The Witch* (1948).

26. Joan Murray interview with Richard Gorman, Toronto, July 12, 1978 (The Robert McLaughlin Gallery Archives), cited in *Jock Macdonald's Students* (Oshawa: The Robert McLaughlin Gallery, 1981), 22. Gorman also credits Macdonald with getting "all the Isaacs [Gallery] gang going" in this interview.

27. Macdonald to Bates, August 28, 1959 (McCord Museum), cited in Zemans, 153. Macdonald's time with Hofmann was more likely twenty days, as he spent two weeks in Provincetown in each of two years.

28. Macdonald to Pailthorpe and Mednikoff, September 29, 1948 (SNGMA, GMA A62/1/171/15), 2.

29. Macdonald to Marion Nicoll, October 21, 1948 (McCord Museum), cited in Zemans, 152.

30. Review (special reviewer) "Macdonald's Art Easy to Live With," *The Daily Colonist*, Victoria, BC, July 20, 1952.

31. Macdonald to Pailthorpe and Mednikoff, September 17, 1951 (SNGMA, GMA A62/1/172/6), front.

32. Zemans, 159.

33. William Ronald, "Abstracts at Home," *Canadian Art*, vol. XI, no. 2 (winter 1954): 51.

34. Macdonald to Bates, May 28, 1954 (McCord Museum), cited in Zemans, 171.

35. Toronto, Roberts Gallery, February 13–28, 1954, *Painters Eleven*, no catalogue, thirty-three works exhibited.

36. Dennis Reid, *A Concise History of Canadian Painting* (Toronto: Oxford University Press, 1973), 246.

37. Macdonald to Bates, May 28, 1954 (McCord Museum), cited in Zemans, 171.

38. Macdonald to Bates, July 30, 1956 (McCord Museum), cited in Zemans, 188–189.

39. Macdonald was convinced that an official in Ottawa blocked the exhibition at the Canadian Embassy in Paris. "Either Jarvis or the Gov. General of Canada Vincent Massey—stopped our approved exhibition for Paris. We had permission from the Dept of External Affairs—Federal Government—to hold a show in Paris, sponsored by the Canadian Embassy there. I was stopped by someone + I think we were stopped because we didn't call for the sponsorship or approval of the Nat Gallery of Canada." Macdonald to Pailthorpe and Mednikoff, January 19, 1959 (SNGMA, GMA A62/1/172/16), 2–3.

40. The touring exhibition went to the London Public Library and Art Museum; Hart House, University of Toronto; McLaughlin Public Library, Oshawa; Willistead Art Gallery, Windsor; Hamilton Art Gallery; and St. Catharines Public Library Art Gallery.

41. Joan Murray, *Painters Eleven in Retrospect* (Oshawa: The Robert McLaughlin Gallery, 1979), 74.

42. Macdonald to Bates, July 3, 1957 (McCord Museum), cited in Zemans, 193.

43. Macdonald to Bates, August 7, 1957 (McCord Museum), cited in Zemans, 203.

44. Macdonald to Pailthorpe and Mednikoff, January 19, 1959 (SNGMA, GMA A62/1/172/16), 4.

45. Macdonald to Bates, February 17, 1958 (McCord Museum), cited in Zemans, 209.

46. Macdonald to Pailthorpe and Mednikoff, December 5, 1959 (SNGMA, GMA A62/1/172/17), 2.

47. Barbara Macdonald to Pailthorpe and Mednikoff, January 28, 1961 (SNGMA, GMA A62/1/173/6), 3.

48. Barbara Macdonald to Pailthorpe and Mednikoff, January 28, 1961 (SNGMA, GMA A62/1/173/6), 5.

Jock Macdonald's Weave of Reality

Anna Hudson

I am mesmerized by *Fleeting Breath*, a mature and confident painting by Jock Macdonald of 1959. Brushstrokes mass together in pigment groups that jostle for space as if they are struggling through a thick crowd. The forms move toward and away from me, pulling me into their flow. I become part of something I cannot explain, while simultaneously sensing that the sum of compositional parts describes a wholeness of being. I can't think of another painter whose work similarly sparks such ambiguity of perspective. The work demonstrates how, by the late 1950s, Macdonald had finally broken through to a unique and singular voice. His abstract paintings of the last years of his life are incomparable precisely because of his ability to compositionally suspend contradictory preoccupation with liberating automatism and rigorous design.

Macdonald's pursuit of the "awakening and releasing of inner consciousness" is detailed by Linda Jansma in "Jock Macdonald, Dr. Grace W. Pailthorpe and Reuben Mednikoff: A Lesson in Automatics," which documents the far-reaching influence of Surrealism in the history of modern art.[1] The artist's association with Pailthorpe and Mednikoff, two British surrealists he came to know personally by 1945, links him directly to the revolutionary advancements in psychology and psychiatry during the first half of the twentieth century. These powerful new fields of inquiry into the world of human experience were rife with a contradiction that defines modernity. As Ian M. Thom identifies in "The Early Work: An Artist Emerges," Macdonald's 1940 lecture entitled "Art in Relation to Nature" demands resolution of the relationship between spiritualism (especially knowledge as felt or intuited) and empiricism (or knowledge witnessed and proven as fact).[2] Revelation of the catastrophic power of industry to destroy life during World War I confirmed that science and religion should not be opposed. No longer could they function as conflicting lenses through which the world and future of humanity might be imagined. The evolution of abstraction in modern art most cogently records artists' intimate grappling with their intersection.

Through profound introspection, as Thom argues, Macdonald strove to make art that achieved "values beyond the material" without abandoning Nature as his inspiration.[3] A comparison of post-World War II abstract painting in Toronto and Montreal is usually framed as the persistence of the landscape in conservative Ontario and its elimination by Quebec's Automatistes. But, as this exhibition reveals, Macdonald's mature abstractions complicate interpretations of landscape references in the work of Toronto's Painters Eleven. I am particularly interested in how Macdonald's training as a designer explains this complication, given—as I propose—his lifetime quest for a reflective revelation of Nature's laws, ever mysterious and surprising. As I will argue, Macdonald's early work in Scotland's textile design and manufacturing

Fleeting Breath, 1959 (detail)
oil, acrylic resin on canvas
122.2 x 149.2 cm
Collection of the Art Gallery of Ontario, Toronto, Purchased with the Canada Council Joint Purchase Award, 1959

sector exposed him to the most recent discoveries in chemistry and industrial engineering, from which he could boldly conclude: "Our knowledge of Nature has changed."[4] From this perspective Macdonald's creative inspiration reads less esoterically than previously imagined.

Macdonald's appetite for philosophical, spiritual and mystical readings—including the work of Rabindranath Tagore, Oswald Spengler and P. D. Ouspensky—is well documented. Joyce Zemans underscores Macdonald's attraction to their rationalizations of universal truths through reference to contemporary discoveries in science and mathematics. As she notes, it was "particularly the theory of relativity, which he believed could explain the most enigmatic problems."[5] In the West, theoretical physicists radicalized understanding of universal atomic structures, questioned the empirical methods of nineteenth-century natural science and destabilized the concepts of classical physics, space, time, matter and causality. A simple and synoptic image of the world was exchanged, according to Albert Einstein, for another as a result of his own General Theory of Relativity (completed in 1915), along with ongoing research into quantum energy following Max Planck's proposition of its existence in 1900. Most remarkably, theoretical physicists in the first two decades of the twentieth century provided a "world-picture" that promised to resolve opposition of spiritualism and empiricism. Macdonald's awareness of their union inspired his interest in "the majesty of the mountain scenery and the cosmic harmony" simultaneously revealed in abstraction.[6] In the bigger picture of the history of science and art during Macdonald's lifetime, human imagination—and the related human capacities for intuition and conjecture—surfaced as shared tools for understanding the phenomenon of existence. Recognition of this intersection reconciled spirit and matter, which had been split since the Enlightenment. When science opened to a commingling with religion, an *Einfühlung* (or "feeling for the order lying behind the appearance") entered the lexicon of experience described collectively by artists and scientists.[7]

Fleeting Breath, 1959
oil, acrylic resin on canvas
122.2 x 149.2 cm
Collection of the Art Gallery of Ontario, Toronto, Purchased with the Canada Council Joint Purchase Award, 1959

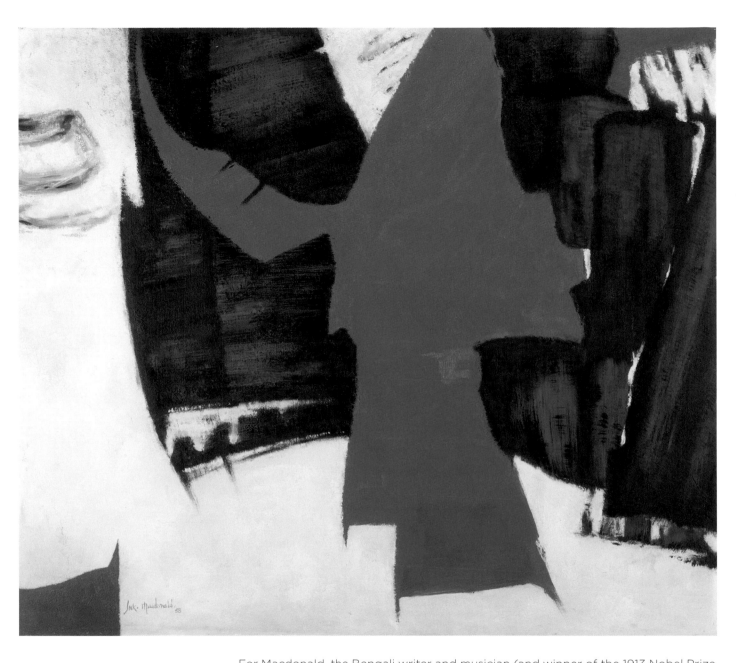

Clarion Call, 1958
oil on pressed board
106.7 x 121.9 cm
Agnes Etherington Art Centre, Queen's
University, Kingston, Gift of Ayala and
Samuel Zacks, 1962

For Macdonald, the Bengali writer and musician (and winner of the 1913 Nobel Prize for Literature) Rabindranath Tagore emerged as one of the most influential members of the international literary, scientific and artistic community who depolarized modern science and spiritualism. Tagore shared with Einstein an acceptance of a paradox: that the scientific observation of reality ultimately reveals the human mind to itself, and is thus subjective.[8] "Art," commented Tagore on his 1929 visit to Vancouver (his only stop in Canada), "represents man's personal world of reality in which he is revealed to himself in his own light, the light that has its numerous rays of emotion, visible and invisible."[9] At the height of his popularity in 1916 and 1917, Tagore led "the most popular philosophic thing in Europe to-day...," as one journalist surmised, "a vague restoration of God and the soul in terms of biology or of mysticism."[10] Returning now to Macdonald's *Fleeting Breath* to explore its unique and singular voice, I am compelled by Tagore's picture of paradox and his dynamic contrapuntal poetic metre through which he conjoined contradictory landscape imagery into a composition of reality:

Here rolls the sea
And even here
 Lies the other shore
Waiting to be reached
 Yes here
Is the everlasting present
 Not distant
Not anywhere else[11]

In his autobiography, *My Reminiscences*, which appeared in English in 1917, Tagore described the delight "of attaining the infinite within the finite."[12] The feeling he captured of suspended time in indeterminable space perfectly describes the atomic world of quantum and the cataclysmic revelation that space and time are too limited for human perception of transcendental reality and cosmic time.[13] By comparison to *Fleeting Breath*, Macdonald's breakthrough *Pacific Ocean Experience* (c. 1935) is a much more literal and awkward expression, as Thom describes, of a connection

Leaded Light, 1958
oil on canvas board
61 x 51 cm
Collection of the Art Gallery of Windsor,
Bequest of Pearce L. S. Lettner, 1977

between the microcosm and macrocosm. What Macdonald subsequently achieved was a multivalent layering of interposing perceptions: a warp of reality intuited over a weft of empirical fact.

A reinterpretation of Macdonald's *Fleeting Breath*, taking into consideration his design and manufacturing education and experience in Scotland's textile industry, can be traced by comparing the painting with two images. The first is a tartan, coincidentally of the so-called MacDonald clan (appropriate to an artist originating from Thurso in the Highlands), and the second shows Alastair Morton, the grandson of the Morton Sundour Fabric Limited founder, Alexander Morton, at work.

The tartan became an enduring nationalist symbol in Scotland during the nineteenth century when Sir Walter Scott, among others, "left us the mental picture of the Clans lined up for battle in faultless evening dress and in tartans identical with those worn by their ancestors at the beginning of time."[14] Tartan designs entered popular culture through illustrated texts like James Logan's *The Clans of the Scottish Highlands*, which was published in sections between 1843 and 1849.[15] The association of particular tartan patterns, or "setts" (distinctive patterns of squares and lines), with family clans captured international imagination by the end of the century, concurrent with Scotland's entrance into the global textile industry. Scottish textile designers traced their lineages to traditional community artist-weavers. As factory workforces for industrialized weaving grew, the familial-clan association deepened and the trade remained proudly male. Their mastery of tartan setts rested on a nuanced understanding that the basic plain check of two contrasting colours could be modified by adjusting the sizes of the checks and adding bars, stripes and lines of other colours "to make a balanced and harmonious abstract pattern."[16] Because of the interweaving of up to four colours (plus black and white) of squares and lines, a tartan sett created both simple and compound areas of colour, resulting in patterns that were ultimately diffuse with softened contrasts, even in the most brightly coloured tartans.[17] By the time of Macdonald's birth, then, tartan was ubiquitous in traditional menswear designed by men. Further, in Edinburgh, where Macdonald studied at the College of Art, textile design had the longest history in Britain.[18]

Mid-nineteenth century expansion of design schools in Scotland (as across Britain) was intended both to raise public taste and reduce expenditure on "foreign designs."[19] "At a time when vast numbers of British people were not receiving any education at all," instruction in the art of design—in particular the application of design to manufactured goods—led to state-supported art schools matching those of France, Prussia and Bavaria.[20] And while design education, with its emphasis on technical skills and manufacturing processes, has more recently been pitted against specialized art school education, Macdonald experienced their overlap not only in his formal education but also in his first workplace. He was born at the apex of the Arts and Crafts Movement and was conditioned by the Pre-Raphaelite's encyclopaedic renderings of British industrial design. I invoke this history in an effort to retranslate Macdonald's mid-1930s admission that "certain expressions of design forms, colour combinations and commercial mannerisms" frustrated his progress as a painter.[21] Did he aspire to eliminate design from his visual vocabulary or his conceptualization of composition? Or, as I think is more likely, did he see painting as the means to explain universal existence as a creative design?

If one exchanges the weaver's yarn for the artist's brushes, *Fleeting Breath* is a tartan design transmogrified into the fabric of life. *Ars longa, vita brevis* (Art is Long, Life is

MacDonald tartan
The Scottish Register of Tartans

Short) was the proverb so often considered by Macdonald's generation of painters.[22] Amidst the explosion of mass visual culture, Canadian artists (the majority of whom were painters) gathered in 1941 to address the role of art in contemporary society. Macdonald attended the Kingston Conference at Queen's University to participate in discussions of current cultural problems intensified by World War II, as well as to attend technical workshops geared to develop artists' awareness of the longevity of their materials.[23] By comparison to photography (and by proxy commercial design, which followed the same explosive trajectory), the medium of painting operated at a different speed, being appreciably slower to produce and digest within its incomparably long historical tradition. As a deep and still unmechanized form of human expression, painting was increasingly valued among psychologists and psychiatrists, including Pailthorpe, as a vehicle to assess emotional and social well-being. Perception of inner consciousness through automatic art and writing, as Jansma unearths from Macdonald's letters to Pailthorpe and Mednikoff, had as its primary objective the reorganization of the self in society.[24] "[T]he real process of thoughts,"[25] which automatism exposed, were in Macdonald's lifetime relatable to quantum field energy jumps. Human thought and atomic structure thus intermingled. Both envisioned patterns of attraction and repulsion, the creation of networks and pathways of communication. In *Fleeting Breath* the layers are all woven in paint and pulsate as if to signal the beating heart of the painter as its witness.

When the influential art and architectural historian Nikolaus Pevsner prepared his 1937 survey *An Enquiry into Industrial Art in England*, he singled out Macdonald's first employer, Morton Sundour Fabric Limited, for their conscious transference of an "unconscious tradition of exquisite weaving to the factory."[26] The success of Sir James Morton (who took over the business from his father, Alexander), was in Pevsner's estimation due to his employment of "some artists of the highest standing."[27] Morton founded Edinburgh Weavers as the independent design unit of the company in 1928, two years after Macdonald left for Canada. But its creation attests to the excited climate of partnership between art and industry, which the artist must have experienced on the job. Good design, as Pevsner argued, took heed of centuries of innovation to achieve a "strong and live tradition." And "[t]he history of the Edinburgh Weavers is of such paradigmatic importance," because, as he explained, it established a laboratory from which "the best of modern textile art" could emerge.[28] "Design in daily life," especially in the industrial age, was not, at

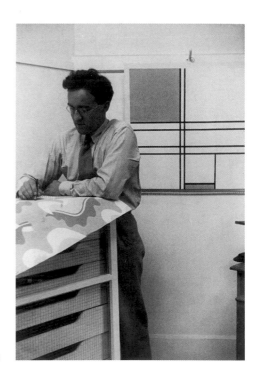

LEFT
Contemplation, 1958
oil, Lucite 44 on Masonite
68.5 x 122 cm
Collection of the Art Gallery of Greater
Victoria, Friends of the Gallery

RIGHT
Alastair Morton in his studio, c. 1957–58,
and in the background Mondrian's
Composition with Blue and Yellow, 1935

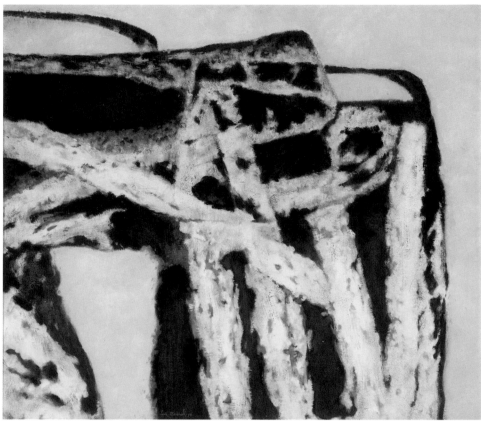

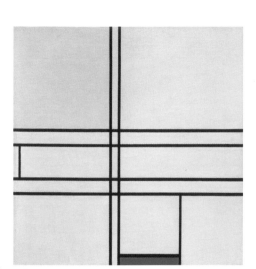

LEFT
Piet Mondrian
Composition with Blue and Yellow
(*Composition Bleu-Jaune*), 1935
oil on canvas
73 x 69.6 cm
Collection of the Hirshhorn Museum and
Sculpture Garden, Smithsonian Institution,
Washington, DC, Gift of the Joseph H. Hirshhorn
Foundation, 1972

RIGHT
Rust of Antiquity, 1958
oil, Lucite 44 on Masonite
106.5 x 121.4 cm
Collection of The Robert McLaughlin
Gallery, Oshawa, Gift of Alexandra
Luke, 1967

this moment in history, "a detached question."[29] So serious were the implications of "a true revival of arts and crafts," that Pevsner unhesitatingly asserted:

> Whereas the reaction of art to changes within our civilization thus remains indeterminate, the consequences of a breakdown of the whole of our civilization and the beginning of a new circle is evident…the first phase to follow would at one blow get us back healthy through primitive conditions of craftsmanship, the unity of design and production, and Morris's "joy in making" which is definitely lost as long as present conditions last.[30]

When Alastair Morton, James' son, posed for his photograph as the Director of Edinburgh Weavers, he chose as his backdrop Piet Mondrian's *Composition with Blue and Yellow* of 1935. The painting, now in the collection of the Hirshhorn Museum in Washington, was loaned to Morton b*y* Winifred Nicholson around 1937 (by which time she had separated from her husband, painter Ben Nicholson, whose paintings Morton translated into remarkable textile designs). His choice of a signature De Stijl composition is a compelling addition to the links from Macdonald's design education and early work in the textile industry to his mature abstraction.

Within Scottish tradition the handloom weaver's reputation was as "a deep-thinking, disputatious and often deeply read man."[31] In the most simple of terms, the visual correspondence of Mondrian's theosophically inspired painting to a tartan sett—in the context of Edinburgh Weavers—documents the Morton family's advancement of the weaver-intellectual culture. It also underscores the company's observance of Pevsner's fair warning of design's fundamental place in life. Macdonald befriended another painter influenced by theosophy, Lawren Harris, in Vancouver in 1940. I can imagine the joy of their summer spent together in 1941 when, as Zemans records, each

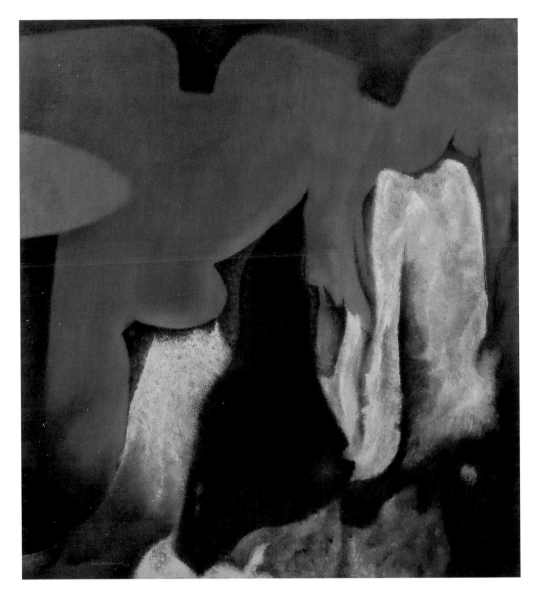

drew from the creative sustenance of nature.[32] The De Stijl movement in modern art was for Macdonald, who was undoubtedly encouraged by Harris, a revelation of artists' ability to materialize spiritual and metaphysical truths.[33] The parallel between his own aesthetic sensibilities and the De Stijl artists' experimentation with architectural design and decoration could not have been lost on Macdonald.

Under Alastair Morton, Edinburgh Weavers began working with the British and European avant-garde to produce compelling new woven and printed textile designs. According to his younger brother, Jocelyn, the director of the company:

> Stimulated by the exciting designs these people were prepared to produce for him, and acquiring all the time, by his work in the "production room" in the factory, the knowledge of fabric construction and a vision of the possibilities that the innumerable fibres and yarns, both old and new, offers for novel types of fabrics...he had inherited in certainly undiluted, possibly even in intensified, measure from both his grandfather and father that gift of three-dimensional creative insight that enabled all three of them to conceive new textile forms.[34]

Lament, 1958
oil, Lucite 44 on canvas
137.2 x 12.9 cm
Collection of the Royal Bank of Canada

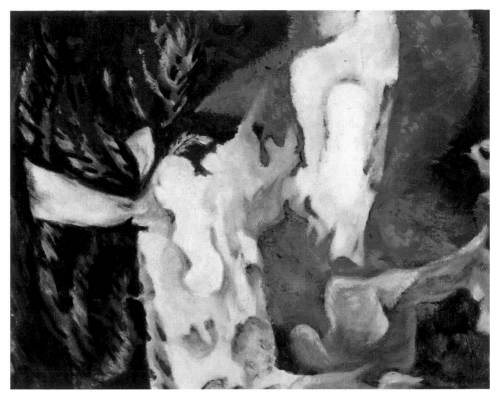

TOP
Drifting Forms, 1959
oil, Lucite 44 on canvas board
40.6 x 50.6 cm
Collection of The Robert McLaughlin
Gallery, Oshawa, Purchase, 1977

BOTTOM
Fugitive Articulation, 1959
oil on canvas
107 x 121.9 cm
MacKenzie Art Gallery, University
of Regina Collection

Far Off Drums, 1960
oil, Lucite 44 on canvas
91.3 x 106.6 cm
Collection of the National Gallery
of Canada, Ottawa, Purchase, 1960

All Things Prevail, 1960
Lucite 44 on canvas
106.7 x 122.1 cm
Collection of the National Gallery
of Canada, Ottawa, Purchase, 1966

A striking adaptation of an artist's painting to a large-scale woven hanging was *Olympus*, a medium-weight curtain fabric in cotton and spun rayon designed in 1963 by Léon Zack, an artist associated with the School of Paris. The fabric takes Zack's painting style of the late 1950s and early 1960s, which was characterized by large impastoed forms floating over neutral grounds into a new dimension. Its conception of imagined and real space is startlingly reminiscent of *Fleeting Breath*. Both test visual and tactile multidimensionality. Only Macdonald, as argued earlier, adds multivalency to the equation, retranscribing a warp of reality intuited over a weft of empirical fact through the connection he made between modern textile design and modern painting. In so doing he captured a fourth dimension of perception that locked, in the words of Mondrian, onto "the grand and perfect composition of life."[35]

In "Finding His Way: Jock Macdonald's Toronto Years," Michelle Jacques emphasizes Macdonald's tremendous influence on scores of students at the Ontario College of Art, including William Ronald.[36] The richness of this influence might now be expanded to shed new light on *Abstracts at Home*, organized by Ronald and interior decorator Carrie Cardell in 1953 for the furniture department of the Robert Simpson Company store in Toronto. The exhibition aligned modern abstract art with interior design and promoted their tandem avant-garde marketability. Ronald must surely have gained from what might now be acknowledged as Macdonald's leading exploration into the aesthetic overlaps between painting and textile design. Furthermore, Macdonald's experience of their association in the European design trade must also have inspired other Toronto artists' interest.

"Modality" was Macdonald's description of his method from the mid-1930s onward. In one of his many efforts to explain it, he wrote to the director of the National Gallery of Canada, Harry McCurry, in 1943:

> I am still doing landscape, but find my semi-abstracts, or what I name "Modalities," a deeper value to me. Those "Modalities" are thought idioms of nature—not completely geometrical, but containing a nature form in extension. That is all I seem to be able to say at present. It means the same as saying the 4th dimension is an extension of the 3rd, but has a different space and a different time, and through its added value of motion, it is an entirely new dimension. And the awakening of a new consciousness will arise out of the new knowledge, from the slow understanding, of the 4th dimension. For me, abstract and semi-abstract creations of pure idiom, are statements of the new awakening consciousness. Thus, I have more than a surface interest in the experiments I make on the extension of nature forms.[37]

Macdonald's embrace of extremes and his union of art and science, automatism and rigorous design, bring *Fleeting Breath* into focus as an inspirational breakthrough to an expanded definition of the history of Modernism in Canada.

Léon Zack
Olympus, 1963 (detail)
Furnishing fabric designed for Edinburgh
Weavers, Carslisle

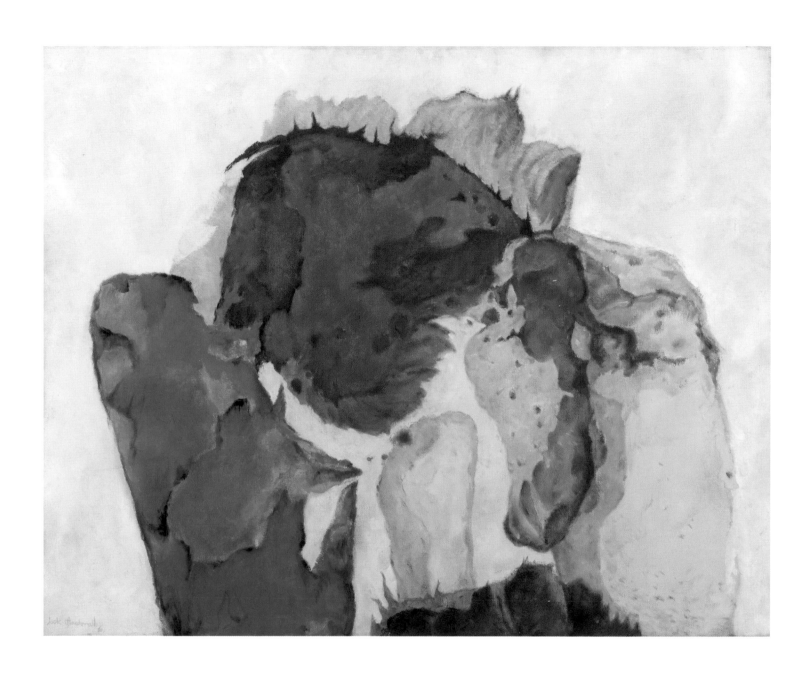

Nature Evolving, 1960
oil, Lucite 44 on canvas
111.8 x 137.2 cm
Collection of the Art Gallery of Ontario,
Toronto, Purchased by Peter Larkin
Foundation, 1962

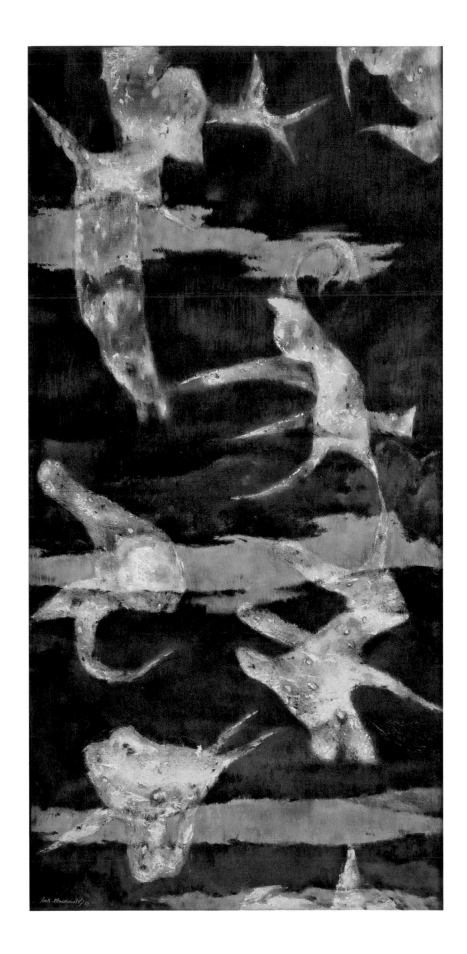

Celestial Dance, 1959
oil on canvas
151.7 x 71.2 cm
McMichael Canadian Art Collection,
Gift of Wendy Hoernig in memory of
Hope Holmested, a lifelong enthusiast
of Canadian art

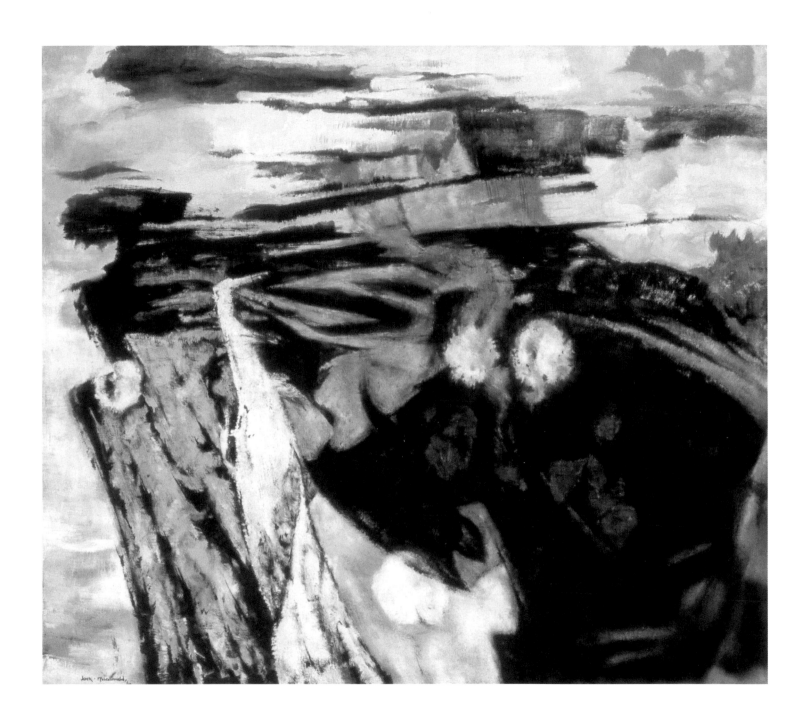

Elemental Fury, 1960
oil, Lucite 44 on canvas
120.8 x 136.7 cm
Collection of the Montreal Museum of
Fine Arts, Purchase, Horsley and Annie
Townsend Bequest

ENDNOTES

1. Linda Jansma, "Jock Macdonald, Dr. Grace W. Pailthorpe, and Reuben Mednikoff: A Lesson in Automatics," 39.
2. As Thom quotes from Macdonald: "Great Art is not found in the mere imitation of nature, but the artist does perceive through his study of nature the awareness of a force which is the one order to which the whole universe conforms. Art in all it various activities is trying to tell us something about life. Art must include in its study of nature the whole universe, if it is to envisage some aspect of the universal truth and help humanity to become conscious of the meaning of life." Ian M. Thom, "The Early Work: An Artist Emerges," 15.
3. Ibid., 15.
4. Jock Macdonald, "Art in Relation to Nature," notes for a lecture first delivered by Macdonald in February 1940, 11; reproduced as an Appendix in Joyce Zemans, *Jock Macdonald: The Inner Landscape* (Toronto: Art Gallery of Ontario, 1981), 278.
5. Joyce Zemans, *Jock Macdonald* (Ottawa: National Gallery of Canada, 1985), 13.
6. Joyce Zemans, *Jock Macdonald: The Inner Landscape* (Toronto: Art Gallery of Ontario, 1981), 104.
7. Albert Einstein, "Preface," to Max Planck, *Where is Science Going?*, transl. and ed. by James Murphy (Woodbridge, Conn.: Ox Bow Press, 1933/1981), 12.
8. Krishna Dutta and Andrew Robinson, *Rabindranath Tagore: The Myriad-Minded Man* (London: Bloomsbury Publishing Limited, 1995), 14.
9. Rabindranath Tagore, "Message of Farewell to Canada," delivered to the Fourth Triennial Conference of the National Council of Education of Canada, Vancouver, April 14, 1929; reprinted in P.C. Mahalanobis, *Rabindranath Tagore's Visit to Canada* (Brooklyn, NY: Haskell House Publishers Ltd., 1977), 66.
10. "A Poet of the Lotus," *The Saturday Review*, December 27, 1913; reprinted in *Imagining Tagore: Rabindranath and the British Press (1912–1941)*, compiled and edited by Kalyan Kundu, Sakti Bhattacharya, Kalyan Sircar (Calcutta: Shishu Sahitya Samsad Pvt. Ltd., 2000), 131.
11. From "Sadhana," his philosophical lectures, given at Harvard University and in London in 1913. Dutta and Robinson, *Rabindranath Tagore: The Myriad-Minded Man*, 361.
12. "This was to put in a slightly different form the story of my own experience, of the entrancing ray of light which found its way into the depths of the cave into which I had retired away from all touch with the outer world, and made me more fully one with Nature again. This *Nature's Revenge* may be looked upon as an introduction to the whole of my future literary work; or, rather this has been the subject on which all my writings have dwelt—the joy of attaining the Infinite within the finite." Sir Rabindranath Tagore, *My Reminiscences* (New York: Macmillian Company, 1917), 240.
13. Hermann Weyl, "Introduction," *Space —Time —Matter,* trans. Henry L. Brose (London: Methuen & Co. Ltd., 1922), 1–10.
14. James Scarlett, "Tartan: The Highland Cloth and Highland Art Form," in *Scottish Textile History*, eds. John Butt and Kenneth Ponting (Aberdeen: Aberdeen University Press, 1987), 68.
15. Ibid., 68.
16. Ibid., 72.
17. "[A]n outstanding requirement was that all colours should be clear and unambiguous, with none so strong as to 'swamp' another. Compound colours should show up plainly as intermediate colours between those that make them. This requirement is generally ignored in present-day tartans..." Ibid., 72.
18. "Before the schools of design were founded the nearest Britain came to providing public instruction in design was at Edinburgh in 1760 when the Board of Trustees founded an academy 'to promote designs on patterns for linen and cotton and flowered muslin manufacturers, carpet manufacturers, paper stainers and for ornamental parts of architecture.'" Maureen Lochrie, "The Paisley Shawl Industry," in *Scottish Textile History*, eds. John Butt and Kenneth Ponting (Aberdeen: Aberdeen University Press, 1987), 106.
19. "[I]t was in the mid-1830s that a Select Committee of Arts and Manufacturers reported a sense of unease amongst manufacturers, artists and politicians...over the growing preference for European designed products, especially French." Ibid., 107.
20. "As these countries had state-supported art schools which placed great emphasis on good design, the case for providing such an education in Britain was overwhelming. The outcome was the opening of a School of Design in London in 1837...and branch schools in the provinces in 1843..." Ibid., 107.

21. Macdonald to G.H. Tyler, January 2, 1936 (copy in National Gallery of Canada Archives).

22. Bertram Brooker, for example, acknowledged the apparent timelessness of painting—its iconicity—in *Art is Long* (University of Lethbridge Art Gallery), a studio still life he painted in 1934.

23. André Biéler, Preface of "Conference of Canadian Artists," reprinted in *The Kingston Conference Proceedings* (Kingston, Ontario: Agnes Etherington Art Centre, 1991), v.

24. "It is impossible to create a well-organised external world *unless at the same time* the internal mental world is harmonized, since it is only through mental acquiescence on the part of the units that go to form the whole machinery of civilization that it can function smoothly." Dr. Grace W. Pailthorpe, "The Scientific Aspect of Surrealism," as quoted in Linda Jansma, "Jock Macdonald, Dr. Grace W. Pailthorpe and Reuben Mednikoff: A Lesson in Automatics," 43.

25. Ibid., 43.

26. Nikolaus Pesvner, *An Enquiry into Industrial Art in England* (Cambridge: Cambridge University Press, 1937), 55.

27. Ibid.

28. Ibid., 56, 58.

29. Ibid., 212.

30. Ibid., 213.

31. Jocelyn Morton, *Three Generations in a Family Textile Firm* (London: Routledge & Kegan Paul, 1971), 5.

32. Zemans, 17.

33. Harris' regard for Mondrian dated at least to the 1927 *Société Anonyme* exhibition of international avant-garde painting, when he singled out the artist's De Stilj abstractions as enlightened creations "from an inner seeing [that] conveyed a sense of order in a purged, pervading vitality that was positively spiritual."

34. Morton, 408.

35. Piet Mondrian, "The true value of oppositions," 1934, as reprinted in H.L.C. Jaffé, *De Stijl, 1917–1931, the Dutch contribution to modern art* (Cambridge: The Belknap Press of Harvard University Press, 1986), 258.

36. Michelle Jacques, "Finding His Way: Jock Macdonald's Toronto Years," 75.

37. Macdonald to Harry McCurry, May 10, 1943 (National Gallery of Canada Archives).

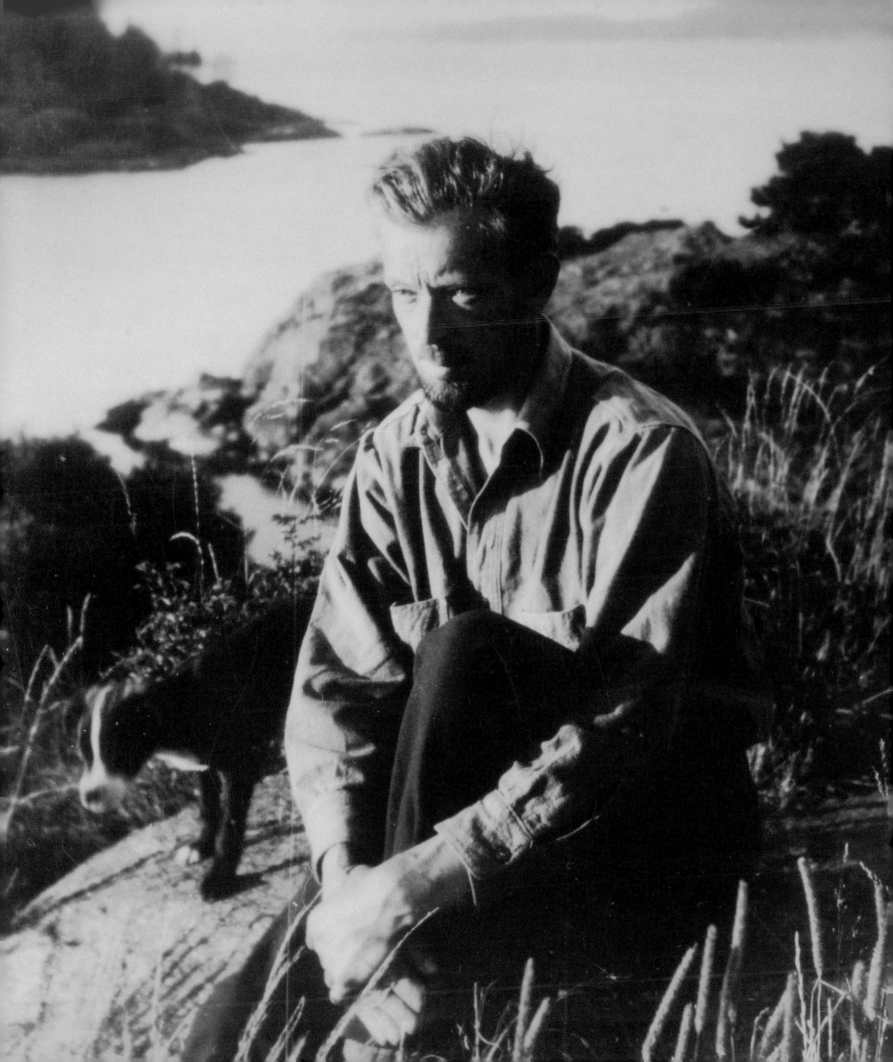

Nootka Diary

In preparation for his family's move to Nootka Sound on the west coast of Vancouver Island, Macdonald had to make considerable preparations—buying supplies, establishing contacts and so on. His notebook, which is comprised of an address book followed by lined pages, records these arrangements in detail. While he was in Nootka, Macdonald used this book to chronicle his experiences and thoughts during this extremely important part of his life. In the late 1990s, with the financial support of the Department of Canadian Heritage under the terms of the Cultural Property Export and Import Act, the Vancouver Art Gallery repatriated this important document, which had been unknown to previous Macdonald scholars. It is published here for the first time and gives a remarkable glimpse into the life and mind of Macdonald during a critical period in his artistic development when he was forming his ideas of landscape and abstraction. In transcribing this document we have endeavoured to retain Macdonald's idiosyncratic spelling and use of language as much as possible, in order to give the most authentic glimpse of his writings; while we have attempted to maintain accuracy throughout, a few minor changes have been made to aid in reading.

Ian M. Thom

Address book

Art Gallery of Toronto
86 Grange Road

Miss A. C. Banks
2 Devonshire Mews
Harley Street, London, W.1.

Sheila Boyd
730 St. Patrick St
Victoria, B.C.

Mrs. Bell-Irving
1847 Barclay Street
Vancouver, B.C.

Harry Beamer
1467 – 18th E.
Vancouver, B.C.

Mr. and Mrs. Frederick Brand
4775 – 4th W.
Vancouver, B.C.

Miss Sheila Boyd
1642 – Chandler Avenue
Victoria, B.C.

God's Witness in Stone
(by) M. Bloscom
(and its Message to the Anglo–Saxon Race).
Obtainable from M. Bloscom
43 Alexandra Rd
Worthing, Sussex, England

Oct.1932
Price 1/–
The Mystery + Prophecy of the Great Pyramid – Knight
Rosicrucian Library –
Vol. XIV
San Jose, California.
Rosicrucian Press
Printing and Publishing Department, Amore College

Mrs. E Bernulf Clegg
2033 – Comox Street
Vancouver, B.C.

Miss Margaret Corry
4287 Granville Street
Vancouver, B.C.

Cornish School
East Bay and Harvard Ave. North,
Seattle,
Washington, U.S.A.

Canadian Society of Graphic Arts
47 Brookmount Road
Toronto 8, Ontario
(W. A. Howard)

Emily Carr
316 – Beckley Street
Victoria, B.C.

Chas Comfort
Secty: Canadian Group of Painters
25 – Severn Street
Toronto

also
George Pepper

Chouinard Art Institute
(Mrs. Caldwell)
741 – S. Grandview.
Ex – 4938

Ronnie Cremini,
2810 Leward Avenue
Copley Square Apts.
Los Angeles,
Califor…
D R. 9871

Miss Amy Dalglish
4565 – 6th Ave. W.

Frank Darling + Co. Sey
4100
1144 Homer St.
Red Cedar Tanks

E. Dyonnet, Secty. R. C. A.
1207 – Bleury Street
Montreal

Rudolf Engler
(Trin 6369 X)
1087 Bute St –
Vancouver, B.C.

Lillias A. Farley
1443 – Nelson St
1728 Haro St.
Vancouver, B.C.

Paul Falk
Christadora House
147 Tompkins Square East
New York City
Tel. Algonquin 4 – 8400

Miss M. Faunt
734 – W. Adams St.
Los Angeles/Calif
Prospect 5602

Mr. Frank Fletcher
Ojai
California

(Tay 7556 L)
W. Athole Gray
2046 Beach Ave,
Vancouver

Edna Goranson
2071 W. 51st Ave,
Vancouver

Mrs. Howser, G. A.
360 – King Road E.
Vancouver (Handlooms)

F. B. Housser
91 St. Joseph Street
Toronto

Hotel Lafayette,
2731 Beverley Boulevard,
Los Angeles, Calif.

Lawren Harris
7 Plaza Chamisol
Santa Fe
New Mexico.

Andrew Innes, Esq.
2045 – W. 14th Ave,
Vancouver

Harry Johnston
c/o Metro–Goldwy–Mayer
Studios
10202 – Waslin Blvd
Culver City
California

Tom Laurie, (Fair 3525 L)
743 – 14th Ave. E.,
Vancouver, B.C.

J. W. Laing,
Armstrong + Laing,
513 Pacific Building,
744 Hastings St. W,
Vancouver, B.C.

Bea Lennie,
202 York Manor – 16th
Avenue – (1565)
1737 Matthews Ave,
Vancouver B.C.

Charles Lindstrom,
San Francisco Museum
of Art

Eileen Mathers,
"Aetnadena"
Burnaby Lake,
New Westminster, B.C.

Robin Moore,
3820 Douglas Ave.
Burnaby, Vancouver.

Daniel T. Mallet,
Artists Index–
363 Prospect Avenue,
Hackensack, N. Jersey,
U.S.A.

Paints Fred Martins
35 Sherbrooke St.
Winnipeg, Man.

Leon W. L. Manuel
John Oliver
43rd Draper
Vancouver, B.C.

W. A. Macdonald
Box 45 – P. O. Tahiti
via San Francisco

John T. McCay
4444 – W. 2nd
Vancouver

Duncan Mactavish
906 – W. King Edward
Vancouver, B.C.

Mrs. J. M. Macintosh
(IVY)
72 Mile End Avenue
Aberdeen, Scotland.

Ian G. Macdonald
"The Nook"
Grange Road
Vicars Cross
Chester – England

Geoffrey Nice
78 Brunswick St –
Edinburgh

Mrs. P. St. Clair Nice,
67 Grandview Bdgs
Kimberlay Road
Kowloon
Hong Kong

Dr. P. C. Phemister
3, Mortimer Road
Cambridge, England

Miss Pauline Parker
1939 – North Kenmore –
Hollywood,
California,
Normandy 2 1361

Mrs. R. Douglas Roe
B.C. Lumber
Commissioner's Office
B. C. House
123 Regent Street
London S.W.1.

Willie Sinclair
3462 Victoria Drive – High
4434 L

Edna Stefanini
(Stone cutting/tools)
2649 Patterson Ave,
Burnaby, B.C.

J. G. Sinclair
2905 – W. 43rd Ave.
Vancouver

Earl L. Stendahl
Stendahl Art Galleries
2006 Wilshire Boulevard
Los Angeles, California
Doescal 0223

Miss Mildred K. Smith
1975 – Crescent Drive
Altadena (Box 146)
California
or Box 1303
Seal Beach, California

G. W. Tyler
202 – Washington Court
~~Suite 3. 1019 Bute Street~~
Thurlow + Nelson
Vancouver, B.C.

Margaret A. Williams
Fort Q'Appelle
Saskatchewan

Dick Windham
1966 – Ogden Avenue

Miss Betty Walker
Arrandale Cannery
Naas River, B.C.
Klaus Westling
2248 – E – 45th Ave.
Vancouver, B.C.

Mrs. Florence Waddington
3306 W. 1st Ave
Bay 4078 Y. Vancouver, B. C.

Mr. Irwin Willat
1414, North Harper Ave
Hollywood, California,
Hampstead, H. E. 2345

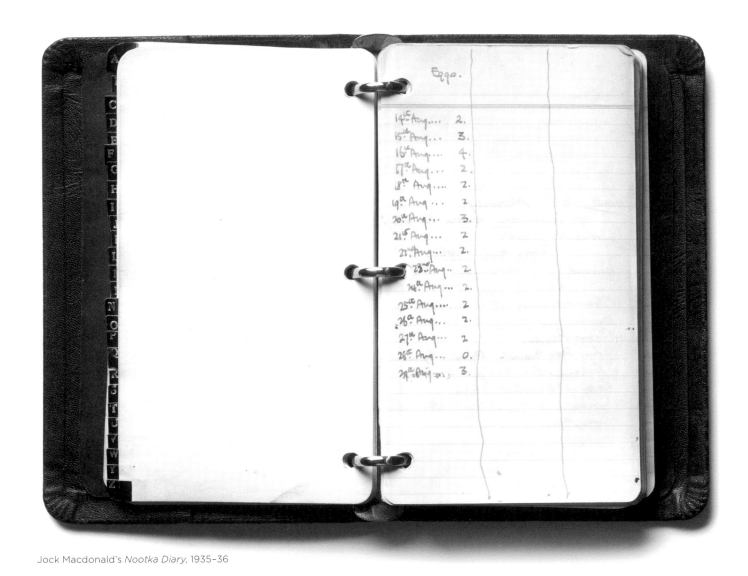

Jock Macdonald's *Nootka Diary*, 1935–36

Notebook

Eggs.

14th Aug... 2.
15th Aug... 3.
16th Aug... 4.
17th Aug... 2.
18th Aug... 2
19th Aug... 2
20th Aug... 3
21st Aug... 2
22nd Aug...2.
23rd Aug... 2.
24th Aug... 2.
25th Aug... 2.
26th Aug... 2.
27th Aug... 2.
28th Aug... 0.
29th Aug... 3.

12 tins Butter ——— $3.96
20 lbs Oats ——— $1.00
2 Boxes Hard Tack ——— ($5.20)

Butter, Soup, Jam,
Toilet Roll,
Tomatoes, White Sugar,
Onions, Milk, Rice.

Mrs. Wintemute
Call for Fur Coat
Goats: Mrs. L. Blakeney
19 Crease Ave. Victoria –
Tel. G 1537

W. + K. Burton
Gordon Hill, Victoria.

(Saaneno) F. H. Staverman
Langford Lake. V. I. BC

Mr. Tyler – Burnaby –
Exhibition Association
(phone Miss Rae) High 555

Mr. George Pilsner,
Live Stock Branch – Deprt of Agric.
Parliament Bdg. Victoria
Editor of "The Bleat" $1 a year
President of B. C. Goat Breeders Association
TogganBarq

[Red pencil crayon drawing of a triangle]

Cushions, Garden Sprinkler,
Toys, Dress Hangers,
Books, White Pajamas,
Cuttlery, Fur Gloves,
Anthroposophy Mag,
Small Tray,
Monks Cloth Curtains.

[Red pencil crayon drawing of three stacked wavy lines]

Books, Sketch Boards,
Blotting paper, Music,
Hot Water Bottle,
Dubbin, Floor Paint Brushes,
Fluid Oil, Rugs.

[Red pencil crayon drawing of a cross on top of circle]

Washing Board, Swing,
Hand Saw, Sealers (Jam).

[Red pencil crayon drawing of a square]

Brown Winter Coat,
Red + White Spotted silk,
Wool + Black skein rug wool,
Photographs (box),
Scraps, Pattern + Knitting books,
Knitting String, Pink wool,
Velveteen (wrap to be),
Fair Isle Caps, Infant clothes,
Fur collar + Strips,
Green Jersey Cardigan,
Yellow Sweater, Brads.

[Red pencil crayon drawing of a circle]

Small Quilt, White fur pieces,
4 Counterpanes, 12 Pillow Slips,
1 Good W. Sheet, 1 thin old W. Sheet,
1 narrow flannel Sheet, 1 Cotton Strip,

2 Table cloths (white large), 2 Sheets,
3 pieces of blanket (2 blue + 1 green),
29 Sugar Sacks, 10 Table napkins,
Sundry tea napkins + tea cloths,
Old Curtains, Books, Doll.

[Red pencil crayon drawing of a crescent moon]

Clothes (Dress + Blue Suit),
Books, Medicines, Diplomas,
Soap – Toilet Paper, etc.

[An arrow is drawn diagonally across this text,
pointing to "Return"]

Return box to Vancouver.
Bread tin, wash board, bread mixer,
mop hand, some pots + pans, sugar,
rice + macaroni + beans. Some plates,
tin mugs, mugs, knife sharpener,
pliers, wash basin, lamp shade
(small), oil lamp.

Food (MALKINS)

60 lbs. Brown Rice	2.00 (?)
10 lbs. Lima Beans	65.
20 lbs. Quick Oats	1.00 (?)
1 case large tin tomatoes	2.20.
24 lbs. Swedish Rye Bread	2.60
60 lbs. Sugar	3.00 (?)
2 lbs. cocoa	.22
15 lbs. tined Butter	4.95.
20 lbs 20/30 dried prunes	2.50.
75 large cans milk	3.60. [corrected to 6.60]
1 quart Vinegar	.15.
¼ lb Curry	.18.
12 tins sardines	.99.
10 large boxes Matches	
1 Box Oranges	5.00
	32.04

[Crossed out check mark]

Food (Woodwards)

25 30 lbs. Macaroni	1.50 (?)	1.55
20 lbs. lentils	1.50 (?)	1.60
10 lbs Peas	.45	.50
24 25 lbs. Graham Flour	.78.	
48 doz. 1 case veg. soups (Clark's)	3.35.	3.28
18 20 large cans of corn	2.00 (?)	2.12

18 20 large cans of Peas	2.40 (?)	2.10
14 lbs 10 lbs Salt	.25	.27
3 gals 4 gals Mazola Oil	2.90.	4.35
20 lbs Brown Sugar	1.00	1.00
15 lbs raisins	1.55 (?)	1.65
75 large cans Milk	6.50 (?)	
½ lb I large tin Mustard	.42	.47
20 6 lbs Orange Marmalade	1.60	1.48
6 lbs Empress Tea	2.40	2.52
3 lbs Empress Coffee	1.12	1.17
5 lbs Baking Powder	.97	97.
4 lbs Plumb Jam	.40	40
4 lbs Loganberrry Jam	.40	41
2 doz. Candles	25.00	
Flash Light	- 5.64	
3 tins Dubbin	30 cts	
2 lbs. Baking Soda (Cow Brand)	.22	
		39.63

[Crossed out check mark]

18TH JUNE, 1935

[Many entries have check marks and crossed out check marks next to them]

Get Car from Garage.
Call to Bank 10 am + cash Hood cheque.
Dentist — 11:15 am.
Meet Mr. Gray about 12.30 cor Pender + Howe St.
See about food order at Woodward's
Get Leslie [Planta] to make 3 ply lids for boxes.
Get labels for boxes.
Get clothes for B. + F. + for self.

B.	F.	Self.
		Shirts
		Socks
		Cordoroy trousers
	Sweat shirts.	Slickers.
		Woollens.
		Beds.
		Tooth Brushes.

Pay School Telephone Bill
Pay own Gas Bill (receipt deposit in carpocket)
Get boxes all ready for Cartage in the morning
Order transfers cartage
Medical supplies.

Soap, toilet paper (School),
Sketch Pads, Ink, Pens, Pencils.

Rubbers, Linoleum tools, Linoleum,
Paint Brushes, Flake White, Oil.

Call tourisms office
Take Slides to Mrs. McCaye
Running Shoes

Zinc Ointment, Lime,
Magnolax, Vaseline,
Burn Ointment, Pickwick Acid Ointment,
Stamps.

NOOTKA:

W. H. Boothroyd.
Land Commissioner, Port Alberni, B.C.
(HARDY)
Alec Ferguson
Nootka Packers, NOOTKA

Mr. Goble intro to Mr. Arthur Park
Fishery Commissioner

MR BOYD – Police Fishing Boat

19TH JUNE, 1935

Buses from Kitsilano to Freight Sheds
See Harry Hood — Art Emporium
See Farleys
See Dentist 12 noon
Pay Dentist
See about Sewing Machine
Return Grass skirt to Mr. Leeson
27th Ave. – 1457 Nanton (Bay 101)

20TH JUNE, 1935

Prizes:
— Post Graduate Scholarship
— Prize in design 1 year earlier
— 4 ½ yrs
— Letter (Testimonial)
— 1929 Diploma
— 6 month post Graduate
— Saturday morning classes
— 2 yrs. 1 year. V.S.A.
— Exhibits. Vancouver Art Gallery
— Designs exhibited + Highly commended in
 Empire Industrial Art Exhibition 1930
— Lilias Ar de Soif Farley

Goats – Whitmore
27th + Main Str

Bank – Tran 1207.

Victoria:
2 Flat Iron – Dark Glasses 4
Absorbent Cotton – Laxative –
Raw Linseed Oil – zinc ointment.

Three designs for a house/studio in Nootka drawn by Jock Macdonald in his *Nootka Diary*, 1935–36, Photo by Rachel Topham

[This date was actually a Wednesday]
FRIDAY, 19TH JUNE, 1935 Harry [Tauber] + Leslie [Planta] left for Victoria tonight as all freight got aboard "Maquinna" for Nootka, B.C.

[This date was actually a Thursday]
SATURDAY, 20TH JUNE, 1935 Barbara, Fiona and I sailed for Victoria at 10.30 arriving at 3 PM when we met Harry + Leslie at 3.30. Went for lunch after which we shopped + then Harry went back to pier + we four went to picture show—rotten! Before going aboard Maquinna at 8.30 PM we had coffee. I remained up until 11.30 for late supper aboard.

[This date was actually a Friday]
SUNDAY, 21ST JUNE, 1935 Heavy roll at sea—windy, most people sick. Harry + I both had breakfast. Barb, Leslie + Fo all sick + poor Fo fell downstairs + put tooth through her lower lip. Arrived at [word erased] at 4 PM so had rest + inside passage all [entry ends]

FRIDAY, 21ST JUNE, 1935 HARRY + LES. left for VICTORIA last night. BARBARA, FIONA and I left at 10.30 AM. For Victoria where we arrive at 3 PM. Met H + L + had lunch in café after which we did our final shopping. B, F, L + I went to picture house to pass two hours before going aboard the "Maquinna" at 8 PM for NOOTKA. H + L went to cabin + so did B + F. I remained up + had late supper on board at 11.15 PM.

SATURDAY, 22ND JUNE, 1935 Heavy swell at sea with S. W. wind blowing so ship rolls unpleasantly. B feeling pretty sick. F got outside cabin door unnoticed so falls down-stairs from upper deck + knocks tooth through lower lip. Both of family sea-sick + so is Leslie. Arrived at Port –– – at 4 PM so will have a quiet sail inside passage. Reached Port Alberni at 8 PM. B + F went to cabin. H, L + I went up to town + gave it the "once-over."

SUNDAY, 23RD JUNE, 1935 OUT AT SEA again this morning but it was better weather + nobody suffered any ill effects. Called at Clayoquot + had a good two or three hours rest on the beach. Sailed inside channel all the rest of the day—very beautiful. Everyone enjoyed excellent meals.

[Written in the top margin: (Found a staving puppy—collie so took it to camp.)]
MONDAY, 24TH JUNE, 1935 Got up at 6 AM to look at NOOTKA landscape. Rained heavily + everything looked miserable. East coast looked wild with big breakers + no shelter. West coast looks better. Arrived NOOTKA at 8 am. so started unloading freight ourselves + found it heavy work with 5000 lbs of freight. We put it in the B.C. Packers freight sheds + then had final meal aboard.

Was introduced to Alec Ferguson of B.C. Packers + also Park of the Fishery Board. There we met Bert Fish of the lighthouse. He was just the man we needed so he gave us much good advice + took us on his boat to the lighthouse where we met his wife, his mother + father. They gave us lunch + were extremely kind. Later Bert took us back to NOOTKA where we launched our boat and packed both his + our own with freight. They were loaded heavily. Rowed back to the lighthouse + had supper. B + F remained to sleep there. Bert came with us along trail to

Maquinna Point + showed us a shack where H, L, + I slept. He returned to the lighthouse.

TUESDAY, 25TH JUNE, 1935 H, L, + I walked back to Friendly Cove + hailed Bert from lighthouse. Got midday meal again. About 5 PM H + L set out in their boat for Maquinna Point, Bert + I in his. It was windy + rough—rather big smooth rollers which made it hard going with our heavy load. H + L landed on the beach + had tough time getting freight off their boat. We came along + waited for largest rollers to go up on the beach first. Then we made for it. Had it very lucky but nearly lost everything—had to simply throw cases, boxes, bags etc, ashore as fast as possible. Everyone soaked with waves. However all was well + we were very glad to be safe on land. Took boxes to cabin + H + L put up tent. Pushed Bert off again with his wife who had walked along coast with Fo. Got up beds + prepared a meal before going to bed. Mighty lucky day + thanks to the lighthouse friends.

WEDNESDAY, 26TH JUNE, 1935 H + L went back to Nootka for more freight after I pushed them out to sea this morning. Awful scramble to get away + the backwash of waves nearly pulled me out to sea. Helped to arrange camp. Cut trail to stream—100 yds in bush. Fred the Russian Hermit who helped us to land the night before stayed for supper + gave us some rhubarb. H + L returned at 8 PM so we all enjoyed Macaroni supper which B prepared. Fred is a Russian who stayed some years in California + has been here 9 years. Lonliness had made him pessimistic and shy, with not bright outlook on life. He is very kind + welcomes conversation. More food + equipment brought in by H + L. Fine Sunny Day.

THURSDAY, 27TH JUNE, 1935 Birds make great din about 6 AM. Ravens, crows, eagles, Robins etc. Lovely blue heron eats in lagoon outside cabin. It is a very wary bird + spotted me moving in bed inside cabin which is 50 yds from the lagoon. Leslie has a cold so H + I went down along the trail to Friendly Cove. The Fishes gave us tea before we went to Nootka for provisions + more freight. We loaded fairly heavily + returned to the lighthouse where we unloaded. Then we filled up packs + returned to camp but L came with our slickers as it was very wet + we had no coats. Les. had helped B all day + made shelves in cabin, also put in stove + cut wood. B gave us a good hot meal. Raining hard so had to put tent over beds to keep them dry.

FRIDAY, 28TH JUNE, 1935 Fred—the hermit came along with four trout for Fiona. Very good. We didn't get up

until 9.30. Went down to Friendly Cove Lighthouse with H + Les. who remained there so that they can take Berts boat + their own to Nootka + try + take up all the freight in the next two days to lighthouse. After a cup of tea I packed up my pack with 60 lbs of food, clothes etc, + went back to Maquinna Point, arriving at 2 PM. Cut wood nearly all afternoon, boarded up windows to keep out the cold, and found lost flour bag on beach but managed to salvage about 10 lbs.

It is difficult to remember the date + day of the week. The world news seems to be a thing of no account + we are quite happy in our isolation—with great seascapes, beach, trees etc. Nootka scenery is most beautiful with rolling hills, conical islands + high distant mountains with eternal snows. The coast is like the North of Scotland. There is lots of timber on the beach. Retired to bed at 10 PM.

SATURDAY, 29TH JUNE, 1935 Gathered firewood in the morning for about 1 ½ hrs. Fred gave us some rhubarb. Spend remainder of the day building a toilet. After supper I took my pack down to the lighthouse—3 miles—to pick up H + Les. Les came over by canoe + at the lighthouse I was given tea and cake. Took over tables, stools, pans, and some cushions + got back to camp about 9.45 to find B + Fo alright. Had a small meal + retired at 12 midnight. We have all been sleeping very soundly. The puppy "Fuzzy" is now pretty strong and much more alive. Fo enjoys the dog as a playmate.

SUNDAY, 30TH JUNE, 1935 Got up at 9.30. Still feeling bodily tired after week of heavy work but everyone looking much healthier. Gathered firewood for an hour or so. After lunch Bert + his wife came to see us + brought some salmon. Bert, his wife, Les, Fo + I went by trail to Fred's house and so did H + B. I carried Mrs. Fish, Les, + Fo over lagoon on my back + then Les went for H + B in punt belonging to Fred. Fred's house is quite good + most tidy. All his garden is layed out in beds of vegetables, the beds being bordered with cedar shakes about 10 feet long. We saw cougar paw marks on beds—made two nights ago. Fred gave Fo some trout for her breakfast tomorrow. Bert gave me a rifle with ammunition for protection against cougars. We all were rowed back to our cabin by Fred and found more cougar footmarks near our cabin. All stayed for supper. The weather seems to have improved so we may have some sunny days now. Got to bed at 10 PM. It was quite enjoyable to have some visitors. Most of the conversation was about cougar, bear, buzzards, racoons, deer, and fishing. If all is true—which I believe it is—this part of B.C. isn't too comfortable + safe. However!!

Indian Burial at Nootka, 1935
ink, pencil on paper
7.4 x 4 cm
Collection of the Vancouver Art Gallery,
Acquisition Fund

from Nootka called at the lighthouse to find out about us but got little information.

TUESDAY, 2ND JULY, 1935 Another bright sunny day. Les + I went fishing + also took the boat to Nootka. We also returned the little dog which came up the trail the night before. It also belonged to the Indians. Bert helped us to get our fishing tackle ready. We only caught two little fish at Nootka harbour but haven't told the family here today. After fishing we got a tea at the lighthouse + got back to camp about 9.30 PM. It remains light quite long here + the evenings are always calm although a wind blows hard every afternoon. Tomorrow I have to go back to the lighthouse as we are to place our orders with the Fish order. It is now 12.30. So time to sleep.

WEDNESDAY, 3RD JULY, 1935 Went down to the lighthouse to give the order for rations which we might require in three weeks time. Had a light lunch with the family there + discussed religion as well as nursed the baby. Got back to camp at 2 PM. so wrote letters to Duncan, Varley, Lilias, Mr. Lennie, + Athole. Misty rain in the afternoon but little or no wind. Sea very calm. Harry spoke on the Jesuits during lunch and at breakfast we spoke about plans for our houses. Retired to bed at 9.30 because of early rise in the morning.

THURSDAY, 4TH JULY, 1935 To meet the Vancouver boat when it arrives at Nootka holds the expectancy of unknown quantities. Will there be letters, will the worlds news be less worried, will we receive word from Victoria—the Land Commissioner—that we can make our choice of land in order that we can advance our building scheme. I rose at 5.30 AM, cooked breakfast and set off on the train to the ROCK (lighthouse) in a drenching rain at 6.30. Bert told me that they generally set off when the boat is on the horizon, so seeing the boat when I was a mile from Friendly Cove I ran for a time so as not to be late only to find that the boat was early + Bert did not set sail until 8.15 with his wife and I. The wind died about half a mile out so we rowed the rest of the way. It rained exceedingly hard so had to bail the boat on arriving.

No word from Victoria. I got a letter from Athole and one from Manuel. Manuels letter was one of financial anxiety + he desires my assistance through returning some money I owe him. This debt I owe to him is one of much worry to me + I can do nothing to help as yet. I wish I could. The newspapers are full of stories, martial law, financial schemes to aid humans but it appears that there is little hope for righting the conditions in the world. We should be glad that we have taken ourself out from the daily conditions of nervous strain + stress. Our only worries here are likely to be the requirements for food and

MONDAY, 1ST JULY, 1935 Fiona is eight years old today so I suppose she is now to be considered a young girl. She is happy in camp + the life agrees with her. She got a nice cake with candles from the Fishes, and had the tent put up. Barb, H + Les went down to the lighthouse so Fo + I stayed out here. I enjoyed two nude sunbaths on the beach + also had a bathe. I prepared macaroni supper for those returning at 8 o'clock. Fo got candy + things from H + Les. Two women

warmth for the winter so we have reduced our anxieties to mainly those two.

I packed the wooden stools to camp as we will be likely to have visitors on Sunday + comfortable seats are desirable.

Going through the forest alone is at present a slightly nervous ordeal as one has heard so much of cougars. I carry a wooden club which one can pick up from the wood piled on the beach. At Friendly Cove I was surprised to find the cows are squatting on the beach at the waters edge. I wonder why they make this choice in pouring rain? Perhaps it feels drier than resting on wct soil.

We plan to make a chess board with one of our tables, to paint this on and to carve the wooden figures.

It rains heavily tonight so the bed had to be moved from the drips falling from the ceiling.

FRIDAY, 5TH JULY, 1935 Still raining until midday. H + Les went down to the ROCK for more provisions and also to get large saw.

Spent most of the afternoon gathering wood, hanging out washing + doing other camp necessities.

In the evening we decided to make a chess set so Les painted squares on one of the tables and I drew about 24 designs for marks. Fiona spent most of the day making a board for herself + also drawing marks. Got to bed about midnight. One feels quite tired early in the evenings with so much fresh air.

My beard is now seemingly beginning to change my appearance as remarks—encouraging ones—are now passed to me by my camp companions. I don't feel so very pleased with my appearance so far.

SATURDAY, 6TH JULY, 1935 After breakfast Les and I went to find Lot 255 which has been suggested to me at Port Alberni as a possible land for purchase. We are now on lot 252 so had first of all to cross the lagoon. Les having gum boots took me over. The tide was out so we got along the beach for a mile and a half. Just around the lagoon point there is a small cabin and also a larger one about 100 yds in the bush. Both are rather dilapidated but have been well made. While we were in the second cabin we heard a crashing in the bush outside. It sounded ominous so we being rather shy of trouble yet got away in pretty quick time. It may have been a deer, or a cow, or something equally timid but of course we imagined a cougar.

About a mile along the coast are many caves, natural arches and half arches. Rather wonderful but the coast reminds me of Northern Scotland. The sea life however is large and generous in growth. The sea-anemonies are fully 3 inches across while the limpet shells can measure as much as five or six inches long.

We were eventually forced into the woods so we looked for a trail which is indicated on the survey map. We failed to find it so got into thick underbrush, moss covered tangled branches and thick heavy Salal. We got back to the beach again as we felt we might lose our sense of direction. Had the sun not been shining we might easily lose all idea of direction.

We eventually came to a deep inlet which cut right into the forest. At the head end was a cave where birds of the cormorant type came flying out and in. They chattered away + their noise was sometimes quite human. We had two efforts to encircle this chasm + after fighting through the densest forest growth I have yet experienced in British Columbia we still came out at the same side of the chasm. Eventually we gave the idea of passing it up as it must have been about one o'clock + we must leave quite a lot of time to get home as the tide would now be in + we would not have the easy walking on the beach. We sat down for lunch but it rained so we sat in the rain.

It was without love that we returned to our fight through the woods on our way home. It was terrible going. The salaal looked just like small bushes from 30 feet away but when we got to it we discovered it 12 or 15 feet high. Twigs go in our eyes, our hair, tripped up, entangled our legs, scratched arms + faces. Every time we saw a sandy beach we made for it no matter what we had to get through to get there. Les fell with his pack over his head + his head pressed into his chest with it while his feet floated around in the air. Having gum boots on in the forest was not his pleasure. At the end of each little beach we tried to round the points by the rocks but never succeeded. The sea was so rough much too strong to venture any dangerous work so up we had to climb—sometimes sixty or eighty feet to get round the points. At one place I could neither get up nor down as my boots were too slippery + I had to have Les to help or drag me up. I felt beastly uncomfortable for a few moments + had Les not been there to help me I would not wish to prophesy the result. I felt that I could make no mountaineer during those moments of danger.

It took us five hours to get back to our camp + we must only have had three miles to go.

So my conclusions are that Lot 255 wherever it is, is no place for our future home + it might as well be forgotten. It is impossible to pack food there and the sea would be impossible in winter.

SUNDAY, 7TH JULY, 1935 We lay long in bed—10 AM but Harry + Les went down to 'the Rock' for their boat + to fish. Nothing was caught but the boat is now up here + we can use it anytime for fishing.

Mr. Fish, Mrs. Fish, two dogs and one of the Indian puppies came to spend the day with us so arrived at 11 AM. This was much earlier than we expected so we were rather caught out. It was lovely + sunny but became dull at noon.

Barbara busied herself + prepared a meal. She cooked up the stewing beef they presented to us yesterday or the day before + gave them rice and soup. Les used some of the Beef as fish bait—we don't eat meat + could not offend them by refusing it. How afraid one is of being outspoken in case of offending the feelings of a friend.

Mr. Fish + his wife stayed until 3.30 so Harry, Les (who had returned from fishing) Fiona + myself walked with them home to as far as the Indian cemetery. There had been a funeral during the week as the graveyard held a new burial ground.

The post with a little cotton flag attached on the beach is a Surveys mark.

We decided at Supper to repair the shack at the creek between here + the Rock as we intend to build there + chance being permitted to purchase the land there. Time is against our settling here for the winter so we must proceed + risk things. The old cabin there can be patched up + used as a work cabin while we build so if tomorrow is dry we get to work on something at last. I feel much more contented with that thought as I fear the lack of development has made me particularly irritable + restless.

MONDAY, 8TH JULY, 1935 Still raining hard this morning so we had to set aside our schemes on building. Les and I decided to go fishing off the rocks so hoped that this time we would catch something. We kicked up the muck for worms which proved to be plentiful. Leslie caught the first fish after an hour + followed with a second ling-cod about ten minutes later. The second fish was about a foot long so we were already supplied with enough for a meal. I caught the third + smallest. We then gathered some more worms + got away from the fishing ground as the tide was coming in quickly + we would soon be isolated. We went to some rocks further west + fished again, being successful with two more ling-cod. We caught one fish which we didn't know so threw it away as it didn't look eatable. Two of the ling-cod had green emerald flesh. This proves to be the sweetest fish + cooks quite white. We cleaned the fish and cut them into fillets so that they would cook nicely. On our way home we found the tide had cut off the way we came so had to climb the cliff and find another way off. We thought that we were trapped but found a steep way down the other side. Coming along the lagoon wasn't easy + sadly we discovered we lost one fish in doing so. In wading across I got into a hole which allowed the water to come over my high gum boots so arrived in the cabin slightly wet. The fish supper was an excellent change of diet + we all enjoyed it. After supper Harry introduced us to a game of chess. It appears to be a most thoughtful and difficult game. Harry informed us it was a highly considered mental builder + had quite a spiritual background. Retired to bed about midnight.

TUESDAY, 9TH JULY, 1935 Still raining so did not rise until 9.30. Leslie + I went fishing again + ran into great luck right away. I caught a small cod + a larger one about 14 inches while Les caught a Perch. All were caught within half an hour. Worms were difficult to get today. It continued to rain until two o'clock or so. We moved again because of the time + went to our 2nd fishing ground of the day before. We remained two hours but only caught a small one so stopped + came home about 4.30. We had an excellent meal of soup, hardtack + tea before setting out again to fish for salmon as the Indians were out fishing in their canoes. We fished all the way to the lighthouse but didn't have even a bite. Bert met us three so up we had to go for tea. We chatted about the Nootka people + were told that we were thought to be members of "The House of David" by them, that Harry was the leader, that Barbara was his wife, Fiona his daughter + Les + I were two youths who were still too young to grow beards but would be doing so when we could. We rowed him without luck.

Fred—the Russian—called in with some rhubarb during our absence.

WEDNESDAY, 10TH JULY, 1935 The weather seems to have cleared so we went down to the creek which is called BARNES PLACE. Barnes appears to have purchased this land years ago + left some twenty years so we hope that the land is now Crown Grant + we have the possibility of purchase. His old cabin is still there + very delapitated so we cleared up the ground all around, took the old shingles off the roof, cleared trails to the stream, and cut some lumber. We (H + L + I) took a small lunch so there was not necessity to return to our headquarters until 6.30 or 7. I felt very tired physically. H + Les went down to The Rock for the axe handles, some freight + other requirements. I went to bed at 8 o'clock + soon fell asleep.

THURSDAY, 11TH JULY, 1935 Still very tired so didn't go to work. Slept for two hours after breakfast and felt much better. The sun shone brightly for a time in the afternoon so B, Fo + I went down to Barnes place and found Les busy reshingling the roof of the cabin while Harry was cutting a trail to the rock where we hope to build one house. We looked over some other ground for a second house + then started to set out poles for surveying but it became foggy. The sun shining on the fog where it went rolling over the land appeared to make a luminous rainbow. It was a very effective setting for a weird play. As we couldn't proceed with surveying work Harry cut my hair and trimmed my beard—first beard trim I've ever had. The barbers shop was out of doors so the odd hair or two flew off in the wind.

In the evening Harry gave B + I the dictation from Steiner's explanation of the Lords Prayer.

We suffer considerably from mosquito bites but for sleeping we have nets over the beds—what a Godsend.

In three days or so the boat arrives again at Nootka so I hope to hear from Victoria about the land. We hear that England says she'll support Ethiopia against Italy + the rest of the world if Italy intends to declare war on Ethiopia.

It may not be long before the world is again thrown into war. We have come here to be away from the foolishness of humanity.

The Japs fishing boats are coming here in Hundreds + the salmon are running. One gas boat brought in 8 tons of fish after 12 hrs fishing. We are told the Whites drive the Japs about 50 miles to sea at the point of a gun and tell them to keep out of Nootka and also cut their anchor lines while boats anchor at night. Such commercial animosity must eventually lead to race hatred and war. Nationalism is an evil.

FRIDAY, 12TH JULY, 1935 I remained at camp today to write several letters while Harry + Les went back to Barnes Place—Les finishing the shingling of the roof + H cutting a trail to the probable place on the west rock where one of our houses may be built. In the afternoon Barbara, Fiona and I went down there and took along some tea + soup. It was a gloriously warm afternoon so we all bathed except H, later having our baths in the stream. I enjoyed my swim as I would wish to have one. Got home about 8.30 so all retired early.

SATURDAY, 13TH JULY, 1935 I went down to the Rock to give my order for supplies. It is most convenient to order in this way and means that I will not have to go to Nootka for any parcels at any time as they will always be taken to the Rock. I remained for lunch + returned with groceries in the pack. This was another glorious day. I am looking forward to the time when I can go sketching. Retired early to bed as tomorrow is boat day once again. The weeks are called boat weeks so seven days now becomes ten.

SUNDAY, 14TH JULY, 1935 Barbara, Fiona, Leslie and I got up at 5.30 AM for breakfast and unbeached the boat at 6.30 or so. The water was quiet so we had no difficulty getting on to the water. It was already warm and glorious sunshine. We called at the Rock to see if we could take anyone down to Nootka but were there too soon. We got to "N." at 8.30 so arrived shortly after the boat. Being Sunday the store didn't open until about 10 o'clock so we had a long wait for our letters.

Everyone is there for their mail—Whites, Indians, Japs, and others. B was glad to receive some welcome cash from P so we will have enough to last us for another five or six weeks. Our money only goes out on food—so it lasts now seeing that we haven't the annoyance of rent, light, heat, etc. It's a great feeling to feel the value of your money.

Bert + his wife and 5 months old daughter arrived by canoe. The infant was placed in a small wooden box.

We were towed back to the rock by Mr. Horse and Fred Vey so all remained for lunch there. It was very hot so the meal was given outside.

It was our intention to take the boat back to camp but the wind had risen + the water was too rough so we left the boat at Friendly Cove + hiked back.

After supper Les + I went out fishing from the rocks. We were not successful so returned about ten o'clock only to find that the tide had rushed into the lagoon so quickly that we couldn't wade across. Here we were stuck until the tide reached its peak + receded again and only 50 yards from bed, rest, and comfort. We gather some wood, lit our fire and squatted. The moon was bright but did not cast its light upon us. The fire gave out good heat but we were afraid to build it too high in case the sparks caught the heavy moss on the fir tree branches above. We took off our gum boots as our feet were already wet through our first effort to cross. Three times we tried to get over in the early hours but could not. We couldn't see where to place our feet and the rush of water was too great to risk anything. It was three in the morning before we were successful—it seemed a mighty long day + we were chilly + tired when we sat down to tea + hardtack which we preferred.

MONDAY, 15TH JULY, 1935 After resting in the morning we prepared to go down to Barnes place but Bert came along with Father Antony and a young boy from Oregon whom we had previously met on the way up here by boat.

We had heard much about Father Antony from our friends at the Rock. He seems to be a very fine man + was able to give us much valuable information about the Seaweeds, flowers + berries. Those things we wish to know as we want to have seaweed or seafood meals. The berries will come in useful for jam and jelly. They all remained for supper. Much discussion took place over the Indian art of the present day (Totem Poles). H discussed the point that the present art of this kind is commercial and therefore loses its value as a creative art. The old poles were true creative efforts. H won his point + cleared up the values given by Father Antony.

TUESDAY, 16TH JULY, 1935 Les + I went down to Friendly Cove for the row boat + after calling at the Rock went down to Nootka with more letters. I wrote mother again as she informed me that she had unfortunately broken her leg. I also was told of Ians success in an essay he wrote on "The Philosophy of Aesthetic Design in Bridge Building."

He had received a gold medal and 100 guineas prize from the Engineering leaders in London, England. I also saw in "The Groat" (local Caithness newspaper) that my old friend David William Gunn or "Pop Gunn" had died in his studio of heart failure. Pop was a very kindly fellow and certainly the most amusing boy I ever knew. I am sorry to hear of this loss.

I also mailed a letter to Alberni (Provincial Assessor) about other possible lots for sale or purchase. I do hope we hear something definite soon. The news from Victoria about lots was most unsatisfactory + we are not further ahead.

After visiting N, Les and I went on a discovery expedition so rowed to Marvinas Bay to inspect two lots. This Bay is quite good but too shut in. The view outside is magnificent of the mountain ranges on the mainland of the mountains. We let the boat drift for a mile + dropped the line for cod—using as bait some Pilchard fish which we got at Nootka. We caught only a dog fish so threw it back.

There is a good river at this Bay but the land is uncleared + not what we would wish. It is quiet and isolated but it would take us years to clear the land.

Returning to N was a stiff row as the wind had risen. The boat "Norah" had not come south so we met Father Antony who was waiting for it. He took me to the hotel to see an oil painting of Friendly Cove by an Indian. It was I suppose a fairly difficult effort for the Indian but contained little or no art. Then we proceeded to the Indian houses to purchase a rug for Harrys birthday.

Those huts were absolutely filthy + terribly untidy. There were about five or six women in each hut + in one was an old man, lying on a single blanket on the dirty floor. He had had a paraletic stroke two days ago + had not yet recovered his voice. It seemed awful to find what he had to put up with—noise + dirt + all sorts of Indians fussing around. The women showed us their weaving + were pleased to make a sale of a cedar fibre mat for one and a half dollars. Very little money for weeks hard work. The mats are woven with strips of fibre which has to be collected from the trees, dyed and cut in even widths. They exhibited samples of the patterns they use on their baskets. They are putrid European things—butterflies, cocks, hens, Mary + the lamb, roses etc. Why they didn't use their own Indian symbolic designs I do not know. I must enquire about this from Father Antony.

Later on Leslie appeared with a 20 lb salmon to take home. He got it for nothing as it was caught in the net of the Seine Boat + it is against the law for those boats to sell, tin or barter in salmon. A welcome find for us as we were wishing salmon for bottling. We gave half of it to the people at The Rock + took the remainder home in the row boat. We also took up the Black tin box as we are now bothered with mice + food must be carefully protected.

I was tired when going to bed at midnight. Fifteen miles rowing is quite a new exercise for me. Leslie stands up to do it much better than I do. I wonder if it is because of my years or is it that I am tired after the past two years of worry and work with continuous mental strain.

WEDNESDAY, 17TH JULY, 1935 At last I take a hand saw and made for a log. Being a novice I had my little difficulties with warping the saw and playing around on the surface of the log before it got a bite. After trying several hand holds I gradually got used to the thing. It was a large hand saw. Leslie was on the long saw so tackled a very respectable log about four times as wide as mine. I found it heavy work, mechanical and just the reverse action from rowing. We enjoyed a bathe after lunch and short sun bath. On returning to camp at 6 PM. I just felt strong enough to flop on bed + have half an hours rest.

After supper Harry dictated to B + myself his lecture on colour abstracted from the spiritual teachings of Rudolf Steiner. We commenced with the examples of colour values used in classical art.

Retired to bed about 11 PM as I felt quite tired.

The mosquitoes were not quite so evil tonight.

The Indian was around looking for his dog—Fuzzy—so hearing that we had it he decided we could keep it until he called again. Just wishes to have it brought up from its infancy, be well fed and taken care of so as to save him the bother.

THURSDAY, 18TH JULY, 1935 Les and I went sawing wood again + this time I used the large 7 foot saw by myself. I found it difficult + heavy at first but after several ends cut off the log I got on better. We sawed with as little clothes on as possible—just shoes—so that we didn't become overheated in the brilliant sunshine. Twice we laid down the tools and ran into the sea. The water is cold, buoyant and very salty. The pool we have for bathing in is sheltered from the waves so is safe and calm. Father Antony came along in his canoe + helped Les for a time. Later he went along to our cabin in the lagoon when we all had supper about 7 o'clock. Father Antony showed his photographs of the Indians, their old cabins, and so on. Fred had also called + left some rhubarb + lettuce.

He got a present of the old riding boots which fitted him excellently. Fred has no socks so just rolls rags around his feet.

Father Antony took his canoe up the lagoon to his own cabin so just had to hop out of the door into it on his return trip.

We anxiously await news from Alberni about the lot we wish. I hope sincerely we have good fortune + can get ahead with our building.

In the evening we took more notes from Harrys translation of Steiners Colour Theories.

"Fuzzy" + "Myseony" the two pups are now growing quickly + appear so much stronger as they have much more energy to scamper around.

FRIDAY, 19TH JULY, 1935 Harrys thirty fifth birthday so he received his presents at breakfast. A large Indian woven floor mat which was made by the Indians of Nootka, candy wrapped up in fancy papers by Barbara and at nine in the morning along came Bert, his wife and five months old daughter (carried in an Indian basket) to present him with a birthday cake made by Mrs. Fish, senior, and a box of chocolates made by Bert + his wife. Together with four bottles of ginger pop he certainly faired just about as well as if he had been anywhere else.

Fiona, Bert, Leslie and I set off about 10.30 for the "The Counterfieters'" house so Leslie nobly carried us all over the lagoon on his back. The dogs Wolf and Peter—which belong to Bert—followed. We called on Fred + found him busy in his garden. Having taken along our trout lines we amused ourselves fishing in every likely hole on the way to the Counterfieters' cabin but only caught a Bull-head.

This cabin is placed back in the forest about a mile from Freds place—quite isolated and hidden. It is a two story building, on the bottom floor there was a six foot wooden bath which had been carved out of a tree. It was fully 2 feet 6 inches deep and as smooth as polished stone. Up a very steep stair you arrive on the second story which is shut off by a wooden trap door. On this floor there was a small room sectioned off. This room was used as the printing room where they kept a press. The door to this room had a small circular peephole with a small drop latch of wood placed over it. Several wooden seats and chairs are left lying round together with some German literature. Leslie fell down the stairs and placed his hand on the only nail to be found. He cut it badly so had to suck it for a time, wash it in the stream and have the dirt picked out. Bert fell on the way up + winded himself with the butt of his rod. Fiona romped around in great form + feared nothing—going across narrow logs over the river in several places.

There being several windows with good glass in this broken down house, we confiscated two of them for our own houses. It felt like theft but the house has been vacated for years. Those four Russian Counterfieters of American money finally were caught and imprisoned in America where they went to pass their money. They were all imprisoned. They must have worked extremely hard on thief land (stolen ground) as they had cleared acres of ground + had a large cow byre built.

We carried the windows to Freds house + took his boat + he rowed us over the lake + down the lagoon to our cabin. Fred gave us some lettuce with roots so that we could keep them fresh for a week if we needed to keep them.

Bert, his wife + child, Fiona, Harry + Leslie took out our boat and rowed the Fish family down to the Rock. Fiona felt ready for anything.

SUNDAY, 20TH JULY, 1935 I took my paint box and went down to Friendly Cove, taking Fiona with me. It was another gloriously sunny day. Looking in the village for subject matter I decided to go over to the lighthouse to view the cove from the light. Nootka Willie, the Indian, took us to the Rock in his canoe. Up on the top of the lighthouse it was quite cold + blowing a good stiff breeze. I got out my paints but found that I had no veridian and that the three brushes I have were much too old + stubby for use so I had to forsake the prospects of obtaining my first sketch. Most disappointing. On the way through the cove I found an interesting composition which should be an interesting

Pine Tree, Indian Lake, Nootka, B.C., 1936
ink on paper
28.7 x 21.6 cm
Collection of the Vancouver Art Gallery, Acquisition Fund

thing to do next time I go there. In the evening Barbara and I took some more dictation on the colour lectures of Steiner. It is extremely interesting but at this time almost impossible to grasp.

MONDAY, 21ST JULY, 1935 Harry + I went down to Barnes Place to continue with sawing firewood. It was again hot + cloudless so I continued working in my shoes and increased my sun tan. Harry did well on his first day of sawing. I got through my nine cuts again—this is three times the success of my first day. It is extremely heavy work but does not tire as much as it did to commence with. Leslie remained at home to rest his cut hand. After supper I laid down + fell asleep. So there was no dictation today.

I wonder if we will get any news from Vancouver about the college and from Alberni about our lot on Wednesday. I do not feel settled in mind yet as I still feel responsible for money loans given to keep the college going for the last two years. I might as well note the fact now that I feel that I have been pretty much of a failure as far as being a practical success. I wonder if I can become a success with the future efforts to be made with paintings from a spiritual expression. Continual depression seems to be the state of my mind. No doubt when we know exactly what the future is to be I can plan definitely for a programme of development.

TUESDAY, 22ND JULY, 1935 Being a foggy morning Leslie, Fiona + I went fishing from the rocks. Fiona has decided to be my companion on all occasions + is full of a new admiration for me which I must not disappoint her in. We had a successful two hours + caught three rock cod, two perch a cat fish and one large (about 7 lbs) scavenger fish by Fiona. This was her first catch so she was very pleased about it. We kept it for the dogs supper.

In the afternoon Barbara, Fiona, H, L, + I took the boat out + rowed around the point to see over lot 253. It was fairly quiet water but when we got to the other beach the tide was high so it was too dangerous to land on the sharp stony shore. It would have meant a drenching for someone. In this evening we wrote letters.

WEDNESDAY, 23RD JULY, 1935 Got up at 5.30 + set out to meet the Norah from Vancouver at Nootka Pier. Called at the lighthouse + took down Mrs. Fish—senior, Bert + Mrs. Fish. I decided to remain at Friendly Cove + make a sketch of the village. It was a very hot day so working was enjoyable. I got on better this time + was able to work for two hours before the tourists from the Norah arrived to inspect the village. Before very long they spotted me so were of course curious + inquisitive; some really interested but

others thought me a unique curiosity + thought that they could go ahead, open my sketch box + examine the work. I prefer not to exhibit as a sideshow so had closed the box. One forward youth tried to grab it + open it but he was prevented by my placing my foot on the box. One finds amazing impertinance in the usually brainless specimans of humanity. I was questioned about the Indian who was 135 years old—the oldest inhabitant is about 85—she is the hunchbacked old soul who goes everywhere barefoot with a wicker basket to pick up her kindling. They also enquired about the caves so I made out there were dozens as it is not the desire of the inhabitants to inform the tourist where the burial caves of the Indians are.

H + Les returned about noon with the mail. No news from Port Alberni about the lots we inquired for but a letter from Mr. Lennie stating that no developments were made in Vancouver over the college. Nor from the possible city art centre—so it appears that we might forget our worries in that city. Mr. Lennie kindly mailed me the newspapers + is doing so for a month. Athole writes to say that they progress but that their business is not complete. Mr. Hood writes + enclosed $25 as part payment for my sketches which he has sold during the past two weeks. We all eat at the Lighthouse + departed home about 5 o'clock. All retired early.

THURSDAY, 24TH JULY, 1935 In the morning we discussed our building plans + redesigned our houses as we have now little time left to build before winter or wet weather commences. After lunch H, L, + I with Fiona set out again in the rowboat for the beach on lot 253. This time the water was quiet as it has been all summer so landing was a simple matter. Bert had arrived at our cabin just before we left to say that his mother has become ill again + was wishing to get down to Vancouver by the boat down so we arranged to take her down in the morning. Bert came over to lot 253 also. We dug a hole to find water + found some at 4'-6" which had a strong sulphurous odour. We scouted around still further + Leslie found a small stream nearly dry. This is a satisfactory discovery as it has been very dry for two weeks now + most creeks show little water or none at all. I found a trail leading away from the stream towards the old small cabin so decided to go along it + have Leslie with me. The shalaal was so thick + high that the only way to get through it was by crawling with heads about 3 inches from the earth. The trail came out about 100 yds along + near the cabin so that is a satisfactory discovery + means that we are now able to have a lot with some water. Rain water would be quite sufficient in winter but before we purchase + build with a permanent intention we want sure water in summer.

In the evening it was decided that I return to Vancouver on the morning boat + arrange a conference with

Mr. Lennie. Our opinion has unanimously been felt that I return to close up our affairs in the city. Well! it seems the only alternative + after all we should be able to exist pretty well on the Nootka Coast. There are few worries + few debts facing us unless illness overtakes anyone or some unfortunate accident. That might happen anywhere.

FRIDAY, 25TH JULY, 1935 Rose at 5.30 + dressed in city finery—blue shirt, collar, tie, + so on. Alas H clipped my first beard off. Fiona didn't wish to say goodbye to me—her only remark being "I don't like your looks" so she seems to prefer my whiskers. No doubt thinks her father is a real man + no longer a boy when is able to get fungus on his face. H + Les rowed me to the Lighthouse where we picked up Mrs. Fish + Mr. Fish. We arrived at Nootka about 10 AM, but the Norah hadn't arrived. We had to hang around the pier + the Hotel until 1 o'clock. I felt famished so had a meal on board + was lucky enough to get a cabin.

The Indians were down on the pier to sell their baskets, rugs, etc. The trippers inspected their work + my conclusion is that the Indians have all the poise, the manners and calm control. The baskets sold at 75 cts + $1, yet those tourists said they were too dear by a long way and one woman was told 75 cts, offered 60 cts + placed that money in the Indian womans hand. She counted it + remarked on the shortage so the civilized money woman remarked—"You can keep the thing give me my 60 cts." The quality of work in those baskets is sincere, good and thorough to the last degree; take about four days to do—that is only weave it + yet 75 cts is considered too expensive. I like the Indians better since I have been able to meet one or two + I feel more happy to be in their atmosphere than be in some of the atmospheres of the sophisticated whites.

Dr. Currothers of Ottawa Geological Department was in Nootka harbour + on his way south with his Geology discoveries. He was wishing to borrow two chisels from the lighthouse in order to dig out of some rocks at Esqualanti Point fossils of a prehistoric fish. He showed me in his book a sketch of his possible find he believes that the bones may be those of a Sea-Serpent.

The Princess Norah came at 1 o'clock but did not depart until 4. Had good lunch aboard + obtained cabin from Mr. Macdonald-Purser. I shared the cabin with a Norwegian logger from C.P.C. He had worked six months in the woods + felt that he would return to Vancouver for good as the life was too lonely. I told him that after three weeks he would wish to return as the situation in that city is still tense with police still patrolling the waterfront even after six weeks.

There was a masquerade dance about but only a few of the eighty passengers dressed. In spite of my whiskers being removed I was still recognised by those who spoke to me while I painted at Friendly Cove. Retired at 11.30 PM.

SATURDAY, 26TH JULY, 1935 Quiet passage. Met a Mr. Raleigh from San Frisco. He is a director of newspaper advertising Bureau with head offices in New York. We talked most of the day together on world conditions, business conditions in the States, art, + other matters. He suggested my trying Frisco but I still prefer to remain in close contact with nature. I immediately feel unhappy + thoughts about returning to city conditions affect my nervous system. I hate the thought of being instrumental over the decision to close up 'The British Columbia College of Arts.' It is an unfortunate happening for Vancouver but after two years of effort, with little or no desire to assist our efforts by wealthy citizens, we need not feel that it is our duty to continue ~~with our efforts~~ + possibly find ourselves in most undesirable financial stress. It is also unfortunate that those others who have helped us will be placed in the condition of no definite occupation. They all deserve a better fate + I hope that it will mean reopening with better financial returns than we have been able to grant.

The boat arrived at Port Alberni at 4 PM I imediately phoned Mr. Roff, the Provincial Assessor at Alberni + was fortunate enough to be given an interview at his office in Alberni. The Barnes Lot cannot be obtained as it is held by a man in Mexico + we will have to go ahead with Lot 253. The decision where we build is therefore settled so I will wire the news to Nootka from Vancouver on Monday morning as I could not get through today to Nootka by phone or wire. I booked a room in the King Edward Hotel. These hotels are comfortless places with no welcome vestibule—not good dining rooms + poorly equipped with washing + bath accommodation. I hate them + feel miserable when in them. It is always my desire to leave off staying in the hotel until I am only left with hours to sleep. I remained out at midnight—putting in part of the time at the local picture house where I saw Maurice Chevalier (for the first + last time) + Jeanette McDonald. Both are not first rankers in the art of drama even though they are most popular with the general public. I found they were mostly sex attractive with no qualities of personality in their features.

SUNDAY, 27TH JULY, 1935 Remained in bed until 11.15 AM for lack of anything better to do. I have no love for Port Alberni—a cross between a town + a village—with its dirty + undressed street designs + buildings, dusty streets, smoke from lumber mills and lack of sociability. Thankfully I departed at 2.10 PM by motor coach for Nanaimo + the Vancouver Boat. The drive is quite interesting around Cameron Lake with the large Douglas firs edging the road. The continual driving of a coach over this road must be destructive to the body in time. Departed from Nanaimo at 5.30 PM after circling around two United States Cruisers anchored near the pier. A fuss is always made of symbols of

destruction—how far removed is humanity from symbols of freedom and in their thought + the expression of joy in observing them.

Shortly before arriving in Vancouver I saw Bill Sinclair who was in the Argylls with me + who comes from Latheron-Caithness, Scotland. He promised to give me Ians. Phoned up Athole so he met me with the car. Phoned up the Farleys so they kindly promised to put me up for several days.

So ends my first trip to Nootka.

[Written at top of page: (Dull + windy)]

14TH AUGUST, 1935 Arrived back at Nootka at 7 AM. Mrs. Fish returned also—having been wired for because Mr. Fish had taken a paralitic stroke three days ago + is not expected to live very long. Bert came down to meet his mother so we had breakfast aboard + then they left for the lighthouse. It is most unfortunate about Mr. Fish as it probably means that the stay at the lighthouse by the Fish family will likely be only a year + it will make a tremendous difference to us not to have their generous help + good companionship. I waited to take off the freight—2 stoves, galvanized pipes, 6 chickens, boxes with curtains, sashs, 4 chairs, groceries etc. We loaded it all on Horals boat which brought Leslie down. There was considerable disappointment that I failed to take along the Goats, the three ply boards + wood for the cabin floors. Naturally we are in great difficulty about having our cabins ready for the winter. We cannot build the cabins we planned but will just repair the ones there are on the Maquinna lot.

Old Mr. Fish looked exceedingly poorly when I saw him. Mrs. Fish was taking the situation very bravely. But the life has gone out of the lighthouse for us, possibly for a time. Les + I rowed Mr. Jackson seemingly was also on the boat to stay for a time with Harry. He + I carried our bags along the trail together with a pack. It was very tiring work but we arrived in camp about five o'clock. Leslie went with Fred Vey in the put-put boat to O'Malleys camp.

Everyone is anxious about the buildings now and still more so that we haven't got any time for floors + ceilings.

[Written at top of page: (Dull weather)]

FRIDAY, 15TH AUGUST, 1935 Les + I rowed to Nootka to mail letters returning to the ROCK about 3.30 PM. We took some ice cream from the Norah to Mr. Fish. He appeared much brighter today so may survive about two or three months. We loaded up the boat with the stove, chickens, etc. Barb + Harry took notes in the evening but I laid down on my bed + fell asleep.

[Written next to date at beginning of entry: Rain]

SATURDAY, 17TH AUGUST, 1935 Slept until 9 AM so didn't get to bed at all in reality last night. Don't know why I was so tired. Set up the chicken run, together with the chicken house. The hens must have been very thankful to get some green food at last. Les + I went into the woods + felled trees for rafters—cedar + hemlock. Harry + Mr. Jackson rowed up the lake for clean water. Fred called with some vegetables + took away the groceries which Les + I took up for him yesterday. I feel an absolute helpless creature when it comes to working in the woods. Les proves himself as useful in the woods as anywhere else. Fiona kept coming with us. She continues to be my pal. We got two eggs today so had omelette for supper.

SUNDAY, 18TH AUGUST TO THURSDAY, 12TH SEPTEMBER, 1935 Practically a month has passed without my having time to write the diary. It has been strenuous work for Les + I falling trees—even up to five feet thick at the saw cut—and cutting shingles or rather one would say Cedar Shakes. We have now cut 1700 and still require some 500 more. We obtained three fallen trees from Fred Janel so obtained about 700 shakes from them. But the others we have taken from a tree we felled with Father Antony's assistance. He also had not fallen a tree so large. In our efforts to escape being injured Father Antony fell flat on his stomach + crawled along quite a while without feeling that he had time to turn round + see that the tree was still standing. He stayed overnight in one of the tents + brought a salmon with him when he arrived. We gather the shakes together in hundreds then put them on the row board + slip out of the lagoon on slack water or as nearly so as we can judge. One day Les + I took Freds flat bottomed boat out with shakes + were all but under water before we reached the beach where we unload. We filled up with a foot of water + it was practically impossible to steer the boat. Several times Les + I were floundering in the waves + properly soaked. We then carried up the shakes on a stretcher to the cabins which we re-roofed. We completed them today (12th Sept) after placing new beams + rafters from trees we felled near the lake. It has been very heavy work + I have felt quite exhausted after several hours of heavy lifting. Unfortunately my back still bothers me quite badly at times + occasionally I suffer cramps from muscular fatigue in my legs.

Tauber's friend Jackson stayed ten days + flooded Tauber with gifts but being misinformed I expect he offered nothing towards food supplies, so Barbara + I still have to supply all the food from the few dollars we receive. We wonder how long we can do this—some food difficulties face us in the near future unless I have time to sketch + have a sale or two. But there is no likelyhood to find time to sketch for at least a month as we have still to place floors, doors + windows, erect a henhouse, two wood sheds and toilets to make.

One day (20th August) Harry + Jackson stated that they would clear a track from the old government trail to

our cabins on the Maquinna lot but they do not do so + without informing us they went astrolling. They failed to call for Les + I at 5.30 with the boat to take us back over the lagoon + so we remained working until 7.30 + crossed the lagoon at fairly low water. They had not returned nor did they return during the night. Having no food + little clothing they would have had a cold + hungry night. At seven next morning Les + I called for Fred Janel + asked him to assist us along the government trail to see if the lost men could be found. He willingly offered his assistance + was just as kind as usual. We followed the footsteps for six miles where they finally ceased along a shingle beach + then appeared again to lead back on to a rock. We called repeatedly but obtained no reply so returned the way we came, reaching our cabin at 3 PM. Still no signs of them. Les + I got out the boat and headed for Maquinna Point (as on the map), calling into all the beaches + inlets we would risk entering. The wind rose quickly as well as did the surf + by the time we arrived at Maquinna Point I was well satisfied not to continue. It became very rough + whitecaps appeared; we were both anxious to be home again but neither of us remarked this at the time. We finally had to row with both oars on one side + none on the other, in order to keep our course with so strong a wind on our side. Finally we reached home about seven to find that Harry + Jackson had returned—very tired, slightly sheepish, and willing to eat. They had taken 12 hours to return the six miles through the forest from the rock which appeared to be where they had spent the night. Had they not returned Les + I would have had to get out the boat again + row to Nootka for help to comb the forest. Perhaps Harry will believe Les + myself when we say that the forests around here are almost impenetrable.

Barbara + I are disappointed with the decisions of Harry over the future affairs of our camp here. We have willingly placed our all on the development of a settlement here + feel that we will share everything equally. My belief is that to develop spiritually, there is the necessity for personal sacrifice, a mutual brotherly help, a losing of the egotistical desires in the development of the camp. Not so Harry. He wishes only to gain for himself, to receive all in personal freedom from work, to satisfy his desire for study no matter how the others are straining their hearts in heavy duties. He wishes to have his own goats, hens + vegetable garden, keep his tools for his own private use, his books + his boat, so we find ourselves with all our money spent on providing fares for all, the freighting of all camp equipment + are left with the knowledge that we must yet obtain all the necessary tools, boat, etc. With providing all the food we are faced with many difficulties but yet we will pull through and find the benefits of this adventure.

The world conditions continue to flow towards the distruction of the white civilization. Mussolini is determined to carry through his desire for territory in Ethiopia + various world powers are massing their fleets for manouvers +

stopping leave for their air force men. With self security we are better able to carry through any disasters which may befall the white race.

FRIDAY, 13TH SEPTEMBER, 1935 The equinoxal storm has commenced with much rain and a South East breeze. The cabin leaks on the beds, the lack of windows makes it damp + cool within. The tide seems high in the lagoon—about 12 ft 6 ins + the hen run is just off our reach of the inflowing tide. The waves are grand + the air is full of action. My back pains slightly today as I am remaining indoors. It is good to have a day of rest.

SATURDAY, 14TH SEPTEMBER, 1935 This morning the sun shone brightly + warmly at seven o'clock but we did not allow ourselves to be cheated from our belief that the equinoxal storms were just "around the corner." Les + I took our slickers, gum boots + warm sweaters as we set out on the trail from Fred Janels cabin to Nootka. This is the first time we have made this trail. It has been well kept by Fred, no overhanging branches, no mud holes + many swampy places with trees placed over them with flat tops. This trail is about five miles long I should imagine as we took about two hours to reach Nootka. The "Norah" was gone as it stayed only to unload. The chicken food failed to arrive so the clucks won't do so well for the next ten days. Bert Fish arrived with Buster so invited us to return by the lighthouse + the sea coast route. The put-put engine in the boat behaved badly + failed altogether for an hour just as we got to the last island in the Narrows. The wind was gusty + strong, it rained, and the waves were facing against us. To hold the boat in position we rowed for the hour + only moved forward about 300 yds. Eventually we reached the lighthouse so were invited to a meal. Mr. Fish, senior has gone to Vancouver with Mrs. Fish. It is amazing how he has so far recovered from his almost fatal illness.

Bert suggested that Barbara + Fiona get down to the lighthouse at once tomorrow as the glass was low + the storm seems to be on hand. They also wish them to remain over until we can finish our cabin across the lagoon. It is tremendous relief to me to know that they can be comfortable + warm until they can return to another warm place.

When I returned with the mail I at once got busy + boarded up three window spaces, put wood triangles into the spaces between the walls + roof and covered over spaces between wall beams.

Barbara + I wrote letters in the evening + decided to move to the lighthouse in the morning.

SUNDAY, 15TH SEPTEMBER, 1935 The early morning was dull + wet so we had to burn our oil lamp. We expected

"Buster" up from the lighthouse to help us with our work. "Buster" is the brother of Mrs. Fish (jnr) + has been a logger since infancy almost. At eight thirty however it commenced to rain very heavily + suddenly the gale arrived—Everything was in a whirl—trees waved like huge fans, rain swept into ones face like needles, the wind on the shore must be about 45 to 50 miles an hour, the waves are cruel + take the tangles from the birds, pound upon the shore with a steady drumming—similar to the guns in France when an attack was about to be made.

Harry + Les lowered their green tent to the ground, covering the boxes with a closely weighted collection of logs and then roped down the other tent as much as possible. After helping them for a short time I returned to our own cabin + decided to move the hen pen as the tide would be 12.6 in the Lagoon + with wind + tide + heavy rain I expected the hen pen would probably be in the water. This proved to be true + it was fortunate that I had arrived at the conclusion I did.

It was much too stormy + windy to go to the lighthouse + to go through the forest would be even more dangerous than to row across from Friendly Cove the 50 yards to the lighthouse. At noon we went to see the sea—all of us—a marvellous sight but hard to believe that nature could so fiercely change its countenance. We have gone from Summer to Winter overnight it seems. Barbara + Fiona were drenched in the few minutes it took to go to the beach.

In the afternoon Harry, Les + Barb took notes on the Biological Dynamic Economy of Gardens. I however decided this house was too cold + drafty, so nailed in the five window panes which we had got from the counterfeiters cabin two months ago. With the other windows boarded up + a nail bent over to keep the door shut, the cabin took on a feeling of a good warm home. The drips from the ceiling fell into tins placed on the floor, the beds, boxes etc., so sweet music came from our old jam tins at last. We had no necessity to go for water today—it all came off the roof—beautifully clear water—it looks so lovely after all the brown cedar seepage we've had to drink + use for the past month. Tonight it rains continually but the wind does not seem so wild—it possibly has changed direction. The rain or sea spray which it might be, as it tastes quite salty, appears to be driven in horizontal lines before + to the wind—not falling from the skies but passing over the land in driven sheets before the wind. Strangely the sun shone at eleven in the morning for ten seconds, with rain falling in torrents. The storm appears to have height.

Tonight we talk of T. E. Lawrence of "Revolt in the Desert." His descriptions of the vivid sunlight seems to be more gloriously depicted when we are surrounded with natures lowest or nearly lowest cloud in British Columbia.

Our letters cannot be taken to Nootka tomorrow—no boat of below 20 feet could breast the waves + to walk through the forest would be playing with death from fallen timber + branches. Some letters are urgent but we now see how isolated + neglectful we may appear to those in cities who cannot hear from us for about three weeks.

MONDAY, 16TH SEPTEMBER, 1935 Strange as it seemed, the storm had completely gone + the sea has considerably quietened so there [w]as quite a rush by Barbara + Harry to dash off letters as I decided that I could take them down to the rock by 10 o'clock. I got there slightly after ten—just as Buster had disappeared around the point for Nootka in the put-put boat. Bert Fish was just coming across on his canoe on his way to our camp to find out how we had weathered the storm but returned to the Rock with me + phoned to Nootka for Buster to return for our mail. A very great kindness for us. I remained for lunch after which Bert came over to our cabin, taking "Wolf" his police dog, gun + ammunition. He hastily shot a gull + I felt upset with him as there was no reason for it. Why humans find enjoyment out of blazing shots at birds which are doing no harm, are inedible + have no other useful value is beyond understanding—they must still retain the child desire to destroy + their minds must have remained in the stage of reasoning. Bert remained for supper + arranged with Barbara that they move to the lighthouse tomorrow so that they will be warm + dry while we move into our cabin across the lagoon.

TUESDAY, 17TH SEPTEMBER, 1935 Buster came up to help us. He felled a tree with Les for more shakes while I cleared out the bush around the new cabin. I used the Bust knife which Harry got from Jackson—a truly useful + handy tool. After lunch Barb, Fo, + I moved off down to the Rock. We decide not to row but walk the trail. I carried the dunnage bag + a black suit case—altogether a heavy load. Barb tried to carry her black suit case but it appeared too heavy for her—she was willing to labour along with it, but I wouldn't wish to see her become a pack horse like the rest of us. When we got to the Rock it became foggy + chilly. We had a nice supper of "Honeymoon Food" (spuds + onions fried) + some gooseberry pie. I thought of returning to camp but they thought it too foggy + I could just squeeze down with B + Fo. We enjoyed the radio "Madam Butterfly" + Listz, retiring to bed at 10.30. I didn't sleep too well—just seemed to have two inches to lie upon + practically decided in the middle of the night to sleep on the floor. In the morning I discovered there was plenty of space but B had reserved or been reserving half of the bed for Fo. She dearly loves her little daughter.

WEDNESDAY, 18TH SEPTEMBER, 1935 I returned to Maquinna Point with Buster, 'Wolf' the dog + the gun at

ten AM. Buster found nothing to shoot + when up here I asked him to keep off our pet Heron (blue). He + I went together to make shakes from the log they felled yesterday. Buster did the sawing + I cut 150 shakes today. The wood was most disappointing. Harry remained in camp + cooked the meals. He did very well, providing soup + beans for lunch, turnip, eggs + salad for supper. The tea was like dishwater so I hinted that it could be stronger. We are now without jam so the shortage of cash is beginning to tell. Before long we will be short of many more things. If it wasn't for Fred Janel providing us with his vegetables + the Fish family with Bread we would be feeling rather flat now. Well, it is part of this adventure, but as soon as the cabins are up I will certainly get busy with my brushes, etc. I miss Barbara + Fiona in my cabin very greatly—it seems a dully dead place without them. We have all retired to bed + it is yet 8.30 PM.

THURSDAY, SEPTEMBER 19TH TO SEPTEMBER 28TH, 1935
We have had a few days of very hard and heavy work but the weather has been simply ideal—bright warm sunshine with cloudless skies, calm seas, and occasionally phosphorous water. Each day we have been moving our things over the lagoon to our winter cabins, and in between the high tides Les + I put the gable ends on to our cabin, placed in the five window panes, put the door of our old cabin in, took the roof and floor off the same cabin, making the floor from the roof and wood shelves from the floor boards, and also the roof supports for the canvas. Barbara + Fiona returned from the lighthouse on boat day—the 24th + lived for three days in a tent, while I remained for a week in a tent on the old site, with the hens and dogs. Our little cockerel died of dyhoma on the 25th—I didn't know what to do to cure it as I have not yet received the poultry book.

One day while we were moving our things Leslie saw a wounded salmon in the lagoon—it had been badly hurt by an eagle so we got the gaff + I caught the fish. On two other days a Japanese fish boat cast its net at the mouth of the lagoon so took the boat out and came back with two salmon + a flounder. Barbara made fish patties also kedgerie—both were very excellent + made a great variety.

SUNDAY, 29TH SEPTEMBER, 1935 We moved into our new cabin + are now enjoying being all together again. It is a very comforting feeling to [part of page cut out] have come to the day when we can settle in our definite place + plan our winter work. The thousands of pounds of heavy carrying is now almost over—we must have moved thirty or forty tons of material during the past five weeks. There has still to be some six or seven hundred shakes for hen house, woodsheds, toilets etc, and still we have all our winter wood to cut, but that seems nothing compared to the labours we have

now accomplished. Fred Janel continues to supply us with vegetables + helps us with anything that might be done when he comes to see us.

Harry is mumpy and does little to help anyone. It makes it very unsatisfactory to find him just doing everything only for himself—having restful days + failing even to help with dishwashing etc. We had had a bitter lesson after all the expressing of financial help etc, we have given to him. Leslie labours for him like a slave + treats him as he would someone he was [part of page cut out] He is being taken the loan of by Harry, but so far he does not see this. He is so good natured a lad that he will be slow to see the situation.

MONDAY, 30TH SEPTEMBER, 1935 Dull + foggy day today but still no rain. Leslie + I put on the canvas ceiling—it was a heavy, awkward + precarious job. In the afternoon I hung the curtain dividing the bedroom from the living room, + stored together some wood for the winter. We did not continue the hen house which we commenced to build yesterday as we require shakes for it. Les made kitchen shelves, etc. Our bedroom is wide + roomy + the whole place is much warmer with the ceiling in. I remade part of the old chicken pen, adding a perch, sand, new nesting boxes etc. The hens do not lay as they are molting and look pathetic birds. Their feed has not yet come from the elevators in Vancouver yet. I am now looking forward to making our home an interesting + comfortable abode. We can be quite happy here with just a little money to provide the necessary staple foods. Meantime we possess about $2 between the four of us—our total wealth.

TUESDAY, 1ST OCTOBER TO 31ST DECEMBER, 1935 We have gone through many hard experiences since I mentioned above that we had $2's left to provide food for the winter. Gradually our table exhibited less and less—for six weeks we were without butter, jam, fish, sugar, flour, and then for a time we had no tea, coffee, milk, oats. The good kind people at the lighthouse helped me out with some provisions, even though we could not pay for them. I took as little as possible, but by the beginning of December we owed them twenty dollars. We fortunately supplied ourselves well with writing paper + envelopes, so we were able to write our friends, but the day came when we could not buy the stamps, the batteries for our flashlights were done, our candles were finished (again the lighthouse supplied us coal oil), we lay awake at nights because of hunger, we could not fish as the seas were too rough, we tried gill netting salmon in the river, but we did have some luck with a net up the river at a hole where the good Fred Janel pointed out—+ we got some beautiful trout, some dying salmon (coho) which we smoked in our smoke house, + that relieved part of the

strain. Les + I tried netting the river for Perch but had no luck. Then out of the clear blue sky came a box of tinned salmon from the Bell-Irvings of Vancouver. They little knew how much we needed that. We had lived on a little rice and macaroni for weeks. We had fortunately reserved some milk, butter, honey, tinned peas, soup and beans for Fiona in the summer supplies, so she did not have any want. Barbara got word from her sister—living in Hong Kong—that she had asked a Victoria lady to send up 25 dollars worth of provisions to us for Xmas, Pamela had sent her a bank draft for the purchases. In this parcel there was to be—Sherry + Gin, cakes + candy, etc; but we wrote to Victoria + asked them to change the order to flour, rice, sugar, oats, malted milk, tea, milk + other plain foods + to send them immediately. At this point some things happened which have altogether altered the colony aspect—the future of the group.

I painted and sketched as much as I could during this time, in the hope that I might sell a sketch + have some funds again. I sent down to Harry Hood of The Art Emporium—Vancouver the following oil sketches—

"The Indian Whiteman"
"Stormy Sky"
"The lagoon mouth"
"Nootka Sound, B.C."
"Tum–Tum's House"
"The Hermit's Cabin"
"The Evening Glow"
"Graveyard of the Pacific"
"The Ocean Whirls"

I also painted a 26" x 32" canvas titled "Friendly Cove, Nootka, BC." which I forwarded along with my "Formative Colour Activity" canvas to be framed + sent to "The Canadian Group of Painters" 1st Exhibition in Toronto.

At the end of November Leslie obtains work at the Nootka Cannery as there was herring fishing + he also gets work loading the Maquinna. We have been desperately short of food + hope this will help. Harry goes down + takes home about three dollars worth of food, which lasts about five days + then he returns to Nootka + does not come back. We find he is living comfortably in the Nootka hotel. He returns in ten days but still does not inform us of his true intentions—returns next day with me to Nootka + remains there. There appeared to be no wish to help my family over their difficulties + my back had hurt me for some weeks so that my being able to saw wood for the fires appeared questionable. There is no wish to be with us at Xmas so we accept an invitation to have Xmas dinner at the lighthouse. Fortunately for us the provisions from Victoria arrive. I sell "Tum–Tum" sketch, my "6000 ft up" Garibaldi canvas, receive an invitation for the family to stay with Mr. Clegg—Vancouver, after the New Year and received $100 cheque for the expenses of the trip, and in the middle of December I unexpectedly sell my "Friendly Cove" canvas for

$350 to Mrs. Clegg. I also receive my congratulatory letter upon my works. Xmas day was wild + stormy but we got to the lighthouse safely + had to remain there for two days because of the storm. Father Anthony is also there. The two canoes are smashed. We receive two post bags of presents + have some thirty letters to write in acknowledgement. We certainly have been remembered by many kind friends in Vancouver + we then had a happy time. Fiona had her Xmas toll also. The weather has been dreadfully wet for a month. I saw wood daily + my back has been painful, but the linament has helped to cure it.

It was Les + Buster who took our provisions over in Father Anthonys new boat. In landing on our beach they have capsized, but arrived ashore safely. After Xmas Father Anthony helped us with our parcels + remained overnight. He is a true sport.

One day (24th December) I had to go to Nootka for the Xmas mail. I had left the boat across the lagoon the night before as the lagoon had been closed by sand for a week. In the morning the lagoon was open so I had to walk the trail to Fred's cabin. The lake was very flooded + the trail was over two feet deep in water. The bridge or log crossing the river was two feet under water so I had to cross or return home. It was a dangerous crossing, with nothing to hold, running water + heavy pack. Fred's garden was flooded + the trail was like a river. I got to Nootka just in time to get Father Anthony's boat back to Friendly Cove.

1ST JANUARY, 1936 Barbara + I sat round the heating drum + heard the Nootka lighthouse blow in the New Year.

A quiet celebration for the year which I believe holds great interest. So different from the bustle + excitement in Vancouver. Fred Janel first footed us at 11 AM + brought some candy, tea + potatoes. He is a dear man + so fearfully generous + yet has so little. He remained for lunch.

I continue to saw wood + my greatest joy in life is to see the end of wood fall from the tree. My back is slowly improving.

4TH JANUARY, 1936 The 10th anniversary of my wedding—a happy day. Was awoke in the morning with a strange noise of pounding waves + long slow rolling of stones. It is sunny, with no clouds or wind. We hurry down the beach to see what is taking place. The sea is tremendous—waves twenty feet high + thundering up the beach about seventy yards. Wood + logs which had remained high on the beach for twenty years are washed out to sea + other logs are washed into the bush. Our drying green is now covered with logs—some 60 ft long—about six feet deep. The sea comes to the south walls of the small cabin—a few feet more + the cabin would have been smashed to kindling. I have seen seas on the Pentland Firth

in the north of Scotland but never have I seen anything like this. The horizon is a mass of foam + high rolling waves. To sketch this I would have been told I was untruthful. It was of such tremendous power.

In the evening after I had towed logs up to Fred's cabin with Fred I came home to find that Harry had returned. He returned to say that he was going to take the boat.

I told him that I could not let him do this as it would leave us marooned across the lagoon. It would be inhuman to strand us like this. I told him to wait until we were gone to Vancouver on the 16th. He also said that he was going to move his things, but was going to continue to keep the cabin. We informed him that if he moved he must leave the cabin to us so that we could get someone to help me + be with us in this out of the way part. We provided meals for him + told him that we felt his leaving us like this to be an utterly selfish attitude.

6TH JANUARY, 1936 Harry + Leslie appear at 10 am to settle the boat question. Leslie sees that it is impossible to leave us without it, states that they are going to stay in Nootka hotel for $5 a month but are looking for a shack at Nootka. Leslie needs to work we know, but it appears that as soon as they can provide for themselves a little, it matters not whether we are able to carry on. The 20 dollars we owe at the lighthouse I inform Leslie will be attended to by us + we give them a final meal in our own cabin. The companionship is broken—not by us. Some people appear only to be your friends when they are in need. I prefer the Fred Janel type, who is your friend + helper + gives when he himself is in need.

Intellectuality + great knowledge does not go hand in hand with brotherhood and kindness all the time—for Tauber to be so sincerely interested + deeply read in Spiritual things and yet to be so utterly selfish and self centered is to me not consistent with a true Spiritual being—I cannot see it. My wife has received a great disappointment and certainly not what she deserves, having prepared those meals for everyone for the past six or seven months. In return she asked for study from Tauber—she is thrown roughly aside in her wish + her sacrifice of time and strength goes for naught.

1936 has awakened in a new life + the isolation for ourselves will strengthen more our courage + determination to gain that which we seek.

19TH JANUARY, 1936 While sailing with Barbara + Fiona to Vancouver I received a cable today informing me that my Father died.

This is a decided shock as I have received no previous news of any illness. My Father was blessed with excellent health, the end has come so suddenly at 70 years. His death will be a great blow to mother. We were sailing past Long Beach when the cable came through.

20TH JANUARY, 1936 We were met by Mrs. Clegg at Vancouver + given one of her modern bedrooms—yellow walls, with low toned blue—Beautifully sunny in effect + simply furnished, low beds, wall lights inset—alcove mirrors, etc. Fiona got a nice little bedroom to herself. I removed my beard.

20TH JANUARY TO 1ST MARCH, 1936 Had a luxurious holiday with Mrs. Clegg—cocktail parties, luncheons, dinners, pictures, theatres, picnics, + parties. One day we drove to Mission to see the Fraser River frozen over—Sunday, February—picniced in the snow. Saw the Drama Festival Finals where "Waiting for Lefty" won the Provincial competition. Had an enjoyable evening at Mrs. Cleggs Girl Guide Cabaret for which I designed posters. Had evenings with Duncan + Eva, Lucy + Douglas, Mr. + Mrs. Innes, Mr. + Mrs. Hook, Dr. + Mrs. Dolman, Mr. + Mrs. Varty, Mr. + Mrs. Hunter + Athole Greys.

4TH MARCH, 1936 Returned to Nootka with John Varley as companion and we are glad to have him. He has been unemployed so long + unable to find peace to write so probably he will have the freedom he needs, the healthy breezes and variety of adventures. We arrived with new equipment, boat, saws, pails, + other tools which Tauber has now given us as a share for their expenses, freight, and meals for six months. B + Fiona remained at the hotel so John + I moved out to the cabins to air them + dry out beds etc. Bert as usual took us to Friendly Cove. It is odd to be back to the "back woods" life after those weeks of plenty, comfort, entertainment, and money expenses. It was a marvellous holiday + I feel much better after treatments to my spine by Dr. Athkinson—osteopath.

MARCH + APRIL, 1936 Storms appear to be over + the cold has departed. By April I enjoyed several sun baths. John took over the post of assistant lighthouse keeper with Bert as Buster returned to the logging. Bert is not to remain in charge of the lighthouse—very unfortunate + somewhat cruel as he has assisted his Father for seven years + is quite capable for the post. The position must be given to a great-war veteran—Bert was too young for war. John helps 4 nights + 3 days at the lighthouse.

On the 24th of April we went with Bert to Nootka in his put-put. When sailing home a gale suddenly came up just as we had passed the Narrows. We fought the

Nootka Lighthouse, Nootka, B.C., 1936
watercolour on paper
25 x 25.5 cm
Collection of the Vancouver Art Gallery, Acquisition
Fund with the financial support of the Department
of Canadian Heritage under the terms of the Cultural
Property Export and Import Act

waves for an hour + a half to gain 400 yards to Friendly Cove, but with oars + engine we only made two hundred yards. Finally waves came over + killed the engine so we were forced to turn back. Waves looked as if we would be swallowed + Bert ordered us to remove our gum boots + have our coats etc, ready to throw off as we expected to be swamped. Our luck held out + after a short stay at Nootka we were taken on a fishing boat to Friendly Cove. Even it was awash from Dawleys Cove to Friendly Cove. Bert had a sheep aboard his boat so I had thought it would be great to life-bouy + would help me towards the rock. None of us felt at all nervous + were quite calmly ready for the worst.

Next day Berts dog killed his sheep so Bert killed or shot his dog, and had to destroy three puppies which our Fuzzy gave birth to. The puppies were Boston Bulls, five sons + a daughter for "Peters" from the lighthouse. I sent several sketches to Hoods + got one sale since returning. I also painted a canvas of "Table Mountain."

MAY 1936 Our hens at last commenced to lay eggs on the 2nd. Great rejoicing by all of us. At last! at last! They laid a hundred eggs this month. John + I did watercolours + I painted "Nootka Lighthouse" canvas which I think has quality.

We received permission from Mr. Smith to make a garden beside the old apple tree across the lagoon. Everyone is busy—Barbara, Fiona, Bert, John + Father Antony— digging + planting. The garden is about one sixth of an acre. In five days leaves were showing so we think that some good vegetables will soon be on our table. Fred came along frequently with trout + rhubarb. He is always kind + generous to a degree. John + I took over the row boat to Friendly Cove quite often but never were about to return as it always became too windy. On my birthday—31st of May—my back went out of position again while digging. We were out of tobacco this day too so John gave me a present of his largest cigarette end which he had saved. So this is our plight—birthday presents are marvellous even when it is only a cigarette butt.

Mr. Fish (lighthouse keeper) died at Point Aktkinson on the 28th. He was a fine kindly man, with keen sense of humour, great love for life, and affectionate to his family.

1ST JUNE TO 15TH JUNE, 1936 While bending down to put a puppy in a box my back went badly out of position. It gave me great pain + being alone in the cabin I had to crawl to bed. I couldn't move from my hands + knees, either up nor down. For three days I was unable to do anything for myself—felt very ill, weak + in much pain. John gave me a massage + I gradually recovered after ten days. This weakness is very unfortunate as it means that I am unable to stand this heavy physical work necessary for this rugged country. I am much worried about what to do—return to Vancouver + try to find a teaching position, try private teaching, or what? Our position is worse than ever. I have only sold a $30 sketch since February, we have no money, no means of leaving here, no sign of money in the near future + now my back makes it very necessary that I take my family where they will not be faced with a total invalid on their hands. We can only hope but we are not downhearted yet. John worked getting wood + water, Barbara worked hard to prepare good meals + to get variety out of potatoes, rice, eggs + macaroni.

John was badly bitten by a dog at the Indian Reserve—leg bleeding badly + trouser leg torn.

Two hens—"Belina" + "No. 5" are sitting. One on two glass eggs + the other on bought eggs. As we have no cock bird we can only hope that the hens will be blessed with a chicken or two.

"Fuzzy" neglects her three puppies—Dot, Dash + Skipper so "Gutty" takes them over + will not permit the mother to interfere. She even tries her best to feed them, but the little things can now lap + at last sleep in the woodshed.

On the 14th I receive word from The National Gallery that I have two canvases—"Black Tusk" + "Friendly Cove" accepted for the Canadian travelling Exhibition to

South Africa, New Zealand + Australia. This is a great joy to me—it even seems finer to be representing Canada in other parts of the world than to be represented in the Royal Canadian Academy for six years + represented with a canvas in the Canadian National Gallery. Only 75 oils + 50 watercolours were to be chosen, so I feel honoured to have been so successful, encouraged to further my output of canvases. My wish would be to travel over the country—especially B.C. and paint continually for the remainder of my days, but alas it seems only possible to obtain a teaching post + paint intermittantly. Such is the life for artists in Canada.

The 16th is a day of rain and gales—no June day. We did not think it possible to get such a day in June—even on the west coast.

Mrs. Fish (senior) arrives back in Nootka.

1ST JULY, 1936 Mrs. Fish (senior) visited our cabins + stayed overnight.

4TH JULY, 1936 In the afternoon Mrs. Fish (snr) Bert + his wife, John + I rowed away from the lighthouse steps to cast the ashes of the late Mr. Fish upon the open sea. Mrs. Fish asked me to cast the ashes. It made a strange impression to be standing in the bow of the boat, slowing letting those white powdered bones sprinkle below the waves while Mrs. Fish offered up a prayer—bravely controlling her emotions. Strange it seemed to me to be doing this service a little more than a year after our arrival at Nootka.

5TH JULY, 1936 Mrs. Fish + Mrs. Bert Fish sailed—the former to England the latter to West Vancouver to receive a new baby. John was called to the Nootka Cannery to serve for the pilchard fishing.

18TH JULY TO 14TH ~~AUGUST~~ SEPTEMBER Barbara, Fiona + I move to the lighthouse to keep Bert company + for me to be assistant lighthouse keeper. We had an ideal time, bathing at Friendly Cove, in the Indian Lake, viewing the Indian Burial Ground in Dawleys Cove, the old cave where the white prisoners were held by the Indians in 1786, attending a Potlatch + dance ceremony given to the Federal minister of fisheries, drawing many days in pen + ink. Barbara did a pastel portrait of Bert, Bert draws in pencil, Fiona also. The fog horn blew often + several nights I did duty until four or five in the morning. It took me some days to be able to start the engines but eventually I could be relied on + while alone on the 24th I started + finished an hour + a half run while Bert was up at Nootka. Mrs. Fish arrived on the 4th of ~~August~~ September with her new daughter—born on 4th of August. Friendly Cove

is gloriously beautiful in the early morning + the Sound of Nootka in the moonlight.

6TH SEPTEMBER, 1936 John returns from Nootka as the pilchard fishing is a failure + local men have been laid off. He is disappointed to have not served long enough to make the full winter stake. We return to find our garden all eaten by the Indian cows, plants growing thro' the floors, mice nests in the boxes, and very little water.

7TH SEPTEMBER, 1936 John + I go fishing + catch a good ling cod.

9TH SEPTEMBER, 1936 Nev Shanks who has wandered up here from Christies school where he resigned from his teaching job because of a miserable salary of $45 a month which meant work from 6 AM to 9 PM every day came over with Gladys Inoiah (who came with Mrs. Fish from Vancouver) to see us. I boarded in the bedroom window in the morning. For supper we only had rice so I gave myself half an hour to catch a fish for supper. John came with me + we were fortunate to get a bass. This is good eating but rather solid + heavy. Nev is a musician, has taken the lighthouse assistant job + walked home with a "barg" to light their way.

Many times during the summer I have hoped to obtain an appointment in Vancouver but without avail, so we are settling down for the winter again with only a few dollars to keep us. I have sold no sketches for six months so we are close to starvation. If Bert was not there to help us with flour, sugar, rice, coal oil + milk we would be in a pitiably state no doubt. His kindness is from his heart. Harry Hood of Vancouver also gives us his help in a dollar each boat day sent in his welcome letters. I am at last living for the day + hold no worry for the future. Something will turn up to see us through.

* Emily Carr—Victoria—the noted painter has died. Strangely enough I woke up two mornings before boat day + told Barbara + Bert that I felt she had died. I had no knowledge of her even being ill—her illness was only known in Victoria for a week. This is my third premonition of this kind—all correct. How to account for this telepathy is beyond ~~human~~ science.

10TH SEPTEMBER, 1936 Boarded up the window beside my bed as the shake covering isn't sufficient—this is a decided improvement to the warmth of the bedroom. John + I rowed over for the hens + final 100 lbs of flour from the lighthouse. The sea was sloppy as a west wind was blowing. Caught a ling off the lighthouse rocks.

11TH SEPTEMBER, 1936 Fred Janel arrived in the morning with a bag of vegetables—turnip, cabbage, lettuce, carrots + potatoes. Spent the day caulking up the cabin walls with sacking—all day to plug 1/8th of the wall area as there are many gaping holes between the wall boards. The cabin should hold this winter but certainly not for many more. The evenings are decidedly chilly now. Last night we got ½ barrel of fresh drinking water as it rained heavily. John had to go out in his pyjamas at 3.30 AM to put up the shutters on his window. A south west wind introduced him to a mild idea of what her winter winds mean.

12TH TO 13TH SEPTEMBER, 1936 Caulking up the cabin both days. About five o'clock in the evening an Indian fishing boat came to the lagoon mouth + cast their net. It takes ten minutes to cast a net but an hour + a quarter to haul it in again in spite of a winch turning a large roller at the side of the ship on which the net is allowed to roll over. As the net comes in ripples appear near the corks which float the circle of net. Dogfish are circling around the edges, nosing their way up + down the net. Gradually the dogfish seem to congregate just at the point where the net is hauled + slowly one by one these are dragged up. The haul appears to be nothing but dogfish but wait— only a small section of the net is still out—the canoe is brought round to side of the ship + the cork floats are hauled into the canoe + tied to the seats. Slowly the net is raised aboard the ship + the fish brought to the surface. There is immediately a great splashing—the water is fish tails + foam. What is so full of fight—not the 40 dog fish but the 64 coho salmon. The canoeist is enjoying a cold showerbath but is busy gaffing the fish. The gaff is a pole about six feet long with a smooth unbarbed hooked clipped to the end. It is dug into the fish—dog fish go flying over the left shoulder into the sea again, coho go proudly shooting onto the ships deck. John + I were spectators in our row boat. We bought a 15 lb salmon for 25 cts, got a small rock cod + flounder. The flounder has a strong tangy odour—quite unpleasant to me.

In the afternoon I shot a grouse so it was already cooked when we came home with the salmon.

14TH SEPTEMBER, 1936 John has run a nail into his foot on the 12th so we rowed down to the lighthouse + went with Bert in his put-put to Nootka. On the way back we were lazily resting in the boat going home when I steered onto a ~~boat~~ rock. UP we went, then slithered + plunked on a level keel again—a most peculiar crunching sound surprised us all. I hear from Vancouver that I have sold the Herring Roe sketch to Dr. Sedgewick + the Maquinna Point Sketch. It has been a long long wait from Feb. since I sold a sketch.

15TH SEPTEMBER, 1936 Caulking up the cabin + a row to the lighthouse in the evening with John—he had to take a letter down. It was a marvellously smooth sea, a dull blue-gray evening.

16TH SEPTEMBER, 1936 The day that the British Isrealites predict from the signs on the Great Pyramid that man will do something to commence a new conflagration—but of world scale. This will probably develop out of the Spanish Revolution. Spent the day caulking the cabin but I am now finished + hope we will be warmer this winter.

17TH SEPTEMBER, 1936 A dull dreary day—everything still and dank I feel dismal, depressed and lackadaisical too.

18TH SEPTEMBER, 1936 John + I sawed 4 ½ ends of wood ~~but~~ + hoped to do eight but Father Anthony + Nev Shanks visit us. Father Anthony still wears his pith helmet + Nev's whiskers are now bristles. They stay for supper + return about 7.30 with a bug. They tell us that France sent a 24 hours ultimatum for 150,000 dollars indemnity to the Spanish rebels because of the death of a Frenchman on the 16th of September. Does this one death mean the reason for commenceing a world conflict?

22ND SEPTEMBER, 1936 Fred Janel came over with some vegetables. As he passed our first lagoon cabin he was doubtful of an attack from a bear so was forced to fire at it with his fowling gun. The animal rose up + pawed the air, rolled backwards into the woods. John, Fred + I went to look for it but it had disappeared.

24TH SEPTEMBER, 1936 Received two parcels of clothes from home—clothes which belonged to my Father, George Irving—the policeman invited me to his room in the hotel to have some "Lions Milk"—a drink made from eggs, lemons, milk, honey sugar + rum. Quite nice + very rich. I hear that Tauber is going back to Vancouver on the 26th. Also hear that Varley is made President of a new Art School in Ottawa. So only the incompitant appear to flourish. I wonder when we will ever get a fair deal. Bert receives his notice to leave the lighthouse in the middle of November. The European news has not startling developments + the 16th Sept seems to have been just an ordinary anxious day.

26TH SEPTEMBER, 1936 Made a sketch of Old Steves Shack.

27TH SEPTEMBER, 1936 Went fishing with J + Fo + caught a dog fish only. Saw the sun set over the sea, marvellously calm.

29TH SEPTEMBER, 1936 John + I went to the counterfieters cabin with Fred. We caught 1 trout, six salmon–trout + 1 salmon with methods we used last year. Another beautiful day of sunshine—the 3rd.

2ND OCTOBER, 1936 High tides + still no gale—but wet.

3RD OCTOBER, 1936 John decides to go back to Vancouver on the 6th. I decide that we cannot remain all winter here alone—no money, no help, a weak back, + feeling of "we might as well starve beside friends." Things are pretty difficult.

4TH OCTOBER, 1936 Barbara's birthday + boat day. Bought B some Sauerkraut + John got her some candy. I mailed a letter to Vancouver asking for financial assistance to enable us to return. John is promised work at the cannery soon so decides not to go away. Mr. Horne returns from Vancouver. Father Anthony + Nev Shanks off to Port Alice. We hiked to the lighthouse. Good weather.

5TH OCTOBER, 1936 Sunny again + warm. In the evening I discover at last a new expression for painting—made four pencil notes for sketches + feel quite excited.

6TH OCTOBER, 1936 Paint the first subject—out on the beach in the sunshine. Barbara + John quite thrilled also as they feel I have got an expression all my own. The subject was—"Waves on a Stony Beach." Only the abstract forms are used but they are intermixed in a bold mass. Purest colours are used + give a brilliant value. John is signalled to the lighthouse in the late afternoon. I go with him to the cove + help to carry his grip. It is a job at the cannery as the herring has arrived.

7TH OCTOBER, 1936 I cut wood + draw up the second new sketch. Still sunny.

8TH OCTOBER, 1936 Barbara, Fiona + I go to the lighthouse to pay a visit in the afternoon. Gloriously sunny. Horal + Gladys Imlah still there. Bert is quiet + appears unhappy. I took B, Fo + Gladys over to the cove in the canoe + thought I'd never make it as I found it awful to keep my balance on the tip end of the canoe. I will never take a load like that again unless we all sit in the bottom of the canoe.

9TH OCTOBER, 1936 B, Fo + I bathed in the lagoon once more—cold but invigorating. A fine warm sun. In the afternoon I paint the new "Moonlight over water" study. It also comes out interestingly.

10TH OCTOBER, 1936 I drew out the 3rd study—"Hiking over the sand." In the afternoon I simply had to go fishing for cod as we have no variety of food—endless rice + macaroni. The sea was fairly rough but after 2 ½ hrs I caught a nice ling-cod. I lost a fine large one however, but we are thankful to get some fish.

11TH OCTOBER, 1936 Spent the day adding to the wood supply + writing letters. Rain.

12TH OCTOBER, 1936 Coloured the 3rd sketch study + feel enthusiastic over it. The new work has merits + should lead to something interesting in the future. Barbara is still keen over it. Very dull but dry. Plenty of rain water to drink now so the fight against cedar poisoning isn't so difficult.

14TH OCTOBER, 1936 Met Bert at Friendly Cove so we rowed to Nootka taking Mrs. Fish, Gladys, Mr. Horal (Pop) + the two children. Quite a squad. Bert got the new engine for the boat but I have not heard yet from Vancouver whether we can obtain money for travelling. The Art Gallery—Vancouver—informs me that my canvas "Heavy Weather on the West Coast" got Honorable mention in the B.C. Artists Exhibition. Max Maynard is given the medal. I visited John but found him not too well. He appears to show decided symptoms of fish poisoning or cedar poisoning or both. His hands fester if cut + there are peculiar large red patches on his legs. Rather worrying. We returned to the lighthouse by 3.15 PM + had a quiet sea. I packed home by 5.30.

15TH OCTOBER, 1936 Painted my fourth new type of sketch—"Wind in the Trees"—it also seems interesting. Fine + sunny.

16TH OCTOBER, 1936 Fine + sunny + warm. Sketched out the 5th painting—"Night"—showing moonlight, stars, milky way + the sun almost hidden behind the world. Gutty returned after 2 days absence.

17TH OCTOBER, 1936 Rowed up to Fred for cabbage. He was not home. It was sunny + decidedly hot. In the afternoon I painted the 5th study—it looks interesting + successful. Reading "Faust" again. Barbara finished her henna sweater after redoing the sleeves. Fiona finds her arithmetic difficult—subtracting a number of cents from $1. Spending the cents would be much easier.

18TH OCTOBER, 1936 Went out fishing with Fiona but was unsuccessful. Fred Janel had left some vegetables on the opposite shore of our lagoon—very kind as usual. Perfect weather.

24TH OCTOBER, 1936 Have completed three more experimental sketches. They are memories of dreams. Still dry sunny weather. Went to Nootka with the Fish family but had to row as the propeller shaft slipped + the engine couldn't use its power.

Still no word of any money <u>BUT</u> I am asked to accept a position in "The Canadian Institute of Associated Arts"—the new art school in Vancouver, by Mr. Rex Mills, B.A. the director. Here is hope at long last and the decided pleasure of having something to return to. It will be an uphill fight once again but I feel that I am used to that. It will cause no end of bitterness with the Vancouver School of Art + The Faulkner-Smith school to think that I should throw in my lot with Mr. Mills. But they should go their ways + not worry about me. I feel that I have work to do in Vancouver + I intend sailing right in. My very excellent friend Mr. Harry Hood is instrumental in proposing me + he has done me a great kindness.

Saw John Varley at Nootka also—he is somewhat better of his fish poisoning. Leslie Planta burst a blood vessel in his nose + was rushed to Vancouver for medical treatment. He has now returned + is better. His return is proof that the illustrious Harry isn't doing financially very much in Vancouver.

26TH OCTOBER, 1936 Returned to Nootka with my letter accepting the position in the new Art School. I tried for an hour to launch the row boat this morning but could not get away. The sea was smooth but the waves were large + breaking in a folding way + sweeping up the sand. I was pitched on rocks, swept ashore again every time I got twenty feet away. Father Anthony returns from the North. Still ideal days.

27TH OCTOBER, 1936 Packing at last. Put the books in milk boxes + Barbara commenced packing the trunks. I will be both glad + sorry to go. Still dry.

28TH OCTOBER, 1936 Went up the lagoon for the row boat this morning so that I could have it on our beach. Coming out of the lagoon was a fight between my rowing strength + that of the inrushing water as the tide was nearly high (water). I eventually won but not before a wave threw the boat into the air + I came down spread-eagled in the bow. Both oars jumped out of the oarlocks but fortunately I retained hold of them. In the afternoon when the tide was out I loaded the boat to take to the lighthouse. Bert is taking some of our freight to Point Atkinson on the "Estevan" when he goes south. Getting off the beach was difficult but again I had trouble as an oarlock slipped out + broke the line holding it. I lost it over the side so had to get out to find it. When I got back a large wave came over the bow + drenched me—filling the boat with two or three inches of water. I struggled to get away + finally succeeded. The sea was smooth as I took the inside passage at the lighthouse rocks, but it was a mistake as three huge waves rose up over "the growler" + I was almost sucked in against the rocks. I had to row out immediately towards the growler—where I was again nearly sucked in as the water sank to meet the next wave—I turned again + played around between both chasms of water until the sea subsided again. I remained a quarter of an hour at the light + then rowed home. Father Anthony had walked over + was with Barbara + Fiona when I arrived. He stayed for supper + spent a long time afterwards looking at my new sketches which greatly impressed him. He also had his ink drawings to show + left us about a dozen snapshots. He left by moonlight— going across the lagoon on a raft—two short logs + three flat boards across it, propelling his way with a branch of a tree. Most precarious, but he got over. Still dry.

29TH OCTOBER, 1936 I spent all day on the wood pile + also gathering the shakes from the old fish smoke house for kindling—which I hope will last until we depart.

<u>Raining at last</u>—the first for fifteen days. It was expected—full moon + thirteen feet tides tomorrow + the next day. So far no wind—I hope we escape that anxiety as the sea will remain smooth + our goods can be removed without much risk.

30TH OCTOBER, 1936 Took three more boxes over to the lighthouse—also curtain rod + drawing boards.

1ST NOVEMBER, 1936 This is the last month in our cabin on the lagoon—at least we expect it to be. Bert + Buster arrived about 10 AM to take over some of our boxes on the "Liona" so we had to hustle some boxes, trunks, chairs, cask, sewing machine etc, together + get off as

much as we could. The continued offering of help by Bert + Buster is most marvellous + is certainly of such a kind that I willingly admit I never found so much in Vancouver or anywhere else. The things were all taken to Nootka direct so I am certainly relieved of half my worries about moving. We have now only a fairly sized load for Father Anthony to take. I saw John at Nootka so he said that he would see the things safely stored. Rowing home was pretty sloppy + unpleasant round the lighthouse rock. On landing at the lagoon the boat had to be dragged about eighty yards. Barbara + Fiona helped with the job + they made a great difference.

[The following November entries are erroneously dated October]

2ND OCTOBER, 1936 Chopping + splitting wood all day.

3RD OCTOBER, 1936 Packing all day—tumblers, cups, paints, etc. A wet day + heavy sea. We have played the gramophone all day—some pricelessly silly songs.

4TH OCTOBER, 1936 Boat day. Received $100 in advance of my teaching at the new Art School in Vancouver. It is now possible for us to leave but very little will be left to settle in the city after freight + fares are paid. Horel was at the lighthouse so he took Bert + myself down + back from Nootka on the "Leona." I walked the beach.

5TH OCTOBER, 1936 Horel came with the Leona in the morning + took away a few things. We gave him the gramophone + 2 hens.

7TH OCTOBER, 1936 Barbara, Fiona + I walked to Friendly Cove in the afternoon + remained at the lighthouse for ½ an hour, then walked back. Probably our last visit. We wanted a large glass ball (Japanese sea float) from the Indians but were unable to get it today.

Fred returned from Nootka so arranged to take provisions to him in the morning.

8TH OCTOBER, 1936 When I went down the trail to go + see Fred at 8.45 AM I met Fred coming up our trail. He had his pyjama jacket round his head + looked pale. Poor Fred was "burnt out" during the night + now "cabin all gone," "Everything gone." Seemingly he awoke about 11 last night + thought he heard rats but when he opened his eyes he saw that half his roof was burnt away + the floor was also on fire. He had to grab what he could + get out in a hurry. He

Playtime, 1936
watercolour on paper
12.1 x 17.7 cm
Collection of the Vancouver Art Gallery,
Acquisition Fund

didn't want to come + disturb us so he wandered about in the freezing air until I met him. He couldn't call earlier as he couldn't cross the lagoon. After he had a hot breakfast with us + some brandy which we happened to have left. He, Fiona + I went up to salvage what we could from his fire. He had three guns left, 1 feather mattress, a few blankets + a few clothes. All his woodsheds burnt except one, also bath house. He lost his 2 pairs of spectacles + now is crippled for mending shoes. The fire may have its advantages as Fred is too old + his cabin here too far from aid to be safe for him. He had still a cabin at Nootka. When coming back with us Fred shot a mallard duck. He remained with us—a sad + sorrowful fellow.

While we were gone Bert + Buster called + took more boxes.

9TH OCTOBER, 1936 Fred went up to his place in the morning + afternoon. I packed last curtains, cut wood + felt anxious about the weather. We expected Father Anthony to call to move us today. We all had the mallard duck for lunch + found it quite nice to eat.

10TH OCTOBER, 1936 We were hoping that Father Anthony would come along in his boat and move us to Nootka today but the morning was exceedingly stormy + very wet. We felt that we are now trapped about moving our beds + remaining boxes as it is only six days until we should sail. In the afternoon the wind dropped + the sea quietened considerably so we are now hopeful that tomorrow may be quiet enough to move. Fred went back to Nootka by the trail this morning. I couldn't take him across the lagoon as the sea was too heavy. He left some things in Johns cabin

so I expect he will make headquarters there when he visits his "ranch." Fred made no grouse about his burnt out cabin. He has had many cruel misfortunes in his life so takes everything very coolly.

11TH OCTOBER, 1936 The sea was too rough this morning to get our boat up the lagoon so as to get Fred's boat back to his place.

Being anxious to get news if Father Anthony has returned I went over to the cove to find out. No word of him so I went over to the lighthouse. Bert isn't feeling well so he cannot help our moving. Bert + I arranged with Paul Johnstone to come over tomorrow at two + move our things. It is very dull + heavy rain tonight so we hope tomorrow we will manage to get away. I am very anxious about things now as the time is so short. We hope this is our last night in the backwoods—I've had enough for a while.

Father Anthony was wrecked. We left Nootka in a 55 mile gale. The Norah had to remain 8 hrs for the gale to moderate—it didn't!

BLACK + WHITE DRAWINGS
"The Tunnel of P.G.E.R." – Mr. Sinclair, Technical School
"Skyscrapers" – Miss L. Farley, Vancouver
"Cedar Trees" – Miss B. Lennie, Vancouver
"The Cove" – Miss M. Corry,
 (Ex. Canadian Academy), Vancouver
"Still Grasping" – Mrs. Notzel, N. Vancouver
"The Cottage at Red Roof" – Athole Gray, Vancouver
"Abstract Forms" – myself
"The Canyon" – myself
"The Camp" – Miss Fiona Sutherland, Vancouver
"Fir Trees" – Mr. + Mrs. Donovan Allan, Vancouver

JANUARY 1936, MY CANVAS PAINTINGS + WHERE PLACED
"Lytton Church B.C." 24" x 30"
 Permanent Collection of the National Gallery
 of Canada (Exhibited Canadian Academy)
"6000 ft. Up" (Garibaldi) 24" x 30"
 Purchased by Dr. Dolman, University of British
 Columbia (Ex. C.A.)
* "Friendly Cove, Nootka B. C." 27" x 32"
 Purchased by Mrs. E. Bernulf Clegg,
 2033 Comox Street, Vancouver, B.C.
 (at present on National Gallery of Canada
 Travelling Exhibition over Canada), (Ex. Canadian
 Group of Painters)
"The White Forest" – Loaned to the Art Emporium,
 Vancouver 24" x 30" (C.A.)
* "The Black Tusk" – Loaned to the Art Emporium,
 Vancouver (C.A.) 28" x 36"
"Sphinx Glacier" – Loaned to the [left blank] 30" x 36"

JANUARY 1936, MY OIL SKETCHES + WHERE PLACED
(all 12 x 18)
"Sphinx Glacier" (Garibaldi Park)
 Purchased by Dr. Dolman – U.B.C.
"Red Mountain" (Garibaldi Park)
 Purchased by Dr. Dolman, U.B.C.
"Meadow Trees" (Garibaldi Park) – Purchaed by Dr.
 Sedgewick, U.B.C., now in International Hall
 Tokyo, Japan
"Meadow Pool" (Garibaldi Park) – Purchased by Dr.
 Sedgewick, U.B.C., now in Travel Bureau
 Shanghai – China
"Beached" – Purchased by Dr. A. F. B. Clarke, U.B.C.
"Howe Sound from Point Gray" – Purchased by Mr.
 Mortimer Lamb, Vancouver – B.C.
"Hop Fields" – Purchased by Mr. John Vanderpant,
 Vancouver, B.C.
"Meadow Pool" (Garibaldi Park) (East Bluff in background)
 Purchased by Mr. Ronald Jackson, Vancouver, B. C.
[A curly bracket is used to indicate that Lort purchased the three works that follow] Purchased by Mr. Ross Lort –
 Vancouver, B.C.
"Checkymus Canyon, B.C."
"Fog Below Panorama Ridge" – (Garibaldi Park)
"Mount Albert Edward" – (Forbidden Plateau)
[A curly bracket is used to indicate that Hood purchased the two works that follow] Purchased by Mr. Harry Hood,
 Vancouver, B.C.
"Table Mountain" – (Garibaldi Park)
"Red Mountain" – (Garibaldi Park)
"The Black Tusk" – Purchased by Mr. Tyler
 Vancouver, B.C.
 (Garibaldi Park) (from Panorama Ridge)
"Graveyard of the Pacific"
 Donated to Mr. Tyler, Vancouver, B.C.
"Garibaldi Lake + Mountain"
 Purchased by Miss Amy Dalgleish, Vancouver, B.C.
"Sphinx Peak" – Donated to Mr. E. B. Clegg
 2033 Comox St., Vancouver (Garibaldi Park)
"Yale – B.C." – Donated to Mrs. Lennie RS
 Matthews Ave., Vancouver
"Mimulus Lake" – Purchase by Miss Marnie Young,
 Ocean Falls Hospital, B.C. (Garibaldi Park)
"Panorama Ridge" – Purchased by Dr. Gee – Vancouver
 General Hospital (Garibaldi Park)
"Nootka Sound" B.C. – Purchased by Mr. + Mrs. Anstey,
 Vancouver, B.C.
"Tum Tums House" – Purchased by Miss Connie Bell-
 Irving, Vancouver, B.C. (Friendly Cove, B.C.)
"The Lagoon Mouth" – Donated to Mr. W. Sinclair –
 Victoria Drive, Vancouver – B.C.
[A curly bracket is used to indicate that the two works that follow were donated to the Mactavishes] Donated to
 Mr. + Mrs. Mactavish, Kg. Ed. Ave. Vancouver

27TH SEPTEMBER, 1936 Went fishing with J + Fo + caught a dog fish only. Saw the sun set over the sea, marvellously calm.

29TH SEPTEMBER, 1936 John + I went to the counterfieters cabin with Fred. We caught 1 trout, six salmon–trout + 1 salmon with methods we used last year. Another beautiful day of sunshine—the 3rd.

2ND OCTOBER, 1936 High tides + still no gale—but wet.

3RD OCTOBER, 1936 John decides to go back to Vancouver on the 6th. I decide that we cannot remain all winter here alone—no money, no help, a weak back, + feeling of "we might as well starve beside friends." Things are pretty difficult.

4TH OCTOBER, 1936 Barbara's birthday + boat day. Bought B some Sauerkraut + John got her some candy. I mailed a letter to Vancouver asking for financial assistance to enable us to return. John is promised work at the cannery soon so decides not to go away. Mr. Horne returns from Vancouver. Father Anthony + Nev Shanks off to Port Alice. We hiked to the lighthouse. Good weather.

5TH OCTOBER, 1936 Sunny again + warm. In the evening I discover at last a new expression for painting—made four pencil notes for sketches + feel quite excited.

6TH OCTOBER, 1936 Paint the first subject—out on the beach in the sunshine. Barbara + John quite thrilled also as they feel I have got an expression all my own. The subject was—"Waves on a Stony Beach." Only the abstract forms are used but they are intermixed in a bold mass. Purest colours are used + give a brilliant value. John is signalled to the lighthouse in the late afternoon. I go with him to the cove + help to carry his grip. It is a job at the cannery as the herring has arrived.

7TH OCTOBER, 1936 I cut wood + draw up the second new sketch. Still sunny.

8TH OCTOBER, 1936 Barbara, Fiona + I go to the lighthouse to pay a visit in the afternoon. Gloriously sunny. Horal + Gladys Imlah still there. Bert is quiet + appears unhappy. I took B, Fo + Gladys over to the cove in the canoe + thought I'd never make it as I found it awful to keep my balance on the tip end of the canoe. I will never take a load like that again unless we all sit in the bottom of the canoe.

9TH OCTOBER, 1936 B, Fo + I bathed in the lagoon once more—cold but invigorating. A fine warm sun. In the afternoon I paint the new "Moonlight over water" study. It also comes out interestingly.

10TH OCTOBER, 1936 I drew out the 3rd study—"Hiking over the sand." In the afternoon I simply had to go fishing for cod as we have no variety of food—endless rice + macaroni. The sea was fairly rough but after 2 ½ hrs I caught a nice ling-cod. I lost a fine large one however, but we are thankful to get some fish.

11TH OCTOBER, 1936 Spent the day adding to the wood supply + writing letters. Rain.

12TH OCTOBER, 1936 Coloured the 3rd sketch study + feel enthusiastic over it. The new work has merits + should lead to something interesting in the future. Barbara is still keen over it. Very dull but dry. Plenty of rain water to drink now so the fight against cedar poisoning isn't so difficult.

14TH OCTOBER, 1936 Met Bert at Friendly Cove so we rowed to Nootka taking Mrs. Fish, Gladys, Mr. Horal (Pop) + the two children. Quite a squad. Bert got the new engine for the boat but I have not heard yet from Vancouver whether we can obtain money for travelling. The Art Gallery—Vancouver—informs me that my canvas "Heavy Weather on the West Coast" got Honorable mention in the B.C. Artists Exhibition. Max Maynard is given the medal. I visited John but found him not too well. He appears to show decided symptoms of fish poisoning or cedar poisoning or both. His hands fester if cut + there are peculiar large red patches on his legs. Rather worrying. We returned to the lighthouse by 3.15 PM + had a quiet sea. I packed home by 5.30.

15TH OCTOBER, 1936 Painted my fourth new type of sketch—"Wind in the Trees"—it also seems interesting. Fine + sunny.

16TH OCTOBER, 1936 Fine + sunny + warm. Sketched out the 5th painting—"Night"—showing moonlight, stars, milky way + the sun almost hidden behind the world. Gutty returned after 2 days absence.

17TH OCTOBER, 1936 Rowed up to Fred for cabbage. He was not home. It was sunny + decidedly hot. In the afternoon I painted the 5th study—it looks interesting + successful. Reading "Faust" again. Barbara finished her henna sweater after redoing the sleeves. Fiona finds her arithmetic difficult—subtracting a number of cents from $1. Spending the cents would be much easier.

18TH OCTOBER, 1936 Went out fishing with Fiona but was unsuccessful. Fred Janel had left some vegetables on the opposite shore of our lagoon—very kind as usual. Perfect weather.

24TH OCTOBER, 1936 Have completed three more experimental sketches. They are memories of dreams. Still dry sunny weather. Went to Nootka with the Fish family but had to row as the propeller shaft slipped + the engine couldn't use its power.

Still no word of any money <u>BUT</u> I am asked to accept a position in "The Canadian Institute of Associated Arts"—the new art school in Vancouver, by Mr. Rex Mills, B.A. the director. Here is hope at long last and the decided pleasure of having something to return to. It will be an uphill fight once again but I feel that I am used to that. It will cause no end of bitterness with the Vancouver School of Art + The Faulkner-Smith school to think that I should throw in my lot with Mr. Mills. But they should go their ways + not worry about me. I feel that I have work to do in Vancouver + I intend sailing right in. My very excellent friend Mr. Harry Hood is instrumental in proposing me + he has done me a great kindness.

Saw John Varley at Nootka also—he is somewhat better of his fish poisoning. Leslie Planta burst a blood vessel in his nose + was rushed to Vancouver for medical treatment. He has now returned + is better. His return is proof that the illustrious Harry isn't doing financially very much in Vancouver.

26TH OCTOBER, 1936 Returned to Nootka with my letter accepting the position in the new Art School. I tried for an hour to launch the row boat this morning but could not get away. The sea was smooth but the waves were large + breaking in a folding way + sweeping up the sand. I was pitched on rocks, swept ashore again every time I got twenty feet away. Father Anthony returns from the North. Still ideal days.

27TH OCTOBER, 1936 Packing at last. Put the books in milk boxes + Barbara commenced packing the trunks. I will be both glad + sorry to go. Still dry.

28TH OCTOBER, 1936 Went up the lagoon for the row boat this morning so that I could have it on our beach. Coming out of the lagoon was a fight between my rowing strength + that of the inrushing water as the tide was nearly high (water). I eventually won but not before a wave threw the boat into the air + I came down spread-eagled in the bow. Both oars jumped out of the oarlocks but fortunately I retained hold of them. In the afternoon when the tide was out I loaded the boat to take to the lighthouse. Bert is taking some of our freight to Point Atkinson on the "Estevan" when he goes south. Getting off the beach was difficult but again I had trouble as an oarlock slipped out + broke the line holding it. I lost it over the side so had to get out to find it. When I got back a large wave came over the bow + drenched me—filling the boat with two or three inches of water. I struggled to get away + finally succeeded. The sea was smooth as I took the inside passage at the lighthouse rocks, but it was a mistake as three huge waves rose up over "the growler" + I was almost sucked in against the rocks. I had to row out immediately towards the growler—where I was again nearly sucked in as the water sank to meet the next wave—I turned again + played around between both chasms of water until the sea subsided again. I remained a quarter of an hour at the light + then rowed home. Father Anthony had walked over + was with Barbara + Fiona when I arrived. He stayed for supper + spent a long time afterwards looking at my new sketches which greatly impressed him. He also had his ink drawings to show + left us about a dozen snapshots. He left by moonlight—going across the lagoon on a raft—two short logs + three flat boards across it, propelling his way with a branch of a tree. Most precarious, but he got over. Still dry.

29TH OCTOBER, 1936 I spent all day on the wood pile + also gathering the shakes from the old fish smoke house for kindling—which I hope will last until we depart.

<u>Raining at last</u>—the first for fifteen days. It was expected—full moon + thirteen feet tides tomorrow + the next day. So far no wind—I hope we escape that anxiety as the sea will remain smooth + our goods can be removed without much risk.

30TH OCTOBER, 1936 Took three more boxes over to the lighthouse—also curtain rod + drawing boards.

1ST NOVEMBER, 1936 This is the last month in our cabin on the lagoon—at least we expect it to be. Bert + Buster arrived about 10 AM to take over some of our boxes on the "Liona" so we had to hustle some boxes, trunks, chairs, cask, sewing machine etc, together + get off as

"The Woods Edge"
"Black Tusk" (between E + W Bluff)
"Evening Glow over Mountain with Stormy Sky"
 ~~Tops~~ – Purchased by Mr. R. G. Mathieson,
 Vancouver, B.C.
"Sunset over Water" – Gift to Mrs. Leeson,
 Vancouver, B.C.
"Gray Sky over Savary Island –
 Purchased by [left blank]
"Fringe of the Coast" – Miss A. Bonnycastle,
 Vancouver, B.C.

AT THE ART EMPORIUM ON EXHIBITION
"The Indian Whiteman" –
"The Hermits Cabin" –
"Evening Glow" –
"The Ocean Whirls" – At Studio now
"Tantalus Range from Table Meadows"
 To Mrs. Wallis, Hong Kong (Garibaldi Park)
"Black Tusk from the North"
 Purchased by Mr. Tyler – Royal Bank
"The Green Sea" (20th March) Sold Sept 1936
"Bajo Point Trail" (22nd March)
"Over the Sea" (26th March)
"The Scrub Brush" (28th March)
"Drying Herring Roe" (31st March)
 Sold Dr. Sedgewick in September 1936
~~"Driftwood"~~ (3rd April)
"The Fringe of the Coast" (13th April)
 Sold Miss Bonnycastle (May 1936)
~~"Morning on Nootka Sound"~~ (24th April)
"Playtime" (watercolour) – (14th May)
"Nootka Lighthouse (watercolour)
 (14th May) Table
~~"Old Steves Cabin"~~ – ~~Friendly~~ Cove (4th Oct)
"Sunset over the Sea" (4th Oct.)
Drying Herring Roe (canvas) To Tate Gallery – Canadian
Pilgrimage (canvas) Century of Art Ex.

SOLD
"English Bay (Evening)" – Dr. A F.B. Clarke, U.B.C.
"Old Indian Shack" – Friendly Cove (Steves Cabin)
 Dr. Sedgewick, U.B.C.
"Nootka Sound" – (Morning)
 ~~Elsie Reid, Pender Island~~ Mrs. George Weir Victoria
"Driftwood" – Elsie Reid, Pender Island

LINOLEUM BLOCK
~~Sailors Sea~~
"The Salmon Rack" (Exhibited Canadian Academy)
 No 1 Miss Mary Gordon – Vancouver

No 2 Miss Rolie Moore – Vancouver
No 3 Mrs. Sinclair Macdonald – Thurso, Scotland
No 4 Mr. Athole Gray – Vancouver
No 5 Mr. Ross Lort – Vancouver
No 6 Miss Agnes Handley, Vancouver

[Luckett's Sterling Line calendar page for 1935]

35
50 [?]
1050
400
350
40
120
1960

[Luckett's Sterling Line calendar page for 1934]

Correspondence

In an interview with Joyce Zemans, Fiona Davenport—Jock Macdonald's daughter—recalls her father "polishing off" four or five letters at a time in the evenings after dinner. Indeed, much of Macdonald's correspondence exists in archives throughout Canada, with a particularly extensive collection of correspondence between Macdonald and his friend and fellow artist Maxwell Bates in the archives of the McCord Museum in Montreal, his student Alexandra Luke in the The Robert McLaughlin Gallery Archives in Oshawa, and museum director H. O. McCurry in the National Gallery of Canada Archives in Ottawa. Although the Dr. Grace W. Pailthorpe and Reuben Mednikoff fond was accessioned into the Scottish National Gallery of Modern Art Archive in 1999 and 2000, the existence of these letters only came to light in 2012 through a fortuitous conversation I had with Alasdair Macdonald, Jock's nephew. This remarkable correspondence began soon after the pair departed Vancouver in 1946 and lasted until months before Macdonald's death in 1960. The letters reveal Macdonald's journey with automatism, a technique that the pair taught him while they were living in Vancouver, as well as his life in education and his obvious personal respect and care for the two artists. The letters' transcription and publication in this book makes this material available to a broader audience for the first time. This transcription was a tremendous undertaking, but as with his *Nootka Diary* we have sought to preserve his use of language—including quirks in spelling and grammar—while also maintaining readability of the texts. Annotations have been added to further supplement and clarify the content of the letters.

Linda Jansma

2699 CAPILANO ROAD
NORTH VANCOUVER, B.C.
3RD APRIL, 1946

My Dear Dr. & Ricci,

We hope that you are happy to be back in England, to be with your good friends again and to be "home" where you can again go forward with your plans without disturbance. Are you really glad to have returned? We want to receive your first letter perfumed with the joyousness of England's Spring and frothing full of sparkle for the future. I wonder how you found the people and the conditions of the country today?

Please excuse this paper. I am writing in a classroom, where there are those beloved "9G" boys.[1] Having blasted them around for the last ten minutes they are now silent. I am starting my letter now because my reply to your very welcome letter from Banff is far overdue and because there is still so

much rush that if I wait until I have a quiet evening you may not hear from me before Christmas.

Excuse me if this letter is disjointed. I do not know how long those morons will remain silent. Good Lord! how I detest this outfit. Unchristian. I am guilty, I admit; guilty of being without love for the less fortunate. How difficult it is in actual practice.

We were delighted to hear that you both were happily resting at Banff. How did you enjoy the flight across the country and the wide Atlantic?

Shortly after receiving your letter, Ricci, I got a long letter from Glyde of Calgary, informing me of the vacancy arising; giving me some details about salary etc, suggesting I apply for the post. Well! I first of all decided to balance the pros + cons of moving + ask myself "how miserable" I was with my present position, should I uproot the whole family, should I be isolating myself, etc, etc. Evidently I am so tired of here, that I still feel today that the change is less dreadful

than the remaining. The situation at Calgary cannot be less pleasant—at least it is an art department + I think the students are not younger than 16 or 17. Yesterday, I received a letter from Mr. Fowler, principal of "The Institute of Technology + Art," (ahem!), inviting me to make application for the position of "Head of the Art Department." This looks better. It looks as if they would like me there (?) and that I would have an excellent chance for the position if I applied. There is one "escape" for them—I may be too old, as I am told that they would like to find someone between 35 + 40. I met Mr. Fowler at Banff last summer, so he knows I am no chicken of 40 summers.

In a few days I will definitely decide about the application. My decision has to be final as I can not jazz around if I should get the appointment. Mr. Fowler has something to do with the Banff summer school, so I can secure my position at Banff or finish it off pretty suddenly if I only feel out the Calgary position + drop out if it turns out inconvenient. The odds are 100 to 1 that I will apply. I remember very clearly, Dr. Pailthorpe, your saying "Nothing can develop here."

Let me write of other things now.

How about "automatic art"? Did you say, Ricci, "That is better, now you're talking"?
[doodle] away we go!!!!

Dr. Grace Morley, San Francisco, has come to town + has returned to the "Golden Gate."[2] I introduced myself to her + gave her your regards. She was very very sorry that you had flown. Would have loved to have seen you again. She is most interested in you both + in your work. She asked me to convey her greetings when I wrote you.

Barbara + I both thought Dr. Grace Morley an exceedingly charming, gracious, and interesting personality. I found her lectures interesting to a point. The lay people found them very educational.

Shortly before Dr. Morley came here, Lawren Harris came over to see my work. I think that happened before you left. When he asked me if he could take Dr. Morley over to see my work I then knew that he was more than just interested. I was going to take some things over to show the Dr. in any case, but this was a much better arrangement. So over they came on the Sunday afternoon for an hour or two.

Knowing of your interest as to the reaction of my work on Dr. Morley I will just tell you exactly what she felt. She was tremendously interested and impressed. What she remarked to outside people was more interesting than what she actually said to me, as she had said to two people whom I know "Mr. M's work is not just art, it is great art." She remarked to me that "your glorious colour makes me drunk, your design is altogether satisfying + superb, it is a privalege to meet an artist so truly creative." Also, I was told that "there is nothing like this form of automatic statement anywhere in the world." Just exactly what you said Dr. Pailthorpe. I am so deeply greatful to you both for lifting the curtain which has enabled me to create a new world for myself in painting. I am to be informed when I can send something for exhibition to San Francisco—Dr. Morley wants me to send some work there. She also is going to give us an exhibition of the Saturday morning childrens work. I also heard from a friend that Lawren Harris said my work "is simply magnificent."

Now that the rumours of new things done by me are going around I find myself pestered with the remark "I would love to come out + see your new work, I hear it is so remarkable." Bah! funny how folks take a sudden interest when they think they are missing out. Those "interested" people will have to wait for the time when something will be in an exhibition—unless I need a hundred dollars I won't have open house.

Oh, yes! I am still working. I did one last night, but owing to the lectures by Dr. Morley and by Mr. Neutra, the internationally known architect from Los Angeles, much time has been taken up. There are several new things done since you went away. I have a canvas ready for action + I have board for black + white work and coloured pencils etc., all piled ready. Now I can get going full out + I feel happy over this fact.

Fiona comes home tomorrow night for her 10 days Spring Holiday.[3] She will not be home at Easter. There is a smallpox (black) epidemic in Seattle. The border is closed except to the vaccinated travellers. Fiona has had her vaccination two or three days ago. There are 24 cases + five deaths so far. It would be most disappointing if we were not to see Fiona. She is so full of her work + evidently very happy over her friends in Seattle.

There is very little news from this city. We haven't seen many people. Barbara saw Florence Waddington last week. She was fine + is still working in the automatic field. Barbara has also (secretly) been doing a little.

I read in the news-week that "Verve" is being presented again + much of the new issue is devoted to Matissé.[4] I hope that I can find copies out here. What is there new in English magazines? Anything added to the Penguin artist series?

I don't suppose you have had time to discover much about the sur-realist work in England yet.

Barbara + I send our fondest greetings to you both.

Please excuse this scribble. Will write soon again + probably a little fuller.

Happy days,
Jock

5TH APRIL/

Have done three or four more things since I wrote the above. Haven't fully warmed up yet but the Easter Vacation will be hit so hard—one long painting spree will just send things swinging along.

Have decided to apply for the Calgary position: no matter what it means, I cannot see myself returning to this purgatory next September. I am sure I would walk out shortly after I returned + that would upset things a bit all around. Even without any hope of getting to Calgary I feel myself smiling with the thought of a possible move in the offing.

I am sure that you will be glad to be back in England. We are so pleased that we knew you over here + that we will hear from you from time to time. Perhaps, someday, we will even meet again in London, or Paris, or Papette, or Tibet.

WILL WRITE SOON—Very soon. Jock

1. Macdonald began teaching at the Vancouver Technical High School in September 1939. The school was founded in 1916.

2. Grace Morley (1900–1985) was the founder of the San Francisco Museum of Modern Art.

3. Fiona, born in 1927, was the only child of Jock and Barbara Macdonald.

4. Macdonald is referring to Henri Matisse.

2699 – CAPILANO ROAD
NORTH VANCOUVER/ B.C.
5TH JUNE, 1946

Dear Dr. Pailthorpe & Riki,

We were greatly delighted to receive your joint letter yesterday, with all your news, adventures and intentions. Also we were pleased to hear that you were both in good health and full of good spirit (I don't mean "Scotch"!) (That might not be too bad at that, eh!).

I have been intending to write you for some weeks, but as I had no definite news to give you I have delayed, in the hope that I could. Since forwarding my application to Calgary, I have received only a line to say that the appointment would be delayed for some time as a number of applications were received. The time is fast approaching when it will become difficult to make so definite a change, as I am due in Banff in a little over a month, and must remain there until the 27th of August. Apparently they are "looking for a younger man"—someone around 40. This phrase I have rubbed against more than once during the past year. Recommendations don't appear to mean much to School Boards or Education (?) Boards if they have set their minds + have maggots in their heads which the good Lord himself cannot move. Jackson, Harris and Glyde[5] (whose former position I have applied for) have all evidently written, privately, stating that I should be selected. This "too old" business is the escape clause in this country today. I know of

two excellent men who ran up against the same remark when applying for positions—one in the Civil Service + one in the Navy. Both men were six years service (commissioned) men.

By the way, the man who was given the Normal School position is now away in the U.S.A. Taking a course of art training, lasting for 15 months, to qualify him for the position he was given, and a special clause put through in Victoria, making it possible for next years' Normal School Students to pass through without any art work. What do you think of that for a kettle or frying pan of rotten fish. Bah! All this is outside my interest now. I merely pass it along as "hot-news." Hot dog (male or female)!

So things are just where they were when you left here. But today my art supervisor called me to her office to introduce a probable plan where I could assist her part time and give art appreciation classes in several schools next year. She stated that she considered I was wasted where I was + I agreed. I told her that my desire to get out of the Technical School was just as great as it was three months ago. Perhaps something may yet happen which will be a little better for me + will prevent me from committing desertion.

At the moment I am not teaching. I am out supervising work in four schools where the kids are making designs on blankets, loin cloths, drums, rattles (and hootch) for the Indian scenes at the Diamond Jubilee celebrations to be spewed out in Stanley Park from the 1st to 15th July. The work suits my qualifications evidently (having been forced to sign some darned school report the other day stating my entire qualifications as "A High School Teacher holding a temporary B.C. Art Teachers certificate"). I escape two weeks work discussing with the morons whether a dead bee is a bee deceased on an expired seedy beast.

This Juboney is terrrifffic!!! Here is John Harkrider of NuYoick—"Director General"—getting one paltry thousand dollars a week to organise + run the affair + him asking everyone else to do everything for love. He will pick up a mere ten thousand bucks. However, he finds only a few suckers who will work. My work is in school time only. All the artists on the north shore were sent telegrams from Vancouver calling them to meetings at the Hotel Vancouver. After paying no attention to about a dozen cards + letters I was finally sent a most distinguished copy of the script (blood red binding with gold label + embossed lettering on it) informing me of the work allocated to myself. I glanced through the script + found to my amazement that the first part of the 1st Vancouver City Hall scene was an expression of joy that the city treasury had made its first cash—$400's, by fleecing twenty prostitutes, picked up on Hastings or Main Street. This was dialogued with one cheery little lass saying she was "a good gal." It didn't say how good (?) This scene is now cut out, as the School Board didn't want any school kids used for such a scene. The script also had Sir Simon Fraser, hot in conversation with an individual who had died seven years before Fraser got here. Doubtless the

conversation would be whether Fraser should try and stay in the hell he was already in or head for the spooks purgatory out here. The Indian Scene was to have 50 war canoes made for it—this dropped to 25 (all floatable) + now it is six, in 3-ply silhouette. The real Indians of Vancouver won't act or take any part in the great events without cash—they are therefore out, + the whites play Indians once again. I could relate many more items of interest but this is probably enough right now. Eddie Cantor is the chief entertainer—coming for nothing but his expenses. Awfully kind of him, eh!

Now for other matters of a more serious nature. I am continuing to paint all I can get time for. There are about 90 things, if not more, in the studio. I have been working recently on larger water-colours—15" by 20" or so, and have a 30 x 36 canvas on the go. I cannot buy water-colour pads any more so bought out all the large water colour sheets in town four weeks ago—about six. When more stock will arrive, nobody can say, so it looks as if I will have to do oils + some drawings.

I sent six things to the B.C. Society of Fine Arts. They are now showing + the only crits I have to give are those—Parker—"In different vein from usual style, JW_____ exhibits a colourful + intriguing series of watercolours executed in sub-conscious automatic mode of expression," and Wingate—"JW____ has produced a beautiful series of watercolour compositions making use of fantasy in colour + line. They combine colour + design in a manner often found in exquisite embroidery + fine jewelry." Well! well! I have heard almost no comments except "they are odd + fascinating in some sort of strange way." The show opened last Friday. People seemed to be clustered around my work but what they said I have no means of knowing. Anyway, Dr. Morley wrote two people here + remarked that the only art of merit she saw, done by B.C. artists, was that of Mr. M. By the way, I hear that she has been asked to accept the position of Supervisor of the Art Museums of the U.S.A. I received a very kind + friendly letter from her several weeks ago. I have yet to reply, but must do so very very soon. So far I have sold no automatic things. This doesn't worry me at all. I am much more anxious to sell elsewhere when opportunity permits. When I have a dollar or two to spare I will get a little slide taken of some of the recent things (in colour). This will keep you in touch with the direction in which I am moving. "Fish" have now disappeared. The things are partly primitive, partly oriental, and often just loose flowing forms. But I greatly miss having a word of advice from both of you.

I find painting in oils still difficult. The slowness of the medium hampers the creation of freedom in the transition areas. Perhaps I have not released myself from the conscious effect of working in the different medium. But I am thoroughly happy in my studio work. Now I am fairly certain that I won't do any more landscape canvases.

Sketches yes, but to do a landscape canvas seems a waste of time + much too manufactured.

6TH JUNE, 1946

Was out at Tech this morning "book-keeping" + found that the alterations are now in progress to bury the Art Room in the basement—opening next Sept. I therefore leave the building, mumbling to myself + saying "isn't there going to be some way out of this hell."

In the Art Gallery Council elections only one change was made. Shadbolt got in and Goss went out. Binning failed to be elected. Those results are interesting.

I flew over to Victoria last Saturday to represent the Vancouver Gallery at the opening of a small Gallery there.[6] This gallery came into being by the efforts of the Hon. Mark Kearley. It is an adapted motor-show room. Quite good. Emily Carr's work was exhibited. The Gov. General Viscount Alexander will officially open the gallery about the 17th of June. He is also to visit the Vancouver Gallery about this time.

Thinking of flying, I am interested that you, Doctor, find flying the only way to travel. I am sure it is—it's fun too. How about you Riki? We heard much news of you both from Florence W. and also some from Mrs. Askanasy, whom we have met two or three times since your departure.[7] We have been following up the Garbovitsky Junior Orchestra + will attend their first performance given in the Kerrisdale Junior High School, on the 17th of this month.

Eugene Ormandy + the Philadelphia Orchestra played at the Hastings Park Forum, to 6000 people, last week. Much as Barbara + I would have enjoyed such an evening we just couldn't afford the prices.

You will have Arthur Benjamin back in London before long. Why cannot he take Goss too?

Lawren Harris was honoured with an L.L.D. bestowed upon him at the U.B.C. some three weeks ago. The Harrises are now in Eastern Canada.

So England is just as beautiful as ever. It is grand to hear that you are happy being back. When you have settled with things around you that you love, re-united with your friends in the full action of art development + exhibitions, a car which will find sufficient comfort and petrol to make travelling a pleasure, and the production of your books Doctor, the happiness and fullness of the spirit will be yours again—well deserved to both of you.

My mother was elated in receiving your letter Riki. It was very kind of you to write. Mother is at last, after 6 ½ years, in her own house again + very happy at 76 years of age. My elder brother, in Chester, appears to be none too well. At least I don't like his condition. Apparently he had to be outdoors in heavy floods, inspecting destroyed bridges throughout the county, after which he was afflicted with partial paralysis of one side of his face. Apparently he is recovering. Cold is suspected, but I wonder? His physical

condition has never been good since he was prisoner in World War I + again after Dunkirk.

I will search out on Saturday the materials you would like me to send you. I will be glad to do all I can, but materials are very very scarce here today. I will also get the Humphries 77 + 34.

We expect Fiona home on Monday. She has gained so much in health, spirit and energy during her year in Seattle. She, who was terrified to get within 3 years of a horse has been out riding several times with friends. She seems to be on the go all the time—working hard + also having lots of fun as well.

I am dying to hear something of the art news from England. Never mind sending me a cheque for an extra $10's worth of art materials. When you come across a good art book or good magazine—like "Transition," or something, you could send me it. I would like to get that last book by Herbert Reid.[8] I forget the title at present.

Please do write to me when you can. We so enjoyed your letter. And, I feel that I so greatly need your friendship and advice that I would undoubtedly be isolated and alone without it. Never can you know how indebted I am to you both for the awakening and releasing of my inner consciousness. Your coming to this distant outpost has been an initiation for me, into the higher plane of creative understanding—one of the most marvellous enrichments in my life. Definitely, for me, an eternal awakening in experience, which my soul was seeking for so many years. Thank you both.

I hope, Riki, that drawing for "Cavalcade" will be immensely interesting. We will keep our weather-eye open for it here. Maybe it can be found at that international magazine shop down past the post office. By the way I read somewhere that "Verve" was again being produced. Have you seen any in England?

Must close for tonight but will keep this letter open until I find out what materials I can mail you.

16TH JUNE/

In looking over the place for materials I have found Grumbacher canvas boards the size you want, priced at 60 cts each—I have managed to get ten at the moment + have placed an order for another ten when the small shipment comes in next month. There are those dull brown heavy canvas boards, the same size, priced at 90 cts, but I am not going to purchase them. It is a crime, I think, to start any painting on a tea coloured base. Japanese paper is impossible to obtain. I have however got what appears to be the best substitute + have bought just a dozen sheets at present—5 cts a sheet. I will also pick up the medicine tomorrow.

Sorry this letter is so long in mailing.

Fiona is home, looking very well + full of life.

The latest news about Calgary is this. The position rests between George Pepper, Head of Drawing + Painting, Ontario College of Art, Toronto and myself. George Pepper is at present in the vicinity of Calgary. Matters should be settled in ten days or so. My chance of a change from the Technical School is now zero as far as Vancouver is concerned.

The only result from my exhibition of automatics at the Gallery is the desire by half a dozen homogenous artists to get me to tell them how things are done. They are biting at the wrong hook.

Regards + the very best wishes from us all.

Hoping the materials arrive O.K. + will be suitable. Glad to send things along at any time.

Jock

5. H. G. Glyde (1906–1988) was head of the painting division of the Banff School of Fine Arts from 1936 to 1966.

6. The "small Gallery" Macdonald refers to was The Little Centre, where Lawren Harris presented a solo exhibition in 1946.

7. Florence Waddington was taught the automatic technique by Pailthorpe and Mednikoff at the same time as Macdonald. Samples of her work can be found in the Scottish National Gallery of Modern Art Archive in Edinburgh, Scotland.

8. Macdonald is referring to Herbert Read, the British art critic who helped organize the 1936 *International Surrealist Exhibition* in London that included the work of both Pailthorpe and Mednikoff.

2699 CAPILANO ROAD
NORTH VANCOUVER/ B.C.
4TH JULY, 1946

Dear Dr. Pailthorpe + Riki,

Cheers! Hurrah!! Yippy!!!

I am appointed Head of the Art School in Calgary, taking Glyde's place.[9] I'm out of prison at last, after seven years, and feel a bit elated over the fact that I am able to hold to my statement that I very probably would not return if they put the art room in the basement, together with the automobiles and flying splinters. The last thing I had to do at the Tech was to plan out the shelving etc., for the basement art room. I did it as I would want it, but I prayed so hard, both consciously + unconsciously that I would never be there to see the result.

Only yesterday I received the wire confirming the appointment, after pottering about over it for three months. The job means an eight month's year with the same salary as I get here for ten months, arriving at the same maximum in three years as here. I have only two night classes in winter per week, for a session of six months and I am not bound to

take the Saturday morning childrens classes, though I think I want to look after them + may do so.

Yes! I think this is a good move. Lots of good landscape around and also near Banff + the possibilities there. Besides I want to separate myself from the groove I got into here + paint as I feel I am ready to paint.

Barbara is quite happy over the move. Fiona will return to Seattle if the inflation there doesn't make living too high for us to meet. We will sell our house as we have no intention of retracing our steps unless a Fine Arts chair at the U.B.C. provided an opening. But I think Alberta will be a happy place for us + do for a year or two anyway.

We hope that you are both happy + well. I'm dying to hear from you + to know all the art news now that you will be more settled.

I have a little more news to give you about the automatics. They are catching on now. I have been asked to put a one man show on in the Hart House of Toronto. It will probably be arranged for me around December. This is news, as I have never heard of any artist West of Toronto being invited to give a one man show there. I sold a small one to a Dr. Agnew on the Art Council of Hart House. I am selling one to a lady doctor from Ottawa, who collects only automatic + surrealist art. I have sold two locally + will likely sell two more next week. This selling worries me a bit as I want to retain most of them for one man shows. There is also San Francisco in the future + you may want some sometime. I now have a hundred pieces. The cash for the ones I have already sold is mighty convenient at this time. I need it for moving etc. The prices range from $75's to $35 unframed. Is this O.K.? Some of the best ones I won't let go as you may want them. They are the ones you marked.

On Tuesday I am sending you the second batch of canvas boards. I have bought your pills for colds + will mail them soon.

Florence and Mrs. Askanasy are very well indeed. We had an amazing afternoon at Mrs. A's home two weeks ago— on the afternoon of our earthquake. She got an awful shock + thought her house would soon collapse. For a full minute our house vibrated like a old car radiator + the noise was like an iron truck unloading gravel on the deck of a liberty ship. Things rocked around, the forest quivered amazingly + the telephone wires swayed about. The seabed at Courtney has dropped 82 feet and 6000 feet of telegraph cable has completely disappeared at Bamfield near Alberta. Fortunately it was a Sunday morning as many kids would have been killed at Comox as the High School was completely ruined and also the Post Office in Courtney. The military hospital here has a split from ceiling to ground. Quite an exciting + peculiar experience for everyone. One woman in Comox ran out of the hotel clutching her nighty in one hand—otherwise nude.

We are off to Banff in a week.[10] There are to be 200 art students. This looks like much work. I will be taking mostly design + will work outdoors.

Calgary + Banff are fortunate things for me but the greatest fortune I have known this last twelve months is your kindness in initiating me to automatic expressions + fortunate enough to be counted as one of your friends.

If you want more materials after I have sent you $25's worth I will be delighted to send it along. If I cannot get it in Calgary I will get it sent to you from Vancouver. Must now put on a pot of tea + try to keep the home fire burning.

We send you both our very special regards + good wishes.

Excuse more at this time.

Jock.

9. Calgary's Provincial School of Technology is now the Alberta College of Art and Design. Macdonald met Marion Nicoll (who was also a teacher at the College) here and taught her the automatic technique.

10. Macdonald first began teaching at the Banff School of Fine Arts in 1945, where he met fellow Painters Eleven member Alexandra Luke.

**PROVINCIAL INSTITUTE OF
TECHNOLOGY AND ART
CALGARY, ALTA.
29TH OCTOBER, 1946**

Dear Doc + Riki,

We were awfully sorry to hear about the motor accident you were so unfortunate to experience, especially you Doctor who received a collarbone fracture. We sincerely hope that you are now feeling completely mended. The shock and throwing around must have been quite awful for you both. How very thankful we are that things weren't much worse. One can of course be much better off without such a misfortune however.

We were delighted to receive your letter, with all your news, and to hear that, in spite of all the difficult conditions, you are happy in England. It seems so very very long ago since I departed from England that I begin to wonder if can remember it very clearly. A return visit is much overdue. It is refreshing to have news of it and of the quality of its landscape, atmosphere, and spirit.

I am ashamed in not having written you long before this, to thank you for the book on "British Craftsmen" which I am certainly pleased to have. The whole arrangement of the book, together with the text, has that particular grace of the English production. "British Romantic Painters" will be most appreciated by us, as also will the book on Sculptress Barbara Hepworth. But please don't spend good money to obtain things to send to us. Much as we love to have the good things, we are very fortunate to have your friendship + it is we that are owing you many things.

Two or three days ago I received from Vancouver six more canvas boards which I will mail over to you by the end of this week at the latest, together with two boxes of 3B pencils. It is difficult to get things now-a-days in Vancouver and quite impossible to get anything here—but as things are sent to me I will keep you supplied. I have noted what you want in brushes and water-colour boxes and will write to Vancouver about them. I doubt if you can get a quill brush anywhere as I haven't seen one for years and would certainly have picked them up if I had the good luck to secure them. I have recently made a good friendship with Maxwell—late of Fraser's Ltd.—+ if things can be got (should I write "gotten") he will send them along.

We are interested to know what is the magazine you are doing the cover for each week? Sorry it gives you "a pain in the neck." When will the day come when the artist can escape such pains? If it ceases to be in the neck it will start up somewhere else I suppose.

We unfortunately were unable to see Mrs. Waddington before we left on the 15th of September. She evidently took to going out a great deal + even though we phoned a dozen times we were unable to find her at home. We must write her very soon.

Now you must wonder how things are going in Calgary + what our feeling are about the change of environment. Had I written you earlier, I am afraid that my letter would have been most depressing, but as the weeks have passed by we feel somewhat better + see the possibility of eventually enjoying it here moderately well, if not quite well or very well.

We are still boarding at the address we gave you. I have however now given you the school address, to write to, as we may move anyday. Again, we may be in our present place quite a while as we have been quite unable to find a suite, apartment, attic or basement, to receive a single reply to advertisements, or replies to a dozen letters we have written. We haven't sold our house at Capilano yet. That may go anyday, but as long as it isn't sold, we cannot buy anything, even if we came to the conclusion that we must. Prices are so high here anyway that it seems sheer stupidity to spend all our money on a small bungalow, especially seeing that we don't know if we intend to stay here very long. There are several reasons why we doubt our remaining here. You will be able to perceive them as I continue with this letter.

I will begin with the brighter aspect of our experience so far. Yes! it is decidedly brighter in Alberta. The sunshine is amazing. We have only had about four or five dull days in the past six weeks. The atmosphere is crystal clear—no smoke anywhere as everything is run on natural gas—and the mountains stand up brilliantly though fifty miles away. You should have seen them early this morning, set back behind a foreground of snow. I would rather have painted than gone to school. However I couldn't paint as our things are in storage + we find it impossible to get them out as Bekin's put many

things together in big crates. It would cost more to have them sent to our place here + we may have to pack up any moment if we should get a flat or suite. My craving is however becoming very strong to get down to work + I may decide that matters cannot be held up much longer. At this point I complete the outstanding matters which mean to us so much in moving. But I have not the slightest regret that I escaped from the Tech even though I have pretty nearly run into the same mechanical environment here.

Since coming to the art department of the Provincial Institute of Technology + Art, plus, plus, plus, I have been in one big fight. Much ground has been won. There is still much more to win before I can have anything near the conditions I want. I doubt whether satisfactory conditions can be obtained under the set-up—it might be quite impossible. The whole institute is run by the Provincial Government—the tightest hamstringing system of education I have ever experienced. I cannot get one sheet of foolscap without sending in a written order; I cannot got $10's worth of art school supplies, lights, easels, mounting boards, etc., etc., without the order being sent up to Edmonton for approval. I am given one box of chalk + one pencil sharpener for six rooms. I cannot get light fixtures for the life room and I cannot get a single female in the city to pose undraped. The school won't let us advertise for models, they resent paying out for models, they want me to use the students at 50cts an hour (for bathing suits), and a thousand other such items I could add.

The school day was from 8.30 to 4. I fought about those long hours, especially as some of us have two hours at night to do, twice a week, and finally managed to get the time changed to 9–3.30—after three long battles. This alteration was the talk of the town two weeks ago. I found out that we were—by law—compelled to give 900 hours teaching in the 8 months school year. This new school time knocks hell out of those famous hours. "Hours be blowed…. never heard of such nonsense….. this place must be run as I think it should be"…. 70 hours mechanical perspective must be taught per year, 90 hours lettering, 90 hours colour, 120 hours still life…… classes must be changed every hour at bells to run smoothly with the shop-hours…. "nonsense," again to all the above….. Edmonton regulations…. teachers must be on duty every hour of the day…. "to blazes with that too." So, we don't need any bells, we don't take any mechanical perspective, we don't pay any attention to hours of this + that, and we don't recognise any criticism or advice from any people from any other department, NOW.

There were about 25 courses that students could choose (+ us with only 6 instructors; one full time + the others all part time) so I cut this choosing courses right out. You took what we could manage—a general course + an experimental course—students dear! No longer were we to be an insane asylum. The reaction was tense, cold and surly for two days by the students. Now they have seen that their daily conditions are far better than they ever were + things are going happily

along—in some order, in a creative way, and with the possibility of harmony throughout the art organisation. Today, we have 80 or more full time day students; fifty five of them veterans—who unfortunately are nearly all wanting a quick course in commercial art. I have to try + suit them, but they will get all the creative + experimental work I can push into them. They seem to be liking it too.

The understanding of art + appreciation of art is dreadfully low in the city. Never have the art conscious people been even slightly introduced to 20th century expressions—they are only able to appreciate sweet conservative + old fashioned English water-colour painting. Barbara + I both felt like weeping after we came out of the first two art lectures we attended in town. "The artist has no right to do anything except to please the public"…. "The work in Alberta is far in advance of those examples of water-colour + graphic art sent out here by the National Gallery of Canada"…. Oh! gosh! oh! OH!!! What a world!! "All this stunting by artists is to attract attention to the artist who undoubtedly has a decadent mind," etc., etc.

SCREAM!! by the Macdonald's.

Anyway, I was asked to talk on Emily Carr last week to the same crowd (some of her work being here on show) so I opened up some howitzers—the first shots have been fired + some targets were hit, and I gave them no question period afterwards.[11] I am asked again to speak in November—more shots coming + a little hint that some should come around to my side + look at the ammunition—might come to like working with it + for it, if they tried to make some effort.

Again, + finally, there is "The Coste House" of The Calgary Allied Arts. This is a useful thing + yet we have been smothering the possibility of a definite opposition by becoming members + entering into its activities in a practical way. The art school was housed in this Coste House during the war, so when it was seen that it would be brought back to the Institute, Glyde + Phillips, with others, set into concrete activity this Allied Arts Council, to conduct art classes, lectures, music, crafts, + so on. Everything was in full activity before I got here. Students were enrolled, lectures every second or third day, travelling exhibitions, and so on. I was not desired. But the Calgary Sketch Club took Barbara + I up—we had new views, they liked us, + they eventually brought sufficient pressure to bear on the Coste House to have me give a lecture. This is where my Emily Carr talk came in. The place was packed—previously we had seen only 30 or so there at any lecture—and evidently they liked my talk, as fully a third of the people told me it was the best lecture ever given + they asked for more. I guess we are "a pain in the neck" to the Coste House opposition. We think the development the best thing for Calgary + we hope that they succeed. I don't have any fears of our art school work being far ahead of theirs. We will always draw the students who want to know.

Calgary is a hick-town really. The faces are distinctly different, the people are very friendly + they are cheery, the transportation system is the worst in the world, the wind can be bitter + already we have had snow on the ground for days + the temperature down to 5° above—no! 4° above. We coast people feel the cold, the Calgary people don't seem to feel a thing. The houses are all delightfully warm + comfortable, with no work to them as there is no coal, wood, or dust.

Fiona is in Seattle. Quite happy + doing alright. I don't expect we will see her this Xmas. She is so well now, + so enjoying her friends + activities, that our worries + hers are apparently over.

Now, I have given you most of our reactions to our new world. Here + there they sound difficult + maybe depressing. There is work for us to do here + that is quite stimulating. When we eventually get our suite, we can gather in our new friends, listen to good music, and paint again. We are so much happier than we were at the beginning, when we discovered the set up at school, no likelyhood of a place for ourselves, the opposition brought into being before our arrival + the lack of any personal friends.

I will send all equipment I can get as soon as possible. It is a great pleasure indeed to help you both all we can. Please never give up asking if we can get the things you need.

Coloured post-cards would be useful to me. I can use them in a projection machine here, which works on the periscope idea + takes magazine illustrations, etc.

Thanks for your love to us both. We sincerely return ours to you both + do so hope that you are better Doctor, + of course you too Riki, and that the car is home again.

Barbara + Jock

11. In 1938 Macdonald purchased Emily Carr's *Young Pines in Light* (c. 1935) from an exhibition at the University of British Columbia.

<div align="right">

1607 – 9TH STREET, N.W.
CALGARY, ALTA.
CANADA
23RD FEBRUARY, 1947

</div>

My Dear Doc + Riki,

I have not the slightest idea when I wrote you last but think that it is certainly quite a long time ago. I regret this happening as I find much joy in writing to you both and still greater joy in hearing from you. First of all I must thank you greatly for "Romantic English Painters" which I thoroughly enjoyed—very nicely written and illustrated—and I feel proud to have it in my library. There are certainly some fine books coming out of England—Good Old England. And, the more amazing, it is to find you, over there, in spite of all the bitter hardships + difficulties, producing books, art, music, plays and films which are the essence of great culture. A

country which retains such poise, in years of stress, is saturated with Spiritual values beyond the possible—genius is still the "essence" (if I may be excused repeating this word) of your being.

We hope that you are both very well + continuing to be cheered in heart in spite of such a winter as you are experiencing.

I am at the moment non-plussed to know where I can find art materials to forward you. My friend, in Vancouver, who managed to get things for me when nobody else seemed to be able to has temporarily gone to Winnipeg—for 5 months—+ will not be returning until a new art store is opening in Vancouver. However, please inform me what are your urgent needs + I will try + find them somewhere.

We are mailing you a small parcel of "dainty-morsels" on Tuesday so hope that they will arrive safely. Not much to send at the moment but we will be more able to send in a few weeks.

Many things have happened since I wrote before. Fiona became very ill in Seattle + Barbara had to be flown out to be near her while in hospital. Barbara has been away three weeks now and I believe she now finds Fiona well enough to leave so she was expecting to go to Vancouver today, where she will take a holiday for two weeks, see her friends and have a good laugh. She needs that as we had plenty of reasons for anxiety. I don't know what you will think Doc, but I have felt pretty furious at a Doctor in Seattle. Fiona took a quinzy throat + was highly fevered.[12] She was living in an apartment with a girlfriend. On the 4th day Fiona sent for a Doctor (any one I suppose). He gave her Sulfa tablets + told her to take one every two hours for 48 hours. She was violently ill on that first one + still more ill on every other, until at the end of 24 hrs she decided to quit them. The Doctor never returned to see her. After stopping the Sulfa pills she felt better + on the 3rd day afterwards she went out, well wrapped up as it was coldish. Outside, she felt her skin itchy but boarded a bus. A few minutes on the bus she felt her lips funny + on looking in her mirror discovered that they were three times their normal size. She opened her mouth to look at her tongue so her cheeks fell into her mouth + she could hardly close her mouth again. Then her fingers + hands swelled, then apparently her body. She stayed on the bus as she was arriving at school where people would know her. When she got there her legs had swelled + they at once sent for a doctor. He had to give her something to deflate her + get her back to her apartment. Next day he discovered an abscess in her throat + later she became delirious. He whipped her off to hospital + had to give her 30 doses of penicillin. Her tonsils had enlarged like golf balls + when she was strong enough to stand the tonsil op. out they came. They were apparently utterly rotten. Fortunately Fiona has a tremendous appetite now so she is gaining weight again + has returned to school, as Barbara thought she would be better to be amongst her friends as soon as possible. But this Sulfa has set her back into an anemic

condition again + she had three of those peculiar amnesia spells, which troubled her so much before she went to Seattle a year + a half ago. However Barbara got this second doctor to give Fiona a tonic and together with her great appetite for nearly raw meat it appears that her recovery won't be too long delayed. She still gets red skin splotches and slightly swollen fingers in cold air. Was the first doctor correct, I wonder, in giving her Sulfa without a blood test + without enquiring about her previous medical history?

We got distressing news of Fiona at noon one Monday + Barbara was flying over the Rockies at 5.30 that night + arrived in Seattle by 9.30 the same evening. Marvellous going. She had to go by plane as the trains were blocked in Sask. for 3 days with snow drifts. Barbara had never flown before + scarcely ever travelled alone in the past twenty years. But she enjoyed the flight tremendously + when returning here she will fly. This has cut the bank balance quite a bit as the hospital, plus requirements, came to $220's. Have to do some sketching and sell some automatics to recover this.

Now for local news. We still have no apartment + I am still stuck about painting, but we expect to have an apartment by the end of March, as we have a definite promise. We are now more accustomed to arctic conditions but found 35° below for 10 days, and one day 40° below, quite a painful ordeal. Now we have suitable clothes to withstand it so didn't suffer nearly so much as we did in November at 25° below. Zero seems nothing now.

Barbara is liking Calgary pretty well. The elevation agrees with her and the brilliant sunshine is cheery. We have met quite a number of nice people, but in the art field and appreciation of new expressions I find myself out on a limb in companionship. This naturally makes it interesting for me to try and awaken the art conscious people but also at the same time I feel a loneliness. The reaction towards myself is rather odd. I find my students very thrilled + things are happening, but the older established conservative artists + their associates are cold, indifferent and actually state that the work we are doing here + at the school has no interest for them + don't see why we should count as having any art value in the Province of Alberta. Huh! They'll discover things ere long. We are pretty well in the same situation as you found yourselves in Vancouver. Actually things are going very well in the school + I have managed to break through a lot of red-tape which was strangling any advancement. In spite of an opposition set of classes being run at "The Coste House" we have a stronger enrollment than Glyde, Phillips, or Leighton ever obtained. There are some creative workers to be found in younger artists + I am trying to have them form a small group, to lift themselves free from the frustration they have so long endured from The Alberta Society of Artists. This is probably dangerous for me in my present position, as it runs counter to Glyde, but I don't care. Something must be born here to give the spirit of creative effort its head. If it costs me my position, in the end, it is worth that I believe. And some new ideas + thoughts would remain behind.

Somehow I seem to feel that we won't be here very long—maybe two years at most. The experience is interesting but I cannot entertain the thought of having it last.

I am dying to get into action myself and think that when we get our apartment that I will be so absorbed in painting etc., that I will grudge any time for teaching.

We hope that you both are getting time to produce art and that you Doctor are able to complete your books. What is happening in the art world? Any hopes of an automatic or sur-realist exhibition in Britain?

I sent two automatics to a show in Montreal this week. Those are the first I have sent east + wonder if they will be thrown out. The exhibition has two sets of juries—one conservative + made up from Canadian Academics + the other progressive. I chose to be judged by the latter.

Did I tell you that I went to Vancouver + Seattle at the New Year? I saw Florence + found her not too well. She seemed to have pain, deep seated around the part where she had the operation + also quite a bit of palpitation. I heard from Barbara yesterday that Florence seems to be ill at present. Cannot tell you more at present.

Will close now. Best love to you both.

Jock

12. Macdonald is referring to quinsy, a complication of tonsillitis.

2506 – 5TH STREET, W.
CALGARY, ALTA.
27TH APRIL, 1947

Dear Doc and Riki,

Here at last is our own home address, thank heaven! We managed to get a nice suite in the Elbo River district where the setting is most congenial, the shopping one block away, the open country + riverside also one block away and merely a ten minute run from the city centre. Also I am far enough away from the school to be seldom disturbed or called upon. The only disappointment is the fact that I still am without a studio. We took this place unseen—grabbed it on hearing what district the apartment was located—+ I had been informed that there were two bedrooms, one of which I had intended making into a studio. I hope to find a place near at hand very soon as I am dreadfully anxious to settle down to a session of work for months to come.

Barbara + I hope that you both are very well + that the summer sunshine will be most invigorating after the dreadfully difficult winter. We greatly enjoyed hearing from you, by air-mail letter three weeks ago. I have also to thank you for another of those decidedly charming books—"English Popular Traditional Art." I am very proud of my collection of those books + want to thank you very gratefully for your selection. I think that I am having much the better bargain having the books in exchange for art materials. I am sorry if

you have felt that I have been somewhat slack in forwarding you more materials, but please know now that I will attend to my duty + have things sent along with regularity. Materials are exceedingly scarce in this village and since I lost my Vancouver friend in business I am somewhat non-plussed at present. My friend should be back in business in Vancouver by June, I believe, + he will try once again to fill my requests. This week I will forward you pencils + if I can obtain them, a few sketch boards. I haven't seen a 16 x 20 board since last year, neither have I seen a decent 12 x 16. Those miserably brown things are being loaded upon people here. They will do for students but are not bright enough for permanent works. The water colour brushes are atrocious + are now away up at $4.50 a piece. They are utterly useless. If you will be patient until June it is possible that our supplies will improve.

In four weeks I will be through my first year of teaching. It has been a hard year, with many difficulties which cannot recur, and endless fights against impossible conditions + sheer stupidity. I feel we have won a lot of fights. Here are some of the accomplishments. Next year we will be given new equipment to the value of three + a half thousand dollars. The record for the past ten years has been three hundred. I have managed to be allowed a separate prospectus for the art department, coming out in June, where in the past the art department in the prospectus was smothered with items about farming, motor mechanics, radio, mathematics + so on. We are to have a formal + dignified closing, with an address by the deputy-minister of Education and presentation of diplomas, certificates and scholarships. We are likely to get the department brought into a single unit on one floor. We have eighty-five full time students + even at this late date we are increasing our numbers.

Some expressions of work will be certainly very new to this location + doubtless cause worry and a shaking of hands amongst the stagnant intellectuals from high places. If they are upset I will be highly elated.

Slowly, very slowly, things are moving towards us. It is rather amusing to watch. We are still kept at arms length by those who ran the art world here before we came + I am quite sure that they hate our innards + wish we stayed where we were. Glyde, who is here this week from Edmonton, is decidedly distant and the conversation I had with him two days ago was most animated, with artful sparring on both sides. But, I have formed a group of six progressive young artists + have obtained the North Gallery for them in Vancouver, next November, for their first showing. Glyde hearing of this development feels like pulling out of the Alberta Society of Artists but hasn't had the courage to ask me what I know of the new group. He won't pull out of course but would certainly like to be one of the new group. Last week the Alberta Society asked me to become an hon. member of the A.S.A. I accepted of course (diplomacy) and when I told Glyde—who is President—he didn't know anything about it, but remarked "Heavens! That's more than I am, I'm only President." Again,

this week the Southern Section of the Federation was reformed with one of the new group as Chairman. I managed to get two of my staff on to the executive + was also elected myself. This gives our department a hold on activities in the South end of the province + this is exactly what Glyde hasn't wanted. He wants to hold all + be the big cheese. I am asked to give the first lecture of the new set up + have promised to do so in three weeks. I intend to put into it as much meat as possible + give those who are present plenty to think about. My subject is likely to be on present day trends in art—which of course eats into the old fashioned doctrines worshipped here.

Don't be surprised if I am never permitted on the staff of the new school which will probably open in Banff in 1948. I am aware of the developing move by Glyde to keep me out. His statement to a certain professor in Edmonton that "we will bring in sound men from England who aren't full of stupid ideas about useless modern expressions" was doubtless said with a reflection to myself. If he thinks that sound English artists are still conservative he is likely to be surprised. Come what may no difficulties or disappointments will alter the directions I want to follow.

Fiona is now in excellent health. She should be returning to us in a few weeks.

I don't know what the outcome will be over my summer. In a letter received when being appointed here, Mr. Fowler, my boss, wrote that I was free to use my four summer months in whatever manner I desired. Two weeks ago he said, at a full staff meeting, that I, being on my first year, would have no holidays. I did not reply to this remark, nor have I brought the matter up, but on the 1st of June I am clearing out for my four months + nothing will alter the statement I have here in his letter. I expect to go painting for the full month of June to begin with. This slippery trickery by Mr. Fowler is detestable and for once he'll find he has "no weak sister" because he can have my resignation if he fails to abide with what he writes. Why cannot educational departments work honestly with their employees? And do they think that their employees are just a bunch of mechanical termites, afraid of themselves + their positions? Huh!

Sometime soon I will write again. We will be delighted to hear from you soon and many thanks to you for the books.

Our very best regards to you both. Happy + successful days.

From Jock

2506 – 5TH STREET, W.
CALGARY, ALTA.
31ST MAY, 1947

Dear Doc + Riki,

We were delighted to hear from you Doc. the other day. Barbara will be replying to your letter very soon I expect. I also have to thank you both for another book "Wood Engravings" by Thomas Bewick. Proud to have it in the nice collection you have sent me. I feel very fortunate.

We mailed you a parcel of "foods" two days ago so hope that "they" arrive safely + that the things will give you as much of a change as the previous one did. We were so glad to hear that they help to make a break to the monotony you have to experience in Britain. I can hear you both say "Yumi" to some of the now strange tastes.

We are both very well + have good news from Fiona. Fiona will not be returning to us until early in July as she is waiting to drive to Banff with American friends. The trip will be most interesting + after all there isn't very much for her to do in Calgary if she came earlier. We are enjoying our suite very well + feel so much better about things through having a place to ourselves.

But, I am in a bit of a puzzle at present and do not know quite what to do. My inclination is to remain here, as things are progressing in a healthy way now and there isn't the slightest doubt that we have made a difference to the art understanding + art advancement in this part of the world. This past week I have been asked to take LeMoine Fitzgerald's position in The Winnipeg School of Art and be acting-Principal next year.[13] I received a letter yesterday from the Board of Directors stating that they were trying to come to some conclusion about what would happen after next year. Fitzgerald is having a years leave. It wouldn't be wise to take the position unless there was some definite promise of a position after the year. The salary would be the same as I will have here next year, so I really lose money through moving + would, or likely would, be faced with the same problem of housing as we had this winter. The only thing to gain is prestige of position. The quality of that is debatable, I believe, as the developments that have been accomplished here now equal if not surpass the quality of the Winnipeg School of Art. Another teasing offer is a renewal of the request to come to the Ontario College of Art in Toronto. They invited me to join them last fall but I preferred Calgary. This time they offer me three hundred a year more than I receive here. The position is nothing more than coming on to their staff. Again, I doubt if it is worth while leaving the Western region. I believe that if people want me now, it is quite possible they will want me in a year or two years from now.

The art closing went off well, with an address by the Deputy-Minister of Education, presentation of diplomas, and an exhibition. In spite of it being a devil of a place to hang a show—the school auditorium—it looked very well. Everyone admitted that it was the finest art school exhibition ever seen here. I hope to have it shown in Eatons' or Hudson's Bay in September—where hundreds of people can really see it. What is interesting is the fact that 90%, or more, of the students want to return next year. Never before have more than 25% returned, our enrolment will be up to 100 full-time day students.

Dr. Grace Morley has reserved space in San Francisco for a one-man show during August. This is exciting. She wants about 50 things of which 30 will be selected for exhibition. This means a lot of framing. I wonder if the catalogue should have some sort of statement about the work printed on it. What do you think? I wonder if you Doc or Riki would be kind enough to write about 150 words which I could have printed on the catalogue under your name? I'd be overjoyed if you would do so.

Again, the Hart House, Toronto, have written me this week to say that they are giving me a one-man show from 10th October to 1st November, giving me 135 running feet of wall space. I wrote to say I will take the space, but wonder if my work can be sent from San Francisco to Toronto in time. I have however more than what is needed for Frisco, but I feel that some of the things I send there will be a help to the Toronto show.

I had hoped to get a fair amount of time to paint this summer but gradually I find time being eaten up. I have promised to go to instruct in landscape, at Edmonton, for two weeks in June. They are paying well. I am interested in going because I have never been to Edmonton + it is right in the centre of Glyde's domain. He is not loving me any better as the months go on—you know the reason why. There will be five weeks to do at Banff—from the middle of July to the end of August. So the summer is being cut up I'm afraid.

You will be surprised + somewhat shocked to hear that Grigsby died—fairly suddenly of heart failure—ten days ago. The Art Gallery in Vancouver was naturally knocked into a tizzy. It is possible that Gerry Tyler will take the position of Curator. He would undoubtedly be the best B.C. man.

Florence Waddington is over in Victoria just now. Evidently she is either selling her house in Vancouver or, if it wasn't hers, then it is to be sold. She seems very unsettled indeed.

I see in the Canadian Art Magazine—several articles—that the English paintings at the U.N.E.S.C.O was quite the most alive exhibition there + it was definitely felt that the younger artists who would lead the new movements in Europe would be there in Britain.

How are you both coming along? We do hope that you will find a flat in London very soon. It will be a happy day when you do.

This place is dreadfully short of art supplies. I will send you some pencils this week—for certain—but I cannot get any 16" x 20" canvas boards yet. Will send along some as soon as I can obtain any.

Will write soon again. Barbara + I send our very best love to you + all good wishes for a good warm summer.

Yours aye,

Jock

12. The Winnipeg School of Art was founded in 1913, a year after the
 Winnipeg Art Gallery opened. Fitzgerald was its fourth principal.

Dear Dr. Pailthorpe + Riki,

We hope that this letter will be a re-union as it appears with your moving to London and our moving to Toronto contacts have apparently become disconnected somewhat. We are dying to hear how things have gone with you both and sincerely hope that you have at last become established in good old London again + gathered together your good friendships there. We await with much interest your news. Meantime we hope that you are both very well + happy about returning.

It is only now that we are beginning to feel that we are fitting into our new life. It has been a long restless period for us since last July. First of all Banff, then returning to Calgary to pack, coming here, living temporarily for a month in George Pepper's studio + finally finding a basement apartment three weeks ago.

Although our basement has to be artificially lighted, on the brightest day, in the living room we are told that we are extremely fortunate to have found a place at all. This is probably very true, but, after our cozy bright apartment in Calgary, we thought the dungeon environment was decidedly depressing. However, we feel cheerier now that we have a few pictures around + some comfortably arranged rooms. We have a nice kitchenette, a bedroom—which of all things is off the bedroom—a sitting room and then a private bathroom across the basement hall. And we have booked the garage. We have no car but I have visions that I could add a few alterations to the garage and use it as a studio. It is likely that we will hang on to this place with the hope that eventually we will be able to get one of the large studios, in The Studio Building, which Lawren Harris built for the "Group of Seven" crowd back in 1914. One of those studios would be ideal for us as we could live there. If we move to better quarters then people may think we don't require one of the studios.

It may have come as a surprise to you that we only remained one year in Calgary + came to Toronto. Much as we liked the Calgary people I felt so far out on a limb from the art world and so bogged down with red-tape at the art school, plus being jipped over holiday periods that I thought we would be better at The Ontario College of Art here. Barbara liked Calgary exceedingly well but she now feels that she is also going to like Toronto. From my own selfish point of view I am certainly very much happier here and things are active and encouraging.

In school I have a devil of a lot of students to look after + exhausting hours on Thursdays + Fridays, plus an added 3 hours on Saturday morning, but I am free on Tuesday afternoon + all Wednesday. I receive quite a bit higher salary than I could ever receive in any

job in the West + I have my four summer months entirely free, plus about three weeks at Christmas. The school is sensibly run. If I have business to attend to I can set the classes to work + leave, if I want a coffee I can go out + have it, I can smoke if I want to but naturally that doesn't bother me, and there is no nonsense about calling the roll, marking attendance registers etc.; all I have to do is teach. Naturally, this environment suits me + this is the first school I have ever been in that has left me free for the job I have been asked to do.

Now, you will ask, what about the instruction? Isn't the place very academic + conservative? Yes! decidedly so. But I have taken it that I have been asked here to break through the old academic instruction + this I am doing already. I am not instructing advanced students. This is better as I have the 1st + 2nd year students + they are formative + there are no barriers to break down. The second year students I have for still-life + composition. I have to give them basic training in technical methods but in composition they are working purely on expressive + creative ideas—with music, with any medium they desire, and all emphasis on space, motion, etc. They are happy + keen + already the 3rd + 4th year—whom I don't have—feel that they have or are missing something. They have of course, poor things. I don't expect to be "hauled over the coals" for being too reactionary as Mr. Haines, the principal, told me I was free to instruct according to my experience + I asked him at the beginning if he really meant that.[14] He said yes, very decidedly.

My automatics caused tremendous reaction at the Toronto University showing in Hart House. They stated that they never had a show which caused so much discussion + gave so unusual an expression. They invited me to talk there + invited me to return time + time again to meet certain people. Prof. Fry, who has just brought out a book on William Blake—"Splendid Symmetry" (I believe) was most impressed + remarked that my short talk was the clearest exposition on 20th century art he had ever heard from any artist.[15] The show is now out at the extension department, at Ajax—30 miles from here—+ I have to go to speak there on Wednesday this week. Then the show is going to Oshawa. Nothing has been bought, but that is to be expected. The interest is sufficient + news of it has travelled around + this has given confidence in me to the art students.

Barbara has been drawing (life) too since coming here + it is likely that we will both do that sometime each week in George Pepper's studio.

We had to leave "Watch" with a friend, in the country near Calgary, as we thought it would be no life for a dog here, before we found where we were to live. We hear that Watch is quite happy + not only enjoys the country but a companion in the home he is at.

Fiona is very well and, if you please, become engaged to an American in Seattle. He is about eight years older than she is + apparently her ideal. There is nothing one can do about it but hope that she knows what she wants to do—I feel she is rather young but I suppose Elizabeth (Princess) is just as young. It wouldn't surprise us if she married in a few months.

I am engaged for Banff again next summer so that will mean a trip out West for Barbara + myself. We would like to see all our friends there + be out of the Toronto summer heat.

We cannot tell you about Florence Waddington at all. She sold her house in Vancouver, + her cottage on the Island + we cannot find out from anyone where she is. Nobody seems to have had a line from her since last May. We haven't heard that she is ill or anything. She was in Victoria in May—that is the last time we had a note from her. I wonder if you have heard from Florence.

I heard last night that the Canadian Group of Painters accepted for exhibition my first automatic oil.[16] The exhibition is to be in Toronto first, then Montreal + after that Ottawa. I wondered very much if they would accept it as it is entirely out of the usual line of exhibition pictures. It is a 24" x 38" (upright). I named the painting "Ocean Legend." Truthfully, I am not altogether satisfied with it—not enough depth in it + a bit too busy. However, it is a start and more will come in the future. If I get a print of it, I will mail one to you sometime. I have really painted 3 canvases but only felt this particular one worth entering.

How about your painting? We hope that you have settled sufficiently to start working again. Would love to hear all the art news of Britain. We had a nice dinner talk, at the Pallisar, in Calgary, with Dr. EFOR EVANS—Vice-Pres of the British Arts Council. We told him about you both + we hope he meets you. He is very charming + has a fine sense of humour. Do you know him?

We are sending you a parcel + do so hope that you receive it.

Love from us to you both. Looking forward to hearing from you soon. What do you want in painting materials? Please don't hesitate to ask for it. We will be delighted.

Yours aye,

Jock

14. Canadian painter Fred S. Haines was Principal of the Ontario College of Art from 1933 to 1952.

15. Literary critic and theorist Northrop Frye was a faculty member in the English Department at the University of Toronto's Victoria College from 1939 to 1991.

16. The Canadian Group of Painters was formed in 1933; Macdonald was an original member.

Dear Doc + Riki,

We are so glad to receive your new address + to hear that you have at last settled in your own home. We wish you every happiness and a full measure of peace so that you can write and paint. What equipment do you require. We can send it from here as supplies are plentiful in Toronto. Please don't hesitate to inform us about this as it is of vital importance that you are not hindered through shortages.

Yes! it was Barbara who mailed you a parcel last July or August. We are glad you got that parcel but we are hoping that you will be able to pick up the one we sent you for Christmas. We mailed it to your address at Harley Street about two weeks ago. It should arrive there within the next week or ten days. Hope the few items will help to relieve the monotony of your severely restricted table. Before long we will send you another parcel.

We are sorry to learn that you have both been so inconvenienced with "flu" + other physical trials. I wonder how anyone keeps body + soul together over in Europe. We are both very well + enjoying the activities in Toronto, as there is plenty of vitality in the art world as well as in the music + drama fields. B + I went to see Katharine Cornell and Godfrey Tearle in "Anthony + Cleopatra" recently + enjoyed it greatly, though we both thought Tearle too old + moth-eaten physically.[17]

Ha! here is a laugh for you—I had my automatic canvas "Ocean Legend" accepted in the Canadian Art Group show here. The only review I read about the show had this to say "The curio of the exhibition is by JWG—who has created a painting, apparently with part of the subject matter a woman, who has her viscara showing." I nervously looked in the dictionary to discover what part of her anatomy was "the viscara." Just a bit relieved it is what it is. Now I am spoken of as "the artist who specializes in viscaras." The painting has pleased those who know but the others are decidedly mute. It will be reproduced in the Canadian Architectural Journal—January 1948—so I will mail you a copy, not that it is saying anything very much but you will be interested to see what has been said by myself so far. Certainly my water-colours have set up all kinds of talk + interest—no sales so far. The show is now out at Oshawa, 30 miles from Toronto. In the Xmas holidays I will have George Pepper's studio to work in so will get into action once more. Dying to start. Pepper is going out West for 2 weeks. Things at the Art College are going nicely—have 2nd year painting students experimenting in expressive arts on Saturday mornings—results promising too + they are very keen + happy. So am I. Thanks for Florence Waddington's address + also for Mrs. Askanasy. We will write Florence + get in touch with Mrs. A.

No special news from Vancouver. Lilias Farley (African Mask) has apparently to undergo a goiter operation soon, poor girl—nervously upset over it. Dr. Hill Cheney + Nan Cheney[18] are selling home as Hill is now doing a lot of X-Ray on Vancouver Island + I expect they will go to Alberni or Comox. Met W.H. Malkin, holding a ticket, on the street car recently. Saw Dr. Agnew—Vancouver too. Hope your winter will be mild. It is warmer here—a blizzard one day + rain the next. No physical misery so far.

Will write you a long letter soon. Looking forward to hearing from you soon. We are so glad to have contacted you again.

All good wishes for Xmas + soon happier days with pen + brush.

Sent your good wishes to Fiona. Best love from Barbara. Yours, Jock

Dear Doc and Riki,

Where should I begin to thank you for all the things you have sent? We were very delighted and most interested to receive the linoprint—all safe and sound, and are thrilled to have it in our special collection. Thank you very specially Doc. Then there was the fine long letter (air mail) from you Riki, with all the interesting news. Don't know how you got so much on so small a space. Again this morning arrived "Britain Today" + a day or two ago the Penguin "Modern" or rather "New Writing." Both are on the bookstall shelves here but I had not bought either + am glad to receive them. I got the previous "New Writing" + have been picking up "Horizon" for the past four of five months—together with the weekly "Listener." But I have never run across "Polemic" or "Transition" here. I wonder if they are still produced? Most interested to hear your views on the state of things in relation to "true creative" art in Britain—it is merciful that you find (still) some evidence of a pulse + that you believe some careful nursing will somewhat revive the vitality in London. Oh Yes! I would be most anxious to send something over to you to be placed in an exhibition of your students work + I hope to have some new things by the time you would desire the show.

Although I have found no studio yet + feel somewhat miserable about this I am never-the-less not letting things slide, as I am working every chance I can (four or five nights a week) on water-colours + black + white in our little kitchen. I am beginning to free myself again after the lay off but realize that it will be a week or two yet before my mind is open for production. I am not worrying over the difficulty of breaking through + not forcing things—continuous devotion to effort is the line to

take I believe. Now that my school work is going well + the students gained faith in my instruction, with enthusiasm, I have no longer any anxiety to retard my effort. It is certain that I can now have a long stretch of production. With more room more variety could be produced—oils, water-colour, lino, pen + ink, monotype, etc. It will come.

Now about materials. I will do my utmost to get all you want. However, it isn't just so easy as I find the art supplier will not give me more than two of a kind of anything at a time. This week I will now send you some water-colour pans, crayons and 4 B's. I will get the College business manager to hunt up the mounts + get two folios. If he can get this he can get it at a cut-rate. David Cose[19] paper I cannot find so far. Can I get Whatman for you? Parcels of material will be small but frequent. This is the only way I can purchase here. If I am stuck then I will write my agent friend in Calgary to mail you the things. He will give me all I want + I also have a friend in Vancouver who would do the same. We are delighted to help you both all we can + please don't worry about sort of squaring things up. It is the least we can do for good old England and art.

Barbara was so glad you received her parcel safely. Will be another coming along ere long. Prices are bounding up very seriously here now + restrictions are somewhat stiff—especially on vegetarians as they have cut off all imports of veg + fruit from the USA. Naturally there is practically nothing left. Cabbage is $1 a lb—all fruit very high too.

My works are still at Oshawa. I have to go out there to talk tomorrow night to a group there. Sales are nil and newspaper reports are similar. But I believe contacts will come up soon across the line—where there is some understanding + probably appreciation. It may take most of a year to find contacts worth while.

Fiona is very well. She has delayed the wedding until Spring. We think it wiser too. Barbara is in excellent fettle +we are both enjoying our associations with the bright young things—the art students. Was at one of their parties last Saturday + it was fun. Will write a full letter soon. There is a fine show of extremely modern sculpture—from the Toledo Art Gallery— in our gallery here at present.[20] Good! Keeps irritating the Academy deadheads. Love from us both.

Jock

17. Macdonald is referring to the play *Antony and Cleopatra.*

18. Nan Cheney was the first medical artist in the Faculty of Medicine at the University of British Columbia.

19. Macdonald's handwriting is unclear here; it looks as though the name could also be David Lose.

20. The Art Gallery of Toronto hosted the exhibition *Sculpture Today* from January 10 to February 1, 1948. The exhibition included work by Henry Moore, Isamu Noguchi and David Smith.

Dear Riki,

I am feeling somewhat restless over the fact that I have hardly sent you any art materials yet + that this is probably causing Doctor and yourself some anxiety. Truthfully, I haven't had much of an opportunity to look around as I was rushing some work through for the Ontario Society of Artists exhibition + had also to prepare a paper for the College Students—on "The Significance of Modern Trends in Art." Several of us are trying constantly to break down the academic narrowness of the College, so my lecture had to have some forceful facts which could not be refuted by the intellectually smug. The interest was sufficient to fill the hall—that in itself must be rather disturbing to the chief who says "nothing but Academic painting will be expressed in the Ontario College." He does not know that I have 70 painting students doing creative painting on Saturday mornings—he is never there to see what we are doing. Someday the lid will blow off, but by then the interest by the students will be so great that it will be impossible to close the door on creative work. I will now attend to the art supplies + see that they get away to you.

Many thanks for the two books—Cezanne + The Russian Ikons—which I am delighted to receive. I have been interested in Ikon paintings for years + enjoyed seeing several in the Toronto Museum recently. Of course I love Cezanne too.

The Ontario Society of Artists took my new automatic oil and also the water-colour I sent in.[21] I am not altogether pleased with the technical finish of the oil as I felt that it required another weeks sound painting—the statement appeared sound enough but the technique needed more finish. I sold the water-colour which the Canadian Painters in Water-colour accepted but now they have sent it on a travelling—the owner is quite pleased about this.

We still have winter—about eight inches of new snow today. It drags along so long. I hope that you have had an easy winter + that you both are enjoying London very greatly. We would like very much to pop into London to see you both. I wonder when that can be managed. We hope that you are managing to find time to paint. Jackson (A.Y.) is going away for 5 weeks so he is loaning me his studio. I expect to use the garage at home after that if the weather is warm enough.

Oh! I nearly forgot. Can you tell me of an art school in London which is up to date in instruction + provides the students with an opportunity for free expression in painting. Some of my students don't want to be tied down to old forms of instruction during their 3rd + 4th year + feel that they would like to go to Britain—

London preferred. It will be most useful for me if I could refer certain students to a good school in England. Please don't forget to tell me which one you would recommend. I would hold those students but I only have the 1st and 2nd year + I wouldn't be surprised if I wasn't given them next year—could be squeezed into the design side so that they kept the painting pure (?) Barbara + I send our love to you both. Fiona is happy + well.

Jock

21. Macdonald had two works, *Birds and Environment* and *Fantasy*, included in the Ontario Society of Artists' exhibition, which ran from March 6 to 28, 1948.

23 MILLBANK AVE
TORONTO -10.
14 MAY, 1948

Dear Doc + Richard,

We were exceedingly disappointed about your being disappointed over those chicken limbs. My mother + sister also had to discard similar parcels. They were sent over by air fright express—new idea—+ were guaranteed to be O.K. Have had refunds but that doesn't mend the regrets all around.

Very interested to hear that the Berkeley Galleries are giving shows of artists of the British Commonwealth and appreciate your mentioning my name very greatly. Certainly interested that you further the idea. Would love to send if I can give interesting enough work. Should manage to contact customs regarding shipping to England in a day or two, so will write you regarding that as soon as I discover the situation. Have been all tied up with work for the last week. It may be as well for me to have until early next year to show—if selected—as I have sold quite a bit of my automatic work—six more having gone in the last month or six weeks. By the way, would London require water-colours or oils or both. Another thing, I recently bought a camera—German "Retina"—+ can now take coloured "Koto"-slides of my work. It may be a good idea to send some along to you as they could be projected + give an excellent idea of what my work is saying. It will take two or three months before you could receive any as the film will have to be fully used + it takes six weeks to have the prints made. I felt that I should get this camera—specially to make a record of my things + to have them to send as examples when trying to get a showing somewhere + to take things in colour for my own lecturing—should I be invited to do so.

Things are going along very happily. Not enough time to produce very much yet but I have a place to work now as I share a studio with a sculptor. This is better than nowhere but I really want a place for myself—

where I can experiment + have no-one coming alongside to see what I am doing. I may change the studio for another soon. I was invited up to London—(Ontario) last week to open an exhibition at the gallery there + to say a few words. Must be a sign of age, eh! Over five hundred people turned up so I gave them an outline on the significance of 20th century art. Judging from contacts after the short talk it was evidently just the subject they wanted to have an artist talk on—the thing was apparently a jolt, an awakening and a necessary confirmation. At the Ontario College of Art the seed of modern creative expression isn't planted on a rock. The soil around it is slowly warming + the first tiny root is digging down. I am allowed a space at the college exhibition in the art gallery—only 10 or 12 feet wall space, but that is a young squid. Nothing but ancient academic work has ever been exhibited before. I am to be retained next year + the boss—Mr. Haines—told me the other day that I had done notably + was a distinct addition. They are adding Carl Shaeffer to the staff next year—another for our side.[22]

Barbara + I are going to Provincetown—Cape Cod—for 2 weeks in June—guests of Mrs. Margaret McLaughlin (Buick Motors).[23] She is going to Hans Hoffmann's summer school + I am taking this chance of meeting Hoffmann.[24] He was associated with Klee, Kandinsky, Franz Marc, Ernst, etc, in Berlin in the early part of the century.

Barbara had a very cheery letter from Florence Waddington today—mailed at Honolulu. She was thoroughly enjoying her trip + new found friends.

Before we go for the summer I will mail you some artist materials. I have difficulty over the mounts but should manage to send some—also some more water-colour. Cannot find good water-colour paper at present.

We hope that you are both very well + that you have now settled down comfortably. And finding time for work. Wish we could see you to have a good talk.

All automatic things—in oil + water colour—which I have sent to shows are on travelling exhibitions—one water colour off to Australia. But I am much more anxious to settle down to production than to show. Next year—or after summer—I really know that I can settle to a long unbroken spell. My school work is now in order + I needn't let it take first place.

Love from us both, Barb + Jock

22. Carl Schaefer was a student at the Ontario College of Art in the 1920s and worked in the painting department from 1948 to 1970.

23. Margaret McLaughlin is the painter Alexandra Luke, who was a keen student of German-born, American painter Hans Hofmann.

24. Macdonald is referring to Hans Hofmann.

Dear Doc + Riki,

It is certainly ages + ages since you heard from us. Although we have been silent for so long we have never-the-less often thought about you both and very much hope that you are both well + that the summer has been both beneficial + interesting.

We are very well and had a very full summer as we were from the Atlantic to the Pacific and back. It will probably be just as well to let this letter flow along as remembrances of the summer crop up in trying to give you our news.

About the middle of June we went down to Provincetown, Cape Cod, for two weeks. Knowing something about Hans Hofmann, who incidentally is having a big one man show in Paris during October or November, I felt that I would like to meet him, so went to his summer school classes in Provincetown as a student. We were very impressed with him + felt that he was one of the great men of the century, in his spiritually poised concepts of plastic-space creative art. We found his wife and himself most delightful, exceedingly sensitive and aesthetically profound. I greatly regretted that I had so short a time + had to go to Banff to fulfill my promise to be there to teach. From Hofmann's dynamic + critical statements I gained most valuable knowledge + was tremendously interested in his philosophy of plastic-space expression from the objective subject matter. He, however, values automatic expression as the essence of creative work + has (+ does) much work in this field. He was very impressed with the one automatic water-colour I did down there + remarked that I should devote the remainder of my days to painting + do nothing else but paint. Wish I could. I expect you both know Hans Hofmann. You will certainly be seeing some reproductions of his work soon + may see his show in Paris. If you went over to see it, we would be exceedingly interested in knowing what you felt. I think "Horizon" of last October or November had an article on him + I know that they remarked that in their opinion they placed him as the teacher of art who had given the greatest contribution in America this century towards the advancement of 20th century art. And by the way we returned to Toronto with a superb automatic water-colour of his, painted in 1945.

Provincetown is a delightful little fishing village, quite un-Americanized + it is an amazing art conscious centre. It has its summer theatre, art gallery, free musical evenings—classical records—and dozens of studios for artists. We loved the place. The shore-studio (gallery) sells no less than $27,000 dollars worth of art in the two summer months, most of it work which, if not sold, would be exhibited in New York galleries in the following winter.

Just before going to Banff we bought a 1935 Oldsmobile so we drove out West through the states. Not knowing the car well + being limited with American funds we took the most Northern highway + avoided large cities. We reached Calgary in six days after a mighty hot trip as the temperature was around 100° to 105° every day. Some of those prairie roads are endless + desolate. We had a little trouble here + there, some excitement in a terrific wind + hail storm in North Dakota + some amusing incidents—like the one where we were locked in a beer parlor for two hours as the town was going to a funeral. We were advised that the "pub" was the coolest place to go for a rest. I slept there for the two hours.

Banff was an exhausting + rather miserable experience. The only happiness was in the meeting of some very nice people + a few good party evenings. The weather was atrocious—only 7 dry days in six weeks. As the school isn't fitted up for indoor work naturally it was just a nightmare trying to keep things going in a worthwhile way for students. Now-a-days, the school has developed into a routine job, with university credit courses for art, music, drama, crafts, etc, and the staff hasn't a holiday at all, as timetables are packed with lectures + examinations, etc. I have been asked to return for my fifth year but I am fairly certain that I will not do so next summer. I think it a stupid loss of ones own time. Here I find myself at long last with 4 months free in summer. I should use this opportunity to work for myself. So it isn't at all likely that I will prevent myself from just doing this next year.

After Banff we pushed along the Big Bend Highway + Fraser Canyon to Vancouver. It was nice to see some of our friends there + somewhat different to see Vancouver from visitors' eyes. For the first time I was convinced that I had gained much by moving to Toronto. In the week at Vancouver I heard so much about the squabbles + tensions in the art world there, about the expanded egos + bitterness that I felt well out of it all. Quite a number of our friends had of course moved away. Florence Waddington is now in Australia + apparently enjoying it. Did you know a Mrs. Ainsworth + a Mrs. Lewin? We spent some hours with them. I took in a restful afternoon at a cricket match at Brockton Point + we went over to see our old home at Capilano. One wouldn't know Capilano. It has completely lost its country atmosphere + is now a busy noisy spot.

After Vancouver we went down to Seattle to see Fiona + her husband. We found them both in excellent health. Fiona was absolutely happy + we both agree that she has a fine sensitive + kindly companion. They will get along very well together. We stayed four or five days + then drove across the states to Toronto.

Although it was late in the year + we were taking decided risks with the old car we visited Yellowstone Park +

the Bad Lands. The park is in Wyoming I believe + the Bad Lands in South Dakota. Both places are amazing geologically but I was not at all impressed with their painting qualities. Wyoming is the greatest painting landscape—semi-desert + magnificent. The rivers of boiling water + millions of steam baths in Yellowstone is something one cannot forget, but so is the landscape in the Bad Lands. The latter is like something that has never been created—a horrible hole really, with a devil of a road for 47 miles. All the land is eroded, tortured, + entirely without vegetation or even mosses. Most of it is a dead blue grey but where there is colour it is an anemic pink, sulphur pea-soup greeny yellow + dead flat and dirty green.

The much further south road which we returned by was far more interesting + we found the American people tremendously kind + helpful. We took ten days to return— again having a little trouble with the car but not anything serious. It is however an uncomfortable business having to travel with so limited an amount of American cash. We hope to see the dollar restrictions taken off by next summer.

Here we are back in our basement apartment— which we now like very much. Toronto is providing delightful fall weather too.

The college is in session again + I have my time table for the session. I created enough fuss at the end of last term that I have managed to escape all night classes. I feel so different about this as I can really plan my winter + be able to devote myself to a programme of painting, either at home or in my studio. Now, I feel settled enough to work + I can work without feeling my time broken up.

You will remember my saying that I introduced to the college last year a course of instruction relating to 20th century creative expressions. Well, this work has been accepted as absolutely necessary + this year I have been specially asked to continue in this way. Not only that, but I am now given classes (painting) in the 1st, 2nd, + 3rd year. To have the college recognizing values in any type of expression other than Academic is really something, as they have been entirely Academic, in painting, for seventy years. Now I will eat a little deeper so that before long the Expressive arts will be definitely one of the feature branches of the place. I am happy in my work + I feel keen about it as the students are very enthusiastic.

Barbara is enjoying life too. She is happy here + enjoys all the interesting opportunities for theatres, films, concerts, exhibitions, etc. And the new friends which are slowly growing.

But how about the two of you? We are dying to hear from you. We hope that your news will be good but with all the complications in Europe + the continued strain of economic conditions + restrictions it isn't likely that you will feel elated over very much. We hope that, even though it may seem far away, you can begin to see a little glow of light in the solemn sky. I feel most neglectful over failing to send you more art materials. I must get busy + see what I can find. I must send you some water-colours + somehow some of those mounts you required. I couldn't find the size you asked for. Again, we will get down to food parcels too—very soon.

Do write a note soon. Love to hear from you. Barbara + I send you our love.

Yours aye,

Jock

23 MILLBANK AVENUE
TORONTO 10, ONTARIO
1948[25]

Dear Dr. Pailthorpe,

James usually writes all the letters and I am not at all sure when he wrote last or what news he gave you. I expect he told you we went to Provincetown in June and that we bought an old car—Oldsmobile 38—and drove to Banff. The fares would have cost us as much as the car, it was a bargain. James was in a fine wit driving an ancient car across the States + us on our very limited amount of American dollars. Oh, that drive across the Prairie—hot as blazes and endlessly on + on! I could have sworn the car stood still + vibrated in the hot landscape, time stood still, or seemed to. After Banff we went to Vancouver by Canada over the Big Bend Highway, pretty rough, + the Fraser Canyon. Much as I liked Vancouver I don't want to go back to live there. This used to shock even James at first but I think he feels the same now! Next we went to Seattle—stayed with our new in-laws. Fiona looked very well + happy. Her husband is rather a quiet young man who reads a lot and we both liked him. I enjoyed the long drive home. We came back further South + certainly had to keep our fingers crossed towards the end. The old car had done well but it was beginning [to] show strain. We had had some stiff mountain passes to pull up over. I kept notes on the trip—it was quite thrilling at times.

This is to wish you both a happy Xmas + I hope the few 'eats' will help out the larder situation!

Very best regards from us both.

Barbara

25. This date has been added by someone other than Macdonald.

23. MILLBANK AVENUE
TORONTO
7TH APRIL, 1949

Dear Doc + Riki,

At least I will start this letter to you this evening. I have wanted to write you for a long time but, as you will discover, my life has been hectic for weeks and my correspondence has been forced into the background.

Yesterday, I returned from New York. But before going into this expedition I must thank you very sincerely for the delightful letter we received from you, early in February, with so much interesting news and telling about the pleasure the small Christmas parcel gave you. We were glad to hear from you + to know that you were very well in spite of "the ordered life" one has inflicted upon one in Britain today. Today, another delightful message comes from you, written on the postcard, inserted in the book of "Woodcuts of Albrecht Dürer" which we very greatly appreciate receiving. Thank you.

Where should I begin our news?

Well! Barbara + I are in excellent health + have come through our second Toronto winter without the whisper of a cold. We continue to be happy in this environment + with the several new friends we have found here. Because of the comfort of our little underground basement apartment, we have not attempted to find any other place to live. Perhaps we should try to get out from under ere long, but it still seems absurd to do so as rents are very stiff—upstairs—in other buildings.

Fiona appears to be very happy in Seattle, writing cheerily all the time + she still remains very fond of her American husband. We hope to see them again in three or four months as we expect to go out west.

I am not teaching at Banff this summer. I decided to have leave of absence, take a good rest from teaching and spend all my time working for my own pleasure. By promising to paint several B.C. landscapes for a patron, in Vancouver, I am able to find sufficient finances to go there for probably two + a half months. The necessary work for my patron will only occupy three weeks, or less, so I should be able to spend quite a while painting differently from the style desired by this patron. What the patron desires will not be rubbish but it cannot be new creative seeking.

Actually, this is the summer I should have taken a quick jaunt to Britain. I couldn't see myself being financially able to do so—maybe next year I will again turn down Banff + come over for a good part of the summer. Barbara feels she doesn't want to go back, but we'll see when the actual possibility of going is more concrete. Would love to see you again but...... £ or $'s?

I expect you are wondering just how my "automatic" paintings are going in this part of Canada? I am eternally indebted to you both for opening this new world to me + I trust that what I produce will be worthy of your great kindness. My work is now on a higher plane + with sincerity it will continue to develop. I am completely sincere about this form of creative work + it is the only source of creative truth.

My work has been exhibited in every show I have entered since coming here. I pass up the Academy. The Canadian Society of Painters in Water Colour took four of them this year in their exhibition—only one other artist had four works accepted—and they elected me a member of their society. Only two new members were elected this year. The other one being John Martin—a brilliant Englishman—who is one of our finest new friends.[26] And, listen to this, the Toronto Art Gallery bought one of the automatics for their permanent collection.[27]

Imagine!!! I was most astonished. There it hangs today with some twenty other water-colours they have bought in all the years, by Canadian painters. This is the first gallery to purchase one of my automatics. Two of the four works were picked for a select national travelling.

The Ontario Society of Artists took one oil (automatic) + one water-colour this spring. And because of their apparent appreciation this society elected me a member—the only one elected this year. They have also retained my work for their travelling. The National Gallery actually included another oil (automatic) for a Canadian show at the Canadian Club in New York + the Canadian Group of Painters also took another in their exhibition in Montreal. I am showing water-colours in Winnipeg at present, joint show with John Martin. Actual purchases have been very few, but I know that it might take me three years to break into acceptance of my work in Eastern Canada. Withestein,[28] in Provincetown, Cape Cod, Mass, U.S.A. placed my work between Stewart Davis + Kuppermann last summer in his gallery there.[29] He sold nothing of mine but has written to ask me for further work this summer. I hope to have some new things for him. Now that the hard part of the school year is all but over I feel that I have a good six months ahead for producing.

My work has been twice mentioned in the American Art magazines this year. I have however yet to say something really good + must truly work full out from now until next October.

I hate writing about myself. How can I tell you things unless I do?

Barbara went over to see the Braque retrospective exhibition in Cleveland recently and I saw it in New York last week when I was the instructor selected to go with 36 students on their fine arts educational trip, from the Ontario College of Art. Altogether there were around 140 pieces—including a few sculptures—and, as one might expect, they were superbly arranged. I found the exhibition a superb statement of colour and design, with a gradual rising spectrum of colour intensity. I also saw a one-man show, in a 57th Avenue gallery, from Ben Nicholson—good, sensitive, plastic and decidedly personal. He seemed to be selling well + should sell everything before the close of his exhibition. Saw several very good automatic paintings in the 1949 Selected American exhibition at the Whitney. The artists were—Boris Margo, Mark Toby,[30] Lucia Salemine, William Sertz, Lawrence Kupperman, Perle Fine, Adolph Gottlieb, Mark Rothko + Gabor Peterdi. I have written the names because you may be interested in having their work in Britain at some later date. I also have the addresses of those artists. The

students were decidedly "knocked for a loop" when they discovered hardly any academic work in New York. We still are fighting old fashioned art in the College. There is a Picasso show (24 works) in the Toronto Art Gallery at present. Five or six v. good things but some others quite difficult to appreciate. However, shows like this do help to prove the uncreativeness of the painting department of the O.C.A.—the lack of creative effort is my constant bleat.

It was decidedly interesting to hear what you thought about Herbert Read, though I must say we were most disappointed to hear you found him changed. In conversation with a New York friend, who heard two lectures by him when he last visited this city, she remarked that he was splendid when he lectured on the significance of 20th century expressions but when he came to slide reproductions + lectured about them he was a very different man. She felt he could write + lecture extremely well but couldn't speak convincingly about individual works. Do you think that there is any truth in this judgment? Perhaps this is the reason why you found him appear uninterested or non-committal.

Barbara had a long letter from Florence Waddington. She was on her way to New Zealand, to stay with Barbara's sister + her husband for an indefinite time. Florence appeared to be her old self again—what with her gatherings, discussions, new finds etc. It is good to hear that she has recovered so marvelously and is truly enjoying life.

I have had a lot of jumping around to do recently. First to Montreal on a Canadian Art Jury, then to London over the opening of a Calgary Group exhibition—the group I formed during the year I was there—later at Sudbury to jury another Arts + Crafts show, then Oshawa + in May I have to go to speak at Hamilton. Artists get expenses and receive from $15 to $25's in this part of the world for services rendered. Every little [bit] helps. And visits bring contacts and new mutual art fellowships.

We expect to go down to Provincetown, Cape Cod, Mass, in the latter half of June. I want to repeat contact with Hans Hofmann. I saw him in N.Y. this week + he was apparently well pleased with the reception of his exhibition in Paris in January. Picasso, Braque, Leger + Matisse received him with great affection + gave his wife + himself much happiness. We find Hofmann one of the great men— magnificently spiritual in personality + in his attitude towards art. In fact we love him. I must get his book to send you—"In search of the Real"—which came out about two months ago. He is now writing a second book—much bigger, comprising his thoughts about art from 1920 to the present. He is about 70 + in his early days, in Germany, was with Klee, Kandinsky, etc.

Edward Bawden is coming out to instruct at Banff this summer. I hope to meet him even though I won't be on the staff. Do you know him? John Piper was asked out but he apparently wasn't free. The Banff school will have 3

buildings up this summer. They are getting nearer to their ambition for the greatest school of the arts in Canada. The day will certainly come when I will have to make the decision—whether to go there or remain here. I now feel that I should remain in Eastern Canada—be near the active centres for a few years yet. We both feel richer for our two years in the East—that is spiritually richer.

Oh yes! I have a good camera now + can make coloured slides of my paintings. I will send you, sometime, the slides for you to look at + perhaps you will return them. This will give you a good idea of how the work is going. As there are 36 on the coloured roll it will be a little while before I use it up. I am all excited + ready to dive into work, so perhaps it won't take so very long.

The trip to N.Y. was very exhausting. We had to travel overnight, both ways, in a chartered bus as the War Vets couldn't afford anything better. It snowed both nights all night so we took 16½ to 18 hours to get + come from there and an average of 2 hours sleep in the 36 to 38 hours from morning of one day to bed time the following night. A bus isn't the best place to sleep. Never again if I can avoid it. N.Y. had a taxi strike all the while + the place was infested with batons attached to police. We stayed in the Y.M.C.A. + the girls in the Y.W. Very reasonable rates + quite comfortable. N.Y is pretty tough just now—ruthlessly mercenary + grabbing. Don't like Canadians because they have no money—being only allowed to spend $150 per year in the USA + not take home any more than $100 of goods. I would hate to have to live there for any length of time. The place is really like a vaudeville show, a circus or something. An amazing city—one moment you are elevated to a tremendous peak + the next you are utterly disgusted. I hear that the new gallery which Frank Lloyd Wright designed for the Non-Objective Gallery is being smothered out by the tenants of 5th Ave. who say it isn't in keeping with the surrounding architecture + will ruin the Avenue. Well? What a world!

We hope that you are both very well. Glad to hear that you manage to go on adventures and make new discoveries. We miss you very much, but are thankful for the Post Office + have contact with you through it.

Our very best love. Will write ere long.
Happy days,
James W.G. Macdonald

26. A British-born, Canadian artist and designer, John (Jack) Martin was born in 1904 and died in 1965.

27. *The Feathered Hat* (1948) is the automatic that Macdonald refers to, which was purchased by the Art Gallery of Toronto in 1949.

28. "Withestein" may not be accurate, as the name Macdonald has written here is unclear.

29. Macdonald is referring to the American painters Stuart Davis and Lawrence Kupferman.

30. Macdonald is referring to Mark Tobey.

"MASTHEAD"
41A COMMERCIAL ST.
PROVINCETOWN, MASS.
8TH JUNE, 1949

Dear Doc + Riki,

Hold yourselves ready for a bit of real news. I very sincerely hope to be able to see you this summer for, if all plans come through as expected, I will be flying over to the International Students Summer Seminar, being held near Rotterdam, about the 8th of July. I will be there until the 11th of August, then will come over to Britain where I expect to be until the 15th of September, when I will fly back from London to Toronto.

This most surprising invitation came to me over the phone, forty eight hours before we left to come here + I was completely taken by surprise. I felt as if I'd won a Derby sweepstake ticket award + hadn't even bought a ticket. You see, all my expenses are being paid. Barbara + I had planned to go out West—to B.C., to see Fiona in Seattle, and to paint landscape, as I had been commissioned to do several for a Vancouver patron. I was given half an hour to decide acceptance. B. thought I'd be crazy to turn it down + naturally I blessed the star that gave me a return visit to Britain after 23 years. Naturally, I will want to spend some days with my Mother—who is now 80—+ go to see my Sister in Aberdeen + brother in Chester, but I must see you both. No matter where you are in England in August or September I will find ways + means to come to see you.

Apparently, I was chosen as the Canadian representative of the Canadian Arts Council (artist). Don't ask me how it came my way. I don't know + I asked no questions. Evidently the few talks I have given, about art matters, around Ontario have rung a bell somewhere, otherwise I cannot see how I was selected. I am not a member of The Canadian Arts Council + I have not continued membership in The Canadian Federation of Artists.[31] Many artists will ask how the blazes Macdonald was picked for this. Their guess is as good as mine.

We won't be returning to Toronto until the 2nd of July. I will keep you informed about my plans. I know nothing yet as I had to come here before things were settled. It may happen that I will land in London before reaching Holland + may be able to have 24 hours there.

Meantime, we are getting well kippered in the sunshine here + I am attending some classes, with Hans Hofmann the instructor. I think he is a very great man—most inspiring, spiritual + modest.

Barbara + I have been very well. Fiona is recovering from a rather difficult operation. I will tell you about her when I see you Doc.

Florence Waddington is in New Zealand. Has been most difficult while staying with Barbara's Sister. She is still doing automatics. I wonder how long she will remain in the Southern Dominion? I believe that she likes Australia.

Excuse more at this time. We hope that you are both very well + that the summer is proving to be a good one.

You will hear from me soon.

We both send our love to you.

Jock

30. Macdonald is referring to The Federation of Canadian Artists, which was founded in 1941 by the artists who participated in that year's Conference of Canadian Artists held at Queen's University (known as the "Kingston Conference").

CANADIAN SEMINAR
CASTLE BOUVIGNE
NEAR BREDA, HOLLAND
JULY 1949[32]
SATURDAY – SOME DATE OR OTHER.

Dear Doc + Riki,

First of all greatful thanks for your letter received just before I left Canada. Looking forward with tears in my optics to seeing you both again. Should be able to do so for a day or two around the 12th or 13th of August. Plans uncertain as I may return by ship + therefore not fly from London. In that case I would probably remain in London for a few days before going to Thurso as I may have to sail from Liverpool.

Having an amazing time here. What an experience but at the same time what a test explaining art perceptions to such an intellectual, international body of students. Damn the intellectual—how can one break through to the other side of consciousness? However, the faculty + students seem to feel that I fit into their world here + that is good. My lecture yesterday—on art—was apparently quite a stimulating surprise to them. I have three lectures to give + about 12 seminars to fill my contract here. Not too stiff a programme.

Before I go further I want to find something out. The Director of the Seminar wants me to try + get Moore, Sutherland, Piper or Herbert Read, over here for a few days so could you advise me how I can contact them or can you advise me about who I should get? How about you Doc or you Riki coming? Expenses will be paid of course but about a fee I don't know yet. I have been asked to find out how to contact someone from Britain.

We are being entertained in a lavish way. This country has absolutely everything—food, clothes, homes, etc, etc. How have they done this so quickly? The Dutch are happy people + exceedingly gracious in every way.

This afternoon we all are the guests for dinner of the Burgomaster of Breda. On Monday we are all the guests of the Canadian Embassy at Rotterdam + will have another great day. Later on we go to Amsterdam + I believe still later we go to Cologne, Boon + sail back up the Rhine. The whole Seminar is one of a reasonable amount of work, much travel + general education. Everyone mixes here in the happiest way. The Germans, Fins, Poles + Checks[33] haven't any money so a nice fund has been gathered from others in order to let them have the same experiences as anyone else.

I still wonder how in heavens name the Canadian Arts Council selected me to represent them. What a fortunate break for me.

The Dutch all cycle so I have rented a cycle too. Everything is practically given away to the Canadians here. The Breda people were liberated by the Highlanders + the Canadians + they have not forgotten the marvellous experience.

I enjoyed the Atlantic flight under ideal conditions. Toronto to Montreal was pretty rough.

Barbara + Fiona were both very well when I heard yesterday. Wish Barbara could have come here. However there may be another chance as the Director remarked yesterday that I would probably be considered their permanent artist representative from Canada—this may suggest another trip next year or in two years.

I want to get this letter down to air mail weight so will wish you both well + hope to hear from you very soon + see you both before the next full moon. Delighted to think I can see you in London. Will write again ere long + if I am to remain in London for a little while, before going north perhaps you could look + tell me what Hotel to come to. Kindest regards,

Jock

the Director thinks that the seminar is too far advanced to make arrangements for inviting such a person. So I am disappointed indeed + once again art is left unfulfilled. I would have been so terribly thrilled to have you both here. Alas! It cannot happen now.

A little later on I will write to tell you when I will reach London. It appears that I will be unable to leave Holland for Harwich until the morning of the 13th, arriving in London somewhere around 6 PM. I don't know when the Flying Scotsman goes north but I am at the moment thinking of staying two days in London before going north. I think it would be quite O.K. to have a room booked for the 13th + 14th (nights). I don't want any posh hotel—in fact I prefer roughing it + will want to be as near you as possible. There won't be anyone I want to see in London at this time except yourselves or friends of yours. Later in September I hope to have 3 or 4 days in London before returning to Canada. I intend going right up to the north of Scotland from London + then by stages come south again—it will be quite a business dodging from place to place.

Tomorrow I go to Amsterdam for the week-end. I should be able to visit several of the galleries there. I was pleasantly surprised to find quite modern murals in the town hall at Rotterdam. No civic building in Canada would have been so daring.

This seminar has bogged down to the routine of lectures + afternoon talks so there is nothing exciting to report. I feel it a bit of a chore as one can't talk eternally about art unless to people who have some slight understanding.

Excuse short note at this time. I will be writing soon again. Love to you both.

As ever,

Jock

31. This date was written by someone other than Macdonald, possibly Mednikoff.

32. Macdonald intends to say "Czechs" here.

HIS MOTHER'S ADDRESS →[34] "GREENGATE"
PRINCESS STREET
THURSO
22ND AUG. 1949

Dear Doc + Riki,

I hope you don't think it dreadful of me in not having written sooner than this. I am sorry for the delay. This is the first evening that life has settled to normal + I have some time to myself. First of all, before giving you the local news, I want to thank you both for the delightful time I had in London + for all your kindnesses. I am greatly looking forward to returning + winding up this expedition in your company.

The plane flew smoothly to Glasgow, but we had to go away out over the Irish Sea, around the Mull of Galloway, to escape "the turbulent air conditions over England." I found myself conducting the blind gentleman to the party meeting him at our destination. He was a most interesting man + turned out to be the American President for the Blind

CANADIAN SEMINAR
CASTLE BOUVIGNE
NEAR BREDA, HOLLAND
22ND JULY, 1949

Dear Doc + Riki,

I delayed replying to your very welcome letter in order to discover definitely what the Director of the seminar was prepared to do about inviting you to Breda or inviting anyone else.

I am sorry to say that the situation has changed. I am told that the Canadian Arts Council would only foot any bill for someone whom they would know and

(whose home was in New York) attending international conferences in France + Switzerland. We had a long talk together + he was greatly interested in finding out exactly where he was on his British embossed map.

I found a berth reservation quite easily + left Glasgow at ten twenty the same night. Putting in the three or four hours at Glasgow was decidedly dull. I wouldn't stand in a queue for a film show so I passed my time in a restaurant, the Y.M.C.A. and a bus depot. I found Glasgow dirty + dead in appearance. On my arrival at Thurso next day at 1.30 PM I was met by my youngest brother (the architect) and by my oldest brother, plus his wife + two daughters. I didn't know any of them. In a few seconds I was at Mother's house + was delighted to find her far far brighter, stronger and less aged than I expected. Apart from slightly stooped shoulders she is remarkably unchanged + is still a good looking woman, with excellent complexion + bright spirit. We have had many long talks together already + I've heard many stories of her romances etc, that I never heard before. THURSO looks so much smaller, so decidedly colourless + so uninhabited that I find it difficult to believe the things I once thought about it. I have now met many of the "kids" I knew as pals long ago. They knew me but I did not know them. I was highly amused at one fellow whom I met today—I haven't seen him for 23 years—who said, "Hullo James, nothing new, eh!" Time certainly doesn't exist for him. It has rained every day since my arrival. I cannot understand the people who have remained here all their lives + still feel that life has been a tremendous experience. Religion + church going has certainly taken a beating—haven't found a soul yet who goes to church on Sunday. Even Thurso people have found the church has failed. And they resent being just a number at the doctor's office. But the horses + carts go up the street, the rain still floods into the shops, the local "rag" continues to print errors, like the following: "Donald Macdonald, the only sun of Mr. + Mrs. Frank Macdonald, passed peacefully away last Monday, in spite of the best medical care." I found this on a gravestone today—"Elizabeth Turnbull, who departed this life May 31st 1846—aged 19—

> Afflicted sore,
> Six weeks she bore,
> The Doctor was in vain,
> Till God did please
> By Death to ease
> And took away her pain."

I really get quite a kick out of the old hometown. I expect to run across many more amusing things before I go to Inverness next Monday. On Tuesday I go to Aberdeen to see my twin sister. A day or two there, then on to Edinburgh. I will get back to London on the 12th of September + should write right away for a room at the same hotel. Perhaps I should book for the night of the 11th—this will give me three complete days in London. I do not know what address to give you as I

will be floating about from place to place on a very irregular timetable. I hope you will forgive me for giving your address for letters which I can pick up before returning to Canada. There should be one or two coming from Barbara. Hoping that all is well. Greatly looking forward to seeing you both again fairly soon. Will write ere long.

Love from
Hamish

34. This note was written by someone other than Macdonald, possibly Mednikoff.

<div align="right">

**23 MILLBANK AVENUE
TORONTO
24 SEPT. '49**

</div>

Dear Doc + Riki,

I have enclosed a pound note which you might as well have to add to the others. The book I would like to receive first is the one you mentioned about Artists Materials, which you had in your library. It is something I could find useful right away.

This is just about my last holiday. I start school again on Monday. My programme this year isn't too bad, as I have all the first year students, now numbering 150, and also the 3rd year students in painting, the present enrolment being 40. Wednesdays I will have completely free so this will give me one day during the week for painting. Incidentally I have no night classes—thank heaven. My eyes must still be considered too weak for night work—splendid way to escape being put upon. I really hope to work hard this year on "automatic" painting. It may not have appeared obvious to you but, never-the-less, I was raised to a point of enthusiasm, to increase my efforts, by seeing your work in your apartment + listening to your confirmation of the fact that the essence of real creative effort (expression) is that emanating from the sub-conscious. Looking at my own work again I realize more fully that what I have been expressing in the past has its own distinct individuality and has more quality than I had thought. This is not egotism—heaven forbid!—but merely the feeling that the work produces when seen with a fresh eye. I am going to start tomorrow and I think that there will be an interesting change.

What effect has the devaluation of the pound produced on the people of England? Do you feel that it is definitely another step toward the approaching death rattle? Goodness! It was quite a chunk off the value of your precious "quid."

Have you given any further thought to the possibility of coming out to Alberta? I was asking Barbara to refresh my memory about the temperatures in Summer in Calgary + she says that she remembers no hot days there. I think the average summer temperature is around 73°. I am sure

the climate would suit you both and as for winter, it is the simplest heating system in the Dominion—no wood, no coal, only the turning on of a gas tap. I really would like to think that you were well out of Socialist England—before that pound is reduced to such a standard that whatever money you might have would be insufficient to get away on. Besides, we would be very happy to think that you were over here.

This country looks pretty good to me after Britain. I am amazed at the menu cards + also at the elaborate plates. I haven't found myself able to eat at all since returning but I feast my eyes on all the good things.

We are liking very much Prof. Röling + his wife from the Amsterdam Academy. They are deeply interested in occult + spiritual things, are very charming people, + quite wide open in their appreciation of creative work. He told me the other night that I was a "very brave artist" doing what I do against the tide + they both appeared genuinely interested in the work. But cheers! my great opposition + the destroyer of my teaching in college has moved away + taken a position in California. This is indeed very gratifying + it means that Rubens reds and Rembrandt's browns has said farewell in the painting department. This bird, who has removed himself, has taught in the college for 25 years so built up the belief that he was the soundest critic of what is art. What luck + what hidden pattern there is in such a change. To me it seems a most purposeful event and, incidentally, it opens the door for decided effort on my part.

Barbara is thoroughly engrossed in "The White Goddess" + is very happy to have it. The other books I brought also interest her but meantime the book mentioned is the one.

The snapshots of London came out very well + the two I took of Mr. Nyberg are clear enough. I did not expect any result from indoor snaps + now wish I had taken more of them. The ones of Greenland taken through the plane window, aren't too bad either. They do show the mountainous landscapes + help to refresh that magnificent flight.

We hope that you are both well + I sincerely hope you were not too "done up" after expending so much energy in giving me so delightful a stay in London. I did enjoy every moment. Thanks to you both + love from us both.

Hamish.

23 MILLBANK AVENUE
TORONTO
14TH DEC., 1949

Dear Doc + Riki,
I hope this letter arrives in time to wish you both a very happy Christmas from B. + myself. Also we pray + hope that the New Year will bring a change of government + put an end to the stupidities. Good for New Zealand and Australia. Many thanks for the three books you sent recently—all delightful. I am just wondering if the author of the book on oil painting methods ever brought out the book on water-colour, litho, wood blocks, etc. If so I would like to get hold of it sometime. Barbara seems to desire certain books, so apart from the water-colour book mentioned above, just hold on to the cash until I write you again, which will be very soon. Everything is going along nicely, though the Christmas season is just a pest. I should be busy painting but cannot get at it for other things. I hope to send work to four exhibitions in January. Did I tell you that I sold four of my automatics recently? Things are beginning to catch in Eastern Canada now. I would love to have your reactions to my recent work. Whether you would like them or not I am, never-the-less, eternally indebted to you both for opening doors to me + bringing so much happiness in my associations with creative work. I just wish that we were closer to you so that we could be enriched by talking with you very often. How isolated one feels when there are so very very few people who talk our language in art. There is very little news to give you from this country. Did you know Dr. Hill Cheney, who lived near us in Capilano. He died about two weeks ago. Dr. Sedgewick also died at the end of the summer. The Vancouver Gallery is now making the gallery twice its original size. Bert Binning is now assistant professor of architecture at the U.B.C.— how utterly stupid, but it's amazing where you get to if you blow a lot + keep in with the wealthy. The reaction to my European trip is just what I expected—nobody (artists) has shown the slightest interest. I expect they say "how the hell did that fellow Macdonald get to Europe + what would he have to say anyway." I have no idea about next summer yet but at the moment I am booked for Banff. I will be released if asked to go again to Europe. Hurrah! Just been told that the college holiday has been altered + we are now to get off a week before Christmas. This means I can paint quite a lot—cheers! Did I tell you that Barbara and I are taking classes in ceramics from the instructor at the College? He is an excellent fellow with several years in the ceramic factories + he has an appreciation for modern work. I think that this work will give me plenty of opportunity to bring in automatic design decoration. I always feel that I want to use my design experience in some practical way—not textiles or carpets. B + I can now "throw a good pot"—have had plenty of practice in our married life?—but it has taken much practice to do this in a delicate manner. After Christmas we begin to experiment in glazes, make template bowls, and produce castings. I get two half days during the week on this work—mornings—and seeing that I haven't my studio now I do get something done. The morning is a poor time for painting at home. I prefer the afternoons + evenings. We hope that everything is going well with you + that you are able to get time to paint. I still think very

happily of the delightful time I had with you in London + do hope that I will be able to repeat it soon, along with Barbara. Must pop along to the dentist now + get myself on edge. Every good wish for a most enjoyable Christmas + may the new year fulfil all your most earnest desires. Love from Barbara + myself.

Yours affectionately,
Jock

23 MILLBANK AVENUE
TORONTO
2ND MAY, 1950

Dear Doc + Riki,

How are you both? It is ages + ages since we have written to you. Ashamed are we. But, never-the-less, we have been thinking of you a great deal + hoping that things have been going well. We specially want to thank you for the books you sent us. I haven't had a moment to glance into them yet but Barbara has been reading them fairly steadily. Truthfully, life has been one terrific rush for weeks with visitors from the West, local visitors, concentrating on pottery classes, juries for me, etc, etc. And it still goes on but it won't be long now until the College winds up + once again we hope to get a little sunshine into our blood. Today is the first day we can say that it is actually agreeably warm. We have been starved of sunshine for months.

Well! I am coming over to France this summer. Only a week ago I received the news that the International organization wanted me to return. Only three of us are asked to come back this year so I feel very fortunate. Unfortunately, it will be impossible for B. to come along. Accommodation can not be found for her on the same ship as I go on and in France she would have to stay in a village ten miles from where I will be stationed. So this is no arrangement. We cannot get a cabin on any boat which would get me to France in time. So B. is going out to Fiona, in Seattle, + she should have a good summer as she will also see her friends in Vancouver + Calgary. I have to sail from Quebec on the 26th of June, for Rotterdam, + will then proceed to Pontiguy, Yonne, about 180 miles south east of Paris. The seminar should be through about the 12th of August. I am likely to be free until I sail again from Rotterdam on 5th September so I do not know yet what I will do.

In a way I am not awfully keen to spend much of this time in Thurso but feel that I should go to see Mother even if it is for only a day or two. Mother will be eighty this summer + another period together is very important to both of us. I would be thrilled to see you both again in London even though my visit is likely to be exceedingly short.

Would you kindly give me the name of the hotel I stayed at in London last summer. A friend of ours is going over to her son's wedding at Cambridge + is very anxious to find accommodation in a London hotel around August 10th or 12th… I cannot find the name of the hotel + I do not remember it.

Art is proceeding spasmodically, unfortunately, but I sold another automatic to the collection of the Toronto University recently and have managed to be accepted in all the water colour exhibitions in Eastern Canada this winter.[35]

Is there any particular thing you would like me to bring over to you this summer. I can carry much more than I could do last year.

Our very best love to you both.

Yours aye,
Jock.

35. The "automatic" Macdonald refers to is *Fish Family* (1943), which is in the collection of the Justina M. Barnicke Gallery, Hart House, University of Toronto.

23 MILLBANK AVENUE
TORONTO
18 JUNE, 1950

Dear Doc + Riki,

Your exhibition will now be on.[36] Excellent! We sincerely hope that it will be given the full attention it deserves. I wish I could be there to see it + do a bit of boasting that I really do know you both. I am certainly very interested to hear from you what the reviewers write about it. It will also be interesting to hear of sales + we wish you both some satisfaction in this line. Many thanks for the catalogue which arrived about a week ago.

I will be in France before I hear anything from you about your exhibition as I am sailing from New York on Wednesday next—the 22nd. We will take eleven days to reach Rotterdam (direct) so the ship doesn't sound very large nor very speedy. Apparently the ship is a prewar German boat now belonging to Norway. We have been in quite a rush lately as both Barbara + myself are going out of town—B. to Seattle—+ we are sub-letting the apartment. At the moment I am not terribly excited about going to Europe but I suppose by the time I get to London + Paris I will be thoroughly elated. From what I hear, the seminar is to be "more organized" this year. Why in the name of heaven people cannot see that when a thing goes along happily it is most satisfactorily organized I cannot fathom—now the authorities will make it a chore very likely + completely ruin the whole spirit of the thing. Well, they'll have a tough time organizing me as I intend to be even less regimented than I allowed myself to be last year.

How splendid that you have a cottage in the country. I do hope that I will be able to be with you there. At the moment I haven't the slightest idea what my free time will permit me to do. We have to return, from Rotterdam, on the 31st of August. I think the seminar is over on the 12th or 13th of that month so there is some time to oneself before returning. What I am wondering about is whether I will go up to the north of Scotland or not. This will take a lot of time + also quite a bit of money—maybe for only two or three days there. If I have money to spend (?) I feel that I would like to go to Switzerland, Italy, south of France or north Africa, if not Spain. I would also like to go to London. I'll just have to see how the pulse beats over my probably not going to the north of Scotland this year.

My recent evidence of some sort of acceptance in Eastern Canada is my being elected as Vice President of the Canadian Water Colour Society. In the voting, from the floor, I received more votes than some of the "important people." This was a distinct surprise to me + doubtless to those people. Recently in a Canadian travelling exhibition over the Dominion, A.Y. Jackson + myself received mention in every newspaper report on the show. Jackson of course pleased everyone but I got highly praised or severely damned. In one paper I was accused of brazen obscenity, in another my work was refered to as the stuff that deserves the ribald laughter of the crowd. But the main line of criticism was distinctly praiseworthy. Certainly the canvas wasn't just a decoration on a wall. The exhibition was a specially selected national contemporary product.

I am still somewhat amused at the complete lack of interest shown by any of the artists here about my going to France. They were dumbfoundered about my going last year + to be asked back makes my appointment even more difficult to understand. Only one has said that my being asked to return is a distinct honour—all the others haven't even whispered to me "good" or "I'm glad to hear that you are having another trip." If it was Jackson, Panton, Comfort, or any of the Toronto artists it would be a tremendous honour + so utterly important. Well! I am much happier sailing along in quiet waters—that's what I would want—but the complete record of avoidance about my going to Europe again is, as I said, decidedly amazing. The artists out west however, are most pleased + very interested to hear about everything.

Barbara will be mailing a parcel of pineapples + salmon to you very soon. I find that I will be fairly loaded with things that I find it safer + easier to send a parcel. We are delighted to forward some "exotic" foods.

Have you come across the new books on "The History of Modern Painting" by Skera—printed in Switzerland, with many superb reproductions. I am wondering what you think of these books. They are selling very rapidly in Canada, even though they are very expensive. The booksellers cannot keep the supply up to fill the demand. Very interesting?

Looking forward to hearing further news about your exhibition + hoping that you are both happy about everything. Our best wishes to you + also our best love. Yours — "Jock"

My address in France is:
> The Canadian Seminar
> Franco – American College
> PONTIGNY (YONNE).
> France.

36. The exhibition *Paintings by G. W. Pailthorpe and R. Mednikoff* was shown at the Archer Gallery in London from June to July, 1950.

CANADIAN SEMINAR
PONTIGNY (YONNE)
FRANCE
SAT. 5TH AUG. 1950

Dear Doc + Riki,

I came up to Paris to make arrangements for next weekend, as my duties are over at Pontigny on Saturday morning next. My booking on the Calais-Dover-to London run brings me to London, Victoria Station—at 7.30 PM (Sunday). As my time is fearfully limited, seeing that I intend going north to Thurso, I think at this time that I will have to try to get the 9.30 am train from Kings' Cross, on Monday, to Edinburgh. I might however wait until Tuesday morning but my feeling is that I should get north as rapidly as possible + then get back to London for two or three days around the 25th of the month.

I have not booked any hotel room in London. I couldn't fix my travelling time until I came to Paris, as I expected different arrangements if my friends hadn't gone from this city. If you would be kind enough to phone the Brentwood Hotel for a room—any room—for one night (Sunday) you would be most kind. I should arrange my own things + not trouble people. I'm sorry. If I don't get a bed, well that's that—it'll be in harmony with a lot of this trip so far.

I am certainly looking forward to seeing you both again. If you have plans to go to your summer place next week-end please, for heavens sake, don't let my arrival in London change any of your plans. I'll have time on my way South to see you in London.

Things have gone along only "fair" this year. There is too much worry over the world situation.

A visitor has called so I'll have to close right away.

Greatly looking forward to seeing you before very long.

Much love,
Jock

Dear Doc + Riki,

I am still feeling the benefits of that most enjoyable week-end with you at Dorking. It was just as well I had a good rest then as I certainly had no rest on the United States navy transport, what with those damnably rude/ cheap U.S. student groups, rough seas and the fussing of cabin inspection, fire drill + general red tape. I was more than thankful to see N.Y., to be well rid of the tribe + be home once again to get down to some sort of organized existence. Barbara enjoyed her summer very greatly + is in first class health after it all. How about you two? I hope that you are feeling completely better Doc + that you have found a good house—one which has quite a bit of lawn, so that Riki can get the exercise he so much enjoys and be able to give demonstrations of his excellent understanding of things mechanical. I am wondering very much what luck you have had over a new place to live. Sincerely hope that you will be able to give me some good news that your plans are now working together happily. I am dying to hear what is what.

By the way the three books arrived directly by post + together with the one I brought over B. feels that she is now well established in reading material for the first part of the winter. Mentioning winter reminds me that yesterday we had snow in the suburbs of Toronto, which is the earliest winter fall in 100 years. As it was the wettest + dullest summer in Toronto for 76 years it is quite possible that we are in for a long dreary spell of wretchedly cold months. Goodness! how I love summer + especially the evenings when one can go out without a coat or hat. I am already looking forward to next summer, which I expect will be out west as I definitely will not return to Europe, even if invited. It is a pity that I had to travel to Europe the way I did because this miserable experience has so much offset the qualities of the many pleasures which I enjoyed. Had I had the pleasures along with pleasant sailings I am sure that I would never have felt the way I do now.

Have you had any further word from the United States? It would be wonderful to discover that the possibility of developing your work there is confirmed. I wish that this could happen.

I have been back at college for the past week so now we are getting settled down to work. My programme of work has improved as I have, at last, been given classes which carry right though the four years in the painting department, and I now instruct in two schools instead of the four buildings I had to manoeuvre around before. I am also free on Friday afternoon, all Saturday + of course Sunday. This gives me an opportunity to get a good spell at my own work. Things are a bit unsettled financially in

college as the staff, unitedly, has forwarded a memorandum to the council complaining of the fact that during the past five years no additions have been added to the salaries to balance with the cost of living increase during that time. The cost of living has gone up 48% here during the five years. I don't know what will come out of this expression of dis-satisfaction—anything or nothing can happen. Anyway it provides an interesting action so soon in the term. Any further word about the commission you have to do, Riki, for The British Fair? I will be mighty interested to hear how you are going to tackle the problem. Anything new in the art world of London since I left? Things are beginning to move again here. I sent out some water colour to Vancouver last week + I would enjoy it very much if I again sold something there this fall. But I am expecting to start painting again this week end—that is much more exciting. Barbara joins me in sending our best love to you both, all good wishes + thanks for the good books. I do hope that you have found just the house you want. Once again I must say that I tremendously enjoyed seeing you both again.

Jock

37. While Macdonald did not include the year here, the envelope has been date-stamped with the year 1950.

Dear Doc + Riki,

I am sorry that I am too late in sending you a Christmas Card but this letter will bring to you our very best wishes for a happy Christmas, a good rest and complete enjoyment in your new home. I haven't heard yet how you are feeling about your new world. We hope that you are very happy over everything. You will see that we are still in our little basement apartment but if rent controls come into being in March then we might move to the "above ground" apartment, we have been waiting nearly two years for, at that time. Much will depend on the rent + still more will depend upon our managing—at College—to get better salary payments. Our situation at College is most unsatisfactory—just as it is for the faculty at the University. It was interesting to read today that the University students (Toronto) decided that they should forgo some of their bursaries in order to pass money over to better the salaries of the Professors. They think that if the[y] can get money for arenas or stadiums they can get money for their Profs. Our Faculty is very busy trying to find ways + means to make our Council improve our state. It might be on the cards that we "sit-down" in Feb. or March. Barbara + I regret very sincerely that we are unable to send parcels to Britain

this Christmas. Is it likely that we will be able to have this pleasure around March or April—hope so! I am reading your book about "Strange Characters" in Britain + I find it highly interesting + quite amusing. What is all your news? How are the doctors getting along with the new resistance to the National Health dictatorship? I read about happenings at a hospital, etc. It would be good to see them take unified action + stop all the nonsense. I should think that this small beginning will bring out the thousand + one other things that are so utterly stupid. Again, what do you now feel about the tensions in the world. How long? I read that the Alberta Government is to prohibit the medical authorities from preventing other (emigrating to Alberta) Doctors practicing. If you wanted to get into Practice in Alberta you would now very easily get in there. The gov. accused the Medical Council of "a closed shop" attitude + therefore stepped in to stop it. I don't suppose you have had any further word from the United States? There is no special news from here. We have been kept busy with a continual flow of visitors from the West + I haven't been able to paint very much. However, I am being loaned a studio for a month + will paint nearly all my holiday. Good! Things are going on very well at College for me as my students are showing more + more enthusiasm to my "creative" teaching efforts + the effect of my influence is just knocking the ground from the academic approach given by other instructors. The stronger the student following I get the more excited I get + therefore the more enthusiasm I accumulate to develop what I am after. Some days I am really very happy over what is happening but I sort of sense that if the effects become much more concrete then I may be cleared out someday. That I would face at any cost as some of my students will become artists, of that I feel fairly sure, + my student following is now definitely developing rapidly. We are going to Banff in 1951. I jacked up the salary I desired by some hundreds + got it. This time we will be able to have something besides a healthy set of lungs when we get through the school. I haven't sold anything this fall but I have been able to have representation in every show so far this season + have had excellent crits of my work. Now that I have a studio I hope to do much that I feel I can do—both in oils + water colour. We are looking forward to hearing from you soon. It was so very enjoyable to see you again in 1950. Wish you both were over here somewhere. Barbara + I send you our love + every wish for a very good Christmas.

 Jock

ONTARIO COLLEGE OF ART
TORONTO
17.9.51

Dear Doc + Riki,

 I am sorry I have been so dreadfully long in writing to you. The spring & summer are both over + now we are about to dig in for the winter. How has everything been going along with you both? We hope that the summer has been very enjoyable + that you are thoroughly happy with your house in Dorking. Do forgive me for not writing sooner + please write soon. We are most anxious to hear that you have been well + hope that you thoroughly enjoyed the trip to Italy you were anticipating during the spring. We are both in first class health, as we should be, after 3 ½ months out west. I went along to Banff but before going there we spent a short time in Vancouver, the Okanagan + Calgary. We enjoyed staying with several of our friends + seeing many more. I am satisfied that I now know that I have no wish to return to Vancouver for any purpose whatever. Of course the landscape is marvellous but the place has grown so very large + I found too much tension in the several art groups there. The gallery alterations were almost complete + today they now have a wonderful place—twice the size of the original building.[38] The facade has been completely removed + is now more modern + much better designed. We had a very good time in Banff through associations with many interesting people but I have no intention of returning there. The whole art section is feeble, very poorly conducted, unfair to Canadian artists as against visiting artists from other places + no students with any experience come there today. We greatly liked William Townsend, from the Slade, a man with no side whatever, delightfully charming, unbiased + a sporting sense of humour. I believe he wrote a delightful small book on Canterbury. He informs me that the Slade has been greatly altered in methods of teaching + today is quite experimental. We also liked Jan Zach, a Check,[39] from Rio de Janerio, much more modern than Townsend. He has come to stay in Canada + is now in Victoria at his wife's home. He was very impressed with some coloured slides I had of my automatic water-colours and feels that a one man show could be arranged for me in Rio in a year or so. Apparently Rio is very very appreciatative of modern (most advanced work). While I was west I learnt how to do batiks on silk + I find this an excellent medium for automatic design. I am quite happy to produce some things in this manner as I believe I have found something which will + can have its art value. Today, my cousin Duncan MacTavish came over to tell me that they are going to Bermuda, as he has been given an appointment there. This means that we will probably take over their apartment + if we do I will have a place at long last where I can paint + where I can do batiks. We would be away out in Eastern Toronto but it would be worth it all if I can have a place to work in. This is the reason why I have put the College address at the head of this letter. If we move we will do so within a month. The College opens in a week with L. A. C Panton as new head.[40] I fear that the place will become a regimented joint—organized right down to the venetian blinds or what have you. Naturally, we will buck hard but I will be most surprised and delighted if things should continue in

the old freedom ways of Haines. I am also expecting to be chocked off by certain classes in creative composition being taken away from me by Pepper, the Head of the painting department, as my influence in this work has grown so powerful that the students give very little heed to any other form of academic instruction. I also feel that I will have things arranged or that I will be subdued (?) as I had a devil of a row with Pepper and most of the Painting staff at the end of last year while judging students work for awards. Carl Shaeffer was the only one who backed me. I first of all objected to instructors passing judgement on students of the final year that they had nothing to do with all year. Then I objected to recognition being given to unimaginative academics + art schooly stuff. It will be interesting to see how they try to manoeuvre me this fall. If I am cut out of certain fields of work I will certainly open up the same doors in the other things left. I was asked to act on the modern jury for the All Canadian Show at the Canadian National Ex, in Toronto, but Cameron of Banff wouldn't let me go, even though the C.N.E. were willing to fly me from Banff to Toronto + back. I should have just gone + not been so polite in asking him. So after this I am going to do just what I want to do + I don't think that I will allow myself to be booked for teaching in the summer anywhere—unless it should be a trip over to Europe. We did not manage to see Fiona this year. She is keeping exceedingly well + is happy in California. At present she + her husband are in Seattle on holiday. She could not get north when we were west. We drove nine thousand miles in our old bus + still the engine gave no trouble. Still think that Wyoming is the most magnificent painting state + sometime we hope to return there. What did you think of the British Exhibition? I would be very interested to hear what you thought of things. We have no news of Florence Waddington except that she is still in Australia. Have you heard from her? Lionel Thomas has been doing very grand work + I believe he is to have a one man show in the San Francisco Gallery.[41] He has also been asked to instruct at the California School of Fine Art next summer + he now has a permanent position in the Fine Arts Dept of the U.B.C. He is the fellow in B.C. alright. Our best love to you both. Sorry not to have written sooner. Jock.

38. This expansion of the Vancouver Art Gallery was in response to a gift of 157 works willed by Emily Carr to the Province of British Columbia. Carr's close friend Lawren Harris led the fundraising campaign for the building's expansion.

39. Macdonald intends to say "Czech" here.

40. Painter L. A. C. Panton was Principal of the Ontario College of Art from 1951 to 1954.

41. Lionel Thomas (1915–2005) painted semi-abstract works in oil and is known for his mosaic murals.

Dear Doc + Riki,

Greetings + all good wishes for a very enjoyable Christmas from us both. Awfully sorry but I expect that the little present of eats will be a little bit late for the 25th table—maybe it will bring an extra heartbeat just thinking or knowing that something, one of those mornings, will be arriving. Things have been so irritating in College ever since we got a new Head that ones mind has been unable to get into the necessary peacefulness or elevation necessary around Christmastime.

Hurrah! We were delighted to receive your good wishes, by card, the other day, to hear that you both were well, had an exhibition + still are thrilled with Dorking + your new home. Sorry to hear that there were no sales. About all one gets nowadays is an appreciation of creative things by other artists. After all, that is all that matters, isn't it? Naturally, a purchase is appreciated too.

Well! as usual I have continued to exhibit in all shows possible, society + national, and selected traveling but never a sale during the past fifteen months until yesterday morning. I actually sold one to a private collection.

I am painting, in water-colour, fairly steadily by managing to do three things every week. This is as much as I can manage as I only have nights and occasionally a Sunday. However, I think that my work is becoming more + more less saleable but to myself more + more interesting. Things are not standing still. It is possible that I will manage to put on a one man show, in The Picture Room Society, around April. All I care about really is that I keep working.

Barbara + I are in first class health, as also is Fiona in California. But about four days a week I am frothing over the College situation. I just feel that all my teaching stands for seems to be going out through the window. Along with a constant fight against systemization and high school methodology we often feel pretty weary of it all. Perhaps, eventually, some of us, by bucking, can change things but it is certain to be months before the smooth freedoms of the past four years can return.

Although things seem to be more difficult in Britain every year one now feels, with Churchill back, that in the future there may yet be a brighter day. Much, I think, will depend on how the fateful year 1952 turns out as it will be the last year that Russia will have her mastery in military might.

So, joyful days to you both during the Christmas season + may the New Year, in spite of this outlook, be a very much happier one. Love from us both.

Jock

Dear Doc + Riki,

We were delighted to receive your letter, forwarded to me to Victoria—but we are exceedingly sorry to hear that you have been so wretchedly unwell Doc during the past months. We do hope that you are feeling quite better + have gained through the only possible way to gain in Britain today—through having a pleasantly warm summer and plenty of sunny days. It is so heartbreaking to realize the utter hopelessness of conditions in Britain + the effect this has today on the physical condition of the people. We are arranging to have a small parcel sent to you but we would appreciate it if you could tell us what items would be most beneficial—items which you need + cannot obtain. It would give us great happiness to see that you have them. I am sorry to have been so remiss about writing. I did not realize it was so long since you heard from us. I daresay I failed to write because I was so upset over things at the Ontario College of Arts, through our new Head being such a boorish dictator, completely upsetting the whole staff + students + treating us all as if we were a brainless bunch of morons. Things were going so splendidly, then the whole structure was destroyed in a few months. We are very unhappy over the situation but I am giving it one more year trial + if things don't ease off I'm going to quit + probably go to Victoria. Barbara calls our new head a "functioning corpse" + this is correct. We cannot get rid of him but through lack of co-operation we may force him to retire. He has no experience of Art College work but is a pedagogic lunatic. We begin again in ten days time—two weeks from now we will be frothing. Five instructors have resigned—there may be more by next week. Well, to get to the brighter side. We were out in Victoria this summer as I was invited as a guest artist to the new Art Gallery there.[42] I conducted five classes per week in painting + gave three lectures. Everything was well attended + I did just as well financially as I would have done at Banff, with only ½ the work. I was also very surprised to sell 5 water-colours (automatics) at a small one-man show there and, incidentally, was invited to give a one man show in Phoenix, Arizona, in March 1953 by the director of the gallery there. We were also offered a free apartment in the gallery if we would remain in Victoria. This was tempting stuff but I prefer to wait a year to see what added security may arise in the way of an income. I was astounded to find the development of so much enthusiasm over art matters in Victoria + to find the interest wasn't Victorian. About 100 people attended + paid to come to my talks + it is in the last summer weather—quite a good average attendance I thought. We drove out + back in our old 1935 car—visiting Seattle, Vancouver + Calgary. We are very pleased to hear that you have been exhibiting again + that you have been speaking so powerfully Doc.

through the qualities you create with the use of the palette knife. I find that through the knife one can speak with power + get purer colour. Most of my work has been in water-colour for the past 3 years. I am Pres. of the Canadian Water Colour Society at present. We were visited by Fiona + her husband in Victoria + this was very enjoyable. Fiona is now perfectly well, strong + happy. It was ages since we heard anything about Florence Waddington so it is good news to hear that she is enjoying life in Victoria, Australia. Thank you for her address. There has been some excitement in the Macdonald family circle as my brother (architect) in Thurso has been commissioned to make the alterations for the Barrogill Castle which The Queen Mother has decided to use as her summer residence in future. This castle is very down at heel + quite isolated, 11 miles East of Thurso—+ near John O'Groats. My brother had to interrupt his summer holiday in order to be interviewed by The Queen Mother near Thurso. He found her very gracious, friendly and appreciative of his suggestions. It is interesting to know that she didn't consider it necessary to call in any Sir this or Sir that architect to recreate this broken down castle—the local talent was quite O.K. Stupid of the National Health to retire you at the end of the year because of age limit. Well! I somehow think that you will be happier working privately + having the new adventure in the antique business and I believe you will feel better in health as well. It will be disappointing for you to move from Dorking, wont it? I would have thought that Dorking would be ideal for your new world. Would business be better in Devonshire? Well! it is wonderful to hear from you both. Best wishes, better heath + our best love to you both. Will write ere long. Jock.

42. The Art Gallery of Greater Victoria opened in 1951 in the Spencer Mansion.

Dear Doc + Riki,

I am of course very ashamed in not having written to you for so many months + especially after receiving your very kind joint letter, together with the books, at the end of January. But, better late than never maybe? We thank you very sincerely for the very kind letter + for the books. Both of great interest to us. We were very upset to hear that in the parcel you received from us at Christmas the butter was not Canadian. Why cannot people advertise truthfully the brand of goods placed in those parcels? I am equally sure that the Montreal Forum profited greatly through the deceitful manipulation. Certainly we are glad that you told us what you received. However, we were glad to hear that you received the small parcel. Well! I expect

that you have had to retire from Harley Street. We hope that you have found your new life much more refreshing and gainful than you expected and that your health has greatly improved, so much so, in fact that you really feel well again. Sincerely hope so. I am just wondering if you managed to get abroad for a welcome change. Perhaps you have delayed this trip in the hope that the number of Pounds you can spend out of Britain would increase. I noticed some increase as well as a slight release in income tax. Doubtless the small gain in income tax release will be very quickly absorbed in increased cost of goods. It will be some consolation to see the economic state of Britain so greatly improved. It looks like a glint of brightness in the still clouded sky. Are you now fully engaged in the antique business world? I am wondering if you have moved from Dorking? You thought that you would have to do so in order to get the new business adventure going. We are both in very good health + have confirmed good news from Fiona + her husband in California. This has been another bitter and dreary year at The Ontario College of Art—we finished on the 15th of May. Several of us have been attacking the deplorably low salaries + I think that we have shaken the Council + the Principal into having to do something—how substantial we do not know yet. If it turns out to be merely a token improvement then it will be questionable how many of the staff will continue. I am not sure what I will do as I am really debating whether I should get out + just run my own private teaching. It looks as if it could be much more profitable. I only hesitate because I am not certain how lasting such a scheme may be. My two private painting classes in Oshawa certainly pay me well—have been entirely successful in enrollment, students expressions of satisfaction + in general happiness + progress. More + more people in Toronto ask me to teach privately + run my own studio. I do not think that I would have any trouble surviving financially in Ontario at any time now if I resigned from the O.C.A. There is also the summer work which is now profitable for me at last. We are going to Banff—my salary there is so improved I accepted. I also had an invitation to the U.B.C. Summer Fine Arts School + also from the Department of Educ. in Victoria. There are also many invitations coming in throughout the winter to instruct groups, give lectures, jury shows in many outside towns in Ontario, but I have turned down most this winter as the money isn't worth the energy after being fairly worn out with the necessary winters work. I feel that the income offered will improve as most experienced artists are not accepting those trips at present rates. It is just a case of educating the groups to higher standards of values. Did I tell you that the Toronto Art Gallery bought another of my water colours for their Canadian Collection—the only water colour they purchased this year.[43] I am disappointed over not having more work done during the past 3 months but I now have

a small studio + expect to produce fairly steadily. The O.C.A. salary committee took up hours of my free time for the last 3 months—I had no energy left. It has been a very easy winter but our spring isn't here yet. We still have only crocus' growing + no leaves on the trees. Now I expect that all England is working up to considerable excitement over the Coronation—droves of people arriving from all parts of the world. It should all be very colourful, memorable + exhausting. Have you any work on Exhib. in London or are there any special exhibitions arranged? The award for "The Unknown Political Prisoner" has no doubt caused endless controversy, aesthetic, political, social + goodness knows what else. Did you see the exhibition at the Tate of the prize winners? What are your views about things? We hope to hear from you soon. In the meantime we send our love to you both—all good wishes that the past few months have given you a lot of happiness. Will be writing you ere long. Hope to have a little more news than I seem to have at this time. Jock.

43. The watercolour that the Art Gallery of Toronto purchased in 1953 was *The White Bird* (1953).

<div style="text-align: right">

**23 MILLBANK AVENUE
TORONTO
15TH APRIL, 1954**

</div>

Dear Doc + Riki,

We were delighted to receive your fine long interesting letter some two months ago and also the unique books which we are proud to have. We are pleased to hear that the antique business is now—at long last almost a reality. We wish you both all success and a great amount of happiness in the venture. Perhaps before long we may be able to see you in your new world. Yes! this is indeed possible as I have just received the very surprising news that I have been awarded a Canadian Government Fellowship to France, for one year.[44] We have to be in Paris by September or perhaps a little sooner. After reporting to the Canadian Embassy we can then go wherever we like in France. I am completely free to paint for the year + am not obliged to adhere to any commitments such as to writing a thesis or produce an exhibition or two. I get $4000.00, my return trip to France and two thirds of the fare for Barbara. Now, isn't this an astonishing thing to obtain. We are naturally highly delighted + cannot yet believe it true. The news is not out officially but when it is released to the press I am sure it will amaze many of the "officially recognized artists" but I am also sure that quite a number of my friends, especially those in Western Canada will be happy to know that I have been given this honour. Those artists around Ontario will say "How the devil does Macdonald manage to get three trips to Europe in five years". Honestly,

I have great good fortune. Here, I was on the edge of resigning from the Ontario College of Art as I find things more + more impossible every month. Now, I have time to decide + make my future + just hold my connections intact. When I told my boss privately yesterday I had received a fellowship he took five minutes or more to say he was pleased about it. He had tried to queer my opportunity in a letter he had to give me but I altered his "mistakes" unknown to him. Now of course he cannot mention this letter + I am sure that he was stunned over my obtaining this award.

 Once again I have finished a "seven" session + start a new experience. I have been seven years at the College. It is likely that I will never return to the College. I left home for a boys school, in Edinburgh, at 14, I got out of the army + went to Art College at 21, came to Canada when I was 28, 7 years at the Vancouver School of Art, and 7 years at the Vancouver Technical School. There was one session of 5 years where I was on my own + one year in Calgary. But the sevens are rather amazing, aren't they? We have had a long cold winter this year— only during the past two days have we been able to go out without a coat. It seems absurd that we finish college, for the summer, on Tuesday next.

 I was not invited to return to Banff this summer. I am not sorry as I felt that it had just become a show piece + that it was merely playing to entertain the public. I complained strongly last year + had decided to cut it off for good. In fact all those who expressed their feelings last year are not returning. In February eleven of the creative painters got together, rented a gallery in town + put on an exhibition of experimental painting.[45] I was one of the eleven, the eldest member. We had a very successful show, with a number of sales + record crowds. It was the bombshell of the Art World in Toronto. It set "the established + recognized artists" on their ears, made them mad as the "Painters XI" received TV, Radio, news galore. And we sold six times more paintings than the Ontario Society of Artists did in their six weeks exhibition which followed us. I received a very nice letter from Mr. James J. Sweeney, of the Guggenheim, N.Y., in which he privately has informed me that he will come to see the work of the group. So you see things have been given a new thrust + on the horizon is a new vitality arising by the younger artists.

 Fiona is keeping very well. We won't see her this summer as she + her husband have just bought a house in Ventura, California, + will be fully occupied in getting it into shape.

 We do not know anything about Florence Waddington but think that she is still in Australia. The people she knows in Toronto haven't heard from her for a very long time. I am sure that she is enjoying her life very much "down under."

 This will have to be all my news for the present. It will be wonderful if we can manage to see you both soon. Coming to England is a matter of cash at the moment—we will know better when we wind up our affairs here. But we will see you eventually. Our best love to you both + our thanks for the kind letter + the books. Happy Summer + success. Jock.

44. Macdonald received the Canadian Government Fellowship from the Royal Society of Canada.

45. Painters Eleven's first exhibition was held at Roberts Gallery in Toronto from February 13 to 27, 1954. The gallery reported that more people visited the exhibition in its two-week run than any other in their history.

"GREENGATE"
PRINCESS STREET
THURSO
9TH SEPT. 1954

Dear Doc + Riki,

 We were delighted to receive your very kind letter here and also your post card in Paris. Very pleased to hear that you are both very well and happy over your home in Battle.

 Many thanks for your kind invitation to us to stay with you for two or three days. We will be delighted to come + greatly look forward to seeing you once again.

 We will leave Thurso on Saturday of this week for Aberdeen, where my twin sister lives. After a day or two there we return to Edinburgh where Barbara is to see her brother. I think that we will leave Edinburgh for Chester, where my older brother lives, on Sunday the 19th if there is a Sunday train + try to return to London by the 22nd of September or try to come from Chester to Battle, if it can be done. So it looks as if we should see you again somewhere around the 22nd, or 23rd of September. I will write you some time before we will arrive. I have no address to give you for any communication unless it might be my brother's address in Chester, which is — 2 King's Crescent East, Chester.

 It would be nice if some warm weather would be given us all when we are in Battle. We find it pretty chilly in Scotland + especially in this northern barren land.

 I find Mother amazingly well + strong, moreso than she was four years ago. Her 85 years hasn't apparently produced any physical difficulties nor lessened her interest in all that happens. Very nice to find her so well + to see her once again.

 Our love to you both for the present. Please excuse short letter today.

 So till we see you.

 Jock.

Dear Dr. Pailthorpe,

Tomorrow we leave Aberdeen for Edinburgh + on Monday we go to Chester. We hope that it will be suitable for you if we come to Battle on Wednesday next—22nd Sept. If the train timetables are correct we expect to arrive in Battle at 2.15 in the afternoon. We will return to London on the 25th.

All the above is rather a blunt outline I fear but I thought that you would be awaiting some definite outlines of our plans. If they are not suitable could you tell us by wiring or phoning to us at Chester c/o Ian G. Macdonald — 2 King's Crescent East, Chester.

We are greatly looking forward to seeing you + having a good talk over everything.

Our trip has been very interesting up in this northern hemisphere but it is quite a comfortable feeling to know that we are going south soon.

Excuse more news at present. Our love to you both.

Jock.

Dear Doc + Riki,

Here we are in the gloriously warm sunny south, in a small studio apartment of our own, just three blocks from the sea. This will be the centre from which we will go out to find probably a small cottage somewhere in the hills but meantime we have taken this place for a month + have the choice to take it up until Christmas. It is wonderful to be free from living in hotels, being able to cook what you want and not having the feeling that you have to get out every morning + stay out until after dinner.

We came to Nice three days ago on the "Blue Train" from Paris which left at 8 p.m. We arrived here at 9.30 next morning after a very comfortable night in a sleeper compartment. We had no hotel reservation but the French "international syndicate" directed us to one on The Victor Hugo Bd which was more expensive than we wanted. In the early evening of the first day I bought a Nice paper + looked to see if any apartments or cottages were for rent. As luck would have it I saw an advert for this place + next morning we looked up the agent + took it after seeing it. We pay $70.00 per month which is certainly cheaper than hotels. There is a fairly large studio room with a large comfortable double bed, a good sized kitchen + bathroom, both tiled, and an empty hall with ample cupboards for all our coats + gear. We feel very lucky indeed + life immediately has taken on an entirely different outlook from living in Paris. Now I can go to work without difficulties and I certainly feel like doing so right away.

You have probably been in Nice before but if not then some remarks may be in order about the place. It is very much quieter than Paris, more colourful in the quiet pink, ochre + dull yellow buildings with sage green, olive green and low toned turquoise shutters. The promenade is of course a burst of forced gaudiness which though sparkling in colour somehow isn't my medicine. I am surprised to find that the beach is all pebbles. How much Nice would like to have sands of St. Raphael. The people aren't as well dressed as in Paris but they are very much more pleasant and seem to be devoid of the hatred which Parisians have for all Americans + all those whom they mistakenly think are Americans. We have no desire to spend any further time in Paris during our stay in France. This is the part to be in + I just hope we find a good place, probably at Vance or Grasse, about 15 to 20 miles from here, so that you can come down for a soul enriching rest. Next week we will go to those places + look over the situation. I believe we will be able to find what we want. If so, you could fly to Nice from London + avoid all the fatigue of other forms of travel. How wonderful it is to have found a place where one has the chance to live peacefully + comfortably and also not expensively.

We hope that you are both very well and none the worse of the busy time you had during our very enjoyable visit. We certainly loved being with you and thoroughly enjoyed the spins around the country. It is now a grand memory but we hope to see you again ere long. Thank you for everything.

Our two or three days in London were very interesting. We visited Gimpels gallery one day + during conversation with George Gimpel I believe he expressed the desire to see the slides I had of Canadian painting.[46] Next day we returned with them + both his wife + himself were very interested indeed in the work + took a note of all the artists. He was surprised that the Canadian Art Magazine hadn't any articles on the work of the Painters XI and realized that the National Gallery of Canada wasn't doing very much in sending out representational work of contemporary painting.

Our two weeks in Paris before coming to Nice we spent mostly looking at contemporary exhibitions. Frankly, I was not very impressed + saw a lot of work which I thought feeble and meaningless. There doesn't seem to be anything very unique happening in France—I certainly didn't find it so far.

How is the antique business? Fairly quiet right now I suppose but each day will have its interest. Does Christmas mean anything in the way of business? You have certainly gathered together many beautiful things. We saw many ancient things in the Flea Market in Paris but prices there weren't bargain prices. Barbara fell for the large brass +

copper trays + it is just lucky that we aren't touring the world with half a dozen decked around us.

Here the trees are still in flower, roses in the gardens—a few—oranges and figs on the trees. I just wonder what the spring must be like + when is it around here.

We had another very interesting day in Paris when we took a trip out to Chartres Cathedral. The drive was through magnificent farming country + the guide who accompanied us through the Cathedral did a very good job. Fortunately there was a small party, only seven, + this meant that he wasn't as fatigued over his duties as he would be in summer with parties of forty or more.

Will write you before long + tell you what we are able to find in the way of studios or cottages in the country and anything else of excitement.

Our best love to you both + once again my thanks to you both for the wonderful time with you. We certainly enjoyed all of it.

Yours aye

Jock.

46. The Gimpel Fils gallery opened in 1946 and supported modern British artists including Barbara Hepworth and Ben Nicholson.

C/O MR. CUNY
30. BD. GAMBETTA
NICE
3RD NOV. 1954

Dear Dr. Pailthorpe,

Very pleased to hear from you this morning + to know that you had an enjoyable + useful trip to Oxford. Your letter was delayed some four days as there was insufficient postage on it + it was delivered by a special postman. The envelope carried a 2 ½ᵈ stamp. It looks as it if should be a 5ᵈ stamp or something to go ordinary rate. Of course the French post-office system is the worst in the world as far as I know + it is a wonder the letter even reached me in four or five days. It is a wonder that the authorities could evaluate the extra charge in so short a time. They have no system. If we want to mail a letter air mail the ordinary small shop where stamps are sold will not sell stamps for an air mail letter. You have to go blocks + blocks to a general post office to get the stamps. They have no regular air-mail envelopes—at least I've never been able to discover any. They won't pass a stamp over the counter, in most places, so that you can affix it yourself, they have to repeat over + over again the number of francs for each letter or post card + then total it all up in pencil on a scrap of paper. There is nothing slower in France than the post office.

It is good to hear that you are really coming down to this part of the world. It would be good for you + Riki if you did as the weather is still warm, sunny and the light is

brilliantly clear. I am told that in December + January it is likely to be damp + somewhat foggy but not really cold.

We have decided to move away from the sea for those months. We are leaving this address on the 19th of November and are going to live in VENCE, about ten fifteen miles inland, in the hills where there will be no fog + no dampness other than some rain now + again. We have been up to Vence + have taken over the ground floor of a villa there for two months to begin with. The agents won't rent anything in Vence for less than two months. We have to supply our own bed sheets and towels. In fact anything rented here never supplies those two items. A nuisance! Again, we had to pay a months rent in advance + will have to let the agents retain this extra months rent until we go. They hold it against damages, etc, + if there are no damages then the months rent is returned when we leave. This seems to be the custom in Vence. In other words we pay three months rent for two months residence + get the extra money paid back on leaving. This is a nice place with a good garden. The village + landscape is attractive + quite quiet. This is the Village where Matisse decorated the chapel.⁴⁷

As far as sleeping accommodation is concerned in the place we have rented there is unfortunately only room for one person besides ourselves. We saw other places for rent, running around £23 per month with two bedrooms but not what I would call comfortable to any great degree. There must be many more places in Vence which might be quite nice but we haven't had enough time up there to see them yet. One has to pay light, heat + gas above the rent.

Do you want a quiet + attractive village or would you want to stay in Nice? When would you want to come?

This place we are vacating isn't suitable for sleeping as it has only one double bed in it. There is also a strange situation in the fact that there is only hot water for baths on two days of the week—Thursday + Sunday. Thursday is I suppose the washing day + Sunday the day for a splash. We have to heat on the gas a pan of water for washing + for dishes, etc. We cannot have this place in Nice after the 1st of January so that is another reason why we thought we would look over Vence right away + try to settle down for a fairly long stretch.

Would you like us to look for a place for you? If you can give us a particular date of arrival then I feel fairly certain that we can find a place + I could pay the advance money necessary to hold it for you—whether in Nice or Vence? It would probably be easier to find a place in Vence, that is a place with a garden where one can have immediate access to + be able to enjoy a real rest. The hundred pound allowance should do fairly well as food isn't nearly as expensive as it is in Paris. Isn't it possible for you to purchase return air tickets from London to Nice + yet leave you this £100 clear for spending abroad? Of course there is the "Blue Train" from Paris to Nice which [text illegible due to a fold in the letter] it would cost you about £10, I believe, for a private sleeping compartment. This

train leaves the Gare de Lyons at 8 P.M. + arrives in Nice at 9.30 in the morning. You can get breakfast on the train + dinner on the evening before. This would not be exhausting travelling either. I don't know what a taxi would cost to Vence but there are some old buses early in the morning but a very comfortable one up from Nice leaving at 1.30 pm.

I will await your letter informing me what you will decide to do. We do hope that you can arrange to come for a while. We will be delighted to make what arrangements you would like us to make. I think you cannot help thoroughly enjoying such a tremendous change after all the wretchedness of the weather you have been suffering in Britain.

We have been greatly enjoying those warm days + the hours of sunshine. The city is so nice + quiet after Paris + the people are exceedingly pleasant. I have done a little painting + feel better about that.

Will now close as I have some more letters to write today.

Hoping that you + Riki can really get down here ere long.

Our very best regards to you both.

Jock

47. La Chapelle du Rosaire de Vence was built from 1949 to 1951 and
 was designed by Henri Matisse, who also supplied decorative
 pieces and furnishings.

PROBABLY 1957[48]

**WITH BEST WISHES FOR CHRISTMAS
AND THE NEW YEAR**

**4 MAPLE AVENUE
TORONTO 5
CANADA**

Dear Doc + Riki,

We send to you our best wishes for a jolly Christmas and may the New Year provide the best of good health and enjoyment. How have things been going? What of the Old Antique Shop, the past summer and the present? We are both in excellent health + things at the Art College have improved slightly from the financial side. Miss Duisberg and I did not manage to meet even though we tried to do so. She, somehow, managed to go off to Saskatoon + then came east to Montreal. She has been back in England for some time now. I painted all summer, producing about thirty things. Quite a number of works being around 54 x 48. Yesterday I closed a one-man show at the Toronto University Hart House Gallery + earlier I had provided my share of things at a "Painters XI" exhib at a new private gallery here. You will be interested to hear that my work has been capturing the attention here—in reviews, radio crits, and brought me something over a thousand dollars in sales + some added sales are still pending. One reviewer at the C.B.C stated that I

was "undoubtedly the best young artist we have in Canada." Clement Greenberg, one of the most highly considered critics of the U.S.A. saw some of my early summer paintings + was decidedly encouraging.[49] He said my new work was good enough for any top gallery in N.Y. + for any sakes keep painting + listen to nobody about your colour, technique, comp or anything else. As a matter of fact I have at last managed to paint freely in oil—automatically—as I did earlier in water-colour. I use a lucite plastic, thinned down with turps, with straight oils, using ordinary house painters brushes of various widths. I like the flexibility of those brushes better than the hogs-hair brushes. Sir Herbert Read visited the "Painters XI" exhib + he stated publicly at Queens University, Kingston, that our work was as good as any recent work he had seen in the U.S.A., Britain + France, The PXI are now said to be the first group to have given a decided contribution to art in Canada since the Group of Seven, 35 years ago. Now that I have found my way, completely my own way—I am now painting continuously throughout my free moments from teaching. Excuse this long ramble about myself. I felt that you would be interested to know that your valuable guidance is now beginning to flower. Fiona is keeping fine in California. Our love to you both.

And the best,

Jock

48. The note "probably 1957," as well as the address, have been written
 on this greeting card in pencil by someone other than Macdonald.

49. Clement Greenberg was invited to Toronto by members of
 Painters Eleven in June 1957; he spent a half day with Macdonald
 in his studio, as he did with others in the group.

**4 MAPLE AVENUE
TORONTO 5
19TH JANUARY, 1959**

Dear Doc and Riki,

We were highly delighted to receive your kind Christmas greetings and good wishes for the New Year. Thank you most sincerely.

We wondered for some time how things were going with you as it was a very long time since we had word from you. It distressed us to hear of your accident and illness, about the vacating of your beautiful house and of the wretched weather you experienced in Spain. Last year was a decidedly unfortunate one. We do hope that 1959 will bring back a return to full health + vitality for you, Doc—that you will quickly find a house to your liking and that you will, if you move away from Britain, find a spot where the climate will be agreeably warm and comfortable.

I expect that you are undergoing a wretchedly cold spell at present. It is hard to take. We are having bitter

weather + have been experiencing this almost steadily for the past three months or more. Doubtless, it will last until the end of April. How we hate it. Around Quebec + Montreal it is the toughest winter in living memory and in northern Ontario the thermometer has been frequently around 50° below zero.

I am very interested to learn about the possible visit of Robert Lyons. We will be very happy to see him + to assist him as much as possible if he definitely wishes to gather a painting exhibition from Canada for a Festival of Art at the time of the Edinburgh Musical Festival.

So far I have no word from Mr. Lyon. I certainly hope that he gets in touch with me before he gets in touch with Allan Jarvis, Director of the National Gallery of Canada, or, for that matter, anyone connected with the Nat. Gallery. I am certainly able to give him an unbiased knowledge regarding the artists he should endeavor to get work from + where he could find the work which I am sure would be representative of Canadian Art. I have on several occasions acted as a single juryman in selecting Canadian painting for exhibitions outside Canada but when it comes to the National Gallery sending a Canadian Exhib abroad I am never asked to submit a work. Jarvis for some reason has his knife in me. When I was over in Europe in 1954 I managed to interest Fils Gallery in London, the Rivé Droit Gallery in Paris, and The Canadian Embassy in Paris in the painting of the "Painters XI" (the most notable group in Canada since Group VII, to which I belong). Either Jarvis or the Gov. General of Canada—Vincent Massey—stopped our approved exhibition for Paris. We had permission from the Dept of External Affairs—Federal Government—to hold a show in Paris, sponsored by The Canadian Embassy there. It was stopped by someone + I think we were stopped because we didn't call for the sponsorship or approval of the Nat Gallery of Canada. We "Painters XI", made a hit in New York— Riverside Museum, 1956—when we accepted an invitation to exhibit there from "The American Abstract Society of Artists."[49] Jarvis had no say in this show either + even though we invited him to accept an invitation to speak at this gallery during the show he failed to do so, even though he went to New York to do so. He did not inform the Riverside Museum he wouldn't lecture until the afternoon before the day he was advertised to talk. A diplomatic error in my opinion. If Jarvis should find that Mr. Lyon is to contact me he is sure to blast me + try to hedge him away from me.

If there was any possibility of my being invited to attend, as a representative artist from Canada, the art Festival at Edinburgh I am certain Jarvis would squash me if he could even though he knows perfectly well that I could lecture very well on Canadian Art + could take up quite satisfactorily any social obligations which may be necessary. Any invitation to me would have to be directed to me + the special request would have to be made because I am the only "Scottish born painter" of National (Canadian) recognition in Canada. In the opinion of the C.B.C art critic I am "the best young

abstract or non-objective painter in Canada, even though 61 years old." In Clement Greenberg's view I am "absolutely able to hold his own with the best modern artists in New York." Greenberg is considered one of the foremost critics in New York. If the National Gallery played fair with me I would be in all overseas Canadian Exhibitions. But I am behind the "8 ball" at present. I am not painting like anyone anywhere. This is not a boast. You can fully understand where I am as all my flowering arose from my blessed good fortune in my being "enlightened" and "educated creatively" by you both. I am entirely indebted to you both + will always be grateful for your kindness in initiating me to creative painting.

No, the tachist painting hasn't come to Canada yet. There is some in New York.

I would very much like to do something about obtaining an exhibition for you in Toronto or somewhere in Canada. There is a gallery here that I might be able to interest but I will have to wait a little time as this gallery is likely to appoint a new Director. The man likely to be appointed is a friend of mine. Toronto people are very slow to buy works from anywhere outside Ontario. I noticed that my work from France didn't go very well. I think I sold three small things—none in Toronto.

I hope that you both find a good house soon + everything will be right for lots of painting. I would love to come over to see your work + to have a good talk about everything.

I would like to write more but it is very very late + tomorrow is a busy day at College.

You will hear from me ere long.

Our love to you both.

I am sorry we have no news about Florence Waddington. I recently heard from a Mrs. Carr, in Calgary, that she was very fit + well. That was good to hear.

Yours aye, Jock

49. The exhibition Macdonald refers to is the *20th Annual Exhibition of American Abstract Artists with 'Painters Eleven' of Canada*, which ran from April 8 to May 20, 1956.

<div align="right">

4 MAPLE AVENUE
TORONTO 5
5TH DECEMBER, 1959

</div>

My Dear Doc + Ricki,

I thought that it would be a pleasure for me to enclose a note along with the greeting card which we are sending along. It is!

We hope that you two good people are keeping very well and that the year has been a good one. It is so dreadfully long since I have written + also the same since we heard from you that I feel ashamed of my neglect and have missed very greatly not having news about you. Christmas has its goodness as it brings news of friends. Good!

This year for us has gone along really quite well. Nothing very unusual happened except that I continue to paint with an increase of production each year + have been selling about ten or twelve works per year. Also I am receiving considerable publicity of a favourable nature. The Toronto Art Gallery bought another large canvas for the perm. collection.[51] I have four things in this gallery now. Several things have been bought for some important private collections + of course there have been the usual number of small collections picking things up. Between the summer of 1959 + 1960 I will have three one-man shows—two of them in Toronto. I have one coming up on 7th January + later in April the Toronto Art Gallery is planning to give me an important + larger show.[52] This Toronto Gallery isn't altogether "a retrospective" but it will contain a few early landscapes. The gallery has only put on one man shows by Group of Seven members during the past twelve years so I consider this show for me is quite exceptional. I am painting at least forty canvases a year—most of them quite large.

Barbara is at present recovering from a broken right arm. This is the second time the arm has been broken—through falling—in two years. This time she tripped on a fuel hose pipe laid across the pavement on one of the main city streets. She was the second women to fall over the pipe. The arm has set well + the cast will be removed in another week.

Just last week Eunice Coutts phoned up to tell us that she received a letter from Peggy Sims, Vancouver, reporting that she had heard that Florence Waddington had passed away in her sleep, in October. Florence was still in Australia. She was aged 81. It is sad to know that she has died. She + Waddie were exceptionally wonderful people and, like you, we were extremely fond of them.

I don't know, Doc, if you knew Dr. Alex Agnew, of Vancouver. He was a specialist who did much for Fiona. He also bought many of my landscapes + kept contact with me until the time of his sudden death, at 57, from a heart attack in September. He was head of the Medical Department of the U.B.C. I lost a very fine friend + a great patron of my early work.

This summer I again spent three weeks teaching at the Doon summer art session, took three weeks rest but all the remainder of the summer I painted at home. It was a very hot summer—wretchedly so. The previous winter was the coldest + longest we have had since coming to Toronto twelve years ago.

During the Easter session I had a few days in New York. I was surprised to again meet William + Mary Scott at a dinner party. I didn't know that they were in N.Y. until they popped into this private home. I enjoyed seeing them again. We met several times during my time in the city. I had a renewed association with Dr. Grace Morely. She is now the assistant director of the Guggenheim Gallery. I also saw Clement Greenberg—the critic, the strange fellow (artist)

Barnet Newman[53] + Dr. Hale, the Director of American painting in the Met.

I found painting in N.Y. not to my liking. New York seems to be filled with set fashions of painting. Last Easter it was all "action" painting on white grounds. I was told that if I painted in this manner I could get a show in the city. I said I wasn't a factory painter + would not go on to any band-wagon no matter what it might mean for me.

Fiona is keeping very well + is still enjoying her home in Ventura, California. We will possibly be down there in 1961 as I have been invited to instruct at the summer art session of The University of Southern California. A very surprising invitation for a Canadian.

As I have all my Christmas Mail to attend to I must now close. Our best love to you + all good wishes for a happy Christmas + the best of health in 1960.

Jock.

51. *Fleeting Breath* (1959) is the "large canvas" the Art Gallery of
 Toronto bought from Macdonald.

52. The "important + larger show" at the Art Gallery of Toronto was
 Jock W. G. Macdonald: A Retrospective Exhibition, which was
 held in May 1960 and included sixty-six works.

53. Macdonald is referring to Barnett Newman.

4 MAPLE AVENUE
TORONTO 5
8TH MAY, 1960

Dear Dr. Pailthorpe + Riki,

We hope that all is well with you and that you will have an enjoyable summer. It is so long since we have heard from you that we wonder about you quite frequently and trust that the reason for the silence is the result of much activity. We will be sorry if either of you have been indisposed in any way.

Things have been going along in an extremely busy manner during the past year. I have had no less than three one-man shows during the last six months and the retrospective, the cuttings enclosed regarding it, has been quite something to gather.

I thought that you would be interested in the cuttings so have mailed them along.

On the whole the critics are very favourable about the show, as also is the general public and the Director of the Toronto Art Gallery. Quite honestly, I am highly honoured being given this show as I am the only living artist outside Lawren Harris, Jackson, Lismer + Varley to have been given a one-man show at this gallery during the past twenty years or more. What is still more amazing is the fact that I have been asked before any Ontario born artist, outside the Group of Seven. I am fast saying this because I am sure that you will

be interested. And to say that I am well aware of the fact that this could never have happened had I not, during the 40's had the great fortune to receive your teachings. From that time I commenced to speak in a creative way and apparently I am still doing so, in the eyes of the so called critics.

This winter has been easily my best selling ever. I have luckily enough sold nearly five thousand dollars worth of work since October, 1959. I anticipate that I will sell one or two paintings from my retrospective before it closes at the end of May.

I will certainly need some money in the bank as I will be forced to retire from college in two years time on a pension (?) of eighty dollars a month. This doesn't worry me very greatly as I can always have plenty of private students + I am quite prepared to start a new life at 65. Fortunately, Barbara + I are first rate physical condition + there is no evidence of any drastic change up to the present or expected in the near future. The only disturbance during the winter was accidental—Barbara fell + broke her right wrist at Christmas through tripping over a fuel hose laid across the pavement on a main street. The company gladly paid all costs + the wrist is 98% well.

How are things in Britain? On the surface things probably appear excellent in the world but the situation continues to deteriorate in the body. There has been Princess Margaret's marriage to pep people up but it looks as if she was determined to marry Armstrong-Jones come heaven or high-water. Perhaps it will work out well enough.

Fiona is keeping very well. We expect to be in California next summer. I have an appointment to teach there next summer but I am not mentioning this around here just yet.

This summer we will remain in Ontario. I have three weeks teaching to do at Doon. Apart from two weeks with friends near Picton, where we will live in a disused lighthouse, I expect to paint all the remaining weeks.

Must now close. Looking forward to hearing from you before long + hoping all is well with you both. Our love to you.

Jock

130 HOLLYWOOD HTS. DRIVE
PORT CREDIT, ONTARIO
DECEMBER 10TH, 1960

Dear Doc + Rikki,

This is not a happy letter but I thought you would want to know James died suddenly of a heart attack on the 6th Dec. If I have the date wrong it is because I am still confused. The only thing that has buoyed me up is that his passing was so wonderful. I felt that I had been privileged to be in the presence of a great mystery. Although he was in great pain and in an oxygen tent he joked with the nurse + the orderly and at the very end looked straight + clear

+ said "Don't worry." So he did unafraid which is a great comfort to me. I had a very dear friend with me + she + I sat in the room for a long time after he had gone, very quietly without grieving. The hospital was kind enough to let us do so although the doctor couldn't understand why we wanted to.

After I get the apartment + belongings disposed of I am going to stay with my daughter in California for a few weeks then I will come home back to Toronto + make some sort of a life for myself.

I hope all is well with you.
Barbara.

100 UNIVERSITY AVENUE
VENTURA, CALIFORNIA
28TH JANUARY, 1961

Dear Doc + Riki,

Thank you for your two letters which have been sent on to me here. I gave up the 4 Maple Avenue apartment but my friend's address in Port Credit will always find me till I find a place to live; I expect to stay in Toronto. I have been staying with Fiona + Bill longer than I expected but it turned out better this way.

I will begin at the beginning to tell you about James' illness. One evening he was refurnishing up some frames + he stopped + came into the room where I was reading + said he felt an awful pain in his chest + thought it was indigestion. He wanted me to get him baking soda but I knew he hadn't eaten a heavy meal so I was afraid to give him any. He had always been told his heart was in good condition yet I remembered people sometimes think a heart attack is indigestion. I made him lie down on the floor + after a while he said he felt fine again. He insisted on going back to his frames although I didn't want him to. Then the pain came on again + he was sure it was indigestion but I made him go to bed where he felt just fine + so I stopped thinking it was a heart pain. He slept well + in the morning said he felt fine. He got up + went to shave but came back immediately with a severe pain + I called a doctor immediately + he came in about fifteen minutes. By this time James was feeling fine again. The doctor gave him an injection + told him he thought it was a slight thrombosis + that he was going straight to the hospital to make arrangements for him to go there as soon as possible. He phoned me back shortly after + said there was a bed for him and then James flatly refused to go in an ambulance. I called a friend + he came up with his car + together we got James to the hospital. The doctor stipulated that he was not to dress or exert himself so we bundled him up but he walked to the car with us making him take a step at a time slowly.

They kept him under sedatives for 4 days. He was 10 days altogether in the hospital and they gave him a thorough check up + then said they could find nothing wrong with

his heart. They said he had a hernia of the stomach + that this had probably disturbed his heart. He was advised to eat small meals + eat often + if he felt a pain to sit up or stand. He really enjoyed his 10 days in the Wellesley + had fun with the nurses. Towards the end of his stay he was allowed to order anything he liked to eat + used to decorate the order slips with little drawings. Everyone was fond of him. He was allowed to walk in the corridor + used to visit other people. He said himself that he enjoyed the hospital—that they were wonderful to him. The doctor told him he would be quite fine + well after a short rest, that his heart was not damaged in the least. In fact they didn't think he had had a heart attack.

So he came home and had two weeks rest and said he felt he had a new lease on life. He seemed well + was happy + went back to his teaching part time for a week + then said he felt quite fit + went back full time. I made him rest + insisted on cutting out all social activities in the evenings so that he had no late nights. I begged him to cancel his one man show which was to be held in February but he wouldn't hear of it. I did notice that he tired easily and he said to me one day "I think my painting days are over." I couldn't think why he said it because his painting was going very well except that he had made a mess of one canvas but everyone does that at times. I told him not to drive himself but to take things easily.

Well then a friend asked me to go to Buffalo with her for a couple days to do some Xmas shopping. James was very keen that I should go but before I would consent we had him go to the doctor + find out if he was really as well as he said. He was told he was in very good condition—his heart was normal + his blood pressure that of a boy of 16 + that there was very little possibility of another attack like he had had and in any case it was not serious so that I could without a doubt leave him for two days. I made him promise to rest + promise not to start a new painting till I came home. I noticed later that he hadn't even stretched a new canvas. He phoned us to Buffalo + was full of fun + teasing + seemed in good form.

We phoned him when we were on the way home but got no answer so I thought he had gone out—he had so many friends. When I got home about 4 p.m. there was a note for me saying he had been taken to the Wellesly at 7 that morning with a heart attack. I phoned the hospital at once + they assured me it was a very slight heart attack + that I had nothing to worry about but when I got to the hospital he was in an oxygen tent + in great pain + vomiting. The doctor got there shortly after I did + they gave him morphine but he died before it took effect. The doctor had called a heart specialist when he was taken in in the morning + yet they both didn't think he was in a serious condition. I think they were looking for a thrombosis + he had angina. It was a terrible shock to me. That silly trip to Buffalo! The landlord, who is a friend of ours came down to him that morning + called the doctor.[54] He was taken to the hospital in an ambulance. He was due to

retire in a year + had been fussing over his pension but he was looking forward to more time for painting.

He died at the peak of his painting career which I suppose is better for him than to have known he had heart trouble + not been able to paint. It was better for him to have gone than live in dread of these painful attacks.

When I go over his papers + slides if I can find any of his work or if I can manage at any time to have some made I'll send you them to give you an idea of what he was doing.

I am going back to Toronto in about a week from now + will be staying in Port Credit with the Van Alstynes for a short while. I will write again when I get things in order.

Yours sincerely,
Barbara.

54. The friend that called the doctor for Macdonald was musician and painter Michael Kuczer, who became close with the Macdonalds after they moved to Maple Avenue in 1955.

16 ST. JOSEPH STREET, APT. 25
TORONTO 5, ONT.
3RD JANUARY, 1962

Dear Doc + Ricki,

I hope this is the right address. In all my shitting about I lost my address book but found an old one of James'.

The Roberts' Gallery is putting on an exhibition of his work so I am sending you the booklet with some black + white reproductions which will give you an idea of what he was doing.[55] I haven't had any slides made. If they sell + I make any money I could try to have some made before the end of the show. In that case I could send you some.

I have been working since August last at the Canadian Handicraft Shop on Bloor Street and have really been hard at it during the Christmas rush doing full time and two nights a week. Now comes the slack time so I am out of a job and am looking around for something else to do. They will need me again in August and I liked working with them.

I hope you are both well and weathering the cold weather. I see by the papers it is very cold with lots of snow in England. It is pretty cold here too with some snow. Toronto lies just outside the heavy snow belt but we do get it sometimes. My 'bachelor' apartment is very well heated so I am comfortable.

A very Happy and Prosperous New Year to you and very good wishes for everything good.
Barbara.

55. The Roberts Gallery presented *Jock Macdonald: A Retrospective* from January 5 to 20, 1962.

List of Works

Dimensions are listed as height x depth

Yale Valley, BC, c. 1932
oil on canvas
77 x 86.5 cm
Courtesy of John A. Libby Fine Art, Toronto

In the White Forest, 1932
oil on canvas
66 x 76.2 cm
Collection of the Art Gallery of Ontario,
Toronto, Purchase, 1975

The Black Tusk, Garibaldi Park, 1932
oil on canvas
71 x 90.8 cm
Collection of the Vancouver Art Gallery,
Gift of Michael Audain and Yoshiko Karasawa

Etheric Form, 1934
oil on panel
38.1 x 30.5 cm
Collection of the Vancouver Art Gallery,
Gift from an Anonymous Donor

Formative Colour Activity, 1934
oil on canvas
77 x 66.4 cm
Collection of the National Gallery of Canada,
Ottawa, Purchase, 1966

Indian Church, Friendly Cove (recto);
Departing Day (verso), 1935
oil on wood panel
37.9 x 30.5 cm
Collection of the Art Gallery of Ontario, Toronto,
Purchased with assistance from Wintario, 1979

Pacific Ocean Experience, c. 1935
oil on panel
34.9 x 27.6 cm
Collection of Ms. Oona Eisenstadt

Day Break, 1936
oil on canvas
56 x 46 cm
Private Collection

Spring Awakening, c. 1936
oil on canvas
76.2 x 60.9 cm
Private Collection

The Pacific Combers, 1936
oil on canvas
60.5 x 76.3 cm
Collection of VBCE Vancouver Bullion
& Currency Exchange

Fall (Modality 16), 1937
oil on canvas
71.1 x 61 cm
Collection of the Vancouver Art Gallery,
Acquisition Fund

Indian Burial, Nootka, 1937
oil on canvas
91.9 x 71.8 cm
Collection of the Vancouver Art Gallery,
Founders' Fund

Pilgrimage, 1937
oil on canvas
78.6 x 61.2 cm
Collection of the National Gallery of Canada,
Ottawa, Purchase, 1976

Untitled Modality, c. 1937
oil on canvas
91.4 x 91.4 cm
Private Collection

Chrysanthemum, 1938
oil on canvas
55 x 45.6 cm
McMichael Canadian Art Collection,
Purchase, 1993

Drying Herring Roe, 1938
oil on canvas
71.1 x 81.3 cm
Private Collection

Rain, 1938
oil on canvas
56.2 x 46.2 cm
Collection of the National Gallery of Canada,
Ottawa, Purchase, 2007

Winter, 1938
oil on canvas
56 x 45.9 cm
Collection of the Art Gallery of Ontario, Toronto,
Gift of Miss Jessie A. B. Staunton in memory of
her parents, Mr. and Mrs. V. C. Staunton, 1961

Departing Day, 1939
oil on canvas
71.5 x 56.1 cm
Collection of the Art Gallery of Hamilton,
Gift of the Volunteer Committee, 1985

Flight, 1939
oil on canvas
36.5 x 46.4 cm
Private Collection

The Wave, 1939
oil, sand on canvas
102.2 x 82 cm
Collection of the Montreal Museum of Fine Arts,
Purchase, Horsley and Annie Townsend Bequest

Castle Towers, Garibaldi Park, 1943
oil on canvas
71.3 x 96.7 cm
Collection of the Vancouver Art Gallery,
Acquisition Fund

Fish Family, 1943
watercolour on paper
36.5 x 44.5 cm
Hart House Permanent Collection, University
of Toronto, Purchased by the Art Committee
1949/1950

Fish, 1945
watercolour, ink on paper
22.3 x 30.3 cm
Collection of The Robert McLaughlin Gallery,
Oshawa, Purchase, 1979

Untitled [10.20 p.m., September 16, 1945], 1945
ink on paper
23 x 30.5 cm
Collection of the Scottish National Gallery
of Modern Art, Edinburgh

Untitled [11 p.m., September 16, 1945], 1945
ink on paper
22.8 x 30.4 cm
Collection of the Scottish National Gallery
of Modern Art, Edinburgh

Untitled [9.5 p.m., October 12, 1945], 1945
ink on paper
22.9 x 30.5 cm
Collection of the Scottish National Gallery
of Modern Art, Edinburgh

Untitled [9.10 p.m., October 12, 1945], 1945
ink on paper
22.6 x 30.5 cm
Collection of the Scottish National Gallery
of Modern Art, Edinburgh

Untitled [9.20 p.m., October 12, 1945], 1945
ink on paper
22.7 x 30.5 cm
Collection of the Scottish National Gallery
of Modern Art, Edinburgh

Untitled [9.25 p.m., October 12, 1945], 1945
ink on paper
22.8 x 30.4 cm
Collection of the Scottish National Gallery
of Modern Art, Edinburgh

Untitled [9.30 p.m., October 12, 1945], 1945
ink on paper
23 x 30.5 cm
Collection of the Scottish National Gallery
of Modern Art, Edinburgh

Untitled [9.35 p.m., October 12, 1945], 1945
ink on paper
23 x 30.5 cm
Collection of the Scottish National Gallery
of Modern Art, Edinburgh

Untitled [9.40 p.m., October 12, 1945], 1945
ink on paper
23 x 30.5 cm
Collection of the Scottish National Gallery
of Modern Art, Edinburgh

Untitled [9.45 p.m., October 12, 1945], 1945
ink on paper
23 x 30.6 cm
Collection of the Scottish National Gallery
of Modern Art, Edinburgh

Untitled [October 23, 1945], 1945
watercolour, ink on paper
30.5 x 22.7 cm
Collection of the Scottish National Gallery
of Modern Art, Edinburgh

Untitled [October 23, 1945], 1945
watercolour, ink on paper
22.8 x 30.4 cm
Collection of the Scottish National Gallery
of Modern Art, Edinburgh

Untitled [October 23, 1945], 1945
ink on paper
30.3 x 14.7 cm
Collection of the Scottish National Gallery
of Modern Art, Edinburgh

Untitled [October 26, 1945–1], 1945
watercolour, ink on paper
22.8 x 30.4 cm
Collection of the Scottish National Gallery
of Modern Art, Edinburgh

Untitled [October 26, 1945–2], 1945
watercolour, ink on paper
22.8 x 30.5 cm
Collection of the Scottish National Gallery
of Modern Art, Edinburgh

Untitled [October 26, 1945–3], 1945
watercolour, ink on paper
22.8 x 30.4 cm
Collection of the Scottish National Gallery
of Modern Art, Edinburgh

Untitled [November 8, 1945–1], 1945
watercolour, ink on paper
22.8 x 15.3 cm
Collection of the Scottish National Gallery
of Modern Art, Edinburgh

Untitled [November 8, 1945–2], 1945
watercolour, ink on paper
30 x 22.8 cm
Collection of the Scottish National Gallery
of Modern Art, Edinburgh

Untitled [November 24, 1945], 1945
watercolour, ink on paper
25.2 x 35.5 cm
Collection of the Scottish National Gallery
of Modern Art, Edinburgh

Abstract-Vermilion Centre, 1946
watercolour, ink on paper
17.8 x 25.5 cm
Collection of The Robert McLaughlin Gallery,
Oshawa, Gift of M. Sharf, 1983

Automatic, c. 1946
ink, watercolour on paper
46.4 x 55.2 cm
Collection of Lynda M. Shearer

Dolls and Toys, 1946
watercolour, ink on paper
25.5 x 35.6 cm
Collection of The Robert McLaughlin Gallery,
Oshawa, Gift of M. Sharf, 1983

Music Hour, 1946
watercolour, ink on paper
18 x 25.8 cm
Collection of The Robert McLaughlin Gallery,
Oshawa, Purchase, 1979

Orange Bird, 1946
watercolour, ink on paper
18.5 x 26.4 cm
Collection of The Robert McLaughlin Gallery,
Oshawa, Gift of M. Sharf, 1983

Russian Fantasy, 1946
watercolour, ink on paper
21.7 x 35.7 cm
Collection of the Art Gallery of Ontario, Toronto,
Purchased by the Peter Larkin Foundation, 1962

Sandpiper, 1946
watercolour, ink on paper
25.5 x 35.8 cm
Collection of The Robert McLaughlin Gallery,
Oshawa, Gift of M. Sharf, 1983

The Ram, 1946
watercolour, ink on paper
17.8 x 25.6 cm
Collection of The Robert McLaughlin Gallery,
Oshawa, Purchase, 1979

Untitled [December 1946], 1946
watercolour, ink on paper
25.2 x 35.4 cm
Collection of the Scottish National Gallery
of Modern Art, Edinburgh

Untitled [January 1946], 1946
watercolour, ink on paper
17.7 x 25.3 cm
Collection of the Scottish National Gallery
of Modern Art, Edinburgh

Untitled [January 1946], 1946
watercolour, ink on paper
25.2 x 35.4 cm
Collection of the Scottish National Gallery
of Modern Art, Edinburgh

Abstract Space, 1947
watercolour, ink on paper
35.6 x 25.2 cm
Collection of The Robert McLaughlin Gallery,
Oshawa, Gift of M. Sharf, 1983

Automatic (Untitled), c. 1948
oil on canvas
69.8 x 83.8 cm
Collection of the Art Gallery of Ontario, Toronto,
Purchased with assistance from Wintario, 1977

Bird and Environment, 1948
oil on canvas
64.9 x 88.1 cm
Private Collection

Land of Dreams, 1948
watercolour, wax resist on paper
38.7 x 48.3 cm
Collection of The Robert McLaughlin
Gallery, Oshawa, Gift of M. Sharf, 1983

The Witch, 1948
watercolour, ink on paper
37.4 x 45.3 cm
Collection of the Art Gallery of Ontario,
Toronto, Gift from the Albert H. Robson
Memorial Subscription Fund, 1950

Birds Dreaming, 1949
watercolour, ink on paper
39.8 x 47.5 cm
Collection of The Robert McLaughlin Gallery,
Oshawa, Gift of Isabel McLaughlin, 1987

Phoenix, c. 1949
watercolour, ink on paper
25.4 x 35.7 cm
Collection of The Robert McLaughlin Gallery,
Oshawa, Gift of Alexandra Luke, 1967

Ritual Dance, 1949
watercolour, wax resist, ink on paper
38.9 x 48.1 cm
Collection of The Robert McLaughlin Gallery,
Oshawa, Gift of M. Sharf, 1983

Leaves of a Book, 1950
watercolour, wax resist, ink on paper
38 x 47 cm
Collection of the Art Gallery of Greater
Victoria, Gift of Mrs. Maxwell Bates

Revolving Shapes, 1950
watercolour, wax resist on paper
24.8 x 25.1 cm
Collection of the Art Gallery of Greater
Victoria, Gift of Colin and Sylvia Graham

Birds in a Field, 1951
brush, black ink, watercolour on paper
41 x 50.9 cm
Collection of the National Gallery of Canada,
Ottawa, Purchase, 1995

Forms Evolved, 1951
watercolour, scraffito on paper
29.7 x 29.4 cm
Collection of the Art Gallery of Greater
Victoria, Anonymous Gift

Bearer of Gifts, 1952
oil on canvas
79.1 x 94.6 cm
Private Collection

Fabric of Dreams, 1952
watercolour on paper
37 x 46.9 cm
Collection of the Art Gallery of Ontario, Toronto,
Purchased by Peter Larkin Foundation, 1962

Scent of a Summer Garden, 1952
watercolour, coloured inks on paper
35.6 x 45.7 cm
Collection of the Agnes Etherington Art Centre,
Queen's University, Kingston, Gift of Ayala and
Samuel Zacks, 1962

The Argument, 1952
watercolour, ink on paper
24.8 x 35.5 cm
Collection of the Art Gallery of Greater
Victoria, General Art Purchase Fund

The White Bird, 1952
watercolour, coloured ink on paper
37.3 x 47.8 cm
Collection of the Art Gallery of Ontario,
Toronto, Gift from the John Paris Bickell
Bequest Fund, 1953

Reflections in a Pond, 1953
watercolour on paper
33 x 45.1 cm
McMichael Canadian Art Collection,
Gift of Mrs. B. E. Macdonald

Nature's Pattern, 1954
gouache, ink on paper
39 x 46.8 cm
Collection of The Robert McLaughlin Gallery,
Oshawa, Purchase, 1971

Untitled, 1954
watercolour, ink
32.9 x 42.9 cm
Collection of The Robert McLaughlin Gallery,
Oshawa, Gift of Mary Hare, 1990

Orange Impulse, 1955
oil, graphite on canvas
73 x 91.8 cm
Collection of The Robert McLaughlin Gallery,
Oshawa, Donated by the Ontario Heritage
Foundation, 1988, Gift of M. F. Feheley

Obelisk, 1956
oil on canvas
101.5 x 61.5 cm
Collection of the National Gallery of Canada,
Ottawa, Purchase, 1984

Airy Journey, 1957
oil on panel
112.5 x 127.5 cm
Hart House Permanent Collection, University
of Toronto, Purchased by the Art Committee

Desert Rim, 1957
oil, Lucite 44 on Masonite
119.7 x 134.6 cm
Collection of Museum London, Purchased
with a Canada Council Matching Grant and
Acquisitions Funds, 1960

Flood Tide, 1957
oil, Lucite 44 on Masonite
76 x 121.9 cm
Collection of The Robert McLaughlin Gallery,
Oshawa, Purchase, 1970

Iridescent Monarch, 1957
oil, acrylic, resin, Lucite 44 on Masonite
106.7 x 121.9 cm
Collection of the Art Gallery of Hamilton,
Gift of the Canada Council, 1960

Real as in a Dream, 1957
oil, Lucite 44 on Masonite
121.09 x 61 cm
Private Collection

Red Bastion, 1957
oil, Lucite 44 on hardboard
121 x 121 cm
Collection of the Vancouver Art Gallery,
Acquisition Fund

Slumber Deep, 1957
oil, Lucite 44 on canvas
121.9 x 135.3 cm
Collection of the Art Gallery of Ontario, Toronto,
Gift from the McLean Foundation, 1958

Clarion Call, 1958
oil on pressed board
106.7 x 121.9 cm
Agnes Etherington Art Centre, Queen's
University, Kingston, Gift of Ayala and Samuel
Zacks, 1962

Contemplation, 1958
oil, Lucite 44 on Masonite
68.5 x 122 cm
Collection of the Art Gallery of Greater
Victoria, Friends of the Gallery

Coral Fantasy, 1958
oil, Lucite 44 on Masonite
106.4 x 122 cm
Collection of the National Gallery of
Canada, Ottawa

Lament, 1958
oil, Lucite 44 on canvas
137.2 x 12.9 cm
Collection of the Royal Bank of Canada

Leaded Light, 1958
oil on canvas board
61 x 51 cm
Collection of the Art Gallery of Windsor,
Bequest of Pearce L. S. Lettner, 1977

Rim of the Sky, 1958
oil on Masonite
40.5 x 50.8 cm
Collection of The Robert McLaughlin
Gallery, Oshawa, Gift of Joan Murray, 1997

Rust of Antiquity, 1958
oil, Lucite 44 on Masonite
106.5 x 121.4 cm
Collection of The Robert McLaughlin
Gallery, Oshawa, Gift of Alexandra Luke, 1967

Transitory Clay, 1958
Lucite 44 on board
106.5 x 122 cm
McMichael Canadian Art Collection,
Gift of ICI Canada Inc.

Celestial Dance, 1959
oil on canvas
151.7 x 71.2 cm
McMichael Canadian Art Collection, Gift of
Wendy Hoernig in memory of Hope Holmested,
a lifelong enthusiast of Canadian art

Drifting Forms, 1959
oil, Lucite 44 on canvas board
40.6 x 50.6 cm
Collection of The Robert McLaughlin
Gallery, Oshawa, Purchase, 1977

Fleeting Breath, 1959
oil, acrylic resin on canvas
122.2 x 149.2 cm
Collection of the Art Gallery of Ontario,
Toronto, Purchased with the Canada Council
Joint Purchase Award, 1959

Fugitive Articulation, 1959
oil on canvas
107 x 121.9 cm
MacKenzie Art Gallery, University
of Regina Collection

Heroic Mould, 1959
oil, Lucite 44 on canvas
183 x 121.8 cm
Collection of the Art Gallery of Ontario, Toronto,
Bequest of Charles S. Band, Toronto, 1970

Memory of Music, 1959
oil, Lucite 44 on canvas
81.3 x 100.3 cm
Collection of the Vancouver Art Gallery,
Purchased with the assistance of a Movable
Cultural Property grant accorded by the
Minister of Canadian Heritage

All Things Prevail, 1960
Lucite 44 on canvas
106.7 x 122.1 cm
Collection of the National Gallery of
Canada, Ottawa, Purchase, 1966

Elemental Fury, 1960
oil, Lucite 44 on canvas
120.8 x 136.7 cm
Collection of the Montreal Museum of Fine Arts,
Purchase, Horsley and Annie Townsend Bequest

Far Off Drums, 1960
oil, Lucite 44 on canvas
91.3 x 106.6 cm
Collection of the National Gallery of Canada,
Ottawa, Purchase, 1960

Growing Serenity, 1960
oil, Lucite 44 on canvas
91.5 x 106.8 cm
Collection of the Art Gallery of York University

Nature Evolving, 1960
oil, Lucite 44 on canvas
111.8 x 137.2 cm
Collection of the Art Gallery of Ontario, Toronto,
Purchased by Peter Larkin Foundation, 1962

NOTES ON AUTHORS

Anna Hudson is an art historian, curator, writer and educator specializing in Canadian art and visual culture. Formerly Associate Curator of Canadian Art at the Art Gallery of Ontario, Dr. Hudson is now an Associate Professor of Visual Art and Art History, and Associate Dean, in the Faculty of Fine Arts at York University in Toronto, Ontario. Extensive hands-on experience in institutional curatorial practice informs her teaching and research. Dr. Hudson is currently leading a major Social Sciences and Humanities Research Council of Canada Partnership Grant project titled "Mobilizing Inuit Cultural Heritage: a multi-media/multi-platform re-engagement of voice in visual art and performance" with ten researchers and nine partner organizations. In addition, she continues to pursue research in the area of her doctoral dissertation, *Art and Social Progress: the Toronto community of Painters (1933–1950)* and to publish on twentieth-century art and scientific humanism in Canada.

Michelle Jacques is Chief Curator of the Art Gallery of Greater Victoria. Prior to moving west, she held various curatorial positions in the contemporary and Canadian departments of the Art Gallery of Ontario, most recently as Acting Curator, Canadian Art. From 2002 to 2004 she was the Director of Programming at the Centre for Art Tapes in Halifax. Her curatorial projects at the AGO included *Brian Jungen: Tomorrow, Repeated* (2011); *At Work: Hesse, Martin, Goodwin* (2011), co-curated with Georgiana Uhlyarik; *All Together Now: Recent Toronto Art* (2008); and *Luis Jacob: Habitat* (2005–6). She was also the Founding and Lead Curator of the AGO's *Toronto Now* series (2010–13). Jacques has also taught writing, art history and curatorial studies at OCAD University, Toronto (2006–11); University of Toronto Mississauga (2006); and NSCAD University, Halifax (2003–4), and has written extensively for catalogues, journals and other publications.

Linda Jansma has been Curator of The Robert McLaughlin Gallery in Oshawa, Ontario since 1994 and was recently promoted to Senior Curator. She completed an Honours BA at Queen's University and an MA at the University of East Anglia, both in art history. She has curated and produced numerous exhibitions that have travelled nationally, including *The Collaborationists: Jennifer Marman and Daniel Borins* (2013), *Simone Jones: All That Is Solid* (2012), *Shelagh Keeley* (2010), *Gordon Monahan: Seeing Sound* (2010), *Walter Tandy Murch: The Spirit of Things* (2009) and *Kazuo Nakamura: The Nature of Things* (2001). She has written essays for catalogues dealing with both historical and contemporary art and has been the supervising curator of over 165 exhibitions for The RMG. She has also lectured widely and served on numerous juries.

Ian M. Thom is Senior Curator-Historical at the Vancouver Art Gallery, a position he has held since 1988. Prior to this, he held senior curatorial positions at the McMichael Canadian Art Collection and the Art Gallery of Greater Victoria. Thom has organized over 100 exhibitions on Canadian and international art and has published extensively on Canadian art, including monographs on David Milne, Emily Carr, Robert Davidson, Takao Tanabe, Gordon Smith, Arthur Lismer, E. J. Hughes and Maxwell Bates. He has lectured widely and has consulted with many museums regarding their collections and collecting policies. Widely recognized as an authority on the work of Emily Carr, Thom is a member of the Order of Canada.

CURATORIAL ACKNOWLEDGEMENTS

Anyone studying Jock Macdonald owes an enormous debt of gratitude to the work of previous scholars. R. Ann Pollock and Dennis Reid made significant contributions to our understanding of Macdonald's work in the *Jock Macdonald Retrospective Exhibition* (1969–70). Most important, however, is the work of Dr. Joyce Zemans. Her magisterial *Jock Macdonald: The Inner Landscape* (1981) remains an invaluable resource for anyone who wishes to study Macdonald's life and work. The present exhibition has benefited enormously from her pioneering work.

This project would not have been possible without the generous cooperation of institutions in Canada and Scotland that loaned works and provided research and other support for the project. We thank Jan Allen and Alicia Boutilier, Agnes Etherington Art Centre, Kingston; Louise Dompierre, Tobi Bruce and Christine Braun, Art Gallery of Hamilton; Matthew Teitelbaum, Andrew Hunter and Greg Humeniuk, Art Gallery of Ontario, Toronto; Catharine Mastin, Art Gallery of Windsor; Barbara Fischer and Christopher Régimbal, Justina M. Barnicke Gallery, Hart House, Toronto; Marc Mayer, Cyndie Campbell, Christopher Davidson, Philip Dombowsky and Charles C. Hill, National Gallery of Canada, Ottawa; Jeremy Morgan and Timothy Long, Mackenzie Art Gallery, Regina; Ihor Holubizky, McMaster Museum of Art, Hamilton; Dr. Victoria Dickenson and Chris Finn, McMichael Canadian Art Collection, Kleinburg; Nathalie Bondil and Jacques des Rochers, Musée des Beaux-Arts de Montréal; Brian Meehan, Museum London; Dr. Stephen Borys and Andrew Kear, Winnipeg Art Gallery; Philip Monk and Allyson Adley, York University Art Gallery, Toronto; and Dr. Simon Groom, Catriona Gourlay and Kirstie Meehan, Scottish National Gallery of Modern Art, Edinburgh.

Additional support was provided by Gregory Betts, Oliver Botar, Yves M. Laroque, Alasdair Macdonald, Lee Ann Montanaro, Iris Nowell, Michel Remy, Nigel Walsh and Marilyn Westlake. We extend our very sincere thanks to you all for generously sharing your knowledge of Macdonald and his work.

We are grateful to Cheryl O'Brien for her photography of works in private collections in Toronto, as well as to the photographers who are listed in the image credits.

We are also extremely grateful to the Royal Bank of Canada, Libby Fine Art and nine private lenders who wish to remain anonymous.

We are grateful to the staff at each of our institutions: at the Vancouver Art Gallery, particular thanks go to Daina Augaitis, Kathleen S. Bartels, Danielle Currie, Glen Flanderka, Julia Hulbert, Amber McBride, Trevor Mills, Adrienne Rempel, Cheryl Siegel, Susan Sirovyak, Monica Smith, Joanna Spurling, Tracy Stefanucci, Kim Svendsen, Rachel Topham, Bruce Wiedrick and Jenny Wilson; at The Robert McLaughlin Gallery, to Olinda Casimiro, Jason Dankel, Sonya Jones, Gabrielle Peacock and Megan White; and at the Art Gallery of Greater Victoria, to Gillian Booth, Corey Bryson, Roger Huffman, Stephen Topfer, Jon Tupper and Nicole Stanbridge.

We thank Dr. Anna Hudson for her insightful contribution to the publication. Duncan McCorquodale and the staff at Black Dog Publishing have been excellent to work with and the results of this collaboration mean that Macdonald's work will reach a far wider audience in Canada and abroad.

The project has been funded by a major grant from the Museums Assistance Program of the Department of Canadian Heritage and we are grateful for this support of historical scholarship. We would also like to acknowledge the support of the City of Oshawa, the Canada Council for the Arts, the Ontario Arts Council, the British Columbia Arts Council, the City of Vancouver and the Capital Regional District for their support of our respective institutions.

— Michelle Jacques, Chief Curator, Art Gallery of Greater Victoria
 Linda Jansma, Senior Curator, The Robert McLaughlin Gallery
 Ian M. Thom, Senior Curator-Historical, Vancouver Art Gallery

IMAGE CREDITS

Published in conjunction with *Jock Macdonald: Evolving Form*, an exhibition organized by the Art Gallery of Greater Victoria, The Robert McLaughlin Gallery and the Vancouver Art Gallery, and curated by Michelle Jacques, Linda Jansma and Ian M. Thom.

EXHIBITION SCHEDULE

Vancouver Art Gallery
October 18, 2014 to January 4, 2015

The Robert McLaughlin Gallery
January 31 to May 24, 2015

Art Gallery of Greater Victoria
June 12 to September 7, 2015

PUBLICATION CREDITS

Editors: Michelle Jacques, Linda Jansma, Ian M. Thom
Editing: Leanne Hayman, Black Dog Publishing and Tracy Stefanucci, Vancouver Art Gallery
Design: Amy Cooper-Wright, Black Dog Publishing
Publication coordination: Tracy Stefanucci
Photography and digital image preparation: Trevor Mills, Vancouver Art Gallery
Rights and Reproductions: Danielle Currie, Vancouver Art Gallery
Printed in the UK

Cover image: Jock Macdonald, *Etheric Form*, 1934 (detail), oil on panel, 38.1 x 30.5 cm, Collection of the Vancouver Art Gallery, Gift from an Anonymous Donor

Jock Macdonald: Evolving Form is generously supported by the Government of Canada through the Museums Assistance Program of the Department of Canadian Heritage.

Art Gallery of Greater Victoria is a not-for-profit organization funded in part by the Capital Regional District, the Province of British Columbia through the British Columbia Arts Council and the Ministry of Housing and Social Development, the Canada Council for the Arts, and the City of Victoria. Additional support is provided by Art Gallery of Greater Victoria members, donors and private sector partners.

The Robert McLaughlin Gallery is a not-for-profit organization supported by its members, individual donors, corporate funders, endowments, the City of Oshawa, the Ontario Arts Council, the Museums Assistance Program of the Department of Canadian Heritage, and the Canada Council for the Arts.

Vancouver Art Gallery is a not-for-profit organization supported by its members, individual donors, corporate funders, foundations, the City of Vancouver, the Province of British Columbia through the British Columbia Arts Council, and the Canada Council for the Arts. The Vancouver presentation of *Jock Macdonald: Evolving Form* is supported by Barry and Drinda Scott.

Vancouver Art Gallery Visionary Partner Supporting Publications:
The Richardson Family

Vancouver Presenting Sponsor: NORTHERN GATEWAY

Black Dog Publishing
10a Acton Street
London WC1X 9NG, UK
www.blackdogonline.com

Art Gallery of Greater Victoria
1040 Moss Street
Victoria, BC, Canada V8V 4P1
www.aggv.ca

The Robert McLaughlin Gallery
72 Queen Street, Civic Centre
Oshawa, ON, Canada L1H 3Z3
www.rmg.on.ca

Vancouver Art Gallery
750 Hornby Street
Vancouver, BC, Canada V6Z 2H7
www.vanartgallery.bc.ca

Dear friend,

Northern Gateway is honoured to be the lead sponsor of *Jock Macdonald: Evolving Form*, the Vancouver Art Gallery's extraordinary new exhibition of the artist's work.

In planning this presentation, Gallery curators have paid tribute to the energy and vitality of a Canadian artist whose influence stretches across borders and generations. An artist and a teacher, Jock Macdonald became one of our nation's leading voices in abstract art, making a powerful contribution to Canada's unique twentieth century artistic voice. In doing so, Macdonald helped to chart new creative paths for many young and emerging artists to follow.

Northern Gateway is also proud to support the Vancouver Art Gallery, an institution that well reflects our country's artistic confidence and dynamism. Northern Gateway's sponsorship is part of our commitment to make a lasting difference to communities by helping showcase our county's magnificent artistic and cultural diversity.

Everyone on the team would like to welcome you to the Gallery and to thank you for supporting the arts in Canada.

Sincerely,

Janet Holder
Leader, Northern Gateway